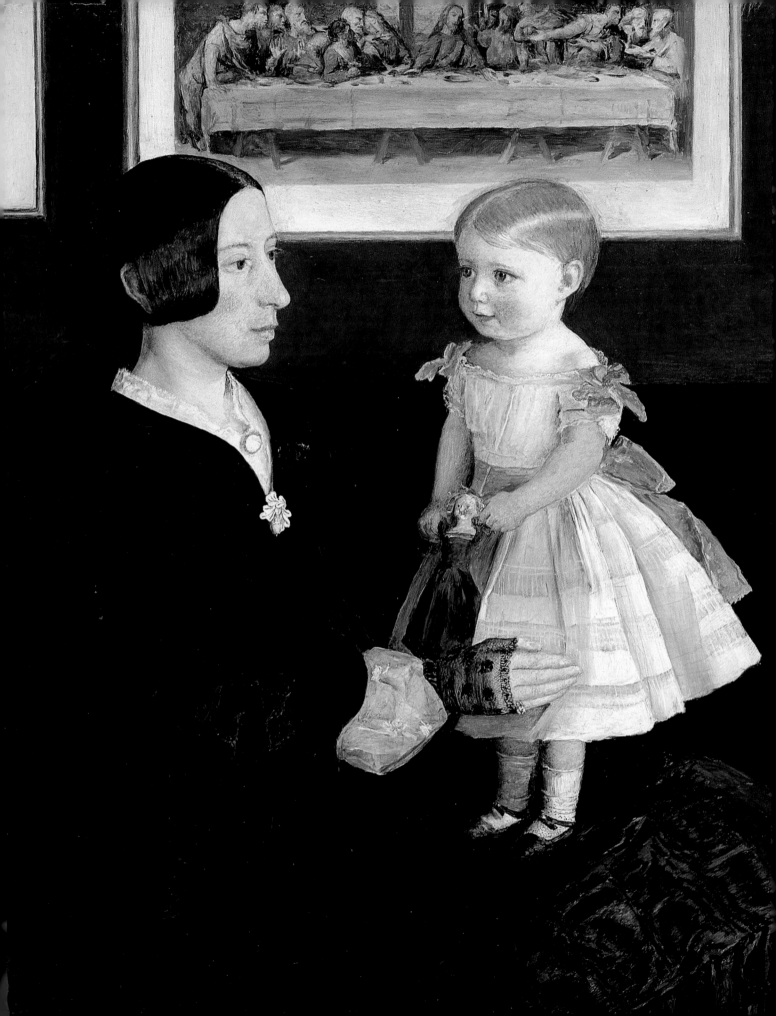

MILLAIS

PORTRAITS

PETER FUNNELL

MALCOLM WARNER

KATE FLINT

H.C.G. MATTHEW

LEONÉE ORMOND

PRINCETON UNIVERSITY PRESS

Published to accompany the exhibition
Millais: Portraits
held at the National Portrait Gallery, London
from 19 February to 6 June 1999

First published in North America by
Princeton University Press
41 William Street
Princeton, New Jersey 08540-5237

Published in Great Britain by
National Portrait Gallery Publications
National Portrait Gallery
2 St Martin's Place, London WC2H OHE

ISBN 0-691-00719-5 (cloth)
ISBN 0-691-00720-9 (paperback)

Library of Congress Catalog Card Number:
98–67804

10 9 8 7 6 5 4 3 2 1

Publishing Manager Jacky Colliss Harvey
Project Manager and Editor Jane Havell
Picture Research Susie Foster
Designer Tim Harvey
Printed in London by PJ Reproductions Ltd

Front cover/jacket
Twins, 1876, private collection
Detail of cat. no. 51

Back cover/jacket
John Ruskin, 1853–4, private collection
Cat. no. 23

Title pages
Eliza Wyatt and her Daughter, Sarah
*c.*1850, Tate Gallery, London
Detail of cat. no. 5

With support from the American Friends of the
National Portrait Gallery

CONTENTS

FOREWORD

One of the great virtues of the National Portrait Gallery's 1996 redisplay of its first-floor galleries was that it separated the formal, political portraits from those with a more obvious narrative and thematic content. The political portraits were placed down the long central aisle between marmoreal busts in a modern-day version of a Victorian 'hall of fame'. The result has been to place a spotlight – quite literally – on the conventions of Victorian portraiture and to make visitors look at, as well as think about, how Victorian political grandees wanted to be remembered.

Halfway down the central hall are two transepts. In the right-hand one are the portraits of George Frederic Watts, a number of which are widely familiar – attractive and accessible works which have for some time been part of the literature of Victorian painting. In the left-hand transept are two separate, but paired, works by John Everett Millais of the great Victorian statesmen, William Ewart Gladstone and Benjamin Disraeli. They are unexpectedly resonant images, concentrating on the character of the sitters rather than the appurtenances of their office, stripped down to the essentials of their personalities.

1996 was not only the year in which the National Portrait Gallery refurbished its first-floor galleries, but also the centenary of Millais's death. Had his reputation not declined to such a remarkable extent and were he remembered not only for his early Pre-Raphaelite phase but also for his contribution to late Victorian painting, it ought to have been the year for a major retrospective exhibition. Instead, the centenary was marked only by a small biographical exhibition in Southampton. So Peter Funnell, the Gallery's nineteenth century curator, suggested that we ought to consider holding an exhibition that would survey Millais's work as a portraitist. It was thought that a fairly tight definition of portraiture – as opposed to genre pictures using named models – would produce a focused and coherent exhibition suitable for our Wolfson Gallery. It was essential that we should include the finest of his Pre-Raphaelite portraits, especially his great portrait of John Ruskin, but we also wished to place equal emphasis on Millais's late work, when he was by far the best-known and most successful, as well as the most highly paid, portrait painter of the late Victorian era.

As such, this exhibition is a work of scholarly restitution. So much of the literature of art history is teleological, looking for pioneers of future artistic developments, that it is often apt to neglect those artists who have chosen to work in the mainstream rather than

the avant-garde. Millais was despised by his more aesthetically minded contemporaries as being too prosperous and too socially conventional really to be taken seriously as an artist. As Peter Funnell shows in his excellent essay in this volume, this has tended to be the judgement of later critics. But if we are to look at portraits not only as works of art but also as documents of social history, then it is essential that we should take seriously the major artistic figures of any period. Millais, who was made a baronet by Gladstone and painted four prime ministers, is surely deserving of better treatment than he has previously received from those who have written about nineteenth-century painting. Indeed, it is our hope that visitors to the National Portrait Gallery in the last year of the late twentieth century will be just as able to appreciate the virtues of the work of the late Millais as were his contemporaries.

As with any exhibition, this has been a work of collaboration. I would especially like to record our gratitude to Malcolm Warner who, as consultant curator to the exhibition, has brought his enormous knowledge of Millais to bear on all aspects of the project. Not only has he helped us to locate a number of portraits for the exhibition, he was also able to find time to contribute all the catalogue entries to this book and thus enable us to include a wealth of previously unpublished research. But most of all I would like to thank Peter Funnell, who has steered the exhibition from its inception, who worked with Malcolm Warner on the selection of appropriate exhibits, and who has ensured that this catalogue is a work of scholarship which will retain its usefulness long after the exhibition has closed.

Charles Saumarez Smith
Director, National Portrait Gallery

ACKNOWLEDGEMENTS

It became apparent at an early stage in this project that many of Millais's most significant portraits were little known, even to enthusiasts for Victorian painting. Some that were widely admired when Millais first exhibited them have remained in family collections, never again to appear in public; others have put in a brief appearance on the art market and returned again to private ownership. First and foremost, then, we are deeply grateful to the private lenders to the exhibition, some of whom are credited in the catalogue while others preferred to remain anonymous. All showed great kindness when we first approached them and have been most generous in parting with their paintings for the duration of the exhibition. Special thanks must go to Geoffroy Millais who, as well as lending, has been characteristically helpful and encouraging during work on the exhibition.

In addition to private lenders, colleagues in institutions both here and abroad responded sympathetically to our requests for loans and ensured their efficient administration. We would like to thank: Alison Brown (City of Aberdeen Art Gallery); Colin Harrison, Sarah Herring, Jon Whiteley (Ashmolean Museum, Oxford); Jane Farrington, Reyahn King, Elizabeth Smallwood (Birmingham Museums and Art Gallery); Janice Reading, Kim Sloan (British Museum, London); Christopher Baker, Dennis Harrington (Christ Church, Oxford); Stephen Bruni, Mary F. Holahan (Delaware Art Museum, Wilmington); George Keyes, Michelle Peplin (Detroit Institute of Arts); Jane Munro, Duncan Robinson, David Scrase, Thyrza Smith (Fitzwilliam Museum, Cambridge); Michael Day, Louise Downie (Jersey Museums Service); Alex Kidson, David McNeff (National Museums and Galleries on Merseyside); Julian Gibbs, Margaret Reid (The National Trust); Laurence Des Cars, Henri Loyrette (Musée d'Orsay, Paris); Gemey Kelley (Owens Art Gallery, Mount Allison University, Sackville, New Brunswick); Charles E. Pierce, Jr. (Pierpont Morgan Library, New York); Brian Glover, Deana Mitchell (RSC Collection, Stratford-upon-Avon); Stephen Wildman (The Ruskin Library, University of Lancaster); Jon Astbury and Robin Hamlyn (Tate Gallery, London). Others who have given invaluable help and advice include Betty Beesley, Martin Beisly, Laurel Bradley, Katie Coombs, Marion Hill, Peter Johnson, Christopher Kingzett, Loveday Manners-Price, Catherine Richardson, Vern Swanson, Simon Taylor and Christopher Wood.

From the outset, we saw the exhibition as an opportunity to produce a book that would consider Millais's portraiture within its broader artistic and historical context while

remaining closely anchored to the exhibition through the catalogue entries. It is a pleasure to thank our fellow authors – Kate Flint, H.C.G. Matthew and Leonée Ormond – for so readily agreeing to contribute essays and for bringing to the subject a wide range of scholarship and intellectual approach. Jacky Colliss Harvey, the Gallery's Publishing Manager, has ensured the book's steady progress from its inception; Jane Havell has edited and managed a complex project with great skill; and the book owes its elegant design to Tim Harvey.

At the National Portrait Gallery, we are grateful to Charles Saumarez Smith for showing his usual keen interest in, and support for, the project throughout. In the Exhibitions Department, Christine Byron and Martha Brookes have been models of efficiency and hard work in taking care of all practical and organisational aspects of the exhibition. The Gallery's designer, Annabel Dalziel, gave invaluable advice throughout the planning phase and, having left the Gallery to live in New York, generously returned to prepare the final design and graphics. Sophia Plender and Richard Hallas looked after the conservation of a number of paintings and their frames; John Cooper has arranged an attractive lecture series to accompany the exhibition; and Pim Baxter, Kate Crane, Emma Marlow and Ben Rawlingson Plant have worked hard to ensure that the exhibition was funded, marketed and publicised. Other colleagues we would like to thank include Susie Foster, Timothy Moreton, Terence Pepper and Jill Springall.

Peter Funnell and Malcolm Warner

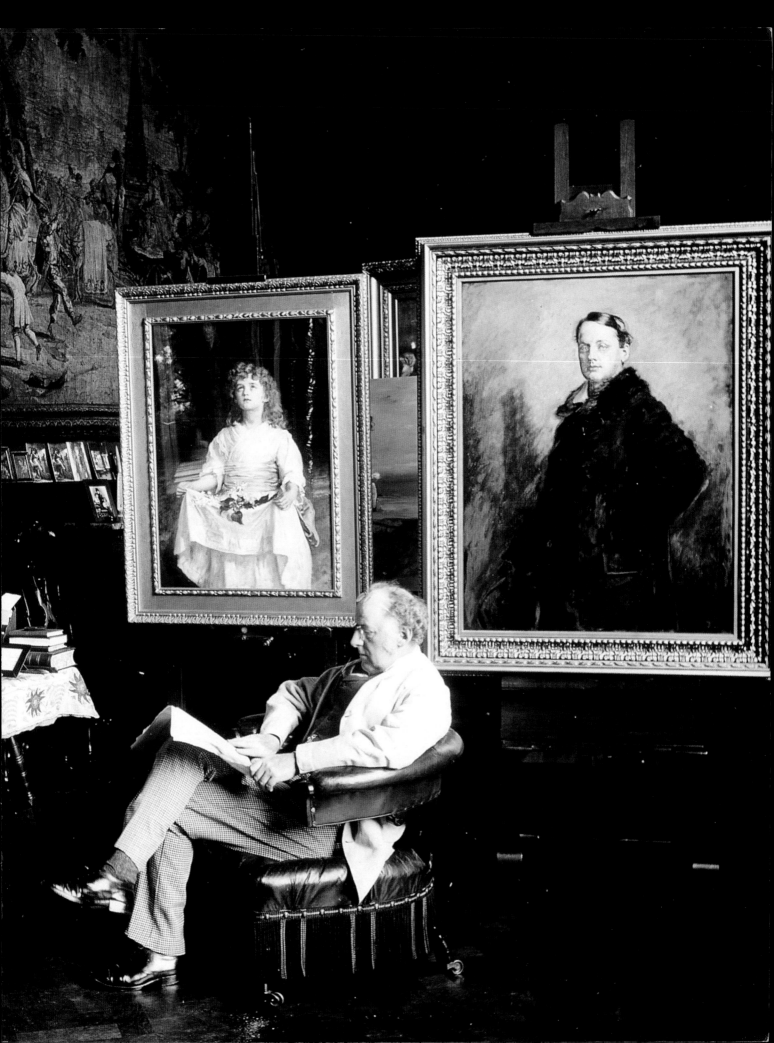

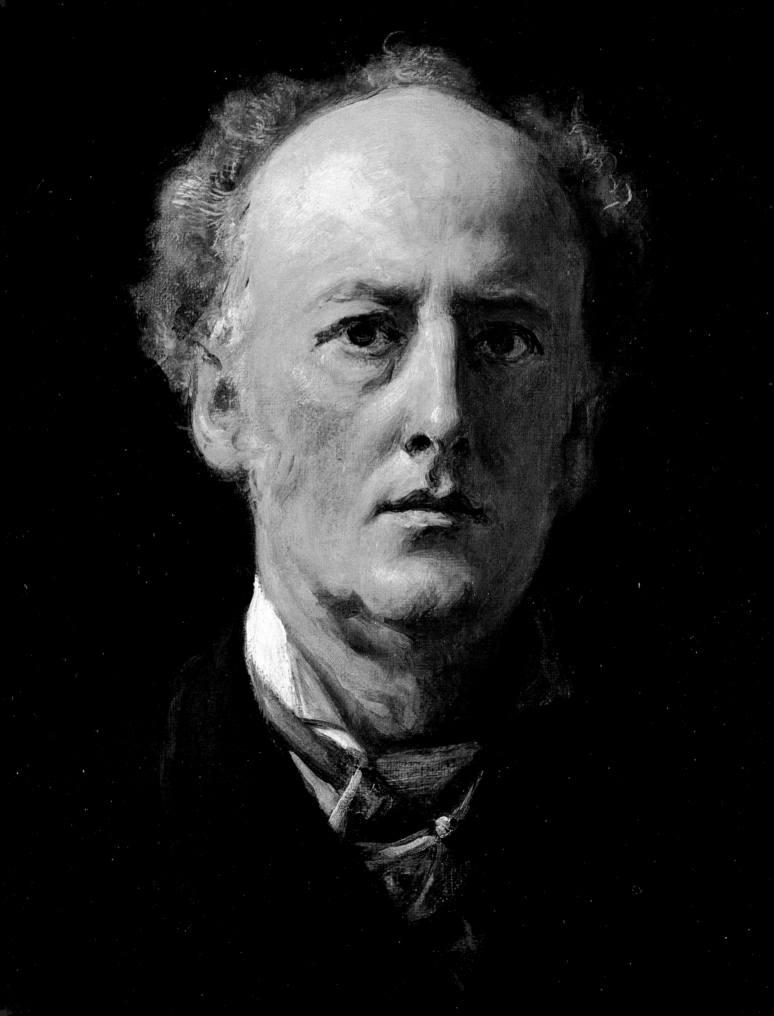

INTRODUCTION

Millais's Reputation and the Practice of Portraiture

Peter Funnell

Writing in the October 1896 issue of *The Savoy* magazine, Arthur Symons reflected on what had been said of Millais in the weeks since the artist's death on 13 August:

> In the eulogies that have been justly given to the late President of the Royal Academy, I have looked in vain for this sentence, which should have its place in them all: he did not make the 'great refusal.' Instead of this, I have seen only: he was English, and so fond of salmon-fishing.[1]

Entitled 'The Lesson of Millais', Symons's short essay presents a damning verdict on Millais's career. Reviewing the early phase of Millais's life, he writes that he had 'a finer promise than any artist of his time', producing 'masterpiece after masterpiece' up to his election to the Royal Academy. But from then until his death, Symons says, 'he painted continuously, often brilliantly, whatever came before him, Gladstone or Cinderella, a bishop or a landscape':

> He painted them all with the same facility and the same lack of conviction; he painted whatever would bring him ready money and immediate fame; and he deliberately abandoned a career which, with labour, might have made him the greatest painter of his age, in order to become, with ease, the richest and the most popular.[2]

The charge is not, of course, that Millais's art suffered merely from a 'falling-off' after a promising start. Rather it showed a repudiation, an exchange, in Symons's words, from 'labour' to 'ease': it was a 'selling out'. A leading proponent of the avant-garde in poetry and art, Symons's artistic allegiances are clear from the context of this issue of *The Savoy*, of which he was editor. With its cover and title-page by Aubrey Beardsley, and stories, essays and poetry by Joseph Conrad, Havelock Ellis and Ernest Dowson, it could barely be more culturally distanced from Millais's later paintings, works evoked by Symons in the phrase 'Gladstone or Cinderella, a bishop or a landscape'. Yet – although he would regard the one as the consequence of the other – it is not so much Millais's painting that Symons attacks as the way he conducted his career: the image of Millais as the respectable English Academician who was 'so fond of salmon-fishing'. He comes back to this at the end of his brief essay, to introduce a striking antithesis between Millais and another artist,

Frederick Henry Evans
Arthur Symons
Platinum print
197 × 133mm (7¾ × 5¼")
*c.*1895–1900
National Portrait
Gallery, London

who exemplified for Symons how the artistic life should be led. 'My thoughts have turned,' Symons writes,

> as I read these commendations of the good citizen, so English, so sporting, whose private virtues were so undeniably British, to a painter, also a man of genius, whose virtues were all given up to his art, and who is now living in a destitute and unhonoured obscurity.[3]

This artist is not named, and it was only when Symons republished 'The Lesson of Millais' in *Studies in Modern Painters* in 1925 that he identified him as Simeon Solomon. A protégé of the Rossetti strand of Pre-Raphaelitism that Symons admired, Solomon had effectively led the life of an artistic outcast since his trial in 1873 for an act of gross indecency with a George Roberts in a public lavatory off Oxford Street. In the cautious atmosphere of 1896, following the trials of Oscar Wilde and the outrage provoked by the *The Yellow Book*, Symons's reticence is understandable. But for those of his circle who would surely have recognised the allusion, the contrast would have seemed subversive indeed. In Solomon's 'immaculate devotion to art, I find the true morality of the artist', he concludes while, in Millais's 'respectability', he finds only 'a desecration of the spirit'.[4]

Although, as we shall see, Symons was not the only one to question Millais's achievement in the period immediately following his death, his was an extreme position.

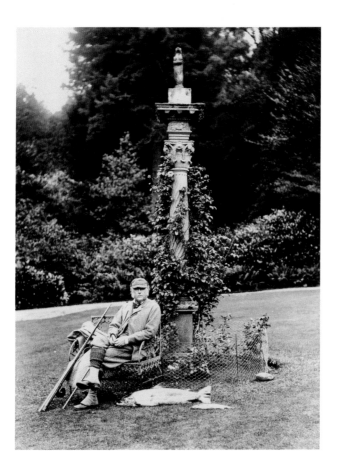

Rupert Potter
Millais at Dalguise
Albumen print
215 × 158mm
(8½ × 6¼")
29 August 1881
National Portrait
Gallery, London

Indeed, its polemic turns on challenging a consensus and, with a measured air of dissidence, in opposing Millais's establishment position with the example of an artistic outsider in the person of Solomon. None the less, Symons's version of Millais has become, by and large, the orthodox way of reading his career during this century. In the 1960s, when Victorian painting was being 'rediscovered', the supposed divide between Millais's Pre-Raphaelite work and the much derided 'later' paintings was, if anything, intensified. In his invaluable 'bibliocritical study' of the Pre-Raphaelite movement published in 1965, William E. Fredeman seized upon Symons's essay as the 'best and most succinct statement of Millais's giant failure', writing that Millais 'threw over the greatest promise of any artist of the century'. He 'renounced the revolutionary affiliations of his youth', Fredeman writes, 'to become the most popular and most highly remunerated painter in England.' Apart from the narrative appeal of this shift from rebel to respectability, there is a sense that to reclaim one portion of Victorian art – Pre-Raphaelitism – it was necessary to revile other aspects of Victorian painting that most sullied its reputation. For Fredeman, 'late Millais' epitomised those aspects which, he continues, 'confirmed the sentimental and saccharine values of the middle classes'.[5] Two years later, an attempt at a 're-appraisal of his later paintings'[6] was made by Mary Bennett in her major survey exhibition of Millais's works, held in 1967 at the Royal Academy and the Walker Art Gallery, Liverpool. Bennett's astute survey of Millais's career in the

exhibition catalogue argues the case well. But for Keith Roberts, writing in the *Burlington Magazine*, the 'lack of vision' revealed by the later pictures was a 'fatal deficiency' and the exhibition as a whole 'a disaster'.[7] Likewise, for the reviewer in *Country Life*, 'this exhibition confirms the justness of the usual account' of Millais: 'that while still a young man he sold his genius for a mass of sovereigns'.[8] Not surprisingly, no attempt has since been made to mount a large-scale retrospective of Millais's works. Malcolm Warner organised two small exhibitions in 1979 and, while Leighton's centenary was celebrated by a large show at the Royal Academy in 1996, a more modest exhibition at Southampton marked the anniversary of Millais's death. Even then, the exhibition co-organiser found it necessary to spend a paragraph or two in her catalogue essay repudiating Alan Bowness's 1984 criticism of Millais's later works for having 'such vacuity behind the conception'.[9]

Although confined to just one aspect of Millais's work, *Millais: Portraits* is therefore the largest exhibition of his paintings to be held since Bennett's retrospective, more than thirty years ago. By focusing on his portraiture, it necessarily ranges from the Pre-Raphaelite period to the later, commissioned portraits, works that helped secure for Millais the wealth and social status he enjoyed during his lifetime but that, in part, have made his reputation so contested since his death. Indeed, part of the interest of the exhibition should be the striking contrast between the small, minutely detailed portraits on panel of the Pre-Raphaelite years and the austere, broadly painted portraits of the great public figures of the late Victorian period; between the originality of his great portrait of John Ruskin (cat. no. 23) and a painting such as *Hearts are Trumps* with its self-conscious reference to eighteenth-century British portraiture and its paint laid on in thick skeins of impasto. It is, of course, hoped that visitors to the exhibition will find much to enjoy and value in the later portraits. But the exhibition has been prompted less by motives of 're-appraisal' than by a belief that these later portraits are of unquestionable historical importance. For his contemporaries, Millais was the foremost British practitioner of portraiture in the 1870s and 1880s, and the display at the annual Royal Academy exhibitions of works such as *A Jersey Lily* of 1877–8 (cat. no. 52) or *Disraeli* of 1881 (cat. no. 41) were significant public events. It was with this in mind – the belief that the special interest of these later portraits lies in their being powerful expressions of a particular historical culture – that the decision was taken to divide them by type and gender, rather than to adopt the usual convention of monographic exhibitions of arrangement by strict chronology. Both in the exhibition and the essays in this book, it is hoped that these divisions will enable the portraits to be reinvested with at least some element of their contemporary cultural significance. Nevertheless, the problem of Millais's reputation remains, and I would like to consider further the terms in which his career was understood by his contemporaries before turning to his practice as a portraitist.

Symons's complaint, that all he had read of Millais was that 'he was English, and so fond of salmon-fishing', will be instantly familiar to anyone who has even glanced at the

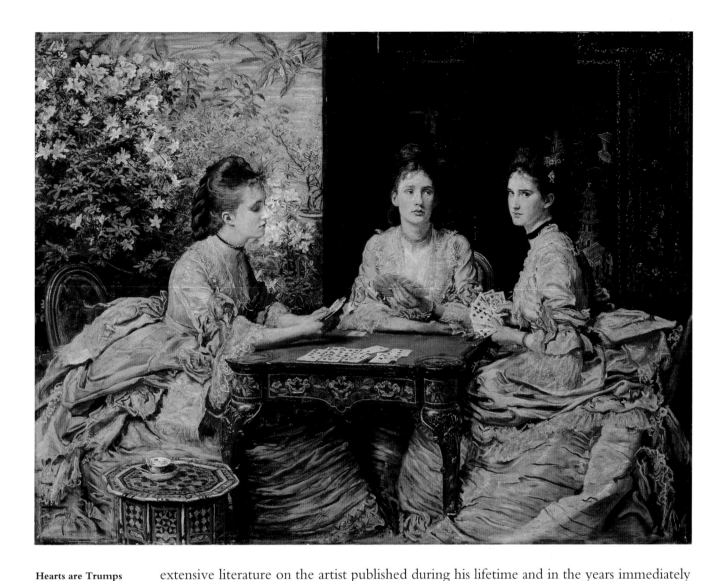

Hearts are Trumps
Oil on canvas
1657 × 2197mm (65¼ ×
86½")
Signed with monogram
and dated 1872, lower
left
Tate Gallery, London
Cat. no. 48

extensive literature on the artist published during his lifetime and in the years immediately after his death. Millais's self-presentation, with its emphasis on conventional dress and annual sporting trips to the Highlands, contributes powerfully to this image. As Walter Armstrong wrote in 1885, approvingly noting Millais's 'high brow and sharply chiselled features', he was 'such a figure as we have come to associate rather with field sports and high farming than with the Fine Arts'.[10] This persona was readily exploited in the many 'celebrity' pieces that appeared in the popular periodicals of the period. John Underhill, writing in the *Review of Reviews*, 'found a delightful breeziness about the man, a freshness which suggests the heather-clad moors of which he is so passionately fond' and also 'a man of simple tastes': 'give him his pipe – a short briar for preference – a comfortable chair and a pack of cards . . . and he is happy.'[11] Such verbal descriptions and evocations were supplemented by wood engravings of Millais seated in his studio reading *The Times* or, a favourite for inclusion in the many 'character sketches' of the artist, Rupert Potter's photograph of him at Dalguise wearing tweeds and a deerstalker, with a gigantic salmon – not 'far short of fifty pounds', Armstrong reckoned[12] – on the grass before him (page 15).

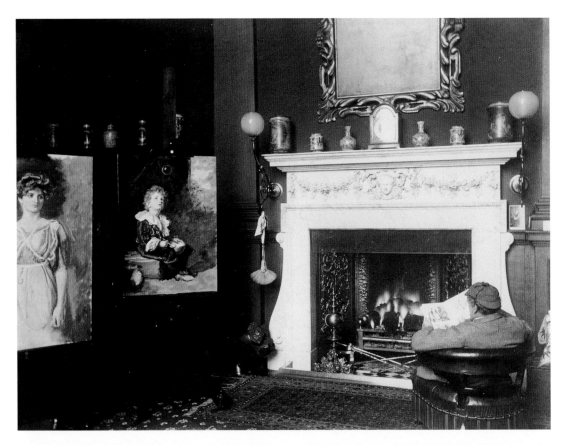

Rupert Potter, a close friend of Millais and father of Beatrix Potter, produced a remarkable photographic record of Millais's studio at Palace Gate, Kensington, London, during the 1880s, including paintings in various stages of completion.

Millais in his studio
with his famous *Bubbles* and, far left, *Portia*
Albumen print, 169 × 223mm (6⅝ × 8¾")
December 1885
National Portrait Gallery, London

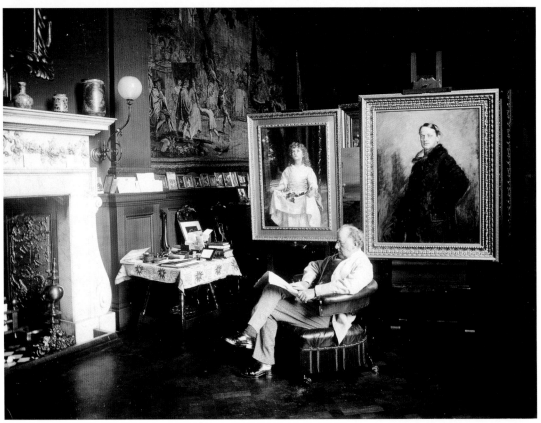

Millais in his studio
with *Lilacs* and his unfinished portrait of Archibald Philip Primrose, 5th Earl of Rosebery (cat. no. 47)
Albumen print, 160 × 215mm (6¼ × 8½")
July 1886
National Portrait Gallery, London

Millais's studio

Albumen print, 170 × 217mm (6⅝ × 8⅛")
31 March 1882
National Portrait Gallery, London
On easels, from the left, are *Evelyn Otway*, *Dorothy Thorpe*, *Sir Henry Thompson* (cat. no. 43) and *Lucy Stern*; hanging on the wall above is *Sophie Caird* (cat. no. 53).

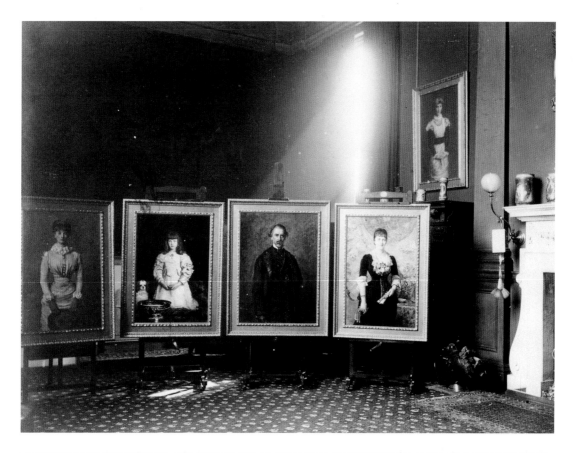

Millais's studio

Albumen print, 165 × 215mm (6½ × 8½")
5 July 1885
National Portrait Gallery, London
Shown, from the left, are unfinished paintings of Thomas Oldham Barlow, the Christ Church portrait of William Ewart Gladstone (cat. no. 46) after two sittings (see page 32, right) and *Little Nell and her Grandfather*.

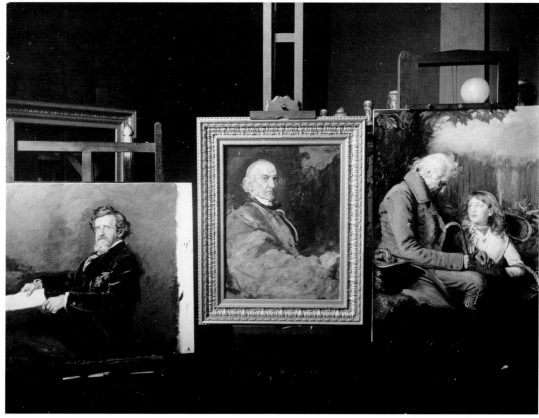

F.G. Kitton
**Millais's House
at Palace Gate,
Kensington**
Published as a wood
engraving in Walter
Armstrong, 'Sir John
Everett Millais, Royal
Academician. His Life
and Work', *Art Annual*
(Christmas number of
the *Art Journal*), 1885

These qualities of simplicity and straightforwardness can also be found in accounts of that most public expression of Millais's success, the large house at Palace Gate, Kensington, which he had built in the late 1870s. Prominent in what might be called the 'artist at home literature' of the period, Palace Gate was seen as a metaphor for its owner and his position in the art world: it was 'characteristic of the man', Armstrong wrote, 'a great plain square house'[13] or, to the writer in the *Magazine of Art* in 1881, 'an artist's house into which the aestheticism of the day does not enter; no, not by so much as a peacock fan.'[14]

These outward signs of Millais's character – plain and unaffected – contribute to a powerful composite image of Millais and his art, an image registered as 'manly' and which is readily transferable between his personality and his paintings.[15] Prefacing the catalogue to Millais's small one-man exhibition at the Fine Art Society in 1881, Andrew Lang wrote that his 'works of the last fifteen years have exhibited Mr Millais in the perfection of his power, as the strongest, manliest, and most certain in his aims, of all modern English painters.'[16] Similar qualities were remarked by another commentator at this time, reported in the *Art Journal*: Millais 'never wavered', but was 'a man of incomparable strength, and endurance like granite'.[17] There is, of course, no sense in such writings of the disjunction between 'early' and 'late' Millais. Rather his career was interpreted as a great and magisterial progression, moving from success to success, to a glorious maturity in which he was found to rival the greatest artists of the past. For Armstrong, 'in the whole of the painter's career there has been neither abrupt change nor a moment of stagnation.'[18] In

these accounts, Millais's Pre-Raphaelite phase was viewed either as a diversion – a quitting of the 'track prepared by ages of experience',[19] in Armstrong's words – or a period of technical preparation for the great works that were to come. Yet Millais's character was registered not only in terms of manly strength. Traits of rugged geniality and an unerring sociability were equally important, and were found to distinguish Millais as being quintessentially English: in the words of the critic Marion Harry Spielmann, as 'a type of the English gentleman, as the *beau idéal* of John Bull'.[20] Thus Spielmann ended his obituary in the *Magazine of Art* by evoking an encounter with the artist in his studio. The 'beloved briar' is between Millais's teeth, the 'travelling cap of tweed' worn 'rakishly on one side' is thrown off to reveal 'a hairy nimbus, like a laurel wreath, lovingly placed by the crowning hand of time'; the 'strong voice . . . sounds fresh and hearty to my ears; the powerful kindly hand is placed with genial roughness on my shoulder.' He appeared, Spielmann wrote, as 'a great, jolly Englishman, unaffected as a schoolboy', 'Anglo-Saxon from skin to core . . . vigorous and full of bluff, full of healthy power of body and mind. I see him true, straightforward, honest.'[21]

Millais's Englishness was celebrated again and again after his death. A review by Claude Phillips of the 1898 Royal Academy memorial exhibition of Millais's works took on an elegiac note, Phillips reflecting on the importance 'of one as thoroughly English' as Millais at a time 'when national landmarks and local characteristics are so fast disappearing'.[22] Or it could be construed with imperialist overtones. As A.L. Baldry wrote in his 1899 book on the artist, 'he was typically English, in the best sense, with all the physical and mental attributes that have enabled our race to dominate the world.'[23] Yet this variously faceted impression of Millais's English manliness found no more powerful expression than in the two thick volumes of biography published in 1899 by his son, John Guille Millais. Rambling and anecdotal, illustrated by poor half-tone reproductions which have probably done more harm than good to Millais's reputation, his son's biography is concerned less with an appreciation of the paintings than with the outward signs of Millais's success – his sporting holidays, the important social connections, the baronetcy, the honours awarded by foreign societies, with the consequent letters of congratulation faithfully transcribed. For the *Edinburgh Review*, it consisted of 'portions' that were 'not much else than an expanded catalogue; others that might be compiled from a visiting list, and a third series again which are like an angler's daybook.'[24] As H.C.G. Matthew notes later in this book, the emphasis on Millais's sportsmanship may well have reflected the son's own passions. But this, like the biography as a whole, can also be seen as a gigantically developed extension of the preoccupation with Millais's 'character' that I have been describing. Many of the earlier writers, Armstrong and Spielmann among them, are treated to lengthy quotation, as are a host of further testimonies specifically requested for the book.

Although there is little sense in these writings that Millais's reputation was even open to question, J.G. Millais dimly conjured up a possible source of cultural opposition when

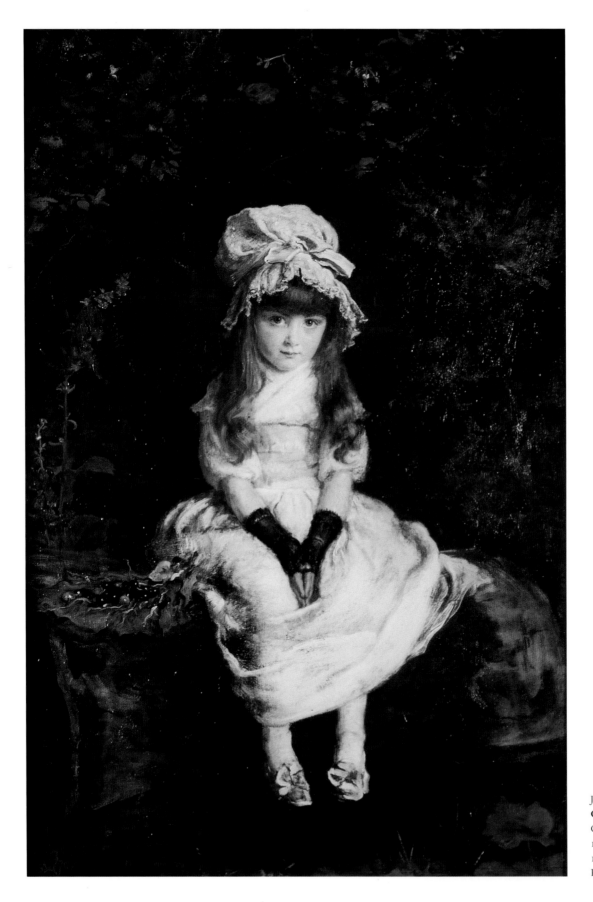

John Everett Millais
Cherry Ripe
Oil on canvas
1346 × 889mm (53 × 35")
1879
Private collection

contrasting his father's dress sense with 'the affectation of the long-haired and velvet-coated tribe',[25] while Baldry more outrightly asserted Millais's exemplary difference from this same 'tribe' when he wrote of 'his manly wholesomeness' as being 'without taint of modern decadence or morbidity'.[26] They were presumably alluding to that circle of 'aesthetes' and 'decadents' for whom Symons was such a prominent spokesman; although the values are reversed, they introduced an antithesis similar to the one Symons made in 'The Lesson of Millais'. This antithesis raises questions of art world factionalism and artistic, specifically masculine, self-styling, but it is also underpinned by broader issues concerning the position of the artist in society. These concerns were at the heart of Symons's essay, and explain why Millais was a key target for him and why 'the lesson of Millais' was such an important one to be learnt. As we have seen, Symons's true artist was one like Solomon, who lived on the margins of society, 'whose virtues were all given up to his art', an art that took little notice of the circumstances of the time in which he lived or of the demands of the market. Millais, however, 'made the democratic appeal': 'he chose his subjects in deference to the appeal of the middle classes; he painted the portraits of those who could afford to pay a great price.' This, Symons explained, was why in his later paintings he worked 'without emotion, without imagination, without intellectual passion', qualities without which 'there can be no great art'.[27] For 'art', according to Symons, 'must always be an aristocracy':

> it has been so, from the days when Michel Angelo dictated terms to the Popes, to the days when Rossetti cloistered his canvases in contempt of the multitude and its prying unwisdom. The appeal of every great artist has been to the few.[28]

As can be gathered from the image of Millais projected by his admirers, his was a life perceived as being thoroughly integrated into the societal conventions of his own time. The ordinary dress and gentlemanly manner, the 'clubbability', the love of sport, and the house 'without so much as a peacock fan' constitute an idea of the artist that is more high bourgeois professional than 'artistic'. For all its flaws, his son's biography gives a very good picture of what it meant to be a highly successful painter in the later decades of the nineteenth century, a period when artists like Millais enjoyed an unprecedented degree of social esteem. His success is registered in terms of his prestigious friendships and connections, the first volume ending triumphantly with a long list of Millais's many famous associates, by vocation. But it is also seen in terms of the popularity of his art. And it was indeed popular. Developments in printing technology meant that a child fancy picture such as *Cherry Ripe*, printed large and in colour in the 1880 Christmas number of *The Graphic*, could sell no fewer than 500,000 copies.[29] As a consequence, his son writes approvingly, this 'sweet presentment of English childhood' found its way 'to the remotest parts of the English-speaking world', eliciting letters of congratulation from 'Australian miners, Canadian backwoodsmen, South African trekkers, and all sorts and conditions of colonial residents'.[30] J.G. Millais makes much of his father's international celebrity: other,

similar, passages detail requests for photographs of the artist or describe how Millais avoided the attentions of autograph hunters. Through the development of the popular illustrated press, Millais's works commanded both wide attention and dissemination, and he himself became a 'personality' or 'celebrity'. Millais was as much the subject of journalistic commodification as was his art. The piece by John Underhill that appeared in W.T. Stead's *Review of Reviews* was typical of the genre,[31] as was an illustrated interview article on his early life that appeared just before he died in *The Strand Magazine* (the publication in which Conan Doyle's Sherlock Holmes stories were first published).[32] Even an account such as Armstrong's, published as a supplement to a specialist art journal, could take on the form of celebrity journalism, with a section devoted to a lengthy interview with Millais and a section on 'The Man Himself'. A contributor to, and the subject of, this sort of popular journalism, Millais was also, apparently, an avid consumer of it. His son recorded that 'his reading [in London] was commonly limited to the daily papers, a magazine or two, and one or two weeklies such as *Punch*, *The World*, and the *Illustrated London News*'; he had 'little or no time for books'.[33]

For Symons, Millais had allowed himself and his art to become totally absorbed into the taste of the 'multitude' or the 'mob'. Others at the time were also prepared to question his achievement, adopting an elitist and exclusionary view of the art public and attributing Millais's failure to a descent into the popular. Liz Prettejohn has recently suggested that a key development in Victorian art criticism was a shift from its being the preserve of the 'generalist' writer to that of the specialist art critic, a development in which art criticism adopted an esoteric, critical language to determine 'purely artistic' value.[34] An important representative of this trend was R.A.M. Stevenson, one of the leading proponents of French Impressionism in the 1880s and 1890s. A piece on Millais published by Stevenson in the mainstream *Art Journal* of January 1898 contained many parallels to Symons's views. Stevenson also regarded Millais's career 'as the great disappointment of British Art in this century'[35] and went on to draw a comparison similar to Symons's concerning the difference between popular and aristocratic taste. Using the example of Velázquez, an artist with whom Millais was often compared by his admirers and on whom Stevenson had written an authoritative monograph, he wrote that Millais 'had to become rich, he had his way to make with a most inartistic public, whereas Velasquez had secured his life-long patron, the connoisseur King; so that afterwards he had only his art to consider.'[36] He also presented his own, decidedly French, paradigm of the artistic life: 'there is no painter in Europe who would have beaten Millais had he lived comfortably in the Latin Quarter on a few hundreds a year of his own money.'[37] A similar line, 'not the popular view of Millais', was taken by the obituarist in the *Saturday Review*, in an unsigned article which has been attributed to D.S. MacColl, another of the 'New Critics'. Finding it difficult 'to distinguish, in this perplexed personality, the artist from the Academician',[38] he also attributed the failure of Millais's later paintings to his tendency 'to give his work the appearance of truth by looking at everything more and more as the

great mass of people look at things.'[39] In an otherwise more sympathetic article by Joseph and Elizabeth Pennell, friends and biographers of Whistler, we find the same view of Millais's career. 'By the general public he was never really appreciated until he stooped to its level,' they wrote, for

> to concede to popular taste is to betray the dignity of art, and it is kinder to forget that the man who, in youth, painted the 'Ophelia', in maturity was guilty of the mere pretty, flashy, Christmas supplement.[40]

Writings such as this of course anticipate the twentieth-century view of Millais. They can also be seen as a small episode in that far broader cultural development traced by the literary critic John Carey in his 1992 book, *The Intellectuals and the Masses*. The belief that great art is the preserve of an elect few, and a contempt for the 'masses' and mass culture, are central to the creed of those Modernist authors and critics who come under Carey's severe scrutiny. Viewed in these terms, it is not surprising that Millais's reputation disintegrated so entirely and, apparently, so rapidly. As early as March 1898, the threat was recognised by the conservative critic Claude Phillips. As mentioned above, he was one of those who had evoked Millais's essential Englishness, remarking elegiacally on the disappearance of 'national landmarks'. Only a couple of months after Stevenson's essay, Phillips noted the attacks made on Millais since his death and, although he felt confident that Millais's art was 'robust enough' to withstand them, he considered that it was in the Impressionist art espoused by Stevenson that the threat lay and against which Millais's art stood as a bulwark. As he concluded his article, there was 'a vast wave starting from France . . . more or less rapidly spreading itself over the whole expanse of the civilised globe, enveloping even us.'[41]

The problem of Millais's popularity, which Symons and the others regarded as such a direct cause of his 'failure', had been addressed a decade earlier, in a lengthy article in the *Fortnightly Review* of July 1882 by Emilie Isabel Barrington, entitled 'Why is Mr. Millais our Popular Painter?' A dedicated aesthete, and a friend and admirer of George Frederic Watts, she later recalled sending the proofs of the essay for Watts's approval. Watts had replied that it was 'quite excellent' and that he could 'criticise nothing, unless that it might appear to some you unduly depreciate Millais; still, you are no doubt right in the direction of your remarks, and Millais can certainly afford the expense.'[42] As this suggests, Barrington's essay was a brave piece, written at a time when Millais was in his heyday and his reputation must have seemed unassailable.

Barrington's essay is of interest not only because it tackled the question of Millais's popularity at an early date but also because, taken together with her later writings on Watts, it offers a way to approach Millais's late work, and specifically his portraiture. As her title suggests, her central concern anticipated the later critics. Proclaiming her belief in the 'intellectual' or 'poetical' aspects of painting as opposed to the 'realistic school' represented by Millais, she too argued that Millais had availed himself 'of the very

unintellectual situation which modern popular taste has created in matters of art'.[43] He had neglected the 'real prize' of art, she wrote, which can only be won by the 'complete devotion of the life of the artist to his best genius'; instead, he had given the 'strength of his genius' to popularity, a popularity whose influence was 'a compound interest always rolling up'.[44] But she also offered a characterisation of Millais and his art of which she did not necessarily approve but which, as will be clear, had resonances with the image of Millais presented by his admirers. Millais's art was 'very national in character, very English'; it was 'invariably pure, transparent, and thoroughly healthy'. 'Very English, too, is the straightforward impression Mr. Millais's work gives', carrying with it 'an air of self-confident cheerfulness and satisfaction; possessing, above all, the quality of qualities which is the most successful in these times, namely, efficiency.'[45] 'Efficiency' is a key word in Barrington's article. For her it characterised modern life, 'this power of "go", of living in the minute, and doing the most in each minute.' It was a 'very valuable power', she wrote, 'in business lives'.[46] And it was also the quality that 'above all' characterised Millais's art and made it popular: 'the whole spirit of the present age is in entire sympathy with efficiency, and admires above all powers the power of doing difficult things with apparent ease.' Everyone would admit Millais's superior facility, the 'freshness, force and ease which triumphs over more laboured efforts', but this she regarded as mere facture:

> paint must always remain paint, and the trick of putting it on the canvas so that it assumes a vivid resemblance to the aspect of any object may startle us, interest and amuse us, but alone can never fulfil the legitimate object of high art.[47]

For Barrington, Millais's 'realistic' art was an act of mere transcription, dealing in 'facts' rather than 'intellect', showing the 'bare outside of the husk',[48] and through the ease of its technique capturing 'the passing and transitory effects' of nature 'at the expense of those qualities in nature which express her more constant laws'.[49] As such it was temporally limited, itself catching only a moment of time but also succumbing to the more general conditions of modern life: 'these days of speed, hurry and effect'.[50] A few years later Millais was drawn into an exchange with Barrington's hero, Watts, which concerned these questions of technique and the painterly representation of nature. Millais, in a somewhat off-hand fashion, had complained about what he saw as the common criticism 'that such and such an artist's work is "careless" and "would be better had more labour been spent on it".' 'As often as not,' Millais asserted, 'this is wholly untrue.'[51] On the contrary, Watts responded, it was 'dexterity' that was often overrated, since this was 'an age of dexterity' whereas 'completeness, the child of sincerity, is never apparently absent in nature'.[52] Millais did not bother to reply, but the contrast in approach was recalled, at least implicitly, in Barrington's *Reminiscences of G.F. Watts* published in 1905. And it is a contrast which she identified in discussing Watts's portraiture. Watts's carefully wrought technique, she wrote, 'gives a palpitating, tremulous quality to the surface of a painting, and approximates, he thinks, nearest to the constant condition in the atmosphere in

nature.' It was this 'constant condition' that he sought in his portraits, working 'quite as much from a mental vision created by the impression which the nature, career, and character of his sitter has produced on his own mind, than from the personality before him.' This was Watts's 'more intellectual conception of portrait-painting', unconcerned with 'the physical aspect of his sitters at one given moment', as opposed to the transitory surface appearances sought by 'many painters of the realistic school': 'how the light struck certain forms and colours at a given moment in the steady north light of a studio'.[53]

A comparison between Watts's and Millais's portraiture was also made by Claude Phillips in his review of the 1898 Royal Academy memorial exhibition of Millais's works. Like Barrington, Phillips emphasised the Englishness of Millais's art, but while for her it was limited for being so locked into its own time, for him its contemporaneity was its prime virtue: 'as truly characteristic, in the higher sense, of the time and country in which he occupied so commanding a place'.[54] Like her, he identified the main constituents of Millais's painting as his technical 'dexterity', his 'masterly and decisive power of execution'.[55] But, unlike her, he found these to be wholly admirable qualities and nowhere more successfully realised than in Millais's later portraits, especially his portraits of men. In these works, according to Phillips, 'he can be called great', 'he shows himself supreme' such that 'no painter of the century can be said to have surpassed him'. He would include Lawrence as being Millais's inferior in this respect and, from France, Ingres and David, but also 'our own Watts'. He allowed that Watts 'in his interpretative portraiture sums up with the higher truth the noblest qualities of mankind'. But 'if Watts gives us the intellectual, the emotional personality . . . Millais gives us the whole man with mind and body in perfect balance, with breath in his nostrils as well as speculation in his eyes' – a balance that he found, for example, in Millais's 1879 portrait of Gladstone (cat. no. 40), a painting that was 'perfect as a portrait', masterly in 'its concentrated force and simplicity', and 'the very personification of elastic force, of watchful and untiring vigour not less physical than intellectual'.[56]

For Phillips there was a physicality about Millais's portraits, an immediacy of presence – the sense that there was 'breath' in the sitter's 'nostrils' – which made him superior to Watts. These are, of course, the very qualities that, according to Barrington, Watts avoided in his more 'intellectual' approach to portrait painting. But then it has to be remembered that Watts was self-consciously painting for posterity, creating a 'Hall of Fame' which would stand as a monument to the key individuals of his own time, but which would also be enduring and transcendent. Crucially, these portraits were also, for the most part, painted as a private project and were not the products of commissions, Watts setting himself against 'professional' portrait painting. As Barrington would have it, they rose above the usual conditions of portraiture through their technical means, through presenting a 'mental vision' of the sitter. But, of course, they were also without the taint of having been painted for money, of being the result of a commercial studio practice such as Millais's, a practice she evoked through her ambiguous use of the word 'business'

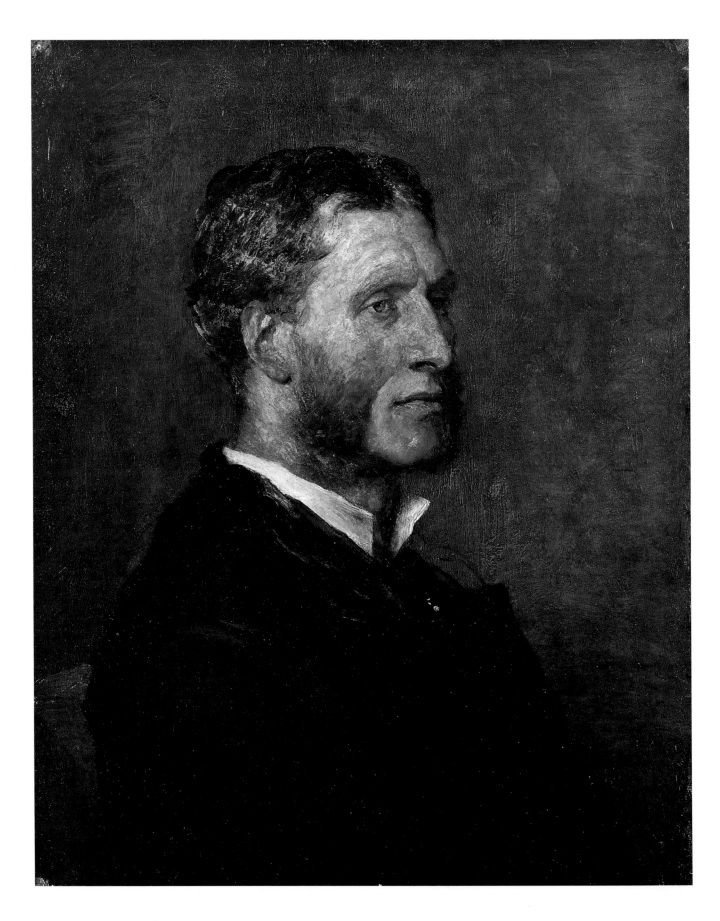

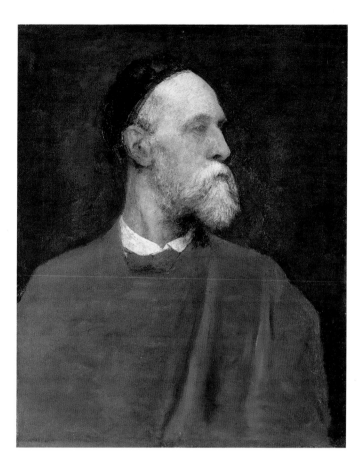

George Frederic Watts
Self-portrait
Oil on canvas, 635 ×
508mm (25 × 20")
*c.*1879
National Portrait
Gallery, London

George Frederic Watts
Matthew Arnold
Oil on canvas, 660 ×
521mm (26 × 20½")
1880
National Portrait
Gallery, London

in her 1882 article or when she wrote of the irresistible attraction of popularity in terms of 'a compound interest always rolling up'.

Millais never produced portraits to the exclusion of other aspects of his art. Portraiture, however, was a major source of income, reaching a peak in the years around 1880 – at the top of his profession, Millais could command the highest prices. Commissions from private individuals or institutions were important, but the real money was to be had through commissions or purchases from dealers such as Agnew's or the Fine Art Society for reproduction as engravings. The 1881 portrait of Disraeli (cat. no. 41), for example, was sold, with copyright, to the Fine Art Society for no less than 1,400 guineas, a sum higher than they had paid for a subject picture by Millais two years earlier.[57] That the financial rewards of portraiture in this period were great is nowhere more brazenly recorded than in a letter of July 1882 in which the German-born artist Hubert von Herkomer described his relatively recent entry into the business, noting that 'here comes in an astonishing item – the extraordinary rapidity with which one can make money'. In the previous two and a half months, he wrote, from thirteen portraits he had earned 'six thousand six hundred and fourteen pound sterling'. As the letter further reveals, Herkomer was having three sittings a day, imposing a social obligation that he dealt with by making it 'a rule to talk with my sitters incessantly'. 'Once you have a fidgetty old lady', he wrote, 'the next hour a political person, or a clergyman, or a great

musician, or a man of law or business . . . so my fiddle must be quickly tuned to play to all these varied conditions.'[58]

Millais's success enabled him to be more selective in whom he painted and how many portraits he produced. Compared to Herkomer's output, Millais painted at most eight to ten portraits during an entire year. This is also far fewer than the twenty-three portraits that Frank Holl, another leading portraitist of the 1880s, was estimated by his daughter to have produced in the year 1885.[59] It is useful to compare Holl's practice with Millais's. Both painted the same sitters – Gladstone and John Bright, for instance – to a degree that underlines the demand in the 1880s for portraits of famous contemporaries. Holl, like Millais, was able to amass a considerable fortune from portraiture, which he practised almost exclusively from the late 1870s until his premature death in 1888, a death widely attributed to overwork. Indeed, Holl's career also demonstrates the strains imposed on the professional portraitist at this time. As Herkomer's account of his daily round of sitters described, portraiture required the painter to perform socially and to enter into engagements with those of very high social standing. That Millais, as his son so assiduously noted, was able to achieve a position of near, if not equal, social parity with his sitters was an important part of his successful practice as a portraitist. There is a sense of social ease in his dealings with his subjects which, to some extent, contrasts with Frank Holl's experience. Even allowing for J.G. Millais's desire to cast all in a favourable light, Millais's encounters with Gladstone, for example, seem to have been entirely comfortable. Holl, on the other hand, recorded a week spent at Hawarden painting the statesman in the autumn of 1887 (Millais, in this period, would never have left his studio for a commission) in terms of intense 'anxiety' and 'sleepless nights'.[60]

If portrait painting imposed social demands on the artist, it was also exacting in terms of stamina and physical endurance. Herkomer noted how his work 'pretty well tests one's powers of endurance', explaining how he was able to avoid fatigue only through the services of 'my Swedish manual manipulators, to whom I go every day after the work'.[61] Millais, in a letter to Holl which is a very frank statement of what it was like to be a professional portraitist, also acknowledged these demands. Probably dating from the summer of 1887, and in response to news of Holl's ill health, Millais's letter agreed that 'portrait painting is *killing work* to an artist who is sensitive, and he must be so to be successful, and I well understand that you are prostrated by it.' He himself was 'finishing two portraits before I leave' – presumably on his annual trip to the Highlands – 'and they have just about settled me'.[62] One gets occasional further glimpses of this in Millais's letters: on 1 August 1884 he wrote that 'the work is terribly hard, painting till five every day'[63] and, on the same date the following year, that the finishing of four portraits has been 'hard, hard work'.[64] Holl's daughter recalled of her father that portraiture 'took up all his time', encroaching 'even upon that which ought to have been the necessary allowance of leisure' – 'not an easy life . . . in fact, it was pretty nigh slavery'.[65] Compared to the fretful, agonised approach that Holl took to his work, however, Millais appears to

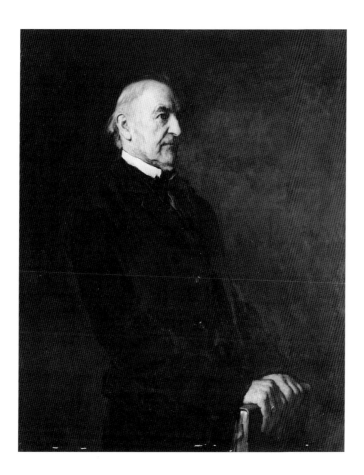

Frank Holl
**William Ewart
Gladstone**
Oil on canvas, 1270 ×
1016mm (50 × 40")
1887–8
Private collection

have been a remarkably fluent painter of portraits. Just as his integration into the highest levels of late Victorian society seems to have eased that aspect of his professional practice, so his performance as a portraitist, though not without labour, was focused and economical.

In contemporary accounts this performance was rendered in terms of those manly qualities so frequently attached to Millais, and also in terms of that intense physicality that Phillips found in the resulting works. John Collier, himself an up-and-coming portraitist in the 1880s, recalled that Millais 'was a very rapid painter', his technique 'extraordinarily vigorous and expressive'. He rarely used preliminary sketches but, 'after very roughly indicating the position of the figure', would 'paint the head straight on to the white canvas, just smudging a tone around it, to represent the background'; 'the first painting was with the full vigour of the palette, the subsequent ones mere modifications of it.' Collier went on to note how Millais would place the sitter side by side to his canvas, and would paint by 'walking backwards and forwards for a considerable distance – putting on a touch and then going back to look at the effect'.[66] Sir Henry Thompson also recalled this method, noting the 'amount of muscular exercise' Millais expended and deducing that the artist must have 'traversed at least a mile during each sitting' (see cat. no. 43).[67] Gladstone, too, remembered the degree of physical effort Millais put into his painting, writing to the artist's son about the 'intensity with which he worked', an intensity he had

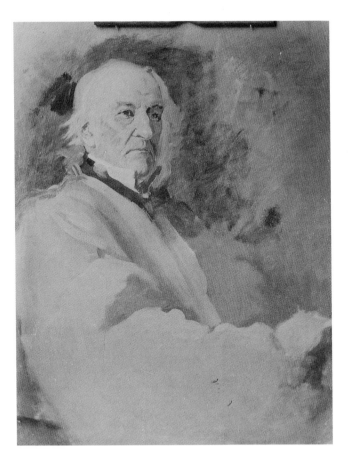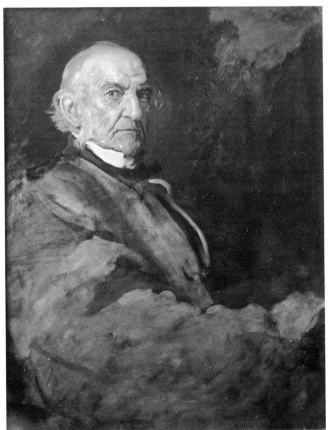

'never seen equalled'. Millais required 'the fewest sittings' Gladstone had known, remembering the 1879 portrait as taking only about 'five hours' of sittings; this was due, he thought, 'to the extraordinary concentration with which he laboured' – 'he had no energies left to spare; and no wonder, when we see what energies he put into his paintings.'[68]

This method – variously described as rapid, vigorous and intense – we are fortunate enough to be able to witness for ourselves in two remarkable photographs, taken by Rupert Potter, which show Millais's progress on a portrait in this exhibition (opposite). It is again of Gladstone, painted in 1885; we know from Gladstone's *Diaries* that it was completed in just three sittings, the first taking place on Monday 15 June between 11.30 a.m. and 12.45 p.m.[69] Potter's photograph (above left), dated 22 June on the reverse, shows that Millais had set the pose, brushed in the background as Collier described and laid in the face and head; Gladstone's gown and hand were sketchily indicated. The second sitting took place on 25 June, took sixty-five minutes according to Gladstone,[70] and was the critical one, as Potter's photograph dated 5 July reveals (above right). A little more has been done to the background and gown, and the head is now much more fully developed. Most crucially, Millais has painted in the eyes, drawing the pupils to their extreme right and giving Gladstone a piercing look directly at the spectator that makes the portrait so powerful. The painting was loosely framed (see page 19, bottom), probably to

Rupert Potter
Millais's portrait of Gladstone
Left: after the first sitting, 22 June 1885
Right: after the second sitting, 5 July 1885 (detail)
Albumen prints
Each 225 × 176mm (8 × 7⅞")
National Portrait Gallery, London

William Ewart Gladstone
Oil on canvas
914 × 698mm (36 × 27½")
Signed with monogram and dated 1885, upper right
The Governing Body, Christ Church, Oxford
Cat. no. 46

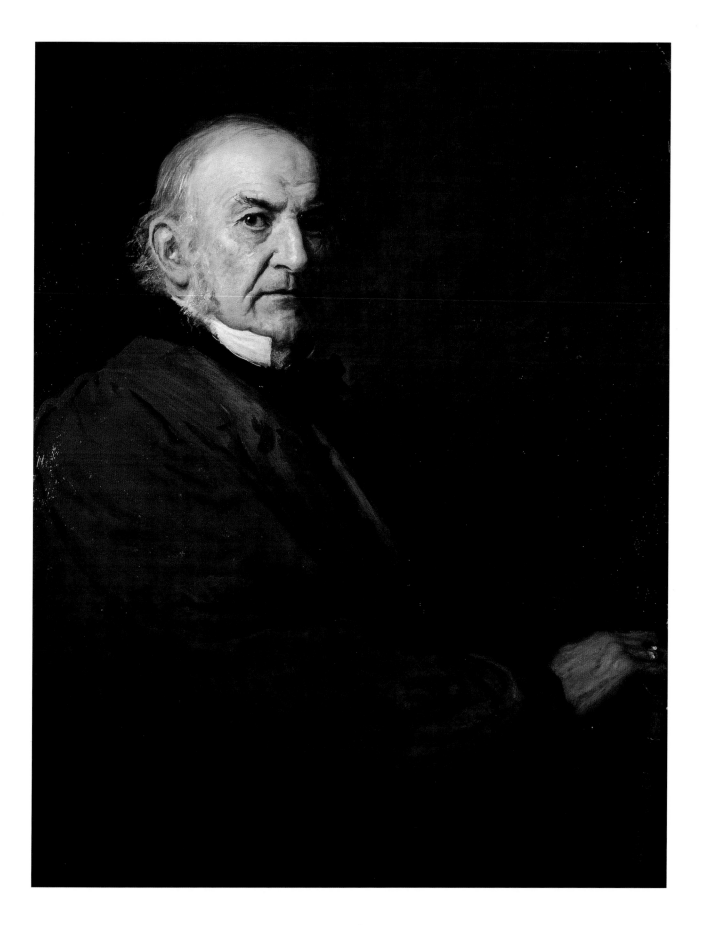

help Millais 'close' the composition and perhaps to prepare for Gladstone's last visit on Monday 13 July.[71] At the last sitting, Millais concentrated on the gown, hand and book, with a certain amount of further overall finishing.

Potter's photographs offer a fascinating demonstration of those qualities of decisiveness and concentration remarked upon by Gladstone and others. That Potter chose to make the record also suggests the importance of the occasion: the painting by Millais of one of the greatest public figures of the age. The photographs are of further value, I believe, given the way that Millais and his art have been so obscured by conflicting accounts that approach him from greatly divergent cultural positions. There were those critics, of course, for whom such a demonstration of technical ability (and even Symons allowed that Millais frequently painted 'brilliantly') could never be enough. On the other hand, there were Millais's admirers, so absorbed in the evocation of his character and the outward signs of his success that his painting itself often became subsidiary to the image of his English manliness, an image compounded and commodified in the popular journalism of his day. Potter's remarkable photographs allow us to glimpse, in a way that is refreshing and even exhilarating, Millais engaged, quite simply, in the act of painting.

NOTES

1 Arthur Symons, 'The Lesson of Millais', *The Savoy, an Illustrated Monthly*, no. 6, October 1896, p.57.

2 Ibid.

3 Ibid., p.58.

4 Ibid.

5 William E. Fredeman, *Pre-Raphaelitism, A Bibliocritical Study*, Cambridge, Massachusetts, 1965, pp.138–9.

6 Bennett 1967, p.5.

7 Keith Roberts, 'From P.R.B. to P.R.A.', *Burlington Magazine*, vol. 109, January 1967, pp.90–94.

8 Peter Ferriday, 'Millais: An Apprentice of Genius', *Country Life*, vol. 141, 19 January 1967, pp.124–5.

9 *The Pre-Raphaelites*, exh. cat., Tate Gallery and Penguin Books, 1984, p.21, and see Claire Donovan and Joanne Bushnell, *John Everett Millais 1829–1896: A Centenary Exhibition*, Southampton, 1996, pp.12–13.

10 Walter Armstrong, 'Sir John Everett Millais, Royal Academician. His Life and Work', *Art Annual* (Christmas number of the *Art Journal*), 1885, p.30.

11 John Underhill, 'Character Sketch: Sir John Everett Millais, Bart., R.A.', *Review of Reviews*, vol. 11, April 1895, p.324.

12 Armstrong, op. cit., p.31.

13 Ibid., p.29.

14 John Oldcastle, 'Mr. Millais' House at Palace Gate', *Magazine of Art*, vol. 4, 1881, p.290.

15 For an extended discussion of manliness and the Pre-Raphaelites, see Herbert Sussman, *Victorian Masculinities: Manhood and Masculine Poetics in Early Victorian Literature and Art*, Cambridge, 1995, especially chapter 3.

16 Andrew Lang, *Notes on a Collection of Pictures by Mr J.E. Millais RA*, Fine Art Society, 1881, p.15.

17 *Art Journal*, 1881, p.126.

18 Armstrong, op. cit., p.16.

19 Ibid., p.1.

20 Spielmann 1898, p.52.

21 Marion H. Spielmann, 'In Memoriam: Sir John Everett Millais, P.R.A.', *Magazine of Art*, vol. 19, September 1896 (supplement), p.xvi.

22 Claude Phillips, 'Millais's Works at Burlington House', *The Nineteenth Century*, vol. 43, March 1898, p.387.

23 Alfred Lys Baldry, *Sir John Everett Millais: His Art and Influence*, 1899, p.34.

24 C.F. Keary, 'John Everett Millais', *Edinburgh Review*, vol. 191, January 1900, p.182.

25 Millais, *Life*, vol. II, p.223.

26 Baldry, op. cit., p.34.

27 Symons, op. cit., p.58.

28 Ibid., p.57.

29 See Laurel Bradley, 'From Eden to Empire: John Everett Millais's "Cherry Ripe"', *Victorian Studies*, vol. 34, no. 2, Winter 1991, pp.179–203.

30 Millais, *Life*, vol. II, p.122, who puts the sales figure at 600,000.

31 See note 11.

32 Frances H. Low, 'Some Early Recollections of Sir John Everett Millais, Bart., P.R.A.', *The Strand Magazine*, vol. 11, January–June 1896, pp.603–11.

33 Millais, *Life*, vol. II, p.233.

34 See Liz Prettejohn, 'Aesthetic Value and the Professionalization of Victorian Art Criticism 1837–78', *Journal of Victorian Culture*, vol 2, no. 1, Spring 1997, pp.71–94.

35 R.A.M. Stevenson, 'Sir John Everett Millais, P.R.A.', *Art Journal*, vol. 60, January 1898, p.1.

36 Ibid., p.2.

37 Ibid., p.3.

38. *Saturday Review*, vol. 82, 15 August 1896, p.161. The attribution to MacColl is by Bradley, op. cit., p.202.

39 Ibid., 29 August 1896, p.214.

40 Joseph and Elizabeth R. Pennell, 'John Everett Millais, Painter and Illustrator', *Fortnightly Review*, vol. 66, n.s. 60, September 1896, p.445.

41 Phillips, op. cit., p.387.

42 Emilie Isabel, Mrs Russell Barrington, *Reminiscences of G.F. Watts*, 1905, p.84.

43 Emilie Isabel Barrington, 'Why is Mr. Millais our Popular Painter?', *Fortnightly Review*, vol. 38, n.s. 32, July 1882, p.64.

44 Ibid., p.77.

45 Ibid., p.62.

46 Ibid., p.64.

47 Ibid., p.72.

48 Ibid., p.63.

49 Ibid., p.72.

50 Ibid., p.73.

51 Quoted in Spielmann 1898, op. cit., p.17.

52 M.S. Watts, *George Frederic Watts*, 1912, vol. 3, p.239. For a recent discussion which compares the portraiture of Millais and Watts, see Paul Barlow, 'Facing the past and present: the National Portrait Gallery and the search for "authentic" portraiture', in Joanna Woodall, ed., *Portraiture: Facing the Subject*, Manchester and New York, 1997.

53 Barrington, 1905, op. cit., p.120.

54 Phillips, op. cit., p.387.

55 Ibid., p.377.

56 Ibid., p.385.

57 Hilarie Faberman, '"Best Shop in London": The Fine Art Society and the Victorian Art Scene', in Susan P. Casteras and Colleen Denney, eds., *The Grosvenor Gallery: A Palace of Art in Victorian England*, New Haven and London, 1996, p.156.

58 J. Saxon Mills, *Life and Letters of Sir Hubert Herkomer*, 1923, p.130.

59 See A.M. Reynolds, *The Life and Work of Frank Holl*, 1912, p.252.

60 Ibid., pp.272–84.

61 Mills, op. cit., p.130.

62 Reynolds, op. cit., p.302.

63 Millais, *Life*, vol. II, p.169.

64 Ibid., p.181.

65 Reynolds, op. cit., p.252.

66 John Collier, *The Art of Portrait Painting*, 1905, pp.60–62.

67 Zachary Cope, *The Versatile Victorian*, 1951, p.105.

68 Millais, *Life*, vol. II, pp.114–17.

69 M.R.D. Foot and H.C.G. Matthew, eds., *The Gladstone Diaries*, vol. 11, 1990, p.356.

70 Ibid., p.362.

71 Ibid., p.370.

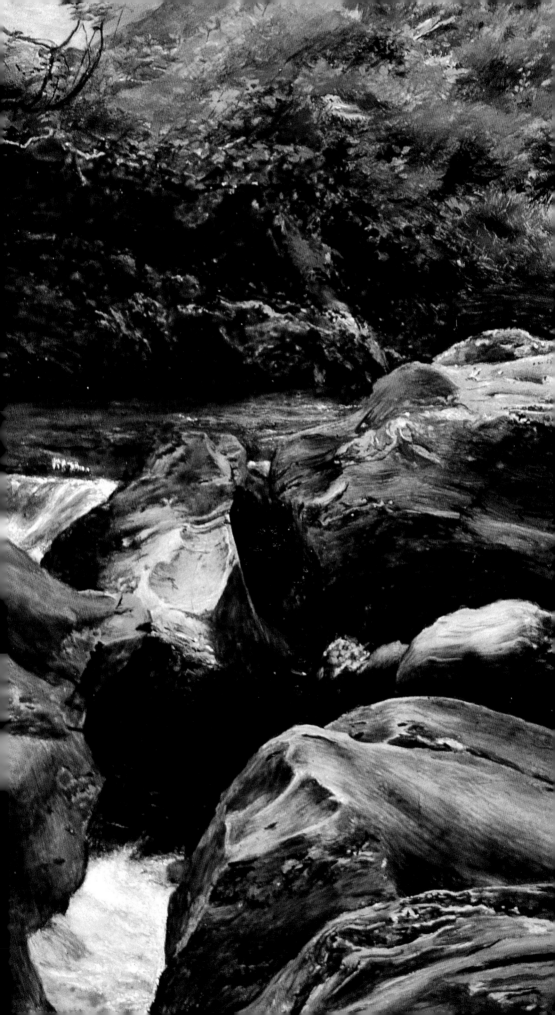

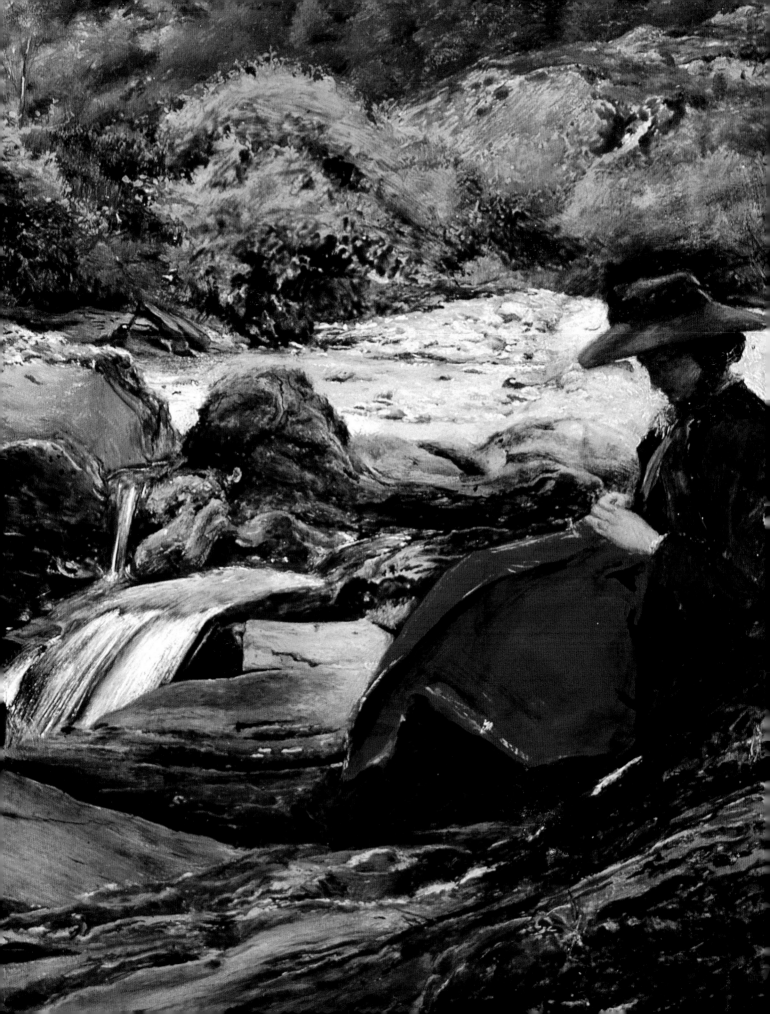

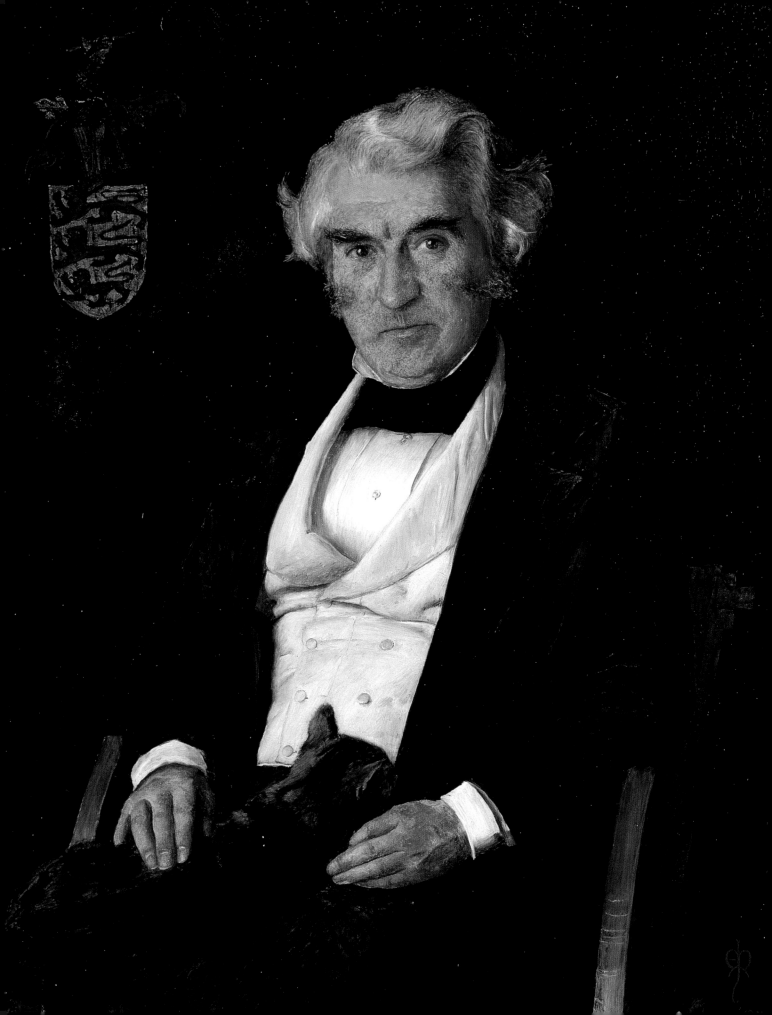

I

Early and Pre-Raphaelite Portraits

Leonée Ormond

Like so many budding and talented artists, the young John Millais amazed his friends and relations with his skill in catching a likeness. Arthur Lempriere, who knew Millais when he was in his teens, recalled how his 'power of observation, even when a boy, was marvellous. After walking out with him and meeting people he would come home and draw an exact likeness of almost anyone he happened to have met'.[1] This was the Pre-Raphaelite painter in the making, able to give a precise reflection of visual truth with pen and pencil. It was also the fashionable portrait-painter in the making, for the gift of capturing the human face was one that Millais retained throughout his working life.

It has been traditional in the past to divide Millais's working life into two parts, the Pre-Raphaelite and post Pre-Raphaelite phases, and earlier critics have favoured the Pre-Raphaelite work at the expense of the later. Such a division oversimplifies the complexities of Millais's career, and encourages an undervaluing of the paintings of the 1860s to the 1890s. In this discussion of Millais's early portraits, which *are* very different from his subsequent work in the same genre, it is hoped that the dangers of falling into this familiar, and false, opposition have been clearly recognised and guarded against. The portraits of Millais's youth are often experimental and, for a short time, he forged a highly individual style as an artist of small cabinet-portraits – some commissioned, others apparently painted for pleasure. The more formal portraits, the oils and watercolours, were a small fraction of Millais's early output in this field. He was much more prolific as a draughtsman, employing ink or pencil, sometimes heightened with wash. Several of these drawings are not, strictly speaking, portraits, but studies for major subject paintings such as *Ferdinand lured by Ariel*, *Isabella* and *Ophelia*. Here we encounter a difficulty. The Pre-Raphaelite practice of using friends and relations as models, rather than professional sitters, complicates the process of division. What constitutes a portrait as opposed to a study for a narrative painting? As will be apparent from the discussion of Millais's drawings of Frederic George Stephens (see page 45), the young artist's actual technique in making portrait drawings differed little from that employed for his preliminary studies of friends and models. The major difference lies, inevitably, in the choice of an angle and a pose. In the preliminary studies, these had to be appropriate to a place in the larger composition of a subject picture.

Among the earliest surviving portrait drawings by Millais are pencil sketches of his two grandfathers, John Evamy and Jean Millais. The latter was executed on Jean Millais's

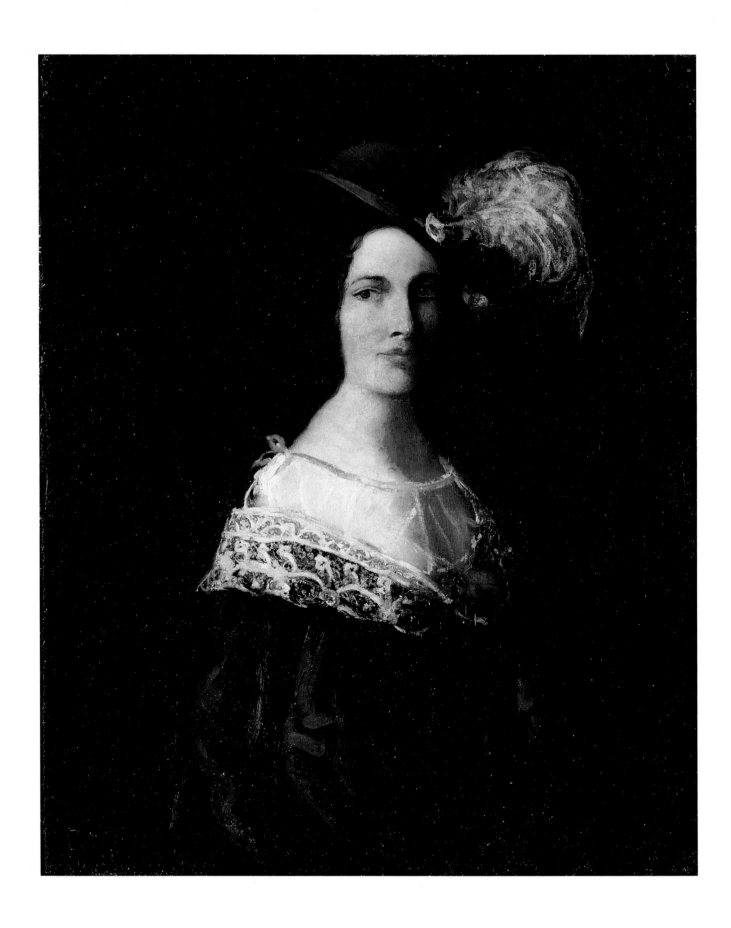

seventieth birthday when his grandson was only ten: the face is characterful, even shrewd, suggesting a gift for observation as well as technical skill on the part of the young boy.[2] Other pencil and ink portraits of family members followed, prefiguring Millais's life-long confrontation with the human face. That of his sister Emily, drawn in about 1844, shows her looking straight at the artist, his intentness mirrored in her response.[3] A half-length oil portrait of her of much the same date shows her in a dark dress with broad red stripes, a wide lace collar and a hat with a huge white feather. The clothing recalls Van Dyck and his hunting portraits of Queen Henrietta Maria, but Millais himself called it 'a fancy portrait – à la Rubens',[4] probably with one of the studies of Helene Fourment in mind. He painted his sister against a dark background, highlighting the lighter features of her face and dress.

In 1839, the nine-year-old Millais entered Sass's Academy, moving to the Royal Academy Schools when he was eleven. He had access to two important public art galleries in London, Dulwich and the National Gallery. The Dulwich collection is strong in eighteenth-century English portrait painters, including Gainsborough and Reynolds, but it is not clear how well Millais knew it. His great friend William Holman Hunt was an habitué, so it is reasonable to assume that Millais must sometimes have gone there with him. It was said later that Millais knew all the paintings in the National Gallery 'by heart'; he and his brother William made small copies of them, William executing the landscapes while John worked on 'the Titians, Rubens, Paul Veroneses, Correggios, and Rembrandts'. Millais is said to have had little enthusiasm for the Dutch school as a whole, but Rembrandt was an exception: 'a Rembrandt . . . was my brother's masterpiece, and the use of burnt lucifer matches in the darker parts was most effective, and certainly original.'[5]

Many of the portraits hanging in the National Gallery today were not acquired until long after the period of Millais's youth. However, he would have known a portrait then attributed to Rembrandt, *Seated Man with a Stick* (known as 'A Jew Merchant') from the Beaumont collection. The technique of posing the sitter against a dark background, so characteristic of Rembrandt and his school, is here demonstrated with powerful effect. The first Rembrandt self-portrait to enter the National Gallery was not acquired until 1851, but Rembrandt's influence is reflected in Millais's choice of a dark ground and tonality for his own early self-portrait of 1847, painted when he was eighteen (page 43). The artist's delicate features and carefully arranged hair differ markedly from Rembrandt's many presentations of his own face, but the quizzical look into the mirror and the prominence of the palette show that he was working within an established and familiar framework – the artist painting himself at work.

With his striking good looks, Millais was to be painted, drawn, sculpted and photographed on numerous occasions through his life. It was said that, as a young man, he was vain about his appearance. If this was the case, he was also capable of self-mockery. He enjoyed making rapid sketches of groups of people, often at parties and dances, and

John Everett Millais
Emily Millais
Oil on canvas, 597 ×
495mm (23½ × 19½")
*c.*1843
Geoffroy Richard
Everett Millais
Collection

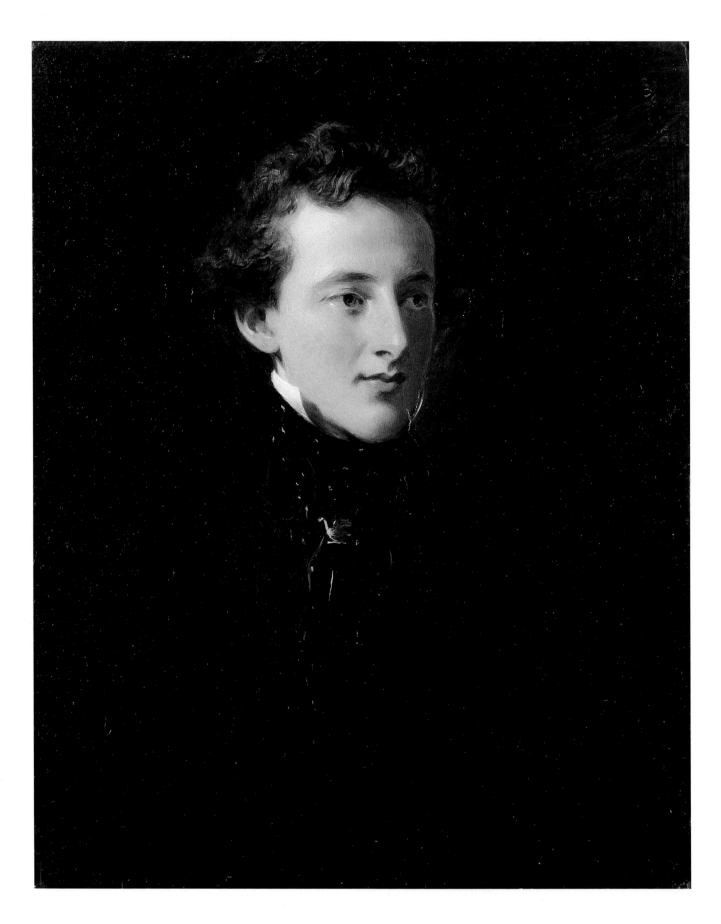

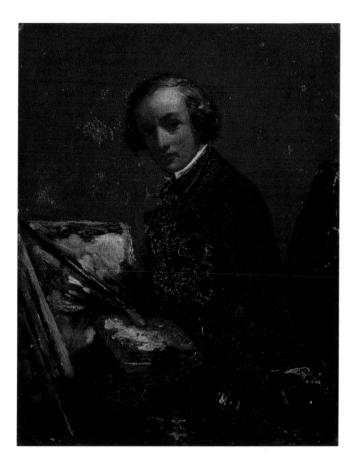

John Everett Millais
Self-portrait
Oil on panel, 273 ×
222mm (10¾ × 8¾")
1847
Trustees of the National
Museums and Galleries
on Merseyside (Walker
Art Gallery)

Charles Robert Leslie
John Everett Millais
Oil on panel, 305 ×
248mm (12 × 9¾")
1852
National Portrait
Gallery, London

his gift became a noted social accomplishment. He himself often appears, sometimes soberly drawing (as in the Lempriere family group, 1847; private collection), but often as a lanky and humorous figure with a bush of fair hair. These group scenes were presented to his hostesses and frequently placed in albums.

Such drawings were gifts, but Millais did make an income from sketching the actors at the Princess's Theatre and selling them to the audience for 'ten shillings apiece, and . . . portraits at from £2 to £3 a head'.[6] When Millais met William Holman Hunt in 1844 he told him that he could earn 'ten pounds, and even double' and asked Hunt, 'Do you paint portraits?' Hunt replied in the affirmative, declaring himself 'terribly behind you', and explained that the next day was his 'portrait day, but don't betray me'.[7] Unlike Millais whose family was well-to-do, for Hunt portrait drawing was carried on in deadly earnest, and his continuing career depended upon it. It was the more remarkable that, three years later when Hunt's father suffered a financial catastrophe, his son refused to return to this mode of making a living: 'even though the painting of likenesses might have somewhat reduced the strain on the family purse, I painted only those portraits which came uninvited'.[8]

From 1848, Millais's portraits must be seen in the context of Pre-Raphaelitism. The concept of painting truthfully what lay before them inevitably divided the Pre-Raphaelite group from conventional portrait painters of the time who relied on well-worn formulae.

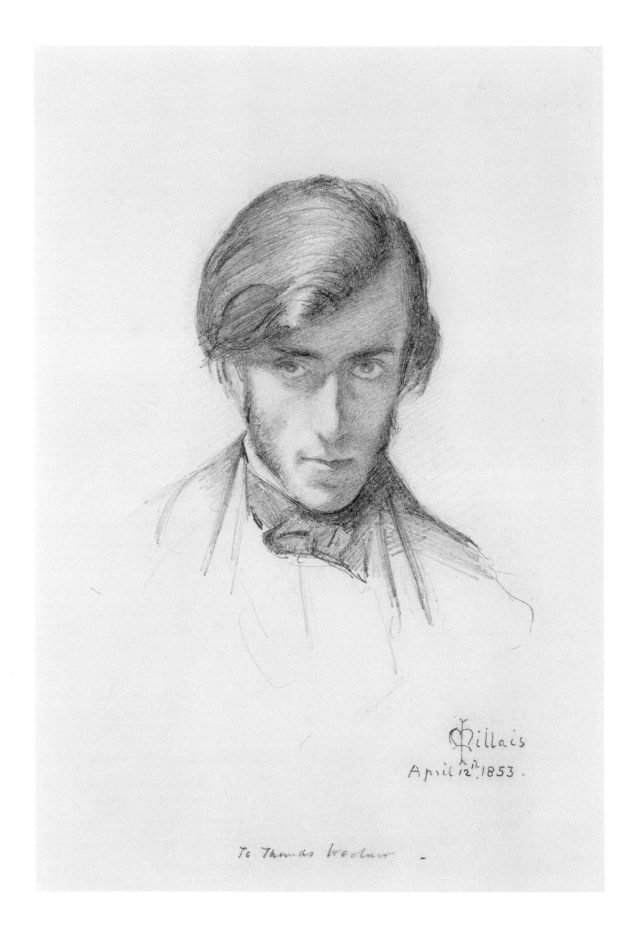

Millais
April 12th 1853.

To Thomas Woolner –

Although Millais was later to pay implicit tribute to Sir Joshua Reynolds in his society portraits, as a young man he and his fellow Pre-Raphaelites held him in contempt, an indication of their response to the idealised and studied portraiture of the eighteenth-century masters. The grand manner, with its air of elaborate artifice and grandiloquence, was rejected in favour of presenting subjects in everyday guise, in their own surroundings and in daily (rather than gala) clothes.

Pre-Raphaelite 'truth to nature', favouring absolute accuracy of representation of the human face, helped to stimulate a series of remarkable portrait drawings by Millais. The head is almost always brought forward and sharply focused, the eyes often fixed upon the artist. In comparison with similar German drawings, these are more heavily worked, with passages of dark colour in the treatment of hair, clothes and accessories, contrasting with the lighter treatment of the face and the background. Millais contributed a head of F.G. Stephens to the group of drawings sent to the sculptor Thomas Woolner in Australia in 1853. Here, the shadowed face and the falling mass of dark hair provoke a sense of unease, as if the sitter were attempting to avoid, but was nevertheless engaging, the artist's full attention. Biographical evidence suggests that this unease was not an invention of the artist but reflected a serious domestic crisis, the financial collapse of Stephens's family.

Millais evidently liked drawing Stephens's face. He used an earlier drawing of him for Ferdinand in *Ferdinand Lured by Ariel* (1849–50; Makins Collection), an experience that Stephens later described:

> Although the face is a marvel of finish, and unchangeable in its technique, it was begun and completed in one sitting. Having made a very careful drawing in pencil on the previous day, and transferred it to the picture, Millais, almost without stopping to exchange a word with his sitter, worked for about five hours, put down his brushes, and never touched the face again.[9]

Stephens's striking looks are shown once more, this time in profile, in the brother holding a glass (second left) in Millais's *Isabella* (page 46). Other figures around the table have been identified as members of the Pre-Raphaelite group: among them are Dante Gabriel Rossetti (the man drinking from a glass, last on the right) and Walter Deverell (third on the left). Millais's father is the man with a napkin, fourth on the right, and the sixth figure on the right, peeling an apple, is William Hugh Fenn, father of Millais's friend William Wilthew Fenn. Treasurer of the Covent Garden Theatre, he used to give the young artist tickets for the opera, which Millais particularly enjoyed and which influenced his work in various ways. Millais painted Fenn's portrait in 1848 (page 47), but it was not for the first time; an earlier portrait was destroyed, presumably because it was untrue to Pre-Raphaelite practice.

Several of Millais's portraits of these years were of middle-class, professional men. Possibly reflecting the wishes of the sitters, he painted them in black, often with black ties and cravats, and white shirts and cuffs. The faces, accurately and exactly rendered, are

Frederic George Stephens (1828–1907)
Pencil, 216 × 152mm (8½ × 6")
Signed, with initials in monogram, and dated 'April 12th 1853', lower right
National Portrait Gallery, London
Cat. no. 13

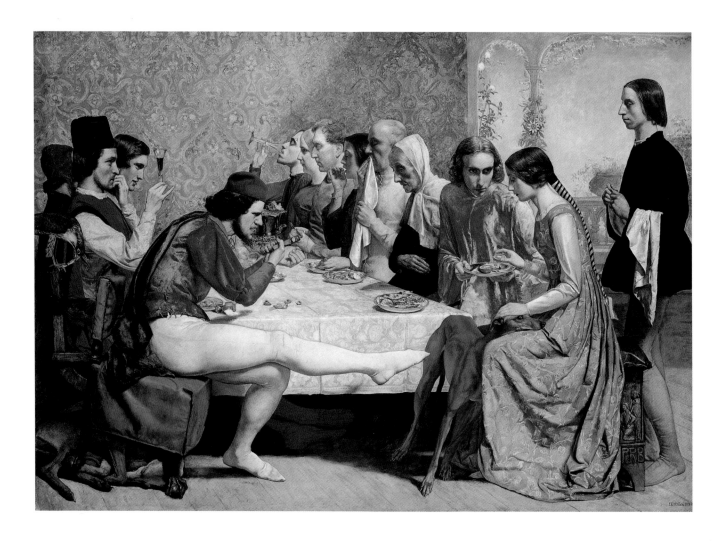

purposeful and intelligent, questioning and thoughtful, rather than relaxed. Hunt compared the Fenn portrait to the work of Van Eyck and Holbein. The latter's portraits of German steelyard merchants are classic early examples of the middle-class portrait, and Van Eyck's *Arnolfini* marriage portrait (1434; National Gallery, London) was a particular favourite with Hunt. Millais's sitters represent the new professional or industrial world from which the Pre-Raphaelites drew many of their patrons. Millais's early patrons treated him not as an artisan but as the son of a family very much like their own. Millais's mixture of practicality and social ease set him somewhat apart from the other Pre-Raphaelites, and he painted more commissioned portraits than they did during these early years.

Two years before the Fenn portrait, which Millais probably painted on a visit to Fenn's cottage in Hampstead in 1848, he had become a regular guest at the home of another of his early patrons, James Wyatt, an Oxford art dealer. Wyatt originally commissioned Millais to paint a watercolour of his granddaughter Mary; then, in 1848, he asked him for a double portrait of himself and Mary, then a child of four. The following year, Millais painted four Wyatt grandchildren in a room hung with pictures from his

John Everett Millais
Isabella
Oil on canvas, 1012 ×
1406mm (40½ × 56¼")
1848–9
Trustees of the National
Museums and Galleries
on Merseyside (Walker
Art Gallery)

William Hugh Fenn
Oil on panel, 305 ×
254mm (12 × 10")
Signed, lower right,
1848
Collection of the
Owens Art Gallery,
Mount Allison
University. Gift of Lord
Beaverbrook
Cat. no. 3

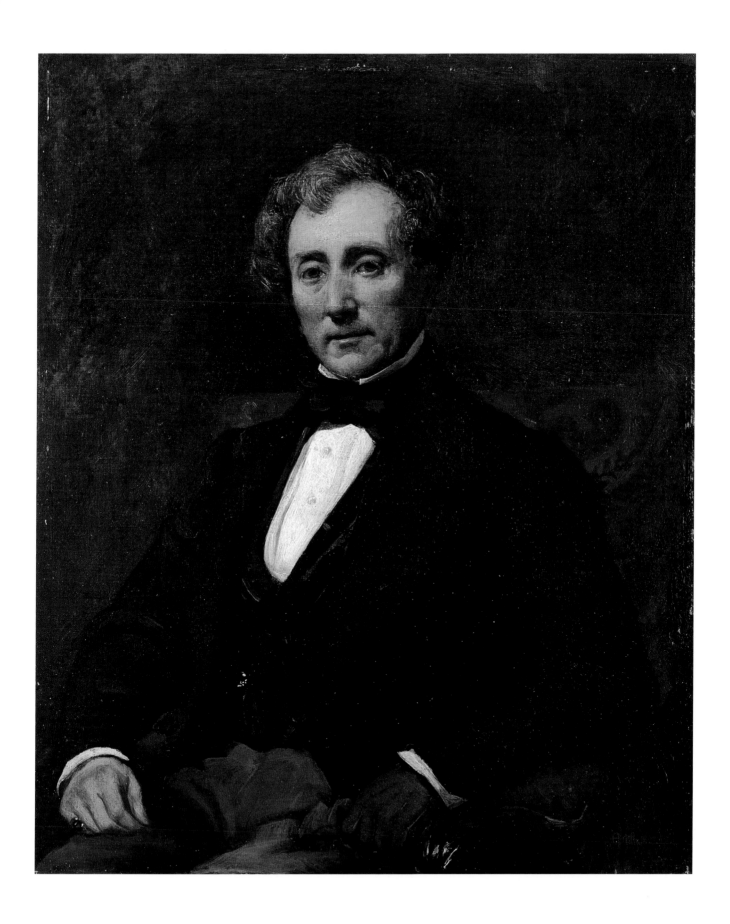

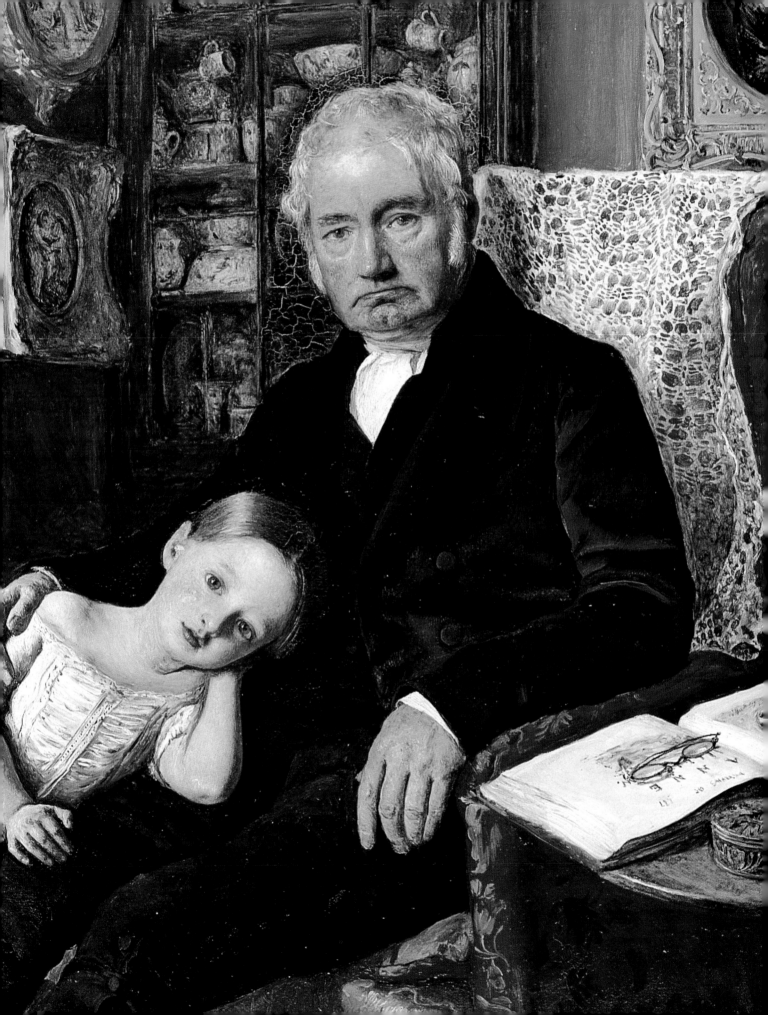

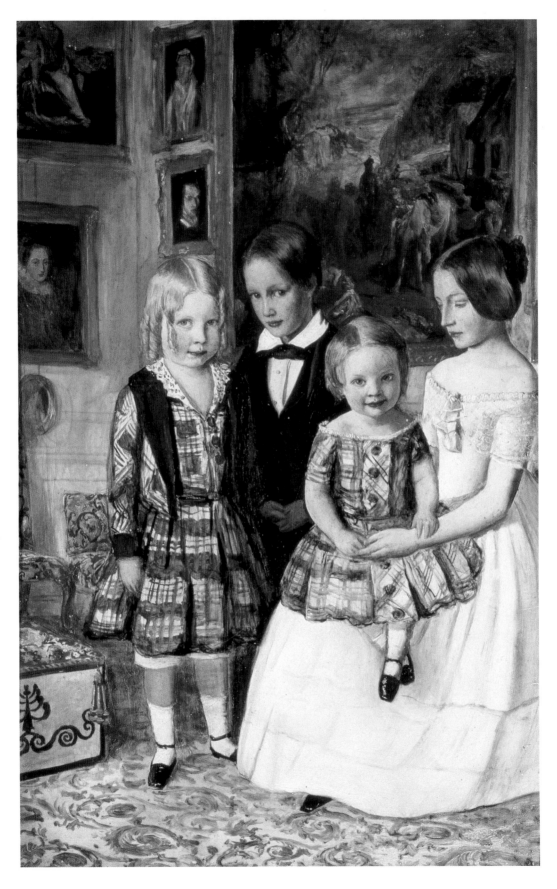

John Everett Millais
Portrait of Four Children of the Wyatt Family
Oil on panel, 457 × 305mm (18 × 12")
1849
Private collection

patron's collection. A third Wyatt portrait, approximately dated to 1850, shows Wyatt's daughter-in-law with her daughter, Sarah. An album that belonged to the Wyatt family contains a number of pencil drawings by Millais, dating from 1846 to 1848, some of them portraits. At this time, Wyatt was Millais's most significant patron; he not only commissioned these works, but paid £60 for *Cymon and Iphigenia* (1848; private collection), which had failed to find a place on the walls of the Royal Academy. The elaborate background settings of the Wyatt works differ considerably from those of other early Millais portraits. It was presumably Wyatt who asked the artist to include his home and his picture collection within the paintings, and such detailed work probably added to the cost of the commission.

In the early autumn of 1849, Millais painted Wyatt and his granddaughter in a first-floor room overlooking the garden at 115 Oxford High Street (cat. no. 4 and detail, pages 48–9). Wyatt sits in a red chair with a lace or crochet antimacassar, the chair-cover patterned in red and gold and the carpet in brown and black. A crowded china cupboard stands behind him, and heavily gold-framed portraits hang on the deep red walls to either side. An open illustrated book adds to the effect of competing patterns and colours, confirmed rather than contradicted by the crowded natural world outside the window. Twigs, leaves, flowers and a striking cactus create further traceries of colours and shapes.

In the midst of this dazzling sunlight effect the old man and his granddaughter seem solid and cool: Wyatt's solemn, remarkably vulnerable, face and black suit, together with the child's untroubled direct gaze and white dress, are points of stillness in the midst of movement. It could be argued that the child's youth is seen in the context of the garden outside the window, while the grandfather is placed against the man-made world of his art collection. The tangled profusion of the garden, however, makes this less probable. A related watercolour (cat. no. 2), presumably an early sketch for the portrait, shows Wyatt and Mary in a far simpler setting than the finished oil. They are directly facing the painter, with the armchair further forward, and with only a part of one painting upon the wall touched in. There is no glimpse of the garden.

Marion H. Spielmann described the child in this portrait as 'doll-like',[10] a comment that could also be applied to the figures of the four children in the Wyatt family group (opposite) or to the baby in *Eliza Wyatt and her Daughter, Sarah* (cat. no. 5 and detail, title pages). In following a strict Pre-Raphaelite style, and in suggesting the simplicity and unshadowed effect of early Renaissance art, Millais has represented the children accurately, but at the same time has deliberately avoided acclimatising them in any way to their settings. The result is a blend of modern clothes and faces, painted in the full knowledge of nineteenth-century realism, and a deliberately archaic manner. These are all family portraits, and concepts of relationship are insisted upon. As Malcolm Warner points out (page 71), the portrait of *James Wyatt and his Granddaughter, Mary Wyatt* introduces a number of other family members through the medium of the portraits on the walls.

The Wyatt children are posed on another patterned carpet, with richly covered

William Holman Hunt
New College
Cloisters
Oil on panel, 355 ×
236mm (14 × 9¼")
1852
The Principal, Fellows
and Scholars of Jesus
College, Oxford

furniture behind them, and with the two youngest girls in blue-and-white check dresses. Once again, patterns render the effect rather uncomfortable. The paintings on the walls (one of which has been identified as a copy of a *Madonna and Child* by Franciabigio) would be incongruous were they not serving as a reminder of James Wyatt's professional activities and the source of the family wealth. By contrast, *Eliza Wyatt and her Daughter, Sarah* has a stylised, almost frieze-like effect, with the severe outlines of the mother's face and hair carried on into the square and rectangular picture frames above her. Interestingly, two of these represent prints by Raphael (of the *Madonna della Sedia* and the *Alba Madonna)*, inappropriate images for a painter who was shortly to declare that he thought the Raphael drawings in the University Galleries (now the Ashmolean Museum) were possibly 'worth a shilling apiece'.[11]

In keeping with Millais's early portrait style, the Wyatt pictures are small, cabinet-size works. So, too, is the portrait of another Oxford figure, Thomas Combe, Printer to the University (page 38). From 1850 Millais and his fellow artist Charles Collins were to be found at the Combes' home in Walton Street, having moved there from the Wyatts' house. Whereas Wyatt had restricted himself to purchasing work by Millais, Combe became an important patron for other Pre-Raphaelite artists. A high-churchman, he bought Holman Hunt's *A Converted British Family Sheltering a Christian Missionary from the Persecution of the Druids* (1849–50) and Charles Collins's *Convent Thoughts* (1850–51),

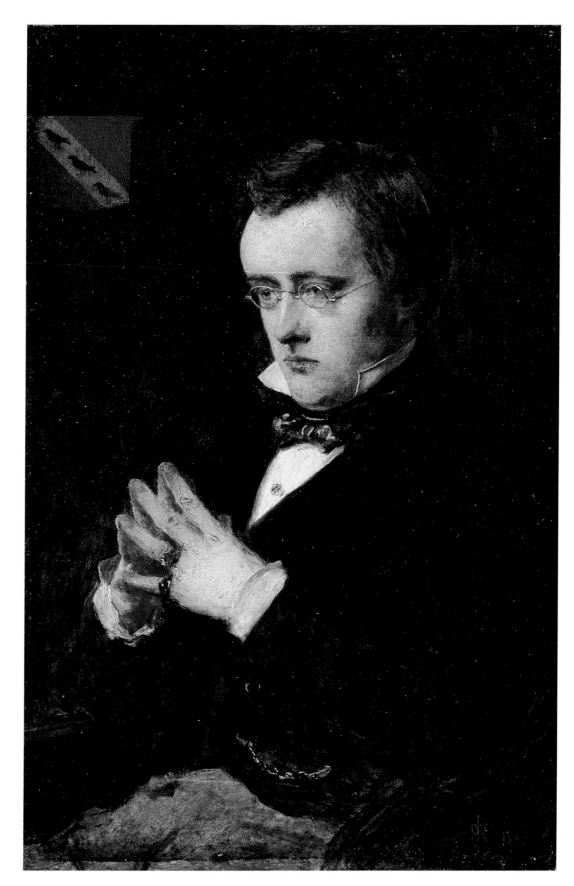

Wilkie Collins
(1824–89)
Oil on panel, 267 ×
178mm (10½ × 7")
Signed with monogram
and dated 1850,
lower right
National Portrait
Gallery, London
Cat. no. 9

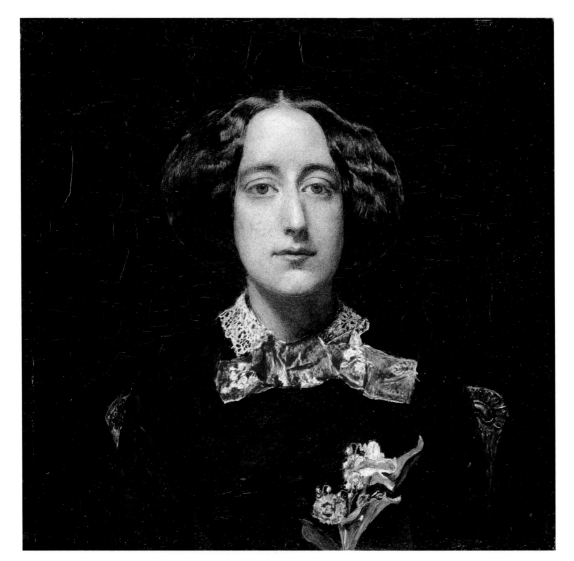

which was painted in his own garden, together with Millais's *The Return of the Dove to the Ark* (1851). Combe's pictures, including Millais's portrait of him, are all now in the Ashmolean Museum, Oxford.

Combe said later that he sat to Millais four times in the autumn of 1850, for a total of eight hours. For the portrait, Millais returned to a plain dark background, posing the seated figure in an upright chair, gently stroking a tabby cat on his lap, and setting off the prevailing dark brown, black and white with touches of red – in the painter's monogram and date in the bottom right corner, in the coat of arms at the top left and in patches of colour in the chair. With his friendly and enquiring gaze, Combe dominates the composition, his head looking slightly too large for his body. Millais introduced the arms of the Stratford Combes as an archaicising decorative feature, in the manner of early German or Flemish portraiture.

While Millais painted Combe, Collins painted Mrs Combe's uncle William Bennett in a similar style, and again with a coat of arms (1850; Ashmolean Museum, Oxford). It is

not clear whether there were ever plans for an oil portrait of Combe's wife, known as Mrs Pat, but Millais painted a watercolour of her, and drew a number of ink sketches of the Combes and their circle (these survive in a sketchbook in the Ashmolean Museum). Millais drew Collins, solemn-faced and anxious like so many of his sitters (cat. no. 8), and Collins drew Millais in return (all Ashmolean Museum). Portraiture clearly became a household activity. In 1852 Combe went a stage further and commissioned William Holman Hunt to paint a tractarian clergyman, Canon John Jenkins, to the same scale as his own portrait by Millais. The resulting portrait, *New College Cloisters*, is one of Hunt's finest portraits, showing Jenkins in an appropriately gothic setting (page 52).

In the year that he painted Thomas Combe, Millais completed one of the most brilliant, intense and concentrated of all his portraits, his study of the writer Wilkie Collins (page 53). The Combe and Bennett portraits by Millais and Collins strongly suggest Flemish or north German influence, and *Wilkie Collins* is unquestionably Flemish in inspiration. It is unlikely to have been a commission, and was more probably a tribute of friendship to a man whose idiosyncratic appearance caught Millais's imagination and whose mother and brother were among his closest friends. The gesture of Collins's beringed hands, while probably characteristic of the man, is apparently a play on the Flemish practice of representing the sitter as if in prayer. Dante Gabriel Rossetti and William Holman Hunt had visited Bruges in 1849, and Rossetti had returned full of enthusiasm for the works of Hans Memling. Hunt was cooler, but Millais must have heard the debate. The size and shape of the painting and the placing of the figure all reflect the Memling style, but Collins was neither saint nor man of prayer. The painting is no parody, but it has its own subdued humour.

Another brilliant small portrait of these early Pre-Raphaelite years was that of Emily Patmore, wife of the poet Coventry Patmore, which Millais exhibited at the Royal Academy in 1852. The sitter is posed full-face against a dark background. Although this is a young woman rather than a middle-aged man, the colour combinations remain almost the same as those in the Combe and Collins portraits. Emily Patmore wears a dark dress relieved by a light collar and red bow, the only other concession to her femininity being a prominent flower on her breast. Emily, well known for her good looks, inspired a poem by Browning, an oil painting and a watercolour by John Brett and a medallion by Thomas Woolner. Millais, however, does not present a typical Victorian beauty. With her elongated oval face and a severe central parting between two bushes of hair, his sitter is eminently a 'character'. There is some irony here, since Emily was the subject of Patmore's panegyric on perfect femininity, *The Angel in the House* (1854–62). In pursuing realism, however, Millais has conceivably presented us with the truth – that Emily Patmore was intelligent, talented and strong-minded.

Patmore summoned Millais from Kingston, where he was working on *Ophelia* (1851–2; Tate Gallery, London), because he wanted the artist to finish work on the portrait while his wife was in good health. Irritated, Millais spent four or five days in

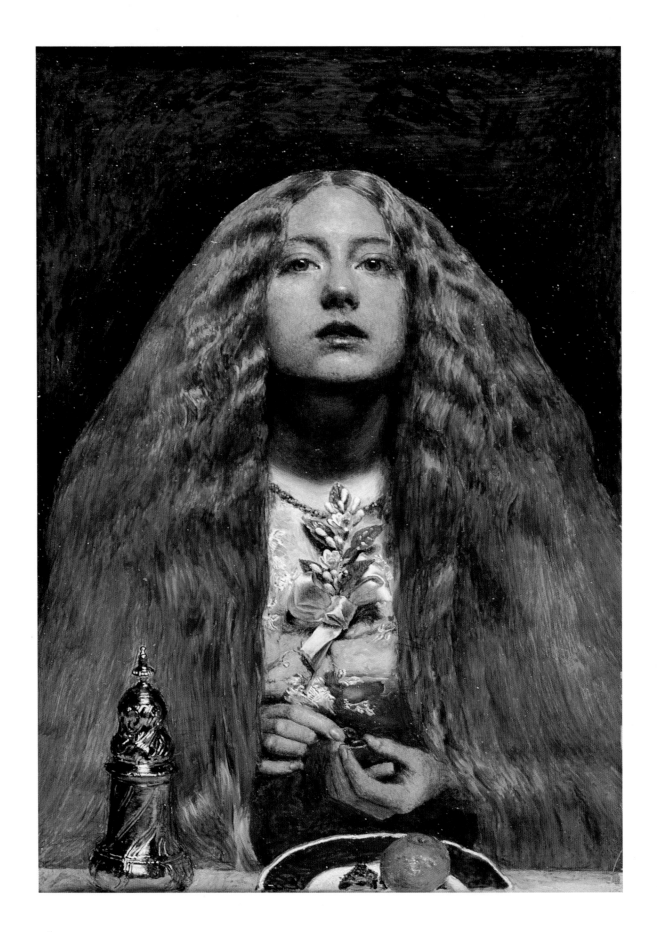

London, worrying that the season was changing and that the flowers and leaves needed for the background of *Ophelia* would not be the same when he returned.

> He spoke with but stinted contentment of his forced labour in town. 'On the last day,' he said, 'some of the colours of the picture had sunk in, and it would have been prudent to leave it for a term to get thoroughly dry; but I was not going to be subject any more to the importunities of the husband and I slobbered it all over with varnish, notwithstanding the sure prospect of cracking; in very truth I don't care what becomes of the picture.'[12]

Patmore, in the event, hated the portrait, although he seems to have convinced Millais that he liked it. After Emily's death in 1862, he hid it away in case his children should believe that their mother had really looked as plain as Millais had made her. Millais had hoped to make a success of it in order to attract further commissions, including one from Alfred Tennyson to paint his wife.[13] In the light of his problems with the portrait of Emily Patmore, it may be concluded that the young Millais was more successful with portraits of men. At a later date, however, he was seriously concerned that portraits of women should be as fine as those of men. He even declared an affinity with two of the eighteenth-century English masters of portraiture, Gainsborough and Reynolds:

> It is only since Watteau and Gainsborough that woman has won her right place in Art. The Dutch had no love for women, and the Italians were as bad. The women's pictures by Titian, Raphael, Rembrandt, Van Dyck and Velasquez are magnificent as works of Art; but who would care to kiss such women? Watteau, Gainsborough and Reynolds were needed to show us how to do justice to woman and to reflect her sweetness.[14]

It is not without significance that Millais made another full-faced portrait of a young woman with a central parting in the same year as Emily Patmore. This was in *The Bridesmaid*, which was exhibited as a subject picture in the 1851 Royal Academy exhibition. It shows a redheaded girl passing a piece of wedding cake through a ring, and was apparently modelled from a professional sitter, Miss McDowall. The woman's head is tilted upwards rather than perceived directly from the front like Mrs Patmore's – this was Millais's most important contribution to the vogue for the aesthetic female portrait, usually associated with Dante Gabriel Rossetti and the 1860s. The sumptuous hair, contrasted with Emily Patmore's severe dark bunches, renders the figure in *The Bridesmaid* an ideal portrait whereas the other is not. The contrast is striking. Portraiture, it suggests, was a precise art for Millais at this time, the aim being to produce a likeness; a subject picture, on the other hand, allowed for the creation of the ideal, even when an actual female sitter (significantly, a professional model) was the subject.

Emily Patmore represents the end of a particular development in Millais's work. Placed against *James Wyatt and his Granddaughter, Mary*, painted only two years before, the

John Everett Millais
The Bridesmaid
Oil on panel, 279 ×
203mm (11 × 8")
1851
The Syndics of the
Fitzwilliam Museum,
Cambridge

Highland Shelter
Rain
July 25th 1853

comparative sophistication of the rendering of the face, and its placing within its relatively subdued background, is apparent. Like *Wilkie Collins*, this is an intense, even mysterious, work, its directness increasing rather than defusing its strangeness.

In the summer of 1853, Millais undertook a portrait commission that brought about a decisive change both in his work and his private life. He agreed to paint a portrait of the art critic John Ruskin for which the sitter's father, John James Ruskin, eventually paid £350. Millais told Charles Collins that his main aim in going to Scotland was to have a holiday with friends and to recover his health. He did not, he said, intend to work hard. Ruskin, on his part, said that Millais was engaged to paint some rocks for his father, although this may have been a modest way of referring to his portrait. Millais was used to living with his sitters while he painted their portraits, having done so twice in Oxford. This commission certainly involved travelling further but, at the outset, it cannot have seemed so unusual.

Highland Shelter
Pen and brown ink
187 × 232mm (7⅜ × 9⅛")
Signed with monogram
and dated 'July 25th
1853', lower left
Private collection
Cat. no. 20

The artist offering Effie Ruskin a drink of water from a stream
Pen and brown ink
184 × 222mm (7¼ × 8¾")
Signed with monogram and dated 1853, lower left
Private collection
Cat. no. 25

Millais had already painted Ruskin's wife Effie, incorporating her face into *The Order of Release, 1746* (1852–3; Tate Gallery, London), the painting of a Highlander rescued from jail by his wife. A letter from Effie to her mother gives an indication of how Millais discussed his work when using friends as models: 'I feel he has not refined the face in the picture as he wished me to look the character, it looks a little stronger than I do but it looks very well indeed and is precisely what he wanted'. The following year, Millais told her, he would paint her in quite another way, 'to refine as well as to paint an equally good likeness – but this is really already like. Any body who has ever seen me once would remember it was something they knew'.[15]

Millais, his brother and the Ruskins travelled to Brig o' Turk in the Trossachs where they eventually stayed for four months. Effie Ruskin was a Scot and it was partly to please her that Scotland was chosen; her husband considered the Trossachs to be an interesting geological site. The story of that summer in Scotland has been told many times. Millais's

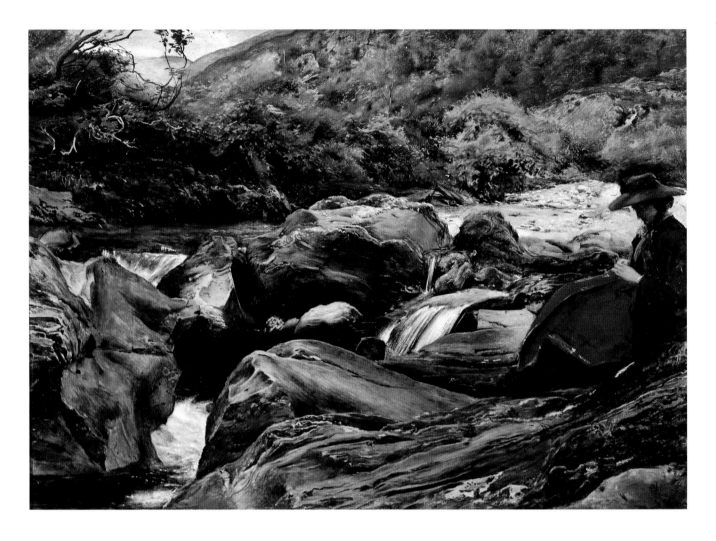

letters make it clear that, in the first place, he had no idea of the true relationship between Ruskin and his wife. Ruskin had married Effie Gray in 1848, when he was twenty-nine and she nineteen; he was not interested in her, and the marriage was never consummated. Millais and Effie fell in love during the time in Glenfinlas and, after the Ruskins' return to London, she went back to her parents' home. Her marriage was annulled in 1854, and she married Millais in 1855. Evidence suggests that Ruskin was by no means dismayed by Effie's departure, while she herself feared that Ruskin's father wanted to entrap her into a relationship with another man. This series of events provides the setting for the painting of the Ruskin portrait.

In the context of Millais's career as a portraitist, the Ruskin painting seems to have come at a decisive moment, unless it was the painting of the portrait itself that created the decisive moment. Millais took the commission seriously: a successful portrait of such a famous man as John Ruskin would bring in more sitters. He began to draw Ruskin while the party was staying, *en route* to Scotland, with the Trevelyans at Wallington in Northumberland (cat. no. 14). At the same time he began a drawing of Effie (cat. no. 15), whom he had clearly marked down as a good model. When they arrived in the Trossachs

Waterfall in Glenfinlas
Oil on panel, 237 × 335mm (9⅜ × 13⅛")
Signed with monogram, lower right, 1853
Delaware Art Museum.
Samuel and Mary R. Bancroft Memorial
Cat. no. 17

Effie Ruskin
(1828–97)
Oil on board, 241 ×
213mm (9½ × 8⅜")
Dated 1853, lower left
Wightwick Manor,
The Mander Collection
(The National Trust)
Cat. no. 18

at the beginning of July, the search for an ideal setting began, and it was soon found amid the stones in a stream running through Glenfinlas. The rocks themselves were gneiss, a type with which Ruskin was preoccupied. Millais had painted outdoor scenes before, for *Ophelia* and *The Proscribed Royalist* (1852–3; private collection), but this was his first attempt at an outdoor portrait. He described himself as painting a small portrait, but by the time the canvas was ordered he had decided that it was to be the largest portrait he had painted so far. He also planned a companion piece showing Effie looking out of a window at Doune Castle, but this got no further than a slight drawing (cat. no. 16).

Prolonged bad weather and delays over the supply of the canvas (the first one was not white enough) meant that Millais began slowly. As a trial run for the difficult task of painting the water streaming over the rocks, he made a painting of a waterfall in Glenfinlas, which shows Effie sitting sewing on the rocks, the stream falling beyond her (opposite). Millais also completed a small study of her with foxgloves in her hair (above) and a small full-length oil sketch (cat. no. 19). It was late July before he started work in earnest on the portrait of her husband. He had made a sketch of Ruskin standing on the rocks, and had established the placing of the figure on the canvas. Detailed work began on

the ash tree behind Ruskin's head, and on the rocks beneath it. Only when these were completed did Millais turn to the task of painting the stream. When he left Scotland in late October the waterfall was still unfinished; he planned to complete it in Snowdonia the following spring, but Ruskin objected that the strata of the rocks would not be accurate. Millais therefore returned to Brig o' Turk in June 1854, and worked for ten days or so on the final passages of the painting.

Millais's letters from Glenfinlas suggest that he was largely concerned with painting the scene rather than the sitter. Writing about the progress of the portrait, Ruskin also described the treatment of the rocks and water, praising the painter's skill and accuracy. Something of Millais's excitement at the challenge can be gathered from a letter to Charles Collins of 17 August 1853, in which he described the stream in flood:

> I never saw anything so suggestive of strength. In some places where the fall is gradual, and then sudden, the surface of the stream took the line of a whale the size of life, transparent and of the colour of amber, where the water sweeps into comparative quiet, in side pools 20ft deep, the foam forms into tranquil cream.[16]

Ruskin's head and face were completed in Millais's London studio in the early months of 1854. By this time Millais was fully aware of Effie's situation, and he himself was in love with her. These occasions were therefore uncomfortable for the painter but not, it seems, for Ruskin. The final sittings took place some time after Effie had left her husband, but Millais felt that it was important for her sake to complete his contractual obligation, however distasteful it had become.

Ruskin, like Fenn, Thomas, Wyatt and Combe, is dressed in a black coat with a white shirt and a black cravat; he carries a brown hat. His dress, which may seem elaborate by present-days standards, was the usual attire for Victorian walkers – the famous climber in Caspar David Friedrich's *The Wanderer over the Sea of Clouds* (*c*.1815; Kunsthalle, Hamburg) is similarly dressed. Even so, Ruskin is an unlikely figure to be standing in a stream – like a thinker, he is lost in contemplation rather than paying attention to the rushing water and the rocks.

For Millais, *John Ruskin* (opposite) was the ultimate Pre-Raphaelite portrait and, at the same time, a true likeness of the sitter. From the beginning of his career Millais had been confident of his ability to 'catch a likeness', and all the evidence suggests that this was a gift that never deserted him (in later years, he was to make some use of photographs as an alternative to extended sittings when his subjects pleaded pressure of time). The size of *John Ruskin* also looks forward to the later works, and marks a departure from the intense cabinet portraits, such as *Wilkie Collins*, which had preceded it. *John Ruskin*, however, is still smaller than some of the near life-size studies of other great Victorians that were to follow. For Disraeli (cat. no. 41) and Tennyson (cat. no. 42), Millais not only chose a grander scale but a plain ground, in the style of Rembrandt or Velázquez. The early portraits make it clear that Millais (presumably on instruction from his patrons) was

John Ruskin
(1819–1900)
Oil on canvas, 787 × 68omm (31 × 26¾")
Signed with monogram and dated 1854, lower left
Private collection
Cat. no. 23

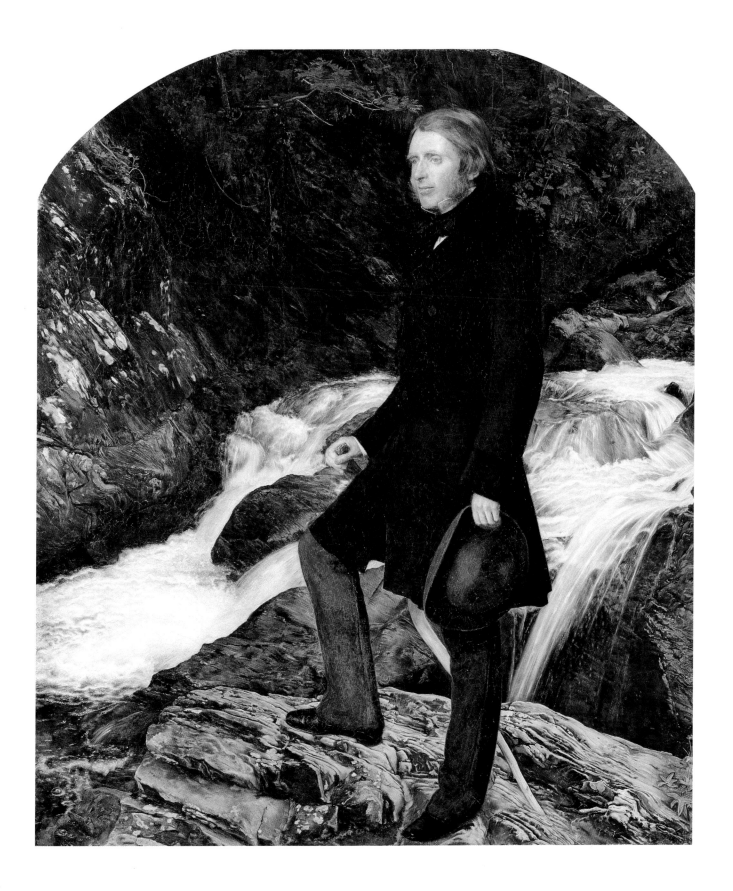

able to vary the settings in which he placed his sitters, from the plain dark background of *Thomas Combe* to the detailed interiors of the Wyatt groups. *John Ruskin* differs from both, representing not only the apotheosis of the detailed setting but the first of the major portraits to be set in the open air.

The genius of the Ruskin portrait lies in its representation of the natural world. It is unique, not only in Millais's own oeuvre, but among Victorian portraits. Its concern with accuracy in the rendering of the rocks recalls the role of geological research in the Victorian analysis of religious beliefs, but, at the same time, the portrait's treatment of rushing water and of man in nature reaches back into the Romantic movement. However it is considered, this is a transitional work, one that marks a looking forward, and a consolidation of past experience.

John Ruskin

(1819–1900)
Oil on canvas, 787 × 680mm (31 × 26¾")
Signed with monogram and dated 1854, lower left
Private collection
Detail of cat. no. 23

NOTES

1 Millais, *Life*, vol. 1, pp.32–3.
2 Boston Museum of Fine Arts; reproduced in ibid., p.13.
3 Reproduced in ibid., p.36.
4 Claire Donovan and Joanne Bushnell, *John Everett Millais 1829–1896: A Centenary Exhibition*, Southampton, 1996, p.30, no. 5.
5 Millais, *Life*, vol. 1, p.18. In fact, there were no paintings now attributed to Veronese in the National Gallery at this time. There were five Rembrandts (or attributions to Rembrandt), but it is not clear which of these Millais copied.
6 Spielmann 1898, p.22.
7 William Holman Hunt, *Pre-Raphaelitism and the Pre-Raphaelite Brotherhood*, 2 vols., 1905; vol. 1, p.37.
8 Ibid., p.66.
9 Millais, *Life*, vol. 1, p.83.
10 Spielmann 1898, p.88.
11 Combe scrapbook, Ashmolean Museum, Oxford, 145 4M, p.2. I would like to express my thanks to the museum for granting access to these papers.
12 Holman Hunt, op. cit., pp.269–70.
13 Millais did make a portrait drawing of Emily Tennyson (private collection) but, as it appears that the artist gave it to his son Lionel in the 1870s, it was evidently not a commission. See Ann Thwaite, *Emily Tennyson: The Poet's Wife*, 1996, pp.289–90, 660–61n and pl. 12.
14 Millais, *Life*, vol. 1, p.147.
15 Letter of 27 March 1853, Pierpont Morgan Library, New York.
16 Bowerswell Papers, Folder S, Pierpont Morgan Library, New York. I would like to express my thanks to the library for granting access to these papers.

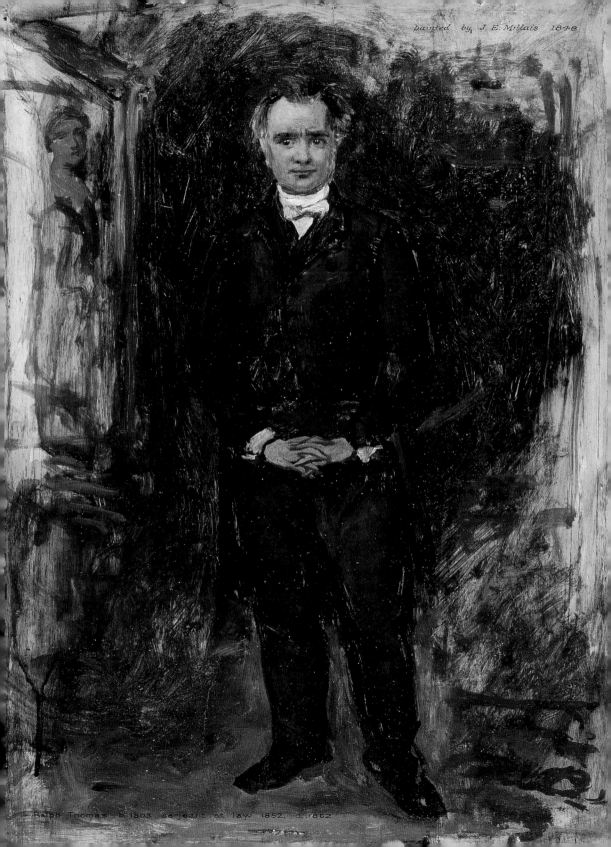

painted by J.E. Millais 1848

Ralph Thomas b. 1803 serjeant at law 1852, d. 1862

I
Early and Pre-Raphaelite Portraits

Catalogue by Malcolm Warner

I

Ralph Thomas (1803–62)
Oil on panel
387 × 286mm (15¼ × 11¼")
Inscribed 'painted by J.E. Millais 1848', upper right
Tate Gallery, London

Thomas was a London lawyer and art dealer; his legal practice was in Chancery Lane and he dealt from his own home in Stratford Place. According to the biographer of the artist John Linnell, 'He had originally pursued some humble calling, but, being dissatisfied with it, he devoted himself to study, and became successively bookseller, auctioneer, and barrister. He was, however, above all a shrewd business, money-making man.'[1] Thomas and Linnell were clearly on close terms, and in 1845 he sold the artist a house valued at £480 to be paid for entirely in pictures. Thomas also knew John Martin, and later had dealings with Mark Anthony and Whistler. In 1852 he was appointed a Serjeant-at-Law, after which he was generally known as 'Serjeant Thomas'.

For a period in the later 1840s, Millais worked for Thomas, painting small genre pictures at his house for a day a week, for which the dealer paid him an annual sum, first £100 and later £150. Millais's son John Guille Millais portrayed his relationship with the young artist as exploitative, and described an incident in which Thomas harangued Millais for arriving late and Millais threw a fully loaded palette at his head.[2] This disparaging view of Thomas was challenged vehemently by the latter's son in a pamphlet: the fact that Millais dined regularly with Thomas and his family and painted their portraits showed, he argued, that they were on friendly terms, and in any case the rate of pay was quite generous for such a young artist.[3]

The portrait is clearly unfinished, except perhaps for the head.

1. Alfred T. Story, *The Life of John Linnell*, 1892, vol. II, p.13.
2. Millais, *Life*, vol. I, pp.33–4.
3. Ralph Thomas Junior, *Serjeant Ralph Thomas and Sir J.E. Millais, Bart.*, P.R.A., privately printed, 1901.

Further literature: Bennett 1967, p.24, no. 16.

2

James Wyatt and his Granddaughter, Mary Wyatt (1774–1853 and 1845–1903)
Watercolour and pencil
349 × 254mm (13¾ × 10")
Signed and dated 1848, lower right
Geoffroy Richard Everett Millais Collection

A frame-maker, printseller and art dealer, James Wyatt lived and carried on his business at 115 High Street, Oxford. He was curator of the Duke of Marlborough's collection at Blenheim Palace, and in 1842–3 had been mayor of Oxford. Millais was his guest on several occasions between 1846 and 1850, and once decorated the windows of the room in which he was staying with designs imitative of stained glass.[1] Wyatt clearly took an interest in Millais's fledgling career as an artist, acting towards him more as a patron than as a dealer: he bought his large painting *Cymon and Iphigenia* (1848; private collection), commissioned a pair of portraits in oil (cat. nos. 4 and 5), owned several oil sketches, and kept a large number of drawings given to him by Millais as expressions of friendship. It was probably Wyatt who introduced Millais to the most important of his Oxford patrons, Thomas Combe (see cat. no. 6). The child Mary was the daughter of his son James Wyatt Jnr and his wife Eliza; she was to become Mrs James Standen.

This watercolour portrait is from an album of watercolours and drawings by

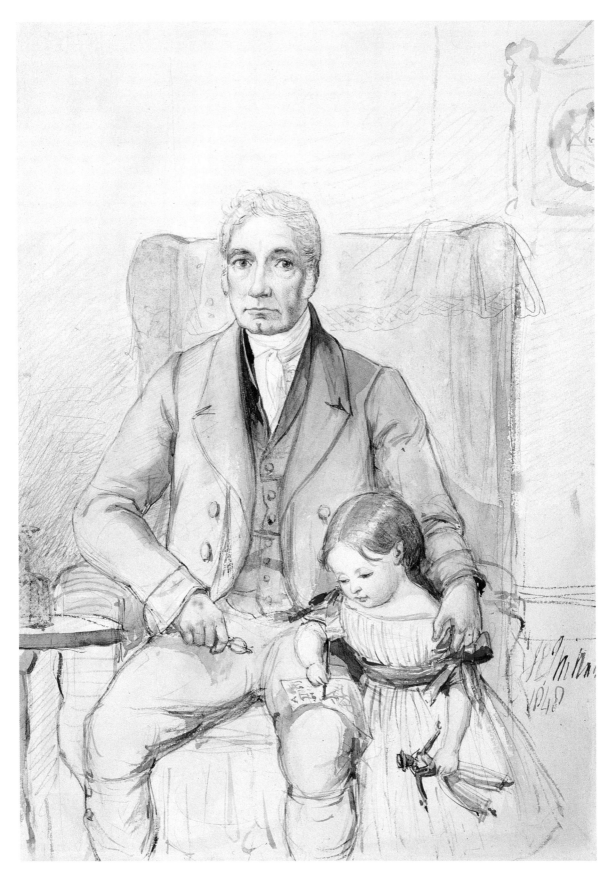

2

various artists compiled by the Wyatts in
the 1830s and 1840s; it contained several
other sketches by Millais of members of
the family and their friends. Clearly,
Millais used the basic idea of the present
work – Wyatt seated in his armchair with
his granddaughter at his knee – as the
starting point for the much more
elaborate oil portrait of the same sitters
that he painted in the following year (cat.
no. 4).

1. Millais, *Life*, vol. I, p.35.

3
William Hugh Fenn
Oil on panel
305 × 254mm (12 × 10")
1848
Signed, lower right
Collection of the Owens Art Gallery,
Mount Allison University. Gift of Lord
Beaverbrook

Fenn was Treasurer of the Covent
Garden Theatre and lived at 136 St John
Street Road, near Smith Square. Millais
knew his son William Wilthew Fenn,
who was an art student and fellow
member of the 'H.B.s' sketching club.
His friend's father took an avuncular
interest in the young Millais, gave him
free tickets to the opera, and in the
summer of 1848 invited him to stay at
the farmhouse he rented at North End,
Hampstead. The younger Fenn
eventually became a successful author;
after Millais's death he wrote his
reminiscences of their boyhood
friendship in a series of articles.[1]
 According to Marion H. Spielmann,
Millais painted the portrait in return for
Fenn's sitting as a model for his first
major Pre-Raphaelite picture, *Isabella*,
and on condition that a portrait he had
painted of him some time before should
be destroyed.[2] Fenn certainly appears in
Isabella (page 46), where he is easily

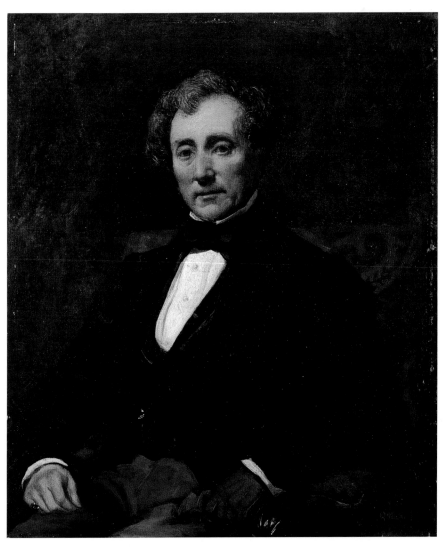

3

recognisable as the man paring an apple,
third from the back on the right side.
 Holman Hunt remembered Millais
painting the portrait before beginning
Isabella in late October 1848; if this is
correct, it was the first painting produced
by any of the Pre-Raphaelites after the
foundation of their Brotherhood. For
Hunt the work was 'so strong in form
and finish, and so rich in well-justified
colour, that it resembled a perfect Van
Eyck or Holbein, and yet its excellence
was in no way mere truth at second-
hand.'[3]

First exhibited: Fine Art Society, London, *The
Collected Work of John Everett Millais*, 1881 (1).

1. *Chambers's Journal*, 6th series, IV, November
1901, pp.833–7; V, November 1902, pp.822–5;
VIII, September 1905, pp.645–7.
2. Spielmann 1898, p.71.
3. William Holman Hunt, *Pre-Raphaelitism and
the Pre-Raphaelite Brotherhood*, 1905, vol. I,
p.157.

Further literature: Spielmann 1898, p.167 (no.
16); Millais, *Life*, vol. II, p.467; Leslie Parris,
ed., *The Pre-Raphaelites*, Tate Gallery, 1984,
p.61, no. 14.

4

**James Wyatt and his Granddaughter,
Mary Wyatt** (1774–1853 and
1845–1903)
Oil on panel
355 × 451mm (14 × 17¾")
Signed with monogram and dated 1849,
lower right
Private collection

James Wyatt of Oxford was an important
early patron of the artist (see cat. no. 2).
This portrait was painted in September–
October 1849, when Millais came to
stay with Wyatt after finishing the
background to his *Ferdinand Lured by Ariel*
(1849–50; Makins Collection) at nearby
Shotover Park. The setting is the first-
floor sitting room of Wyatt's house,
overlooking the back garden. In a sense,
the portrait embraces not just two but
four generations of his family: the man in
a top hat in the small watercolour portrait
to the right of the window is his father,
Thomas Wyatt, painted by William
Waite of Abingdon; and the young
woman in the circular portrait in the
upper right corner is his daughter-in-law
Eliza, Mary's mother, painted by William
Boxall (both of these remain in the
family's possession). The other pictures,
ceramics and *objets d'art* serve to
emphasise Wyatt's activities as dealer and
collector. The book at his side is open at
an engraved portrait of a lady; the text on
the opposite page, though hardly legible,
may be Dryden's poem 'To the Memory
of Mrs Anne Killigrew'.

Millais submitted this painting for
the British Institution exhibition of 1850,
enlisting William Michael Rossetti to
write an illustrative sonnet so that he
could pass the work off as a genre picture
since portraits were not normally
admissible. 'He has sent off his picture
to the British Institution, with my sonnet
as title,' Rossetti noted on 12 January.[1]
But the ploy failed and the portrait was
rejected; Millais submitted it instead for

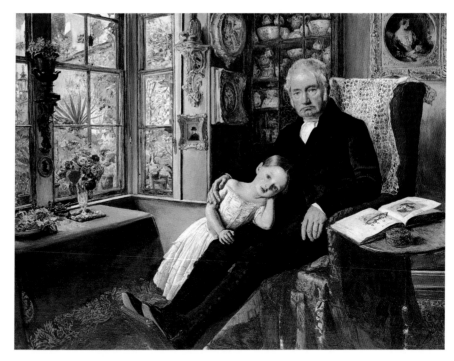

4

that year's Royal Academy exhibition.
The sonnet is untraced.

First exhibited: Royal Academy, 1850 (429).

1. William E. Fredeman, ed., *The P.R.B.
Journal*, Oxford, 1975, p.42.

Further literature: Spielmann 1898, pp.87–8,
167 (no. 18); Millais, *Life*, vol. I, pp.41, 53
(ill.), 88; vol. II, p.467; William Holman Hunt,
*Pre-Raphaelitism and the Pre-Raphaelite
Brotherhood*, 1905, vol. I, p.194; Bennett 1967,
pp.26–7, no. 20; Leslie Parris, *The Pre-
Raphaelites*, Tate Gallery, 1984, pp.80–81,
no. 28.

5

Eliza Wyatt and her Daughter, Sarah
(1813–95 and 1849–1916)
Oil on panel
353 × 457mm (14 × 18")
c.1850
Signed with monogram, lower right
Tate Gallery, London

The sitters were the daughter-in-law
and granddaughter of James Wyatt, who

commissioned this portrait as a pendant
to that of himself and Sarah's older sister
Mary (cat. no. 4). Eliza Wyatt, née
Moorman, was the wife of Wyatt's son,
James Jnr, who worked in his father's
business; their daughter Sarah later
became Mrs Thomas. Since Sarah was
born in 1849 and appears to be about a
year old, the portrait can reasonably be
dated to Millais's stay in Oxford in the
summer of 1850, during which time
he also painted the background to *The
Woodman's Daughter* (1850–51; Guildhall
Art Gallery).

On the wall in the background are
prints after famous paintings of the High
Renaissance, Leonardo's *Last Supper*, and
the *Madonna della Sedia* and *Alba Madonna*
of Raphael. Millais held Raphael in the
deepest contempt at this time, and the
prints are probably not included as an
homage. Raphael's idealised figures and
flowing, harmonious compositions serve
to set off the awkward realism of the
modern mother-and-child group in front
of them. When hung next to the earlier
Wyatt portrait, the work also invites us

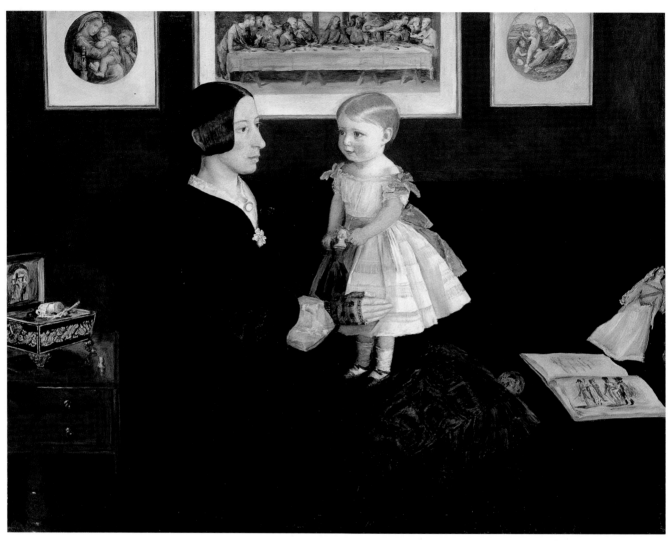

5

to compare Millais's severe treatment of
Eliza Wyatt with the dreamy, romantic
portrait of her by William Boxall. With
its circular format and curvaceous lines,
the Boxall is likened to the *Madonna
della Sedia*. As if painting a kind of Pre-
Raphaelite manifesto, Millais spells out
the 'Raphaelite' nature of recent British
art, and offers his own style as a
corrective. For further discussion of the
significance of this portrait, see pp.105–6.

Literature: Millais, *Life*, 1899, vol. I, p.41n;
Bennett 1967, p.27, no. 21; Leslie Parris, ed.,
The Pre-Raphaelites, Tate Gallery, 1984,
pp.81–2, no. 29.

6

Thomas Combe (1797–1872)
Oil on panel
330 × 269mm (13 × 10⅝")
Signed with monogram and dated 1850,
lower right
The Visitors of the Ashmolean Museum,
Oxford

From 1838 until his death, Thomas
Combe was Printer to the University and
Superintendent of the Clarendon Press,
Oxford. He and his wife Martha lived in
a house in the quadrangle of the Press.
They were devout Christians, staunch
supporters of the Anglican High Church

or 'Oxford Movement' – they were
married by John Henry Newman (see
cat. no. 44) – and were on friendly terms
with a number of local clergymen.
Staying with them in June 1852, Holman
Hunt wrote to Walter Deverell: 'My
good host is such a glorious fellow as to
be perfectly delightful as a companion
altho 60 years of age, or nearly . . . I must
say that he comes more nearly up to my
conception of a good practical happy
Christian than any man ever met by me,
and is in proof of the truth of the above,
loved and respected everywhere.'[1]

Millais may have met the Combes
during his summer visits to Oxford in

1848 and 1849; they were probably introduced by James Wyatt (see cat. no. 2), although Hunt says it was a Dr Martin.[2] The high point of their friendship was the several weeks Millais spent as the Combes' guest in the autumn of 1850; he and his friend Charles Collins (see cat. no. 8) were staying with them by 21 September and left on 11 November. Millais referred affectionately to Combe as 'the Early Christian' and 'the Patriarch', and to his wife as 'Mrs Pat'. The letters he wrote to them for several years after this visit are quoted extensively in his son's biography.[3]

Clearly, the Combes were enthusiastic about the highly controversial Pre-Raphaelite style, and provided Millais and his friends with much-needed moral and material support; no doubt the Pre-Raphaelites' belief in the purity of art before the High Renaissance resonated with their nostalgia, as Oxford Movement Christians, for England before the Reformation. In addition to the present portrait and many drawings, they owned Millais's painting of *The Return of the Dove to the Ark* (1850–51). Thanks to Millais's efforts on behalf of his fellow P.R.B. members and associates, they also acquired works by Hunt, Collins and D.G. Rossetti; their collection remains intact as the Combe Bequest at the Ashmolean Museum.

Millais referred to his portrait of Combe in a letter to Hunt of 24 September 1850: 'Collins and self have been painting portraits, and have given *great satisfaction* in the PRB style.'[4] Collins was painting a portrait of Mrs Combe's uncle, William Bennett (also now in the Combe Bequest); it is close in size to Millais's portrait of Combe, with a coat of arms similarly placed in the upper left corner, and the two works were clearly intended as pendants (see cat. no. 7). The artists gave them to the Combes as expressions of friendship and gratitude.

In a note attached to the back of his portrait, Combe wrote: 'This portrait of myself was painted by J.E. Millais in the Autumn of 1850 while he was residing in my house . . . I sat four times or about eight hours. It is admired for the brilliancy of his colouring – he has not produced anything brighter. The likeness at the time was excellent.'

The coat of arms in the portrait is like that of various Combe families of different parts of southern England; whether Thomas Combe had any real claim to it is unknown. Certainly he enjoyed heraldic decorations, and painted shields himself. On 6 October 1850,

writing to Hunt to relate how pleased the Combes were with his *Christian Missionary* picture, bought for them by William Bennett, Millais told his friend: 'I assure you it hangs in a very *beautiful* room, no paper but painted pure white; all round the top are hung shields with arms painted thereon, all done by Mr Combe.'[5] A few months later Combe sent Millais some shields to decorate his studio in London.[6]

First exhibited: Grosvenor Gallery, *Winter Exhibition. IX: Works of Sir John E. Millais, Bt., R.A.*, 1886 (77).

6

1. Huntington Library, San Marino, California, HM 12917.
2. William Holman Hunt, *Pre-Raphaelitism and the Pre-Raphaelite Brotherhood*, 1905, vol. I, p.232.
3. Millais, *Life*, vol. I, chapters 3–6.
4. Huntington Library, Holman Hunt Collection, 333.
5. Ibid., 336.
6. See Millais, *Life*, 1899, vol. I, p.101.

Further literature: Spielmann 1898, pp.88, 148, 167 (no. 21); Millais, *Life*, vol. I, p.88; vol. II, p.467; Bennett 1967, p.30, no. 28.

7

William Bennett
Pencil
197 × 146mm (7¾ × 5¾")
Signed and dated 1850, lower right
The Visitors of the Ashmolean Museum, Oxford

Bennett was the uncle of Martha Combe, wife of Millais's great Oxford patron Thomas Combe; he appears to have been staying with the Combes at the same time as Millais and Charles Collins in 1850 (see cat. nos 6 and 8). In late September 1850, encouraged by Millais, he made the Combes a present of Holman Hunt's painting *A Converted British Family Sheltering a Christian Missionary from the Persecution of the Druids*.[1] Around the same time, Collins painted a portrait of him in oil as a pendant to Millais's of Thomas Combe (all these paintings are in the Combe Bequest at the Ashmolean Museum). Hunt described Bennett as a capricious old gentleman who disliked the Combes' clergyman friends.[2]

1. See Mary Lutyens, 'Selling the Missionary', *Apollo*, vol. 86, November 1967, pp.380–87.
2. William Holman Hunt, *Pre-Raphaelitism and the Pre-Raphaelite Brotherhood*, vol. I, pp.232–4.

7

8

Charles Collins (1828–73)
Pencil with grey wash
165 × 127mm (6½ × 5")
Signed 'John E. Millais PRB' and dated 1850, lower right
The Visitors of the Ashmolean Museum, Oxford

Charles Allston Collins was the son of the genre painter William Collins, and younger brother of the novelist Wilkie Collins (cat. no. 9). He studied at the Royal Academy Schools, met Millais and other members of the Pre-Raphaelite circle, and showed his first picture in a Pre-Raphaelite style, *Berengaria's Alarm* (Manchester City Art Gallery), at the Royal Academy exhibition of 1850. Millais proposed him for membership in the Pre-Raphaelite Brotherhood but he was never admitted. As Holman Hunt recalled, he had striking looks, with strong blue eyes and brilliant red bushy hair.[1] His sensitive, introspective character, tendency to asceticism, and attraction to the ritualistic aspects of the High Church are all reflected in his best known and most successful picture, *Convent Thoughts* (1850–51; Ashmolean

John E. Millais PRB
1850

8

Museum). In the later 1850s he abandoned painting in favour of the pen, publishing humorous essays and accounts of his travels. In 1860 he married Kate Dickens (see cat. no. 54), daughter of the writer Charles Dickens. After many years of ill health, he died of gastric ulcers at the age of forty-five.

Collins was one of the most intimate friends of Millais's youth; the only others with whom he shared such close companionship were William Holman Hunt and John Leech. 'Carlo', as Millais affectionately called him, was with him in Oxford in September–November 1850, staying at the home of the great Pre-Raphaelite patron Thomas Combe; this portrait, a gift for Combe, was almost certainly drawn during this visit. Collins was at work on *Convent Thoughts*, which Combe was to buy, and he also painted a portrait of Combe's uncle William Bennett, as a pendant to Millais's of Combe himself (cat. no. 6); all three works are now in the Combe Bequest at the Ashmolean Museum, Oxford.

1. William Holman Hunt, *Pre-Raphaelitism and the Pre-Raphaelite Brotherhood*, 1905, vol. I, p.271.

Further literature: William Holman Hunt, op.cit., vol. I, p.238 (ill.).

9

9
Wilkie Collins (1824–89)
Oil on panel
267 × 178mm (10½ × 7")
Signed with monogram and dated 1850, lower right
National Portrait Gallery, London
(NPG 967)

Millais knew the writer Wilkie Collins through the latter's brother Charles, who was an artist and one of Millais's dearest friends (see cat. no. 8). When this portrait was painted, Wilkie was living with Charles and their widowed mother Harriet Collins at 17 Hanover Terrace, Regent's Park, where Millais was a frequent visitor; no doubt he gave them the work as an expression of friendship. Wilkie was enjoying a modest celebrity, following the publication of his historical novel *Antonina*. He was to begin his series of 'novels of sensation', the stories of mystery, suspense and crime that made his name, with *Basil* (1852); among the most successful were *The Woman in White* (1860) and the seminal detective novel *The Moonstone* (1868). According to John Guille Millais, the original of the 'woman in white' was a beautiful, distressed young woman in flowing white robes

who suddenly emerged from the gates of a villa as the Collins brothers were walking Millais home after an evening together.[1] This would have been Wilkie's future mistress, Caroline Graves.

Holman Hunt claimed that Millais's portrait of Wilkie 'remained to the end of his days the best likeness of him', adding: 'It will be seen he had a prominent forehead, and in full face the portrait would have revealed the right side of his cranium outbalanced in prominence that of the left.'[2] The coat of arms at the upper left belongs to various Collins families, to which the sitter may or may not have been related. It was perhaps suggested by Thomas Combe, who had an interest in heraldry and whose own portrait features a similar device (cat. no. 6). Charles Collins also made a small panel portrait of Wilkie in 1850 (private collection), perhaps at the same time as Millais was painting his; he made another in 1853 which he apparently gave to Millais (Fitzwilliam Museum, Cambridge).

First exhibited: No. 4, Russell Place, Fitzroy Square, Pre-Raphaelite exhibition, 1857 (51).

1. Millais, *Life*, vol. I, pp.278–81.
2. Willaim Holman Hunt, *Pre-Raphaelitism and the Pre-Raphaelite Brotherhood*, 1905, vol. II, pp.185–6.

Further literature: Spielmann 1898, p.178 (no. 343); Millais, *Life*, vol. I, pp.279 (ill.), 281; vol. II, p.469; Bennett 1967, pp.29–30, no. 27.

10

Emily Patmore (1824–62)
Oil on panel
197 × 203mm (7⅞ × 8⅛")
1851
The Syndics of the Fitzwilliam Museum, Cambridge

Emily Augusta Patmore was the daughter of the Revd Edward Andrews, a Congregationalist minister who died young. She married the poet Coventry

10

Patmore, then an assistant in the printed books department at the British Museum, in 1847. Their courtship and marriage were the inspiration for his best-known work, *The Angel in the House*, a sequence of long poems published between 1854 and 1862. They had three sons and three daughters. Mrs Patmore herself published some small books under the pseudonym of 'Mrs Motherly', and assisted Patmore in compiling his anthology of poetry for children, *The Children's Garland* (1862). She died of consumption in 1862, aged thirty-eight.

Coventry Patmore was on close terms with the Pre-Raphaelites in the early 1850s, and played an important part in bringing them together with John Ruskin, prompting the critic to write controversial letters in support of their work to *The Times* in May 1851. The portrait was begun about that time as a

gift to him, perhaps in gratitude for his help with Ruskin. It was unfinished when Millais left for the country in the summer to paint the background to *Ophelia* (1851–2; Tate Gallery, London). Though mentioning no name, Holman Hunt was probably referring to Patmore in his story of an impatient husband who annoyingly insisted that Millais break off from *Ophelia* and return to London for a few days to finish a portrait of his wife, while she was 'at her best in health'.[1]

The portrait was finished by 22 October 1851, when Millais wrote to Patmore saying he was pleased to hear of his satisfaction with the work, adding: 'I am very anxious that Tennyson should see it, that he may give me leave to paint his wife's.'[2] The idea of an oil portrait of Mrs Tennyson came to nothing, although he did paint her in watercolour in 1854 (private collection). Patmore may have

been pleased with the gift at first, but later found the likeness distasteful. On 30 November 1885 he wrote to F.G. Stephens: 'Millais painted my wife's portrait for me (a present) but it omitted all the refinement of her face; and had the truth and untruth of a hard photograph. I keep it locked up as I do not like the children to think it like their mother.'[3] In comparing the portrait to a photograph, Patmore was echoing the comments of reviewers when the work was first exhibited at the Royal Academy in 1852. The *Spectator*, for instance, noted that 'the face is lifelike in its vigour of rendering, yet has not the shifting look of life. It is a daguerreotype whose production has taken hours instead of moments.'[4]

Other descriptions reveal that it originally included the sitter's hands, which were shown arranging the flowers. 'The sitter looks you very determinedly in the face,' wrote the *Illustrated London News*, 'whilst her hands are engaged in putting together a small nosegay'.[5] Clearly the panel has been trimmed at the bottom. It may have been cut to its present, near-square format for display as a circular image – perhaps to suggest a halo for Mrs Patmore in her role as angel. Certainly it was mounted as such, inside a window six inches in diameter, when Patmore lent it to Millais's Grosvenor Gallery exhibition of 1886. The cutting explains the unusual absence of any signature, monogram or date.

First exhibited: Royal Academy, 1852 (156).

1. William Holman Hunt, *Pre-Raphaelitism and the Pre-Raphaelite Brotherhood*, 1905, vol. I, p.269.
2. Basil Champneys, *Memoirs and Correspondence of Coventry Patmore*, 1900, vol. II, pp.326–7.
3. Bodleian Library, Oxford: Stephens Correspondence.
4. *Spectator*, 19 June 1852, p.592.
5. *Illustrated London News*, 22 May 1852, p.407.

Further literature: Spielmann 1898, pp.29, 70, 168 (no. 32); Millais, *Life*, vol. II, p.468; Bennett 1967, p.35, no. 37; J.W. Goodison, *Fitzwilliam Museum, Cambridge. Catalogue of Paintings. Volume III, British School*, Cambridge, 1977, pp.166–7.

11, 12
Anne Lynn
Pencil and watercolour
220 × 192mm (8⅝ × 7½")
Signed with monogram and dated 1852, lower right
Trustees of the British Museum

Fanny Lynn
Pencil and watercolour
215 × 188mm (8½ × 7⅜")
Signed with monogram and dated 1852, lower right
Trustees of the British Museum

Millais knew a local man named Lynn during his stay at Hayes in the summer of 1852, when he was painting the background to *The Proscribed Royalist* (1852–3; private collection). In letters to his cousin Emily Hodgkinson of August–September, he mentioned Lynn's having made him a rustic easel and 'a regular artist's sketching stool, shutting up and portable'.[1] Anne and Fanny were perhaps his daughters.

1. Victoria and Albert Museum, London.

Further literature: Malcolm Warner, *The Drawings of John Everett Millais*, Arts Council of Great Britain, 1979, p.21, nos. 16, 17.

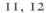

11

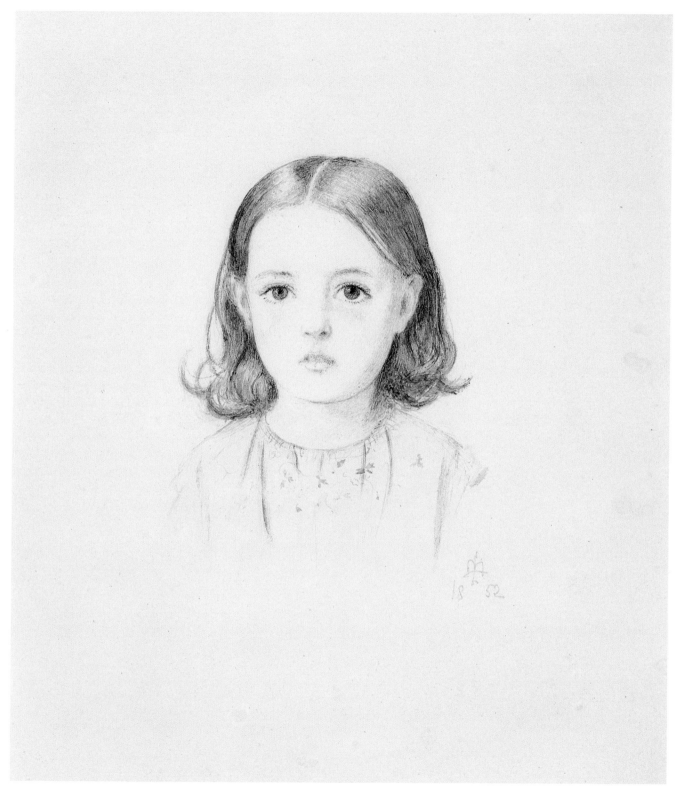

12

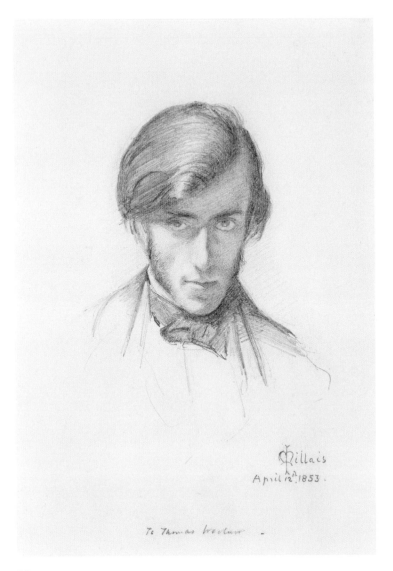

13

The portrait was drawn to be sent to another P.R.B., the sculptor Thomas Woolner, who had sailed to Australia in July 1852 to dig for gold. At a party on 7 January 1853, Woolner's friends in London decided that there should be some 'act of communication' between them, and D.G. Rossetti decreed that 'on the 12th of April . . . at 12 o'clock in the day, we shall each of us, wheresoever we be, make a sketch of some kind (mutual portraits preferable) . . . and immediately exchange them by post.'[1]

A Pre-Raphaelite drawing session was duly held, on the prescribed date, at Millais's studio in Gower Street. Stephens recalled: 'Millais fell to me to be drawn, and to him I fell as his subject. Unhappily for me, I was so ill at that time that it was with the greatest difficulty I could drag myself to Gower Street; more than that, it was but the day before the entire ruin of my family, then long impending and long struggled against in vain, was consummated . . . My portrait, which by the way is a good deal out of drawing, attests painfully enough the state of health and sore trouble in which I then was. This meeting was one of the latest

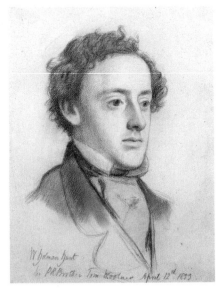

William Holman Hunt, **John Everett Millais**
Pastel and chalk, 327 × 248mm (12⅞ × 9¾"), 1853
National Portrait Gallery, London

13
Frederic George Stephens (1828–1907)
Pencil
216 × 152mm (8½ × 6")
Signed, with initials in monogram, and dated 'April 12th 1853', lower right; inscribed 'To Thomas Woolner', lower centre
National Portrait Gallery, London
(NPG 2363)

The artist and critic F.G. Stephens was a student at the Royal Academy Schools and founder member of the Pre-Raphaelite Brotherhood. His attempts to paint an historical picture for exhibition in the late 1840s and early 1850s ended either in abandonment or rejection, and his only exhibited works were the portraits of his parents shown at the Academy in 1852 and 1854. He sat as a model to Millais for a figure in *Isabella* (see page 46) and for Ferdinand in *Ferdinand Lured by Ariel* (1849–50; Makins Collection). From 1850 he was increasingly drawn to the criticism of art rather than its practice. His first published pieces appeared in *The Germ* and *The Critic* in that year, and from 1861 to 1901 he was principal art critic for the *Athenaeum*.

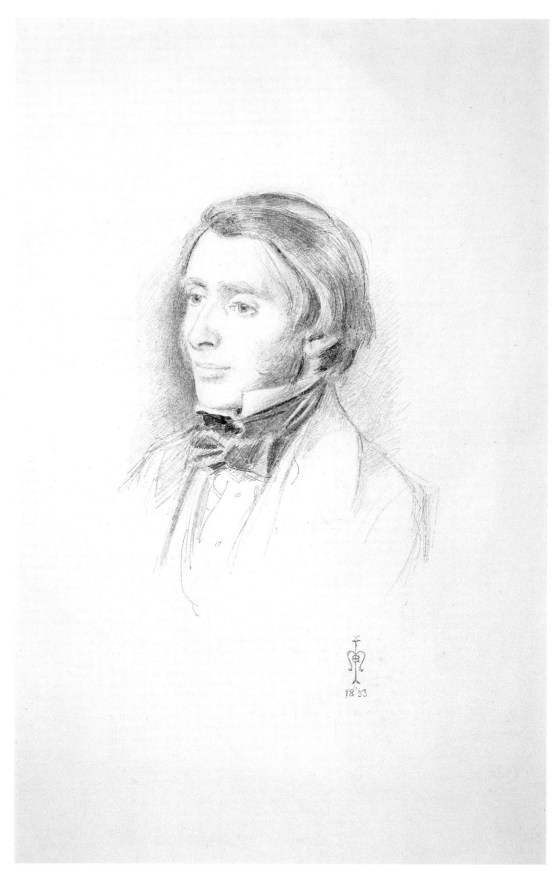

14

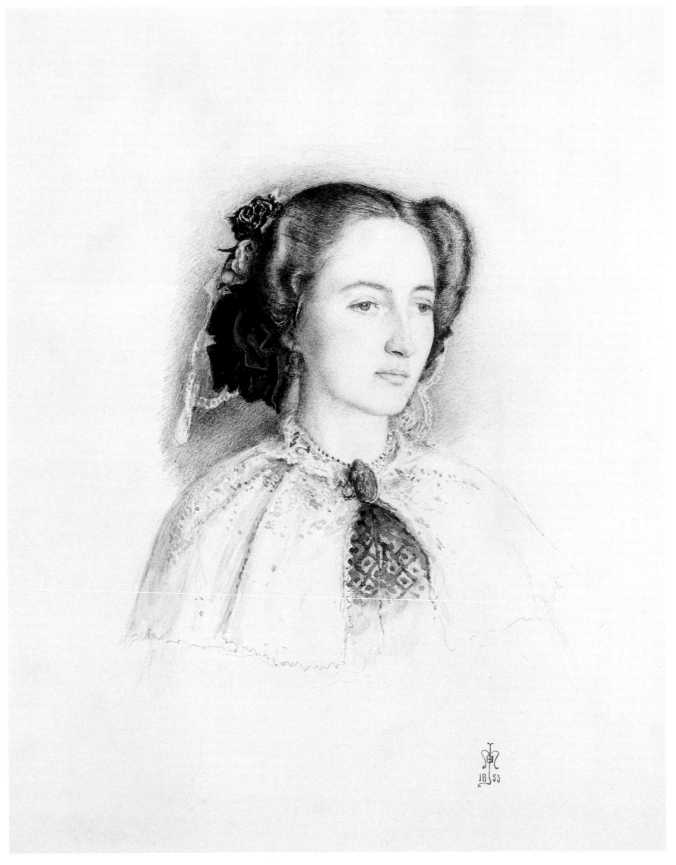

"functions" of the Pre-Raphaelite Brotherhood in its original state.'[2]

The fact that Stephens and Millais were drawing each other at the same time explains the forward tilt of Stephens's head and his upward look. In the event, he gave up his drawing, and the task of portraying Millais for Woolner was taken over by Holman Hunt (see page 80, bottom).[3]

1. Amy Woolner, *Thomas Woolner, R.A.*, 1917, p.48.
2. Millais, *Life*, vol. I, pp.81–2.
3. Ibid.

Further literature: William Holman Hunt, *Pre-Raphaelitism and the Pre-Raphaelite Brotherhood*, 1905, vol. I, p.341; Amy Woolner, *Thomas Woolner, R.A. Sculptor and Poet. His Life in Letters*, 1917, pp.50, 58, 62; H.F. Stephens, *Frederic George Stephens and the Pre-Raphaelite Brothers*, privately printed, 1920, pl. 11 (ill.); Bennett 1967, p.82, no. 288; Richard Ormond, 'Portraits to Australia: a group of Pre-Raphaelite drawings', *Apollo*, vol. 85, January 1967, pp.25–7.

14
John Ruskin (1819–1900)
Pencil, with touches of brown wash
336 × 260mm (13¼ × 10¼")
Signed with monogram and dated 1853, lower right
The Ruskin Foundation (The Ruskin Library, University of Lancaster)

Millais's relationship with John Ruskin, the great critic of art, architecture and society, was to be of crucial importance to both his art and his life. The two men met in 1851, after Ruskin had written his controversial letters to *The Times* defending Pre-Raphaelite pictures at that year's Royal Academy exhibition. By 1853 they were on close terms, and Millais painted Ruskin's wife Euphemia (Effie) as a Jacobite woman in *The Order of Release, 1746* (1852–3; Tate Gallery, London). The Ruskins, Millais and his brother William decided to spend that

summer together in Scotland, where Millais painted the background to his portrait of Ruskin (cat. no. 23).

On the way to Scotland, the party visited Sir Walter and Lady Trevelyan at Wallington in Northumberland; they arrived by train from London on 22 June 1853 and stayed for a week. Millais drew the present pencil sketch on the 25th. 'Millais kept drawing all the while he was there – he could not be kept from it,' Ruskin wrote to his father on the evening after they had left. 'First he made a sketch of me for Lady Trevelyan – like me – but not pleasing, neither I nor Lady Trevelyan liked it except as a drawing: but she was very proud of it nevertheless.'[1]

Thomas Woolner later remarked that the likeness was good 'but the expression that of a hyena, or something between Carker and that hilarious animal. Enemies would call the expression characteristic, but friends would declare that it did him injustice.'[2] James Carker is the villain of Dickens's *Dombey and Son*, and the comparison was presumably to his appearance as drawn by Phiz.

1. Mary Lutyens, *Millais and the Ruskins*, 1967, p.54.
2. *Magazine of Art*, XIV, 1891, pp.77–8.

Further literature: Bennett 1967, p.83, no. 293.

15
Effie Ruskin (1828–97)
Pencil with watercolour
254 × 216mm (10 × 8½")
Signed with monogram and dated 1853, lower right
Geoffroy Richard Everett Millais Collection

The artist's future wife, born Euphemia Chalmers Gray, was the eldest child of a solicitor, George Gray, of Bowerswell in Perth, Scotland. She married John Ruskin, the son of a business friend of

her father, in 1848; he was nine years her senior. She flourished in the aristocratic and fashionable society of Venice during the periods she and Ruskin spent there in 1849–50 and 1851–2, but grew increasingly unhappy in her marriage. In 1853 she sat to Millais for *The Order of Release, 1746* (1852–3; Tate Gallery, London) and, by the end of the rainy summer that she, Ruskin and Millais spent together in Scotland, she and the artist had fallen in love.

On 15 July 1854 Effie obtained an annulment of her marriage to Ruskin on the grounds of non-consummation. She and Millais were married on 3 July 1855; they had eight children.[1] As his success and income grew, she encouraged him to move in high social circles; she ran a large household, and entertained in style at their homes in Kensington: 7 Cromwell Place (1861–77) and 2 Palace Gate (1877–96). She also assisted her husband in his work, helping him to find models and props, doing historical research, and dealing with some of his business correspondence. She died the year after him, aged sixty-nine, and was buried in Kinnoull churchyard, Perth.

The present portrait was made while Millais and the Ruskins were staying with Sir Walter and Lady Trevelyan on their way to Scotland in June 1853. 'Today I have been drawing Mrs Ruskin, who is the sweetest creature that ever lived,' Millais wrote to Holman Hunt on the 28th.[2] As Ruskin told his father in a letter of the following day, the portrait was originally intended as a gift for Lady Trevelyan, like the portrait of Ruskin himself (cat. no. 14), but Millais was 'so pleased with the drawing that he kept it for himself and did another for her.'[3]

First exhibited: Grosvenor Gallery, *Winter Exhibition. IX: Works of Sir John E. Millais, Bt., R.A.*, 1886 (159).

1. The story of Effie's life up to her marriage to Millais is told in detail, largely through her

16

letters, in a trilogy by Mary Lutyens: *Effie in Venice*, 1965; *Millais and the Ruskins*, 1967; and *The Ruskins and the Grays*, 1972.
2. Mary Lutyens, *Millais and the Ruskins*, 1967, p.55.
3. Ibid., p.54; the whereabouts of the second portrait are unknown.

Further literature: Millais, *Life*, vol. I, p.286 (ill.); vol. II, p.487 (list); Bennett 1967, p.83, no. 291.

16

Effie Ruskin by a window at Doune Castle, with portraits of James Simpson and other sketches

Pen and brown ink
184 × 225mm (7¼ × 8⅞")
1853
Inscribed 'Sir J. Simpson / from memory', lower right
Birmingham Museums and Art Gallery

On 2 July 1853, on their way to the Trossachs, Millais, his brother William and Effie Ruskin visited Doune Castle (Ruskin was not with them, having sprained his ankle). Here Millais thought of the idea of painting each of the Ruskins in a different setting. 'Millais . . . has been more struck by the castle of Doune than anything,' Ruskin wrote to his father on the following day, 'and is determined to paint Effie at one of its windows – inside – showing beyond the window the windings of the river and Stirling castle. He is going to paint *me* among some rocks – in a companion picture.'[1] On 4 July he told his father: 'The pictures will be simply called "Glen Finlas" and "Doune Castle".'[2]

The Doune Castle painting would have made a suggestive pendant to the Ruskin portrait, offering the experience of landscape as a distant view rather than in close-up. It would hardly have been a portrait of Effie since she was to be shown looking away, but this is less surprising when we remember that the paintings were conceived strictly as 'pictures' as distinct from portraits, and were to have titles indicating the places represented rather than the people.

The painting was never even begun, however, and the only record of what Millais had in mind is the present sketch. He used the same composition as the basis for a highly finished drawing he gave Effie early in 1854 (private collection), in which her figure becomes the nun who yearns for death and Christ 'the Heavenly Bridegroom' in Tennyson's poem *St Agnes Eve*.

James Simpson (1811–70), portraits of whom appear on the right side of the sheet, was Effie's doctor. He treated both her and Millais for sore throats in Edinburgh on 1 July, and spent that evening with them at the home of Andrew Jameson, Effie's uncle. Simpson was already celebrated for his work as a pioneer in the use of chloroform as an anaesthetic, and was later created a baronet. On the verso of the sheet are some of the comic imitations of the Old Masters that Millais drew in Scotland for his friends' amusement, parodies of Raphael, Guercino and Teniers.

1. Mary Lutyens, *Millais and the Ruskins*, 1967, p.59.
2. Ibid., p.60.

Further literature: Mary Lutyens, 'Millais's Portrait of Ruskin', *Apollo*, vol. 85, April 1967, p.249 (ill.); Mary Lutyens and Malcolm Warner, eds., *Rainy Days at Brig o' Turk*, Westerham, 1983, pp.14, 15 (ill.), 16, 17 (ill. verso); Tim Hilton, *John Ruskin. The Early Years, 1819–1859*, New Haven and London, 1985, pp.184–6.

17

Waterfall in Glenfinlas

Oil on panel
237 × 335mm (9⅜ × 13⅛")
1853
Signed with monogram, lower right
Delaware Art Museum. Samuel and Mary R. Bancroft Memorial

The Ruskin–Millais party reached the village of Brig o' Turk in the Trossachs,

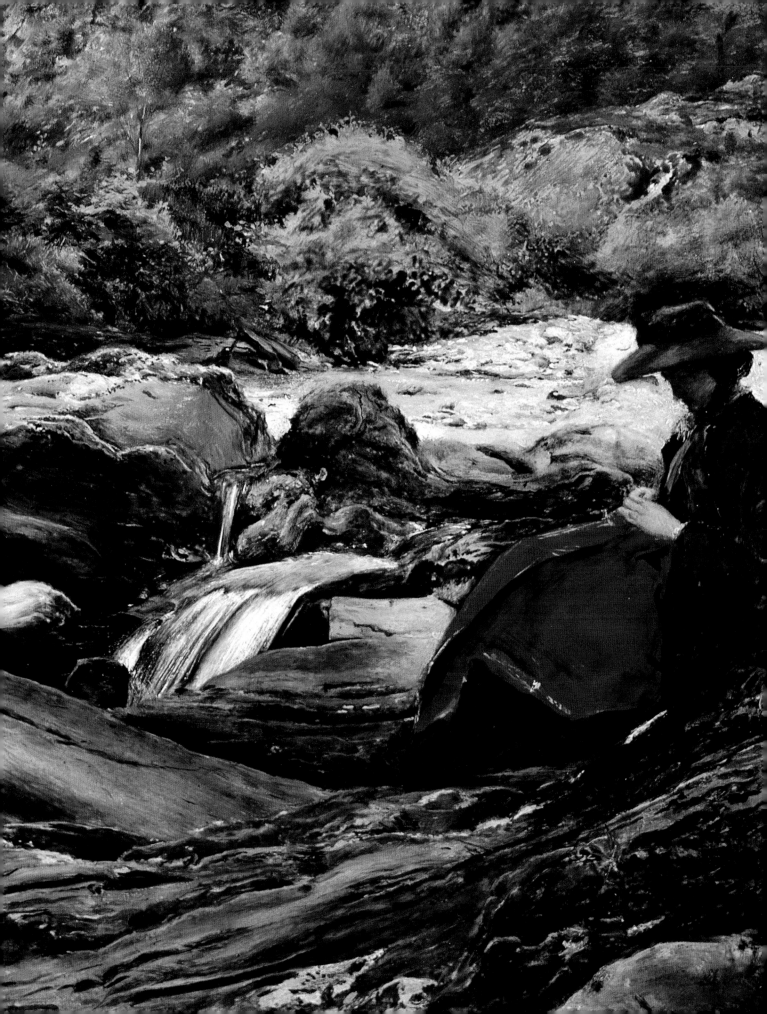

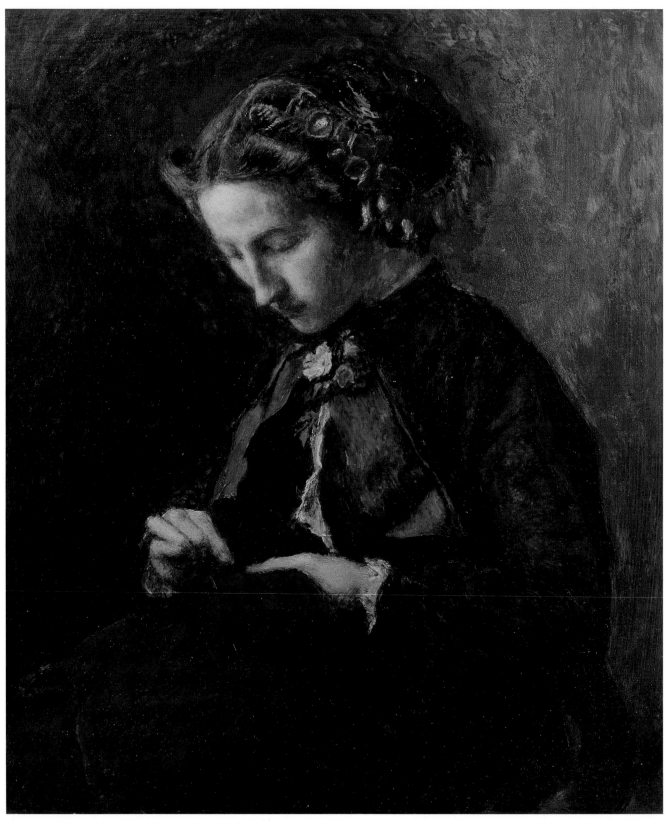

18

where Millais was to paint his portrait of Ruskin, on 2 July 1853. As a setting for the portrait, Millais and Ruskin chose a waterfall in nearby Glenfinlas, after which Millais painted this study of another waterfall, lower down the glen, by way of preparation for the larger work to come. The woman sewing on the right is Effie Ruskin. When the work was begun, Millais, his brother and the Ruskins were staying at the New Trossachs Hotel. Ruskin wrote to his father from there on 8 July 1853: 'We have been out all day again sitting on the rocks – painting and singing and fishing . . . Millais himself is doing a bit for practice . . . beautiful thing it will be when done.'[1] On 9 July they moved into lodgings with the schoolmaster Alexander Stewart and his wife. Writing from the Stewarts' on the 10th, Millais told his old friend Harriet Collins: 'Every day that is fine we go to paint at a rocky waterfall and take our dinner with us. Mrs Ruskin brings her work and her husband draws with us. Nothing could be more delightful . . . I am painting at present a fall about a mile from this house.'[2]

First exhibited: Liverpool Academy, 1862 (105, as *Outdoor study*)·

1. Mary Lutyens, *Millais and the Ruskins*, 1967, p.64.
2. Ibid., p.68.

Further literature: Spielmann 1898, pp.152, 168 (no. 41); Millais, *Life*, vol. II, p.469; Allen Staley, *The Pre-Raphaelite Landscape*, Oxford, 1973, pp.48, 51, 150, pl. 21a; Leslie Parris, ed., *The Pre-Raphaelites*, exh. cat., Tate Gallery, 1984, p.115, no. 55.

18
Effie Ruskin (1828–97)
Oil on board
241 × 213mm (9½ × 8⅜")
Dated 1853, lower left
Wightwick Manor, The Mander Collection (The National Trust)

19

Effie is shown sewing some red cloth, as in *Waterfall in Glenfinlas* (cat. no. 17), with a garland of foxgloves in her hair. Ruskin wrote to his father on 14 July 1853: 'Wet weather again – but Millais has painted a beautiful study of Effie with foxgloves in her hair,' and again on 19 July: 'Millais . . . has been making me innumerable presents of little sketches and a beautiful one of a painting of Effie with foxgloves in her hair – worth at least £50.'[1]

Though painted as a gift for Ruskin, the work was still in Millais's hands at the time of the Ruskins' annulment a year later. 'By the bye,' he wrote to Effie on 21–22 July 1854, 'what am I to do with the little portrait I did of you with the foxgloves? I have never sent it to him, and now I suppose it is impossible and yet I do not like to keep it after giving it to him.'[2] By 26 July he had decided 'The better way perhaps will be not to say a word about your little portrait to J R.'[3] The work remained in the Millais family until bought by Lady Mander for Wightwick Manor in 1949.

First exhibited: No. 4, Russell Place, Fitzroy Square, Pre-Raphaelite exhibition, 1857 (50).

1. Mary Lutyens, *Millais and the Ruskins*, 1967, pp.64, 69–70.
2. Ibid., p.235.
3. Ibid., p.239.

Further literature: Bennett 1967, p.36, no. 40.

19
Effie Ruskin (1828–97)
Oil on board
241 × 57mm (9½ × 5")
1853
Private collection

On 17 July 1853 Millais wrote to Charles Collins from Brig o' Turk: 'The last three days I have been painting Mrs Ruskin who sits like a real model, so that I have not lost time.'[1] 'The last 4 days we have

20

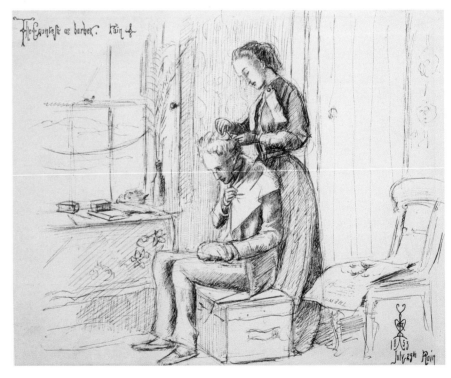

21

had incessant rain,' he wrote to Holman Hunt on the same day, 'The dreariness of mountainous country in wet weather is beyond everything. I have employed myself painting little studies of Mrs Ruskin.'[2] The present study shows her standing in the brown 'Linsey wolsey' dress and green jabot that were her everyday wear at Brig o' Turk.

1. Mary Lutyens, *Millais and the Ruskins*, 1967, p.68.
2. Ibid., p.69.

Further literature: Bennett 1967, p.36, no. 41.

20
Highland Shelter
Pen and brown ink
187 × 232mm (7⅜ × 9⅛")
Signed with monogram and dated
'July 25th 1853', lower left
Private collection

During the rainy summer at Brig o' Turk, Millais made a number of diary-like drawings in sketchbooks. Here, he and Effie take shelter under a plaid, drawn together for protection against the elements like a modern Dido and Aeneas. Millais's left hand is heavily bandaged: on the previous day he had crushed his thumb while laying stepping stones for Effie to cross a stream.[1]

1. See Mary Lutyens, *Millais and the Ruskins*, 1967, pp.70–71.

Further literature: Bennett 1967, p.84, no. 300; Mary Lutyens and Malcolm Warner, eds., *Rainy Days at Brig o' Turk*, Westerham, 1983, pp.36–7, no. 15.

21
The Countess as barber
Pen and brown ink
187 × 232mm (7⅜ × 9⅛")
Signed with monogram and dated
'1853 / July 25th Rain', lower right;

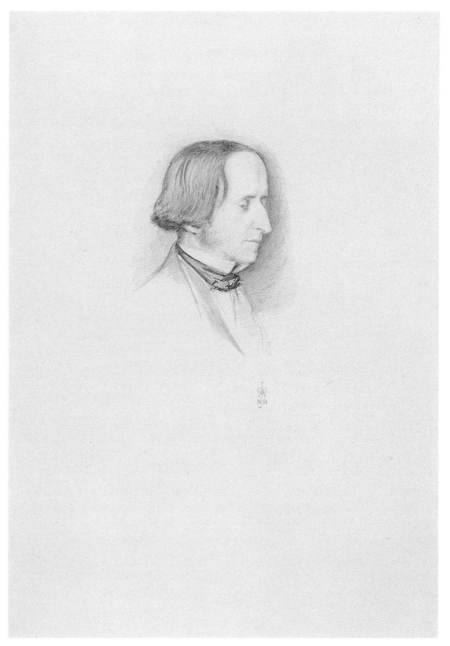

22

inscribed with title and 'rain', upper left
Pierpont Morgan Library. Purchased as the Gift of the Fellows

Effie Ruskin gives the artist a haircut. His favourite nickname for her was 'the Countess', perhaps a reference to the neglected wife in *The Marriage of Figaro*. Since Figaro was a barber, this would have given an extra touch of humour to

the idea of her cutting hair. On 5 June 1854, after she had left Ruskin, Millais wrote jokingly to her mother: 'Should the Countess find all the world condemn her she can at last resource obtain a situation in the Burlington Arcade as a hairdresser and cutter'.[1] This drawing was made on the same day as *Highland Shelter* (cat. no. 20), and also shows Millais with his wounded hand in a bandage, as well

as a scarred nose. On the chair is a copy of the Edinburgh newspaper *The Witness,* in which Effie is collecting the cut hair.

1. Mary Lutyens, *Millais and the Ruskins,* 1967, p.222.

Further literature: Millais, *Life,* vol. I, p.212 (ill.); Bennett 1967, p.84, no. 299; Mary Lutyens, *Millais and the Ruskins,* 1967, opp. p.98 (ill.); Mary Lutyens and Malcolm Warner, eds., *Rainy Days at Brig o' Turk,* Westerham, 1983, pp.34, 35 (ill.).

22
Henry Wentworth Acland
(1815–1900)
Pencil and watercolour
324 × 254mm (12¾ × 10")
Signed with monogram and dated 1853, lower right
The Ruskin Foundation (The Ruskin Library, University of Lancaster)

Henry Acland was a student with Ruskin at Christ Church, Oxford, where they forged a lifelong friendship. From 1840 he studied medicine in London and Edinburgh, returning to Christ Church in 1845 as Lee's Reader of Anatomy. In 1846 he married Sarah Cotton, with whom he had seven sons and a daughter. From 1857 to 1894 he was Regius Professor of Medicine at Oxford, where he campaigned successfully for the introduction of biology and chemistry into the ordinary curriculum, and, with Ruskin's assistance, established the Oxford Museum. He was created a baronet in 1890 for his services to medicine and medical education.

Acland was on holiday in Edinburgh in the summer of 1853, and joined the Ruskin–Millais party at Brig o' Turk from 25 July to 1 August, staying at the New Trossachs Hotel. Before setting out to meet him at Dunblane, Ruskin reported to his father that Millais was glad he was coming as he thought his head a very noble one and wanted to make a

study of it. Millais and Acland had met before at the Combes' in Oxford.

In 1871 Ruskin made Acland a gift of Millais's portrait of him (cat. no. 23), which he kept until his death.

Literature: Bennett 1967, p.86, no. 314.

23
John Ruskin (1819–1900)
Oil on canvas
787 × 680mm (31 × 26¾")
Signed with monogram and dated 1854, lower left
Private collection

Millais's portrait of Ruskin shows him as the patient observer of nature he believed the artist or critic should be, and the meticulous painting of every ridge in the rock and bubble in the waterfall bears out the same principle. The natural setting may also have been intended as symbolic. This particular kind of rock, which Ruskin called gneiss, carried distinct associations for him. He was already thinking of discussing gneiss in the next volume of *Modern Painters* – his broad, polymathic treatise on the history and practice of art, especially landscape painting – and in a letter of 6 September 1853 referred to a drawing of his own showing the same rocks as 'a study for modern painters vol. III'.[1] In the event, he wrote the third and fourth volumes of *Modern Painters* together, and dealt with the beauty and the poetry of gneiss in volume IV. Describing the undulations in its strata as 'the symbol of a perpetual Fear', he wrote:

> The tremor which fades from the soft lake and gliding river is sealed, to all eternity, upon the rock; and while things that pass visibly from birth to death may sometimes forget their feebleness, the mountains are made to possess a perpetual memorial of their infancy.[2]

Though written later and not published until 1856, this may well represent Ruskin's thinking about gneiss as he and Millais chose Glenfinlas, in the Trossachs, as the site for the portrait. His reading of its strata as petrified motion, contrasted with the transitory movement of water, certainly gives point to the background of gneiss and waterfall: whereas the turbulence in the water subsides as it reaches its level, the rocks stand as a permanent and profound reminder of natural violence.

Millais painted most of the background to the portrait during the four rainy months that he and the Ruskins spent in the Trossachs in the summer of 1853. The portrait was originally to have been the pendant to another of Effie at Doune Castle (see cat. no. 16). They chose the exact site in Glenfinlas on 6 July, when Millais wrote to Charles Collins: 'Ruskin and myself have just returned from a glorious walk along a rocky river near here and we have found a splendid simple background for a small portrait I am going to paint of him . . . I am going to paint him looking over the edge of a steep waterfall – he looks so sweet and benign standing calmly looking into the turbulent sluice beneath.'[3] Though for many years believed to have changed beyond recognition, the site of the portrait has recently been rediscovered and photographed by Alastair Grieve.[4]

The portrait was commissioned by Ruskin on behalf of his father, John James Ruskin, to whom he wrote on 6 July: 'I think you will be proud of the picture – and we shall have the two most wonderful torrents in the world, Turner's St Gothard and Millais' Glenfinlas.'[5] Turner's watercolour of St Gothard, *The Pass at Faido,* was one of the critic's most treasured possessions, and his reference to it in connection with the Millais portrait is more than casual. He regarded Millais as a potential successor to Turner; he

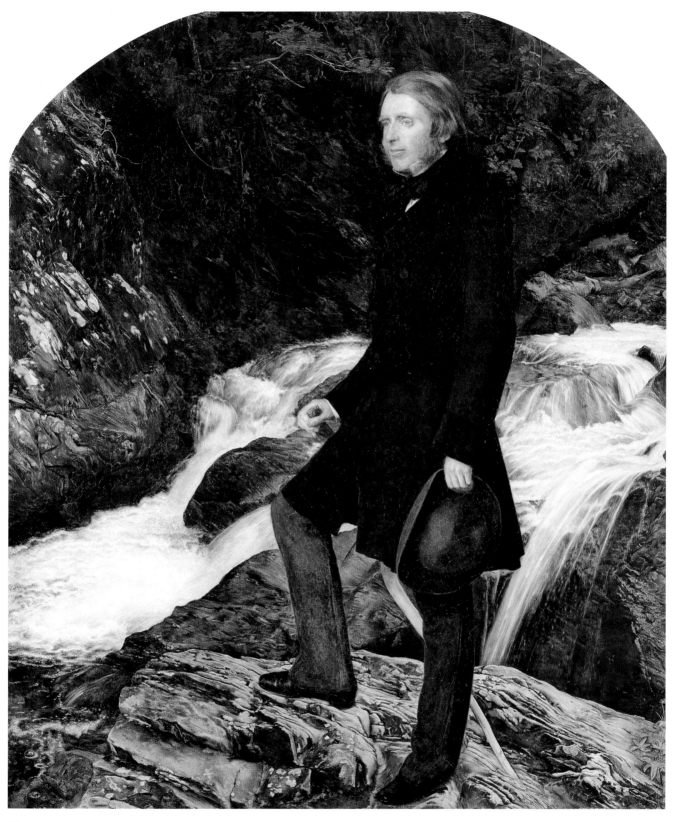

23

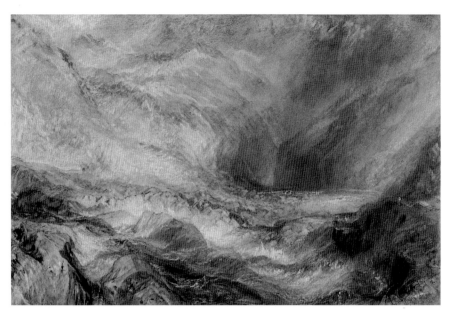

J.M.W. Turner, **The Pass at Faido**, watercolour, 305 × 470mm (12 × 18½"), 1843
Pierpont Morgan Library. Thaw Collection

the effect of making me slightly squint – which whatever the other faults of my face may be – I believe I don't. My Father and mother say the likeness is perfect – but that I look bored – pale – and a little too yellow. Certainly after standing looking at that row of chimnies in Gower Street for three hours – on one leg – it was no wonder I looked rather uninterested in the world in general . . . I need not, I hope, tell you how grateful I am to you for finishing this picture as you have.[7]

Millais's reply was brief and cutting: 'I can scarcely see how you conceive it possible that I can desire to continue on terms of intimacy with you.'[8] He still hoped to exhibit the portrait at the Royal Academy in the following year; Ruskin's father had agreed to this, but after the rebuff he changed his mind: 'I have now the greatest objection and it cannot for *any* purpose leave my House'.[9] It was not to be displayed in public for thirty years. Though disappointed at Millais's refusal to carry on their friendship, Ruskin could still write favourably of his work, and his *Academy Notes* of 1855–6 contain some of the highest and most eloquent praise the artist was ever to receive.

hoped through his friendship, patronage and instruction to mould him as such, and in the portrait encouraged him in the painting of those subjects he most closely associated with Turner – the rocks and running water of a mountain landscape. It was his opportunity, in the words of Tim Hilton, 'to enforce, rather than merely assert, his old view that Pre-Raphaelitism was Turnerian'.[6]

Millais made slow progress on the portrait, amid the increasing tension of the emotional entanglements between himself, Ruskin and Effie. The work was begun on 27 July, and Millais left Brig o' Turk with about three-quarters of the background finished on 27 October. By this time infatuated with Effie, and maddened by Ruskin's neglectful attitude towards her, he went on with the portrait with ever-deepening resentment. The sittings for the face and figure took place at his studio in Gower Street in January– April 1854, although the hands may have been painted some time later in the year. In order to complete the background from nature, in true Pre-Raphaelite and Ruskinian fashion, he spent a further

month at Brig o' Turk, this time with his friends Charles Collins and John Luard. He was there from 24 May to 28 June 1854, by which time the background was at last finished, after a total of four months' work. On 15 July the marriage of John and Effie Ruskin was annulled.

John James Ruskin paid Millais £350 for the portrait on 4 December. On the 11th, having received and hung the work at his parents' house on Denmark Hill, Ruskin wrote to Millais:

We have just got the picture placed – in I think the very light it wants – or rather – for it cannot be said to *want* any light – in that which suits it best. I am far more delighted with it now than I was when I saw it in your rooms. As for the wonderment of the painting there can of course be no question – but I am also gradually getting reconciled to the figure's standing in the way. On the whole the thing is right and what can one say more – always excepting the yellow flower and the over large spark in the right eye, which I continue to reprobate – as having

First exhibited: Fine Art Society, 1884.

1. Virginia Surtees, ed., *Reflections of a Friendship. John Ruskin's Letters to Pauline Trevelyan, 1848–1866*, 1979, p.57.
2. E.T. Cook and Alexander Wedderburn, eds., *The Works of John Ruskin* (Library Edition), 39 vols., 1903–12, vol. VI, p.152.
3. Ibid., p.61.
4. See Alastair Grieve, 'Ruskin and Millais at Glenfinlas', *Burlington Magazine*, April 1996.
5. Mary Lutyens, *Millais and the Ruskins*, 1967, pp.60–61.
6. Tim Hilton, *John Ruskin. The Early Years, 1819–1859*, New Haven and London, 1985, p.186.
7. Mary Lutyens, op. cit., p.247.
8. Ibid., p.248.
9. Ibid., p.249.

Further literature: Spielmann 1898, pp.30,

59 (ill.), 98, 168 (no. 40), 181; Millais, *Life*, vol. I, pp.201, 203, 206, 215, 226; vol. II, pp.469, 497; Cook and Wedderburn, eds., *The Works of John Ruskin*, vol. XII, frontis. (photogravure), p.xxv; Joan Evans and John Howard Whitehouse, eds., *The Diaries of John Ruskin*, 3 vols., Oxford, 1956–9, vol. II, p.479; Bennett 1967, pp.36–7, no. 42; Mary Lutyens, 'Millais's Portrait of Ruskin', *Apollo*, vol. 85, April 1967, pp.246–53, *passim*; Allen Staley, *The Pre-Raphaelite Landscape*, Oxford, 1973, pp.25, 48–53, 90, 132, 150, pl. 20; Leslie Parris, ed., *The Pre-Raphaelites*, Tate Gallery, 1984, pp.115–17, no. 56.

24
John Ruskin (1819–1900)
Sketch for cat. no. 23
Pencil on pale blue paper
197 × 127mm (7¾ × 5")
1853
The Visitors of the Ashmolean Museum, Oxford

Millais began his portrait of Ruskin on 27 July 1853. Ruskin noted in his diary: 'Millais's picture of Glenfinlas was begun on Wednesday [27th]; outlined at once, Henry Acland holding the canvass, and a piece laid in that afternoon. None done on Thursday [28th] – about an hour's work on Friday [29th].'[1] Henry Acland was an old friend of Ruskin who was staying with the Ruskin–Millais party at the time (see cat. no. 22). He later owned the present drawing (he may have brought it with him when he left Brig o' Turk), and an inscription by him on the back reads: 'The first sketch of J.E. Millais's Picture of John Ruskin / done in the bed of the stream at B. of Turk / Thursday July 28. 1853'. If this date is correct, the work presumably records the outline of the portrait that Millais had drawn on the canvas the previous day.

1. Joan Evans and John Howard Whitehouse, eds., *The Diaries of John Ruskin*, Oxford, 1956–9, vol. II, p.479.

24

Further literature: Bennett 1967, p.83, no. 294; Mary Lutyens and Malcolm Warner, eds., *Rainy Days at Brig o' Turk*, Westerham, 1983, p.9 (ill.).

25

25

The artist offering Effie Ruskin a drink of water from a stream
Pen and brown ink
184 × 222mm (7¼ × 8¾")
Signed with monogram and dated 1853, lower left
Private collection

'Every afternoon,' the artist's brother William later recalled, 'Ruskin and I spent our time with pickaxe and barrow and spade to try to cut a canal across a bend in the river – whilst he preferred that E.C.G. [Effie] should roam the hills with J.E.M. [Millais] – and frequently they didn't return till quite late – Ruskin's remark to me was, "How well your brother and my wife get on together"!'[1] Here Millais hands Effie the 'cappie' she carried with her for drinking from streams. The chivalrous, almost sacramental feeling about their gestures recalls those of the star-crossed lovers in his painting of *Isabella* (page 46). Perhaps it is not by chance that his

'J.E.M.' monogram takes on an unusually close resemblance to a heart inscribed with an 'E'.

1. Private collection.

Further literature: Millais, *Life*, vol. I, p.215 (ill.); Bennett 1967, p.84, no. 302; Malcolm Warner, *The Drawings of John Everett Millais*, Arts Council of Great Britain, 1979, p.23, no. 23; Mary Lutyens and Malcolm Warner, eds., *Rainy Days at Brig o' Turk*, Westerham, 1983, pp.66–7, no. 32.

26

The artist in his bedroom at Brig o' Turk
Pen and brown ink
225 × 175mm (8⅞ × 6⅞")
1853
Geoffroy Richard Everett Millais Collection

From 9 July to 1 August 1853 and for periods during the rest of his stay at Brig o' Turk, between stints at the New

Trossachs Hotel, Millais lodged in a tiny room in the cottage of the local schoolteacher, Alexander Stewart. He wrote to Harriet Collins on 10 July: 'This new residence is the funniest thing you ever saw, my bedroom is not much larger than a snuffbox. I can open the window, shut the door, and *shave* all without getting out of bed.'[1] This comic self-portrait, which plays off the famous Vitruvian man of Leonardo da Vinci, is probably the drawing Millais sent to his friend John Leech, the *Punch* draughtsman (see cat. no. 31), with a letter of 27 September. 'My bedchamber is so small that I am troubled to find a resting place for the candle when I retire,' he told Leech. 'I enclose an illustration which will give you a better idea.'[2] His inscription along the bottom reads: 'My foot ought to be against the wall'.

1. Lutyens, *Millais and the Ruskins*, 1967, p.68.
2. Private collection.

Further literature: Bennett 1967, p.84, no. 297; Mary Lutyens and Malcolm Warner, eds., *Rainy Days at Brig o' Turk*, Westerham, 1983, pp.28–9, no. 11.

27

William Holman Hunt (1827–1910)
Pencil and watercolour
203 × 178mm (8 × 7")
Signed with monogram and dated 1854, lower right
The Visitors of the Ashmolean Museum, Oxford

Millais and Holman Hunt became close friends as fellow students at the Royal Academy Schools. In September 1848, following discussions about the state of British art, they and Dante Gabriel Rossetti, also an R.A. student, founded the revolutionary Pre-Raphaelite Brotherhood (the P.R.B). Hunt's idealism and seriousness had a profound effect on Millais's early development as an artist. In 1854, much to Millais's distress, he went

My feet ought to be against the wall —

26

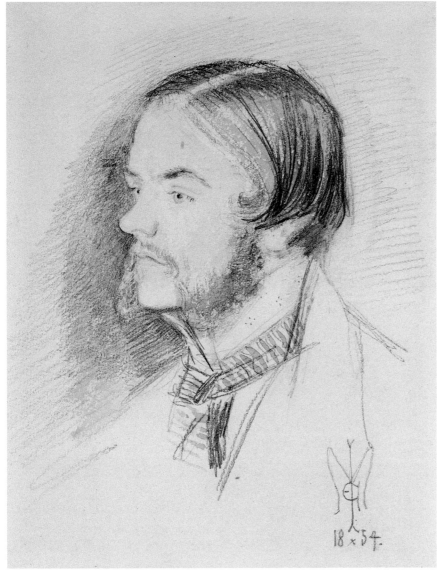

27

of the one I have got but another I drew on Sunday evening. I will get it framed for you (as it would rub sent as it is), and forward it as soon as it is out of the framemaker's hands.'[2]

1. Millais, *Life*, vol. I, p.221.
2. Ibid., p.226.

Further literature: Bennett 1967, p.90, no. 339; Leslie Parris, ed., *The Pre-Raphaelites*, Tate Gallery, 1984, p.267, no. 199.

28

John Ruskin (1819–1900)
Pencil, pen and brown ink, and touches of watercolour
279 × 251mm (11 × 9⅞")
Signed with monogram and dated '1854 / Jany. 17', lower right
Pierpont Morgan Library. Bequest of Prof. Helen Gill Viljoen

Millais made this drawing of Ruskin for his parents during a sitting for the large oil portrait (cat. no. 23). He had recently made similar portrait drawings of Effie Ruskin's sisters, and wrote to their mother on 17 January 1854: 'Ruskin sat to me this morning . . . Having done these drawings for you I thought it would look unkind of me not to make a sketch of him for his loving parents who would naturally conceive it to be strange that I had never made them a present of a portrait in the same manner.'[1]

By this time Millais and Effie's mother were exchanging letters in which they freely disparaged Ruskin's character. 'He is an undeniable giant as an author,' he had written to her on 20 December 1853, 'but a poor weak creature in everything else, bland, and heartless, and unworthy – with his great talents – of *any* woman possessing affection and sensibility.'[2]

1. Mary Lutyens, *Millais and the Ruskins*, 1967, p.130.
2. Ibid., p.122.

to the Holy Land to paint biblical subjects; after this and Millais's marriage the following year their relationship grew more distant, although they remained on affectionate terms all their lives.

Hunt left for the Holy Land on 13 January 1854, and Millais drew this and another portrait of him as souvenirs before his departure. The earlier of the two is a pencil drawing of December 1853 (National Portrait Gallery, London); it was originally intended for the Combes in Oxford (see cat. no. 6), but Millais found himself unable to part with it. 'I am so pleased with it, that as I have no other, I must keep it for myself, but will copy it for you and send it in the course of a week or two,' he wrote to Thomas Combe on 26 December. 'Now that Hunt is going I don't know what will become of me.'[1]

In the event, the portrait he made for the Combes was no copy of the first drawing but an independent design. He drew it on 8 January 1854, writing to Thomas Combe on the 12th: 'I have made a drawing of Hunt, which I think you will find very like. It is not a copy

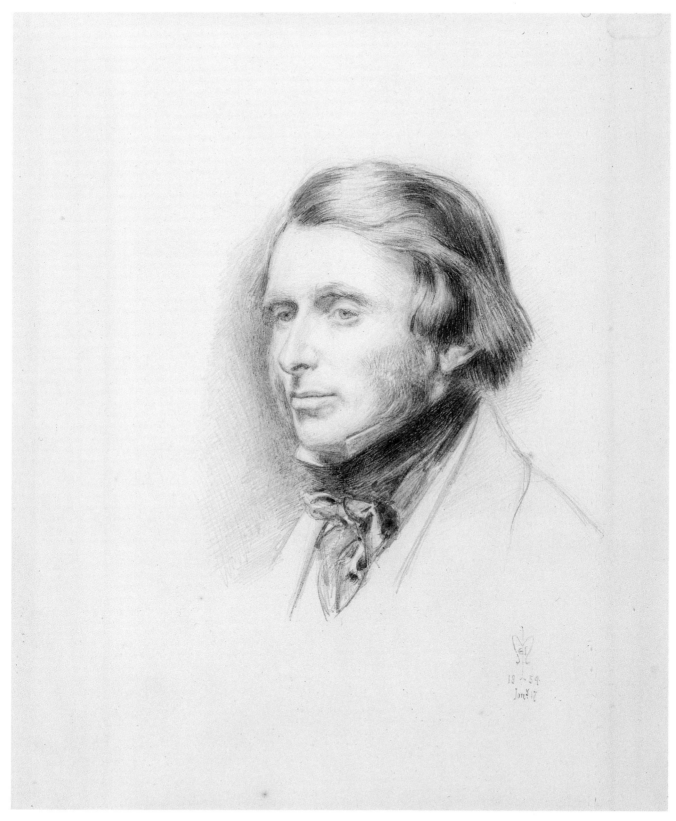

28

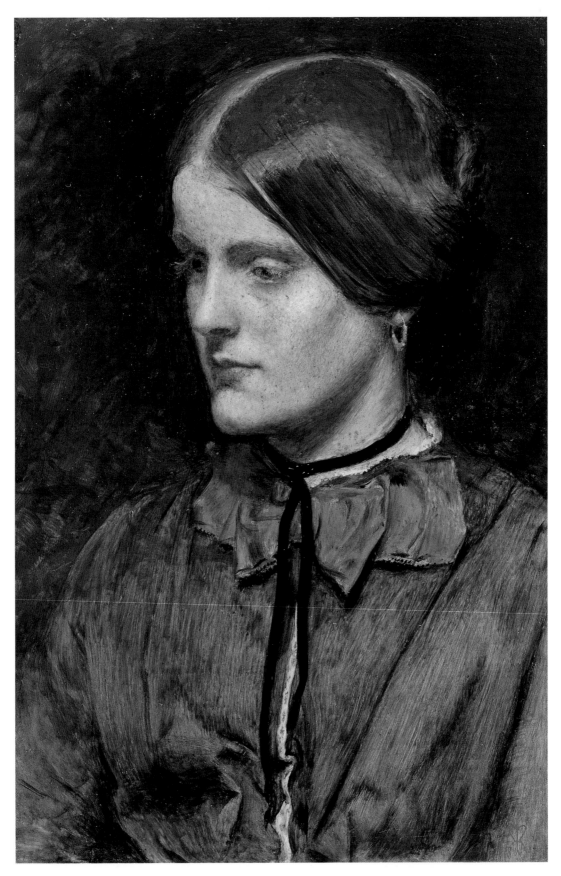

29

29

Annie Miller *(1835–1925)*
Oil on panel
227 × 149mm (9 × 6")
Signed with monogram and dated 1854,
lower right
Collection of Mr Harry Oppenheimer

Not having an exhibition picture to
complete for the Royal Academy
exhibition of 1854, Millais occupied
himself in the early months of that year
with drawings, the completion of the face
and figure of the Ruskin portrait (cat.
no. 23), and the painting of some small
'cabinet' pictures, mostly female heads.
On 23 March Effie Ruskin wrote to her
mother that she had seen Millais's artist
friend Michael Halliday, who reported
that 'he was working very hard at some
heads.'[1] For two of these, the present
work and another entitled *The Violet's
Message* (private collection), the model
was Annie Miller, a striking, barely
literate young woman with whom
Holman Hunt was in love. Hunt had left
for Egypt and the Holy Land in January
of that year, and on 10 April Millais
wrote to him: 'Annie Miller has been
sitting to me and I have painted two little
heads from her. She is a good little girl,
and behaves herself very properly – she is
not sitting to anyone now but Rossetti.'
Again on 4 May he wrote: 'Anne Miller
sat to me several times, and I believe is
sitting at present, to Halliday.'[2]

 Hunt 'discovered' Annie Miller in
a Chelsea slum in the spring of 1850 and
attempted, by providing her with lessons
in reading, writing, elocution and
manners, to turn her into a suitable wife.
It was no coincidence that he used her
as the model for the 'fallen woman' on
the brink of redemption in his painting
The Awakening Conscience (1853–4; Tate
Gallery, London). On his departure for
the Holy Land, he left his friend F.G.
Stephens (see cat. no. 13) with a list of
carefully selected artists for whom he

would allow her to pose. Later, he
regretted that she had worked at all as
an artists' model, which was no job for
the respectable young woman he hoped
she would become.[3] During his absence
she sat for D.G. Rossetti, as Millais
mentioned, and she may have had an
affair with him. In any case, in 1859 Hunt
and Miller acrimoniously broke off their
engagement, and he was to exclude
all mention of her in his autobiography.
In 1863 she married Captain George
Thompson, a cousin of Viscount
Ranelagh.

30

1. Mary Lutyens, *Millais and the Ruskins*, 1967,
p.159.
2. Huntington Library, San Marino,
California: Holman Hunt Collection, 380,
381.
3. See Virginia Surtees, ed., *The Diaries of
George Price Boyce*, Norwich, 1980, pp.20–21.

30
William Monteith
Watercolour over pencil
282 × 219mm (11⅛ × 8⅝")
Signed with monogram and dated 1854,
lower right
Lent by the Syndics of the Fitzwilliam
Museum, Cambridge

William Monteith served as Church of
Scotland Minister to the Trossachs from
1851 to 1862 (he was ordained in 1855).
He lived at Brig o' Turk, and when
Millais and the Ruskins were there in
1853 he had a room in the same cottage.[1]
After attending the kirk for the first time
on 3 July 1853, Millais wrote to Holman
Hunt: 'The sermon we heard to day was
really splendid, such a fine stern sensible
fellow. He made me feel quite small with
my wretched trinkets about me. Here is
a man not three years older than myself
working amongst the poor, refusing
better appointments, and otherwise
behaving as he should.'[2]

When Millais returned to Brig o' Turk
in 1854 Monteith was still at the cottage,
occupying the sitting room where Ruskin
had slept, but was about to move into a
house of his own. On 30 May 1854 he
dined with Millais, and afterwards showed
him some letters from Effie Ruskin about
her marriage. 'I had an irresistible wish to
know the contents', Millais wrote to
Effie's mother Mrs Gray, 'which are
more painful than I could have
anticipated.'[3] Later, after Millais and his
friend Charles Collins returned from a
walking tour, Monteith invited them to
tea. 'We went to the old room and took
tea with the Minister,' he wrote to Mrs
Gray on 9 July, 'and since then, I have
made a sketch of him to hang up in his
new house.'[4]

1. Mary Lutyens, *Millais and the Ruskins*, 1967,
p.67.
2. Huntington Library, San Marino,
California: Holman Hunt Collection, 365.
3. Mary Lutyens, op. cit., p.221.

4. Ibid., p.227.

Further literature: Bennett 1967, p.91, no.
342; Malcolm Warner, *The Drawings of John
Everett Millais*, Arts Council of Great Britain,
1979, pp.24–5, no. 31.

31
John Leech (1817–64)
Watercolour, over pencil
340 × 254mm (13⅜ × 10")
Signed, and signed with monogram
and dated 1854, lower right
National Portrait Gallery, London
(NPG 899)

Though twelve years his senior, the
Punch draughtsman John Leech was
among the two or three closest friends
Millais ever had. Having met perhaps
through Thackeray, they admired each
other's work, shared much the same sense
of humour, and were both passionate
sportsmen. They were on fairly close
terms from 1853, and Millais sent
drawings to Leech from Brig o' Turk
that summer and autumn with a view
to publication in *Punch*. Their friendship
was sealed early in the following year
when Leech introduced Millais to
foxhunting; this was shortly after the
departure for the Holy Land of Holman
Hunt, whom Leech came to replace
as Millais's most cherished companion.
Leech used incidents from their fishing
and shooting trips in Scotland as the basis
for some of the adventures of his beloved
Punch character Mr Briggs. He suffered
from acute nervousness and angina, and
his early death – aged only forty-six –
left Millais devastated. Millais was a pall-
bearer at his funeral, and wept openly as
the coffin was lowered into the grave.[1]

When Millais gave evidence before
the Royal Academy Commission in
1863, he called Leech 'one of the greatest
artists of the day' and suggested that the
Academy should be able to accept him as
a member despite the 'low' nature of his

art.[2] In a letter of 12 February 1882
to George Evans, who was collecting
material for a Leech biography, he wrote:
'He was one of the best gentlemen I ever
knew, with an astounding appreciation
of everything sad or humorous. He was
both manly and gentle, nervous and
brave, and the most delightful companion
that I ever had. I loved John Leech (and
another who is also gone) better than any
other friends I have known.'[3]

The portrait dates from the summer
of 1854, when Millais spent a long
holiday with Leech, his wife, baby
daughter and sister Esther, at the Peacock
Inn (now the Cavendish Hotel) at
Baslow, near Chatsworth. Millais
travelled down from Scotland on 13 July
and stayed for almost six weeks. 'Some of
the happiest days we spent together were
at the Peacock Inn, Baslow, Derbyshire,'
he wrote in the letter to Evans, 'where
every kindness was shown him by the
Duke [of Devonshire] and Sir Joseph
Paxton, shooting, fishing, and cricketing.
We played together in a match with a
neighbouring village, and at a supper he
gave to the teams he sang "King death"
with becoming gravity.'[4]

First exhibited: Royal Academy, 1855 (1098).

1. Millais, *Life*, vol. I, p.274.
2. Simon Houfe, *John Leech and the Victorian
Scene*, 1984, p.239.
3. Houghton Library, Harvard University, MS
Eng 1028; William Powell Frith, *John Leech.
His Life and Work*, 1891, vol. II, p.277 (the
other deceased friend Millais mentions was
probably Charles Collins).
4. Ibid.; Frith, op. cit., vol. II, pp.279–80.

Further literature: William Powell Frith, *John
Leech. His Life and Work*, 1891, vol. I (ill.
frontis., autotype); vol. II, pp.279–80; Millais,
Life, vol. I, p.263 (ill.); vol. II, p.487; Bennett
1967, p.91, no. 343; Richard Ormond,
*National Portrait Gallery: Early Victorian
Portraits*, 1973, pp.266–7, pl. 524; Malcolm
Warner, *The Drawings of John Everett Millais*,
Arts Council of Great Britain, 1979, p.25,
no. 32; Simon Houfe, *John Leech and the
Victorian Scene*, 1984, pp.129, 131 (ill.).

31

2

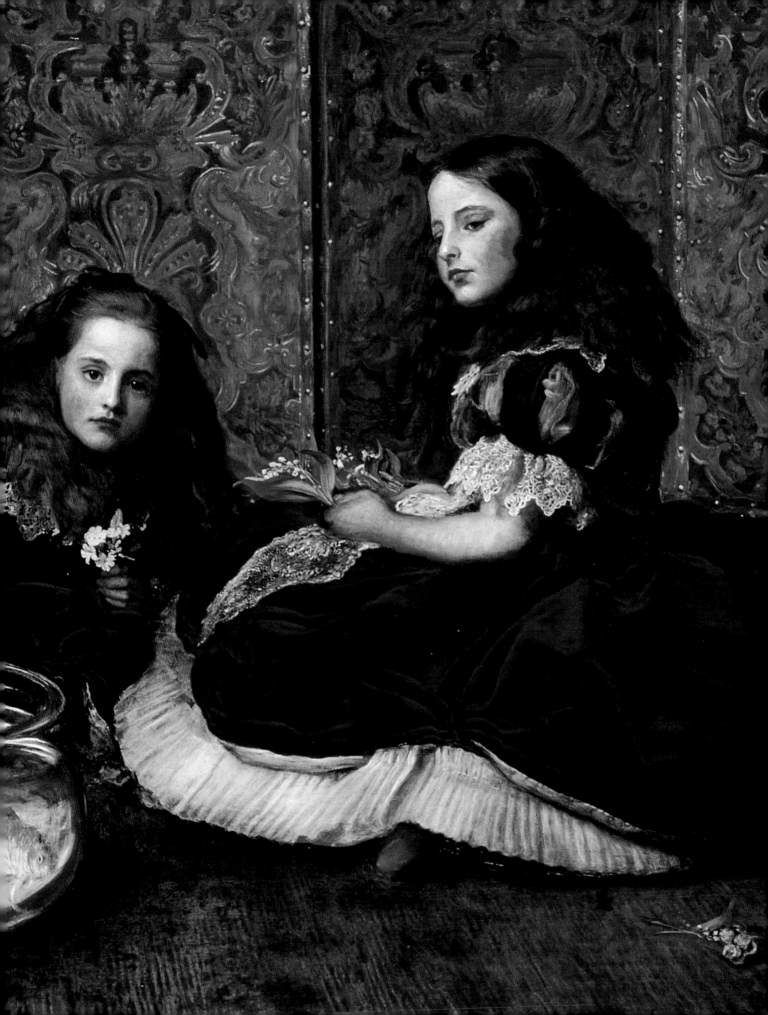

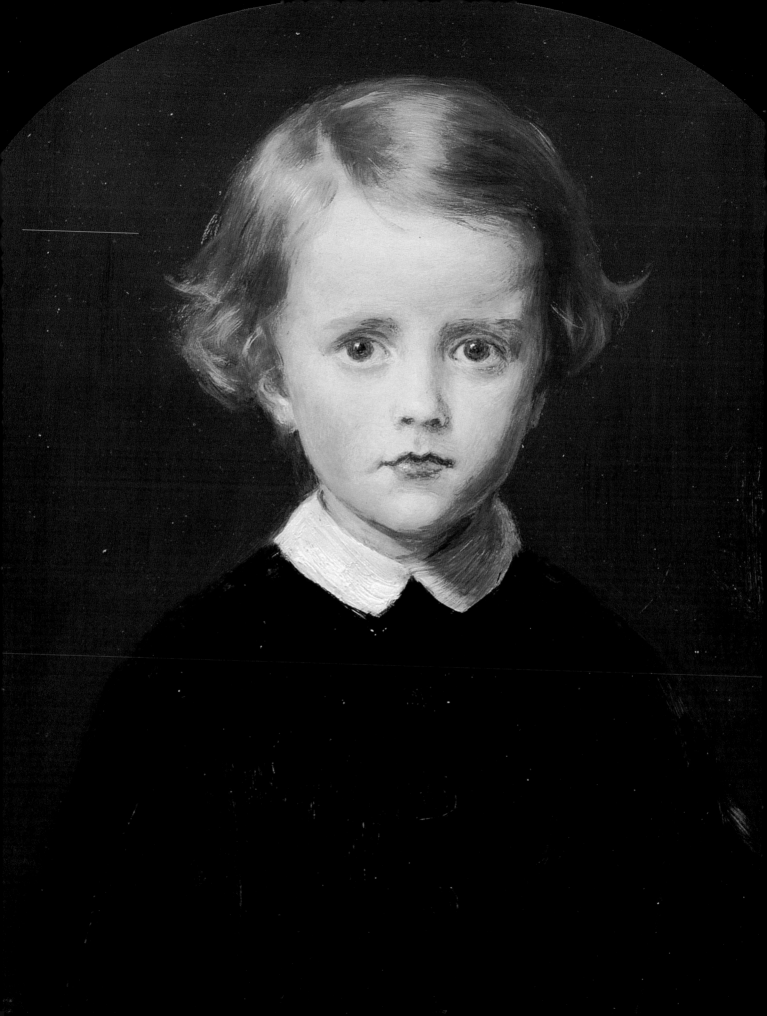

2

Portraits of Children: The Pathos of Innocence

Malcolm Warner

Previous pages
Leisure Hours
Marion Pender
(1856–1955) and Anne
Pender (1852–1902)
Oil on canvas, 864 ×
1168mm (34½ × 46¾")
Signed with monogram
and dated 1864,
lower left
The Detroit Institute of
Arts, Founders Society
Purchase, Robert H.
Tannahill Foundation
Fund
Detail of cat. no. 33

John Wycliffe Taylor
(1859–1905)
Oil on panel, 350 ×
266mm (14 × 10⅝")
Signed with monogram,
lower right, 1864
Private collection,
Greenwich, Ct.
Detail of cat. no. 34

Millais painted children often. He found child portraits an especially sympathetic vehicle for his ideas about art – first about truth, then about beauty – and in them offered a view of childhood that was representative of the age in which he lived.

The members of the Pre-Raphaelite Brotherhood, which the young Millais helped found in 1848, aspired to subject-painting rather than what was considered the 'lower' genre of portraiture. Yet portraiture was in a way the foundation of their whole artistic creed. The taking of individual likenesses was their antidote to the classical ideal, the perfect beauty never found in nature but supposedly attainable by the artist through careful selection and improvement. Given the task of representing, say, the Virgin Mary and Christ Child, the classically minded artist would try to create a mother and child of heavenly beauty, whose bodily perfection expressed their spiritual perfection. If he used models, he would 'correct' imperfect and individual characteristics. The Pre-Raphaelite, on the other hand, tried for an impression of raw reality; he chose his models – less obviously good-looking ones, by and large – and observed the particulars of their appearance in great detail, allowing the sense of a real individual to come through.

This was Millais's approach in *Christ in the Carpenter's Shop* (page 106): the Virgin, Christ and St Joseph are portraits respectively of his sister-in-law, the son of an artist friend, and his own father. The fact that these are actual likenesses would be obvious even if we knew nothing of the models; their sheer presence puts the work of portrait specialists of the day to shame. It was this seemingly unmediated portraiture within a subject picture, especially a sacred subject picture, that was so deeply shocking to its first audience and lay behind the famous attacks that the work attracted from the press.

Christ in the Carpenter's Shop was Millais's first important child subject and, of course, the early life of Christ was *the* child subject. In the stiff, almost hieratic gesture and stance of the Christ Child, he was trying to throw off the conventions of easy gracefulness that had governed the painting of sacred figures since the Renaissance. Christ looks pre-Raphael or, in terms of the art history of the day, like a child from the childhood of art. It was a brave patron who would employ an artist with such inclinations to paint family portraits, and in the few instances when the young Millais did paint portraits to commission it was for friends who were sympathetic to Pre-Raphaelite ideas.

This was the case with his portrait of Eliza Wyatt and her daughter Sarah (cat. no. 5), and the work is an almost manifesto-like exposition of Pre-Raphaelite principles. Here

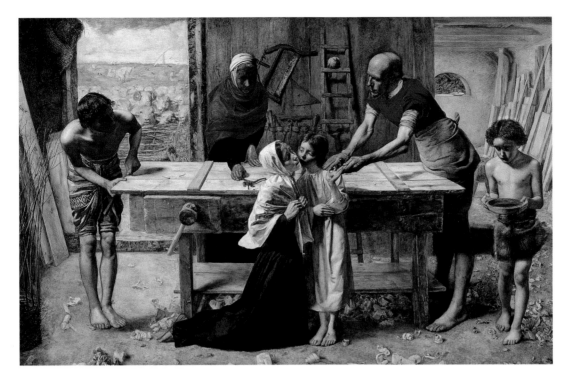

John Everett Millais
**Christ in the
Carpenter's Shop**
Oil on canvas, 864 ×
1397mm (34½ × 55⅞")
1849–50
Tate Gallery, London

were a mother and child of the artist's own time, a practical, factually minded time that seemed to demand its own factual kind of art: the sitters are presented with a hair-by-hair attention to detail, unflatteringly, and their positions have the ungainliness of real life caught at a random moment. The awkward, unpredictable physical relationship of mother to child, as with the Virgin and Christ in *Christ in the Carpenter's Shop*, suggests an imperfection and complication in their emotional relationship. To point up the modernity of his approach, Millais sets Eliza and her daughter against prints after paintings of the Virgin and Child by Raphael on the back wall. The old, Raphaelite way was to idealise, to make the mother and child as beautiful as they ought to be, and compose them as beautiful patterns of curves within circles and triangles; the new, Pre-Raphaelite way – the portrait affirms – is to document truly and let beauty and composition take care of themselves. Here and in *Christ in the Carpenter's Shop*, Millais makes portraits of children test cases of the effectiveness of the Pre-Raphaelite style: against all the sweet, pretty, familiar images of the Christ Child, they stand out vivid and real.

A scene from Christ's childhood with foreshadowings of his death on the cross was a fairly apt prelude to Millais's paintings of childhood in general – there is at least a certain sadness about most of them, and suffering and death are recurrent themes. Like Dickens and many other Victorian artists and writers, Millais tended to see children as forever under threat, moving in a world of sadness, pain and occasional horror. His later Pre-Raphaelite pictures *The Woodman's Daughter* (1850–51; Guildhall Art Gallery, London) and *L'Enfant du Régiment* (1854–5; Yale Center for British Art, New Haven) are also on the theme of doomed childhood. In the first, a country girl accepts a gift of strawberries

from the squire's son, a premonition of the affair they will have later, which leads to her giving birth, drowning the child, then committing suicide. In the second, a girl wounded by a stray bullet lies sleeping on a tomb.

His most resonant painting on the theme of childhood and mortality – perhaps his greatest work – was *Autumn Leaves* (page 109), ostensibly a genre subject set in the artist's own garden in Perth, Scotland.[1] The girls gathering and burning the leaves go about their task with the solemnity of a sacred rite. Judging from their melancholy looks, they seem to understand the meaning of the leaves and the other signs of the transience of life around them. It is sunset, the dying time of the day, and the apple held by the girl on the right suggests the Fall of Man. Millais may have been inspired both in his choice of subject and in the mood of the work by Tennyson's well-known song 'Tears, idle tears' from *The Princess* (1847):

> Tears, idle tears, I know not what they mean,
> Tears from the depth of some divine despair
> Rise in the heart, and gather to the eyes,
> In looking on the happy Autumn-fields,
> And thinking of the days that are no more.

The idea that 'all things must pass' applies to life in general, but Millais's cast of girls – portraits of his sisters-in-law Alice and Sophie Gray along with two other girls from Perth – turn the viewer's mind especially to the transience of childhood. Autumn leaves play something of the same part near the end of *Alice's Adventures in Wonderland* (1866). When Alice wakes up, the pack of cards conducting a trial in her dream turn back into what they were in reality – some leaves falling on her face as she slept. When the Wonderland of childhood ends, it is a kind of death.

The pathos in Millais's view of childhood comes through even in the generally happier realm of his later fancy-pictures, the portrait-like studies of usually single figures in settings and costumes gently suggestive of a storyline but with no real narrative content. The children in these are often shown with emblems of transience such as cut flowers (these are common in the child portraits too) and, in the most famous instance, soap bubbles. The fishergirl in *Caller Herrin* (1881; Armand Hammer Museum of Art, Los Angeles) appeared to Ruskin 'the most pathetic single figure I ever saw in my life – though there is no sign of distress about the girl . . . nothing to indicate hard life but a little bloodstain on the hand from the fish – but quite unspeakably tragic'.[2]

From the clearly doom-laden *Autumn Leaves* to the most unassuming, symbol-free portrait, the remarkable feature of Millais's child paintings is how lacking the children are in merriment, mischievousness, and all the livelier traits we normally associate with childhood. Seldom do they laugh, smile or play; for the most part their expressions are serious, tending towards sadness. To Millais's mind, apart from any consideration of emotion, there was an aesthetic basis for this. From the mid-1850s he tried to forge a style

that retained the truthfulness and observation of Pre-Raphaelitism but could still in some way embrace beauty – both beauty intrinsic to the subject and beauty in the elements of form, especially colour and brushwork. In his thinking about beauty of subject, he came to the conclusion that the most beautiful faces were the faces of children, and that the most beautiful expression for a child's face was a subdued, gently melancholy one. While painting *Autumn Leaves*, he wrote an unusually theoretical letter on this issue to his friend Charles Collins:

> The *only* head you could paint to be considered beautiful by *everybody* would be the face of a little girl about eight years old . . . With years, features become so much more decided, expressive, through the development of character, that they admit of more or less appreciation . . . A child represents beauty more in the abstract, and when a peculiar expression shows itself in the face, then comes the occasion of difference between people as to whether it increases or injures the beauty. Now this is evidently the game the Greeks played in Art, they avoided *all* expression, feeling that it was detrimental to the capacity of understanding in the mass. I believe that perfect beauty and *tender* expression *alone* are compatible and there is undoubtedly the greatest achievement if successful. In that case hundreds would say '*but she looks so pained and unhappy*' but I think there would be less dissension than in any other treatment.[3]

In other words, the face of a child is perfect because it is not yet stamped with the particulars of a personality – which makes it the nearest thing in nature to the ideal beauty of classical art. To preserve this quality, the artist should keep expression to a minimum: no happy smiles or *espièglerie*, just a 'tender' look that inevitably reads as wistful. As an example, Millais goes on to mention the 'very lovely expression' in the eyes of the ten-year-old Alice Gray who appears on the left of *Autumn Leaves*: no doubt some would say 'there is such an odd miserable look about her, I don't like that for a child, etc. etc.', but for Millais it was the essence of child beauty.[4]

Taken by the beauty of Alice and Sophie Gray, Millais painted and drew several portraits of them in the 1850s. But his most active phase as a painter of child portraits began later, after he had taken even further the loosening of the Pre-Raphaelite style that is evident in *Autumn Leaves*. At the Royal Academy exhibition of 1863 he scored a huge hit with one of the most anecdotal and immediately likeable of all his child subjects, *My First Sermon* (page 110). By now he had five children of his own, and his eldest daughter, four-year-old Effie, was the model for the girl in the painting. This was the beginning of his line in child fancy-pictures, and a number of them were to feature his own children. Less predictably, it also launched him as a child portraitist.

When *My First Sermon* appeared at the Royal Academy exhibition of 1863, the critic of *The Times* wrote: 'No more delicious and unaffected picture of childhood was ever painted . . . No mother of a little girl can look at it without wishing to have her child so

John Everett Millais
Autumn Leaves
Oil on canvas, 1041 × 737mm (41 × 29")
1855–6
Manchester City Art Galleries

page 110
John Everett Millais
My First Sermon
Oil on canvas, 927 × 724mm (36½ × 28½")
1862–3
Guildhall Art Gallery, Corporation of London

page 111
John Everett Millais
Lilly Noble
Oil on canvas, 897 × 706mm (35⅞ × 28¼")
1863–4
Private collection

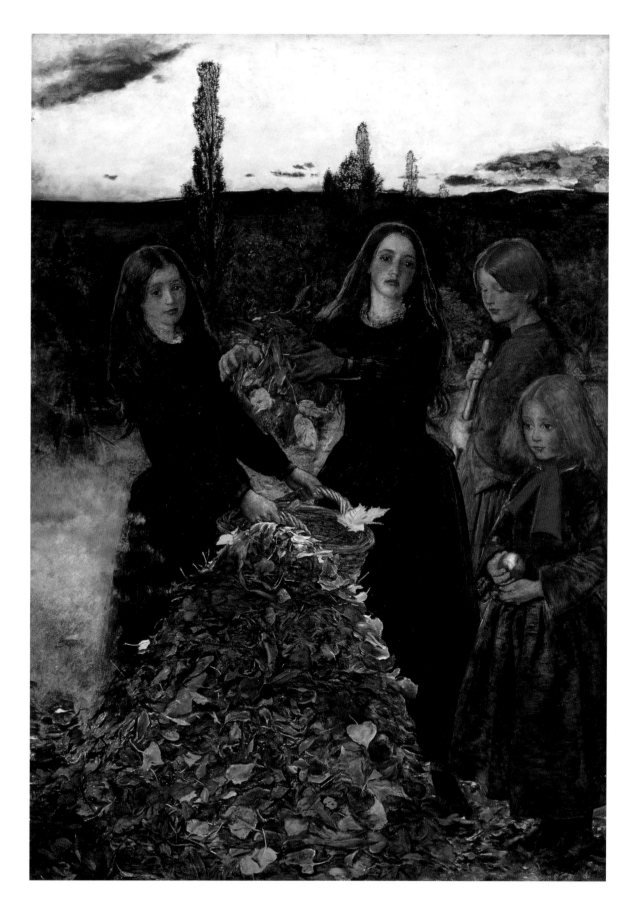

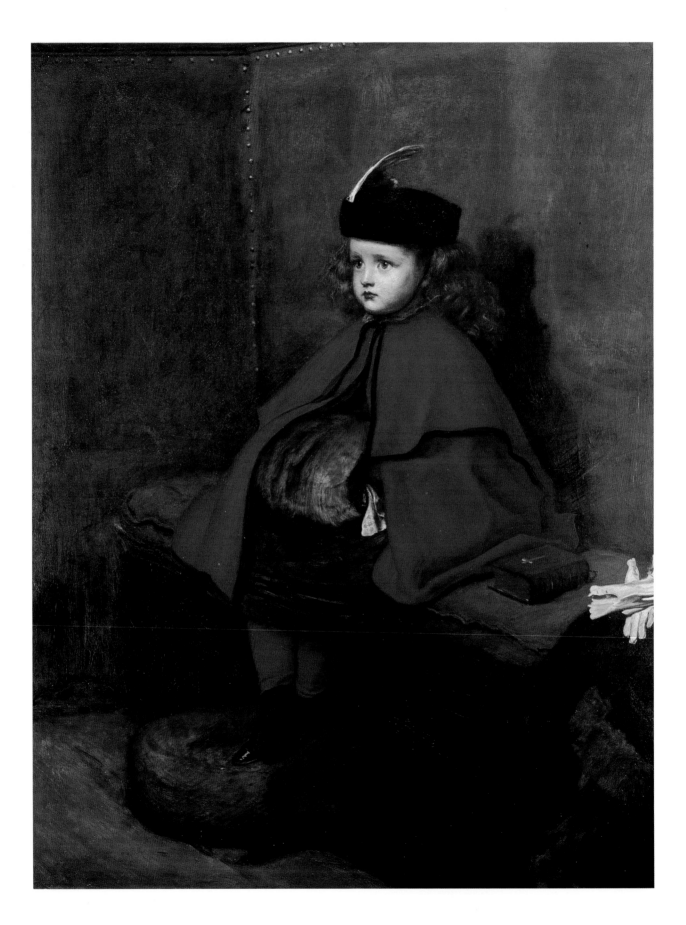

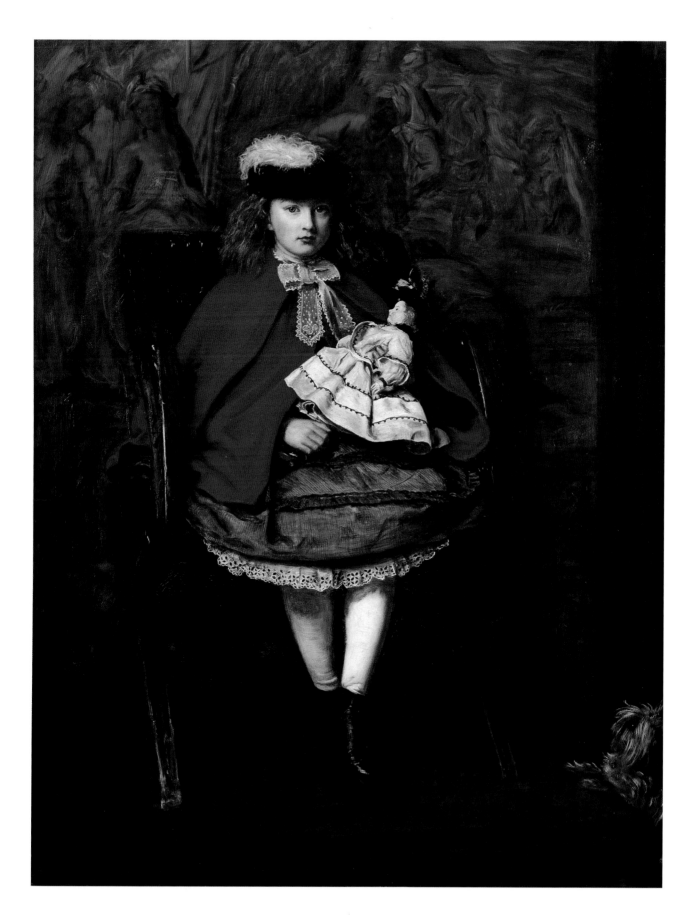

painted.'[5] And he appears to have been right. In the wake of this picture Millais painted a number of child portraits, and the most elaborate, *Lilly Noble* (page 111), was clearly composed as a variation on the same theme (he might have entitled it 'My First Sitting'). It is interesting to see him at the outset of his portrait career making the mechanics of portraiture the conceit for a portrait. There is a more subtle form of the same deliberate self-consciousness about certain of his other child portraits, a point picked up by William Michael Rossetti in his review of *Sisters*, a portrait of Effie with two of the artist's other daughters:

> The arrangement of the group is so far artificial that one clearly perceives the sisters are posing for their portraits: no effort is made to disguise this fact, and it cannot, I think be counted as a blemish – rather as one legitimate method of portrait-painting, though not so popular now as the contrary scheme.[6]

Lilly Noble marked the beginning of Millais's career as a portraitist of children, and from this time onwards he painted an average of one child portrait a year. He was known as a portraitist of children for some time before he turned seriously to adults; indeed, his child portraits of the 1860s are a distinct early phase in his portrait career, before he set up his real practice around 1870. Generally, the early portraits are more rewarding than the later ones, perhaps because they were largely commissioned through personal channels, by friends or friends of friends – the portrait of Lilly, for instance, arose from Millais's brother William's friendship with the Noble family. The child portraits of the later, more wholly professional phase tend to be larger and grander, and to refer back in style and costume to the past, especially to the eighteenth century. He continued to paint fancy-pictures for which his own children were models, and portraits for which they were the sitters; and in both cases, the results later formed the basis for commissioned portraits. *Sisters*, for instance, served as a kind of rehearsal for the grand *Hearts are Trumps* (cat. no. 48).

During the 1860s Millais played an important part in forming the advanced tendency in British art known as the Aesthetic Movement. As he explained in his letter to Collins, he regarded the appeal of his painting of children as aesthetic. Unlike the many scenes of carefree children at play that dotted the walls of the Royal Academy exhibition each year, his child portraits and fancy-pictures did not depend on storyline or anecdote even if they had them – the point was not character or charm but beauty, a beauty all the more entrancing because subdued in expression and tinged with sadness. The beauty that the painters of the Aesthetic Movement sought was not necessarily noble or classical in the old 'Raphaelite' way; it could take many forms, its only essential quality being a feeling of removal from the mundane realities of life. They wanted motifs that represented beauty 'in the abstract' (to borrow a phrase from the letter to Collins), and for Millais this meant children just as for Dante Gabriel Rossetti and Edward Burne-Jones it meant remote, dreamy-eyed young women. The rich brushwork and colour harmonies in *Leisure Hours* (page 114), the placing of the girls in idleness among objects that are there only to be

John Everett Millais
Sisters
Oil on canvas, 1067 ×
1067mm (42 × 42")
1868
Private collection

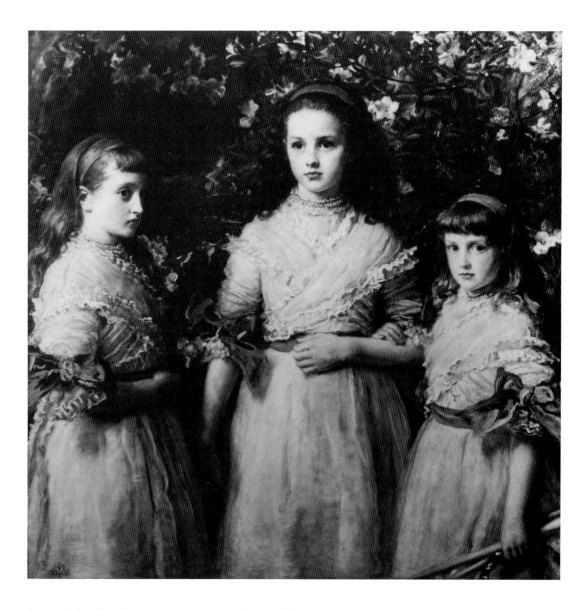

beautiful (the decorative screen, the goldfish, the flowers) show Millais bringing to portraiture some of the ideas of 'art for art's sake'. In the portrait of Hugh Cayley (detail, page 115), the boy holds the very emblem of aestheticism, a peacock feather.

Among his painter contemporaries, there was no one whose career Millais followed with a keener eye, or whose work he was more apt to play off, than that central figure in the Aesthetic Movement, James McNeill Whistler. His portrait of Nina Lehmann (page 117), for instance, alludes in a fascinating and suggestive way to Whistler's *Symphony in White, No. 1: The White Girl* (page 116). The Whistler in turn owed much to *Autumn Leaves*, so Millais could be said to be repaying a compliment. The relationship of the works is not simply complimentary, however: in his plays on Whistler, Millais was always looking to offer a corrective, to demonstrate a more robust, more English type of aestheticism. How pleased he must have been at the French critic Philippe Burty's comments on *Nina Lehmann* when it was shown at the Royal Academy in 1869:

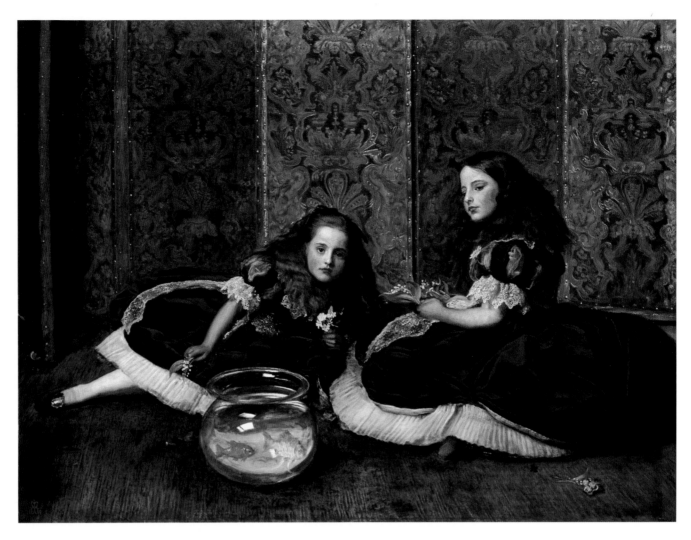

Not since Reynolds, who painted less exactly; not since Gainsborough, who would have given those large eyes a more expressive look, has the English School produced a more appealing and more perfect portrait. The symphony in white, unhealthy and troubling in the sketches of Mr Whistler, is here sonorous and forthright.[7]

Nina Lehmann's expression takes us back to *Autumn Leaves* and, again, to the intimate connection in Millais's work between child beauty and child pathos. He may have been trying in some ways to outdo Whistler, but he took over the essential, slightly disturbing effect of *The White Girl* unchanged – the girl dressed in white, with its connotations of purity and innocence, looking as though she were in mourning. Through the fallen blossoms and bearskin, Whistler suggests that his white girl's regrets are for her lost virginity: she is older than a girl, more a young woman. Millais's subject is really a girl, and her sadness hints at losses that are yet to come – the loss of childhood innocence in all its aspects, sexual and otherwise.

The sense of loss intrinsic to so many of Millais's child paintings may have had some basis in his own childhood – not because he was miserable as a boy, but the contrary:

Leisure Hours Marion Pender (1856–1955) and Anne Pender (1852–1902) Oil on canvas, 864 × 1168mm (34½ × 46¾") Signed with monogram and dated 1864, lower left. The Detroit Institute of Arts, Founders Society Purchase, Robert H. Tannahill Foundation Fund. Cat. no. 33

Hugh Cayley of Wydale (1861–1924) Oil on canvas, 724 × 470mm (28½ × 18½") Signed with monogram, lower right, 1866–7 Private collection Detail of cat. no. 35

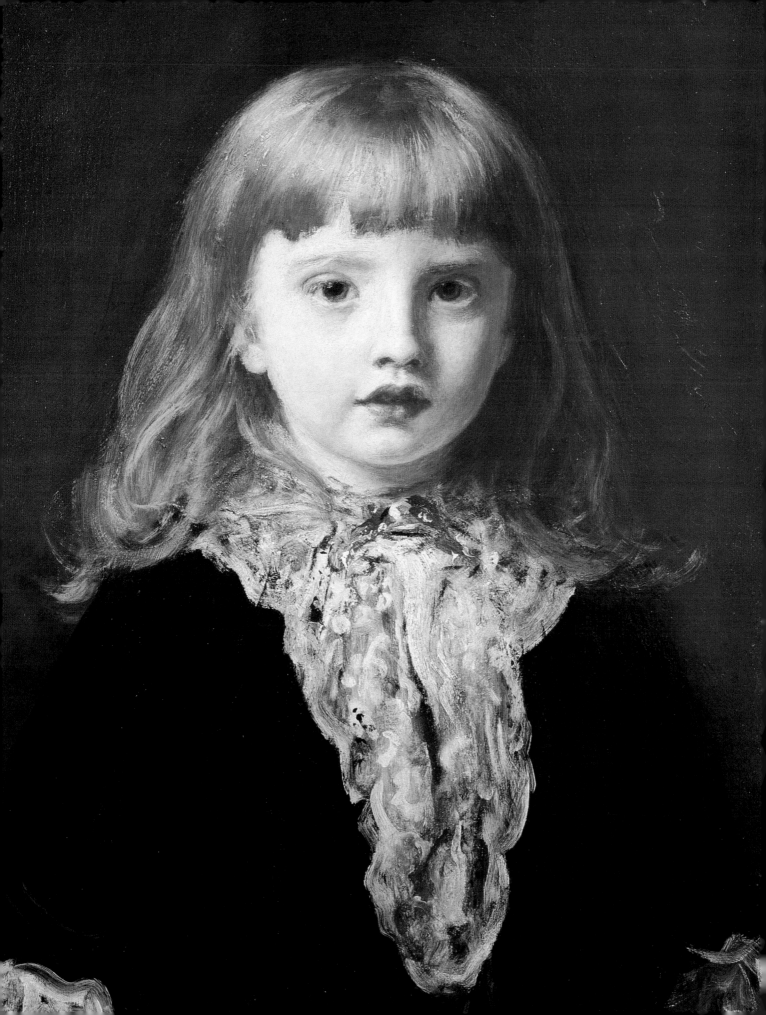

because he was unusually happy. A child prodigy, he was the son of devoted parents who made sacrifices for the sake of his career as an artist. He was handsome, popular and successful. One incident that, tellingly, stayed in his memory occurred during the time he and his parents lived in Dinan, when he was about seven. He later spoke of it to Ruskin, who made these notes:

> Never quiet but when he got pieces of paper to draw on. Drew soldiers for a boy he used to play with – the officers saw them and would not believe they were done by the child. They made a bet of a dinner about it – he recollects their calling to him and taking him into the great square under the sycamore trees, and making him draw soldiers and guns; and laughing, and being delighted; and then his being called in to the dinner given by those who had lost the wager, and put in the middle of the table, and made a show of, and all their glasses held in a circle round him.[8]

Millais's extraordinary talent won him praise and congratulation throughout his boyhood. This may actually have been the happiest time of his life; it certainly figured as such in his adult memories. The sense of childhood as a lost state of grace is likely to be more pronounced in grown-up prodigies – adults who were remarkable children and celebrated as such, but never so wholeheartedly admired again. The looks of the children in Millais's paintings are perhaps a projection of his yearning and regret for his own happy boyhood.

Whether or not his own experience predisposed Millais to find sadness in childhood, the artistic and literary culture in which he moved made it practically inescapable. As historians of childhood have pointed out, the idea of childhood as a state significant in itself, rather than a mere nondescript preface to adulthood, was an invention of the eighteenth century.[9] The special, precious thing about childhood, as described by the French philosopher Jean-Jacques Rousseau and other thinkers of that time, elaborated by Romantic artists and writers, and understood by adults ever since, is its innocence. Though men and women live under the burden of original sin, children are blessed with an original innocence. They are closer to God and to Nature; they know nothing of sin or guilt, worldly or sexual desires, or the burdens of social custom, and their ignorance is bliss – they are open to the purest, most intense, most spiritual feelings. The idea found its classic form in British art in that white girl whose whiteness is as pure and simple as it should be, Joshua Reynolds's *The Age of Innocence*.[10]

The great poet of childhood as a higher state of being was William Wordsworth, and it helps to look carefully at his view since the prevailing Victorian view, shared by Millais, was very much that of Wordsworth with a different inflection. In the famous 'Ode: Intimations of Immortality from Recollections of Early Childhood' (1807), Wordsworth wrote of childhood as a paradise of heightened perception and imagination, which we lose by degrees as we grow up, gain experience and become part of society. We are born 'trailing clouds of glory'; the heavenly light about us dims through our youth, and as adults we feel it 'fade into the light of common day.' His thanks and praise are not for the

Joshua Reynolds
The Age of Innocence
Oil on canvas, 765 ×
638mm (30⅛ × 25⅛")
*c.*1788
Tate Gallery, London

Eden-like state of childhood in itself, however, but for the way even 'shadowy recollections' of its glory illuminate adulthood. The adult cannot help feeling the loss, but should be grateful for what remains:

What though the radiance which was once so bright
Be now for ever taken from my sight,
 Though nothing can bring back the hour
Of splendour in the grass, of glory in the flower;
 We will grieve not, rather find
 Strength in what remains behind;
 In the primal sympathy
 Which having been must ever be;
 In the soothing thoughts that spring
 Out of human suffering;
 In the faith that looks through death,
In years that bring the philosophic mind.

Wordsworth was among the Victorians' most beloved and popular poets. The many Victorian editions and selections of his works included, for example, an illustrated *Wordsworth's Poems for the Young* (1863) for which Millais drew the title-page vignette of a

girl reading. Although the Victorians regarded Wordsworth as the great poet of, and for, childhood, however, in their own art and literature a different, only partially Wordsworthian, attitude emerges.

The form in which the Romantic idea of the innocent child survived into the later nineteenth century is well represented by Millais's *Autumn Leaves* and the verses from Tennyson that are its literary gloss. Where Wordsworth cherished those radiant early recollections as 'the fountain light of all our day', the Victorians tended to grieve over what they had lost. For them the child within was no source of life and joy but the object of intense regret, and the whole imagery of childhood became infused with a mournfulness projected from adult feelings. The suffering and death that haunt Millais's child paintings and the fascination with the dying child that is so evident throughout Victorian art and literature are simply the more morbid signs of this association of childhood and loss: if innocence must die, so must innocents. How telling that Tom Taylor, writing to thank Millais for the portrait of his five-year-old son (detail, page 104), should already have been thinking of the work as a memorial: 'you have given us a quite inimitable treasure, which, long years hence, will enable us to recall what our boy was at the age when childhood is loveliest and finest. Should we lose him – which Heaven avert – the picture will be more precious still'.[11] At root the Victorians' tendency to dwell on loss bore witness to a decay of religious belief. While Wordsworth recollected childhood with 'the faith that looks through death' and affirmed 'We will grieve not, rather find / Strength in what remains behind', the doubting Tennyson looked back with 'Tears from the depth of some divine despair', and made grief his whole theme.[12]

Nostalgia, grief over a lost happiness there is no hope of regaining, coloured almost every aspect of Victorian thought. As the most advanced industrial society of the age, nineteenth-century Britain felt the glories and sorrows of the modern world with a special intensity. Alongside the pride in technical and commercial achievements proclaimed in the Great Exhibition of 1851, there grew a feeling of mental and spiritual unease: the bewildering speed at which society and ideas were changing, the transitional state of everything, brought with it a general yearning for simpler, less mind-wearying times. In 'The Scholar Gipsy' (1853), the poet Matthew Arnold wrote longingly of

> . . . days when wits were fresh and clear,
> And life ran gaily as the sparkling Thames;
> Before this strange disease of modern life,
> With its sick hurry, its divided aims,
> Its heads o'ertax'd, its palsied hearts, was rife.

Nostalgia for all that modernity had destroyed – an idyllic pre-industrial society, life in the countryside, a more secure pattern of belief – often became bound up with nostalgia for childhood. The child became the symbol of a better world. In *The Nemesis of Faith* (1849), writing of the pervasive 'homesickness' associated with modern life, James Anthony

Froude embraced Wordsworth's idea of childhood as a paradise, only, typically, to stress how absolutely lost it was:

> God has given us each our own Paradise, our own childhood, over which the old glories linger – to which our own hearts cling, as all we have ever known of Heaven upon earth. And there, as all earth's weary wayfarers turn back their toil-jaded eyes, so do the poor speculators . . . whose thoughts have gone astray . . . turn back in thought, at least, to that old time of peace – that village church – that child-faith – which, once lost, is never gained again – strange mystery – is never gained again – with sad and weary longing![13]

In the Victorian litany of loss, childhood went together with nature and the past, and the imagery of childhood tended to take in these other objects of nostalgia, too. This is the case, for instance, in Jean Ingelow's poem 'A Mother Showing the Portrait of her Child' (1863). Though obviously no Wordsworth or Tennyson, Ingelow was another author Millais knew and illustrated.[14] In her poem, the mother addresses the portrait of a son or daughter who has now grown up:

> Is it warm in that green valley
> Vale of childhood, where you dwell?
> Is it calm in that green valley,
> Round whose bournes such great hills swell? . . .
>
> Are there voices in the valley,
> Lying near the heavenly gate?
> When it opens, do the harp strings,
> Touched within, reverberate? . . .
>
> Yes, you know; and you are silent,
> Not a word shall asking win;
> Little mouth more sweet than rose-bud,
> Fast it locks the secret in.
> Not a glimpse upon your present
> You unfold to glad my view;
> Ah, what secrets of your future
> I could tell to you![15]

Ingelow shows how charged with pathos the portrait of a child could appear to the Victorian adult viewer. To the Wordsworthian idea of childhood as close to nature and to God, she adds that of innocence as unknowable to the adult, and – with those two cruel lines at the end – that of the child's wonderful present as doomed to be spoilt. For her, the world of childhood has become like a painted image – silent, unhearing, and closed within its frame.

From the 1870s onwards, Millais's child portraits are more clearly nostalgic because more redolent of the past. In his portrait of Charles Liddell, a cousin of Lewis Carroll's Alice, the copy of *Don Quixote* and the medieval knight's helmet on the table give the direction of the boy's imagination: his Wonderland is the world of chivalric dreams and adventures. Occasionally, Millais gave a painting the title 'souvenir of . . .' in tribute to an admired master, and this is a souvenir of Titian, alluding to the latter's magnificent state portrait of the Spanish king Philip II (page 133). When Reynolds made this kind of allusion in a child portrait – as in the famous portrait of Master Crewe in the manner of Holbein's portrait of Henry VIII (1776; private collection) – his intention was comic, and the child himself seems to be enjoying the joke. With Millais, the point was the very serious one of wrapping childhood in the romance of the past.

As Millais's sparring with Whistler fell off in the 1870s, it was replaced by a self-conscious striving to identify himself with the Old Masters, and especially with Reynolds as the Old Master of the British School. Again, the tributes are not without a competitive edge: Millais generally plays down the elements of classical poise and abstraction in Reynolds in the interests of a more direct, realistic effect. This aside, when he painted Dorothy Lawson in a white eighteenth-century costume against a woodland background (page 125), it was in homage to Reynolds as the canonical painter of childhood, one of the eighteenth-century inventors of 'the age of innocence'.

In his 'souvenirs' of Reynolds, Millais associates childhood both with the past and with nature. As the remarks of Burty on the portrait of Nina Lehmann show, Reynolds's child paintings offered an obvious point of comparison for Millais's. Reynolds was indeed the father-figure of Millais's whole life as an artist – as the young and idealistic Pre-Raphaelite, he despised Reynolds and his legacy to British art, casting him as 'Sir Sloshua', a villain of empty artifice and sloppy painting; the older Millais grew to like him and to be like him. Reynolds's critical reputation rose during this time, particularly the reputation of his child paintings. The trend was given momentum by the popular essay *English Children as Painted by Sir Joshua Reynolds* published in 1867 by F.G. Stephens, another former member of the Pre-Raphaelite Brotherhood. 'It must have occurred to the minds of many among my readers', he begins,

> that Reynolds, of all artists, painted children best – that the childless man knew most of childhood, depicted its beauty in the truest and happiest spirit of comedy, entered into its changeful soul with the tenderest, heartiest sympathy, played with the playful, sighed with the sorrowful, and mastered all the craft of infancy.[16]

Stephens held to the Pre-Raphaelite view on most of Reynolds's portraits of adults, deploring them as theatrical and affected, but discovered in his treatment of children and landscape backgrounds a wonderful naturalness. In Reynoldsian child portraits such as *Dorothy Lawson* (page 125), Millais implies that the great tradition of painting established in Britain by Reynolds lives on in him, and that the naturalness Reynolds found in

Charles Liddell
(1861–1911)
Oil on canvas, 1613 × 1054mm (63½ × 41½")
Signed with monogram and dated 1871, lower left
Private collection
Detail of cat. no. 36

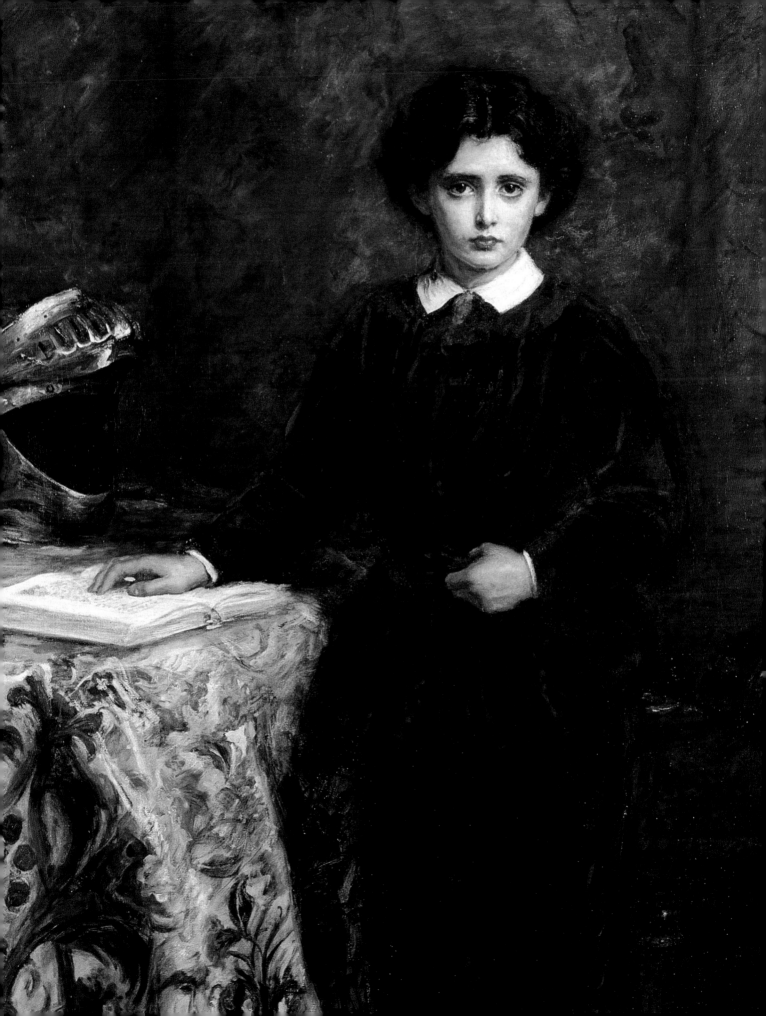

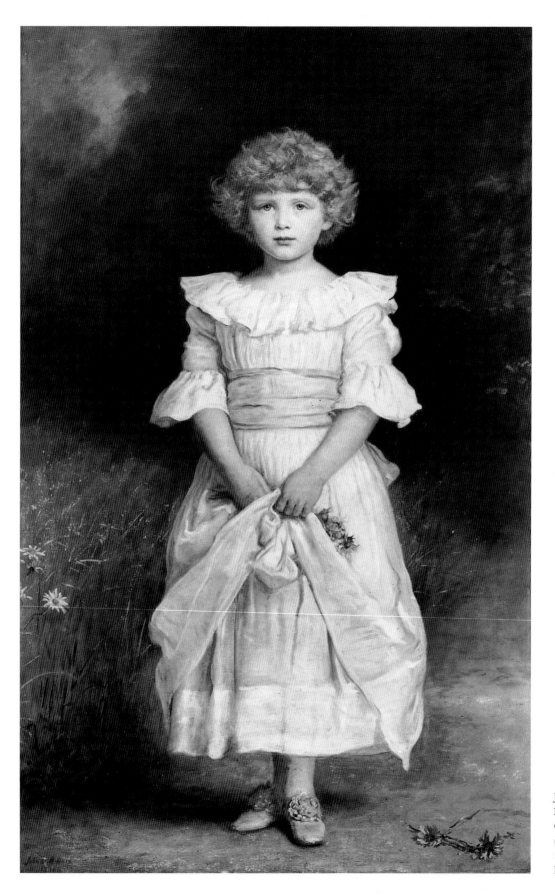

John Everett Millais
Dorothy Lawson
Oil on canvas, 1315 × 825mm
(51¾ × 32½")
1890–91
Private collection

English children lives on in Dorothy: despite all the changes brought about by the nineteenth century, childhood was still natural, still pre-industrial, still innocent. Much as adults might yearn for such a state, however, it is forever lost to them. Millais may have taken over the general look of Reynolds's child portraits, but there is an essential difference between an eighteenth-century girl in the dress of her own time and a nineteenth-century girl in costume. Most immediately, his imitations of Reynolds are about the charming sight of children dressing up, but the impression they leave is elegiac rather than anecdotal. They touch more openly than most of his child portraits upon the themes that run through them all: nostalgia, and the pathos of innocence.

NOTES

1 For a full discussion of the genesis and imagery of this painting, see Malcolm Warner, 'John Everett Millais's "Autumn Leaves": "a picture full of beauty and without subject"', *Pre-Raphaelite Papers*, ed. Leslie Parris, Tate Gallery, 1984, pp.126–42.

2 E.T. Cook and Alexander Wedderburn, *The Works of John Ruskin*, Library Edition, 39 vols., 1903–12; vol. 37, p.398.

3 Bowerswell Papers, Pierpont Morgan Library, New York, quoted in Warner, op. cit., p.137.

4 Ibid.

5 *The Times*, 2 May 1863, p.11.

6 *Notes on the Royal Academy Exhibition, 1868* (1868), Part I, p.2.

7 *Gazette des Beaux-Arts*, 2nd series, II, July 1869, p.45.

8 Joan Evans and John Howard Whitehouse, eds., *The Diaries of John Ruskin*, 3 vols., Oxford, 1956–9; vol. II, p.480.

9 The standard history remains Philippe Ariès, *Centuries of Childhood: A Social History of Family Life*, trans. from the French by Robert Baldick, New York, 1962.

10 For a highly engaging study of the idea of childhood innocence in art from the eighteenth century to the present, see Anne Higonnet, *Pictures of Innocence. The History and Crisis of Ideal Childhood*, 1998.

11 Millais, *Life*, vol. I, p.383.

12 On the child in English literature, see Peter Coveney, *The Image of Childhood* (rev. edn, Harmondsworth, 1967), to which I am much indebted.

13 Quoted in Walter E. Houghton, *The Victorian Frame of Mind 1830–1870*, New Haven and London, 1957, p.344.

14 See Jean Ingelow, *Studies for Stories from Girls' Lives*, Alexander Strahan, 1866, for which Millais contributed two illustrations.

15 Jean Ingelow, *Poems*, 1863, p.249.

16 Frederic George Stephens, *English Children as Painted by Sir Joshua Reynolds*, 1867, preface.

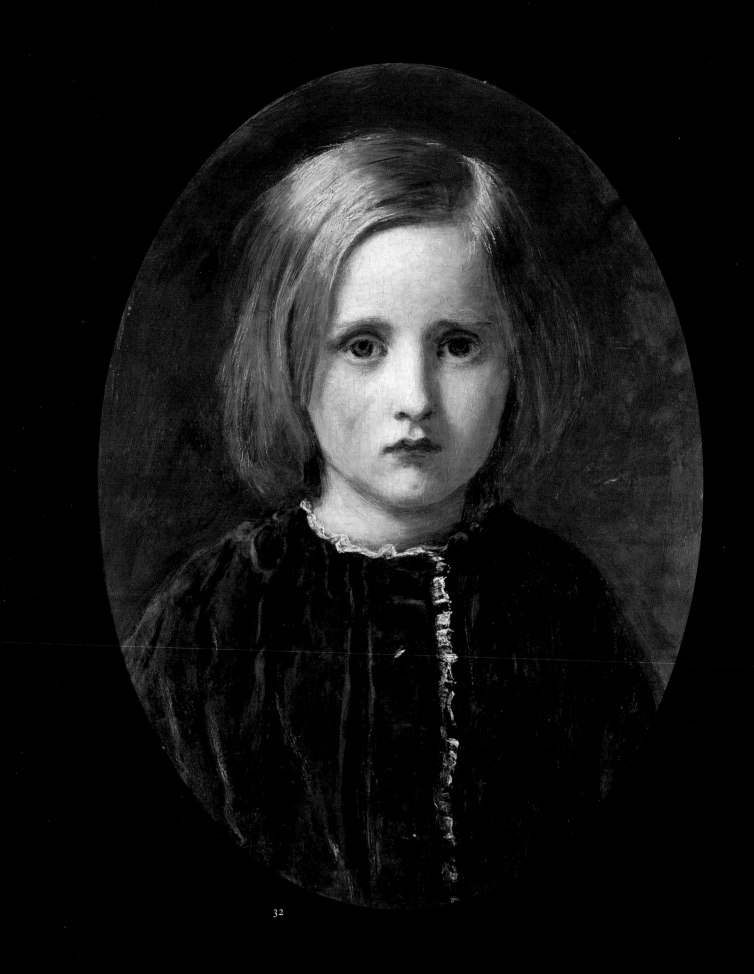

32

2
Portraits of Children

Catalogue by Malcolm Warner

32

Harold Heneage Finch-Hatton
(1856–1904)
Oil on panel
299 × 226mm (11¾ × 8⅞")
1863
Signed with monogram, lower right
Winchilsea Settled Estate

The sitter was the fourth son of the
10th Earl of Winchilsea and his third
wife, Fanny Margaretta Rice. The Earl
was sixty-five years old when the boy
was born, and died when he was only
sixteen months old. The earldom passed
first to Harold's much older half-brother
George, then to his brothers Murray
and Henry in succession. The portrait,
which shows the boy aged six, was
commissioned by his mother, now titled
the Dowager Countess of Winchilsea.
She paid Millais £50 on 13 July 1863.[1]

As a young man Finch-Hatton spent
seven years in Queensland, Australia,
afterwards writing a book about his
experiences, *Advance, Australia!* (1885).
His travels left him with a keen interest in
British imperial affairs, which he pursued
as a Conservative politician. From
1895 to 1898 he was MP for Newark,
Nottinghamshire. He was an avid
sportsman and outstanding amateur
golfer, and prided himself on his skill
with the boomerang. He never married,
and died of heart failure at the age of
forty-seven.

First exhibited: Royal Academy, 1864 (135).

1. Artist's bank account, Coutts.

Literature: Spielmann 1898, p.170 (no. 93);
Millais, *Life*, vol. I, p.383; vol. II, p.472.

33

Leisure Hours

Marion Pender (1856–1955) and
Anne Pender (1852–1902)
Oil on canvas
864 × 1168mm (34½ × 46¾")
Signed with monogram and dated 1864,
lower left
The Detroit Institute of Arts, Founders
Society Purchase, Robert H. Tannahill
Foundation Fund

Marion and Anne Pender were the
daughters of John (later Sir John) Pender
and his second wife, Emma Denison; the
family lived at 18 Arlington Street, off
Piccadilly. Pender had begun his business
career as a cotton textile manufacturer,

first in Glasgow and later in Manchester,
but from the early 1850s had been active
in a succession of submarine telegraphy
companies. From 1862 to 1865 he sat as
Liberal MP for Totnes in Devon. He was
well known as a collector of British art,
and his collection included three major
works by Millais: *The Proscribed Royalist,
1651* (1852–3; private collection), which
he bought from Agnew's in 1862; *Leisure
Hours*, which he commissioned,
apparently for £1,000;[1] and *The Parable of
the Tares* (1864–5; Birmingham Museums
and Art Gallery), which he bought from
the artist in 1865.

With its rich colour harmonies,
its mood of dreamy idleness and the
accumulation of beautiful objects – the

girls, their fanciful costumes and the
flowers they hold, the screen and goldfish
bowl – *Leisure Hours* is representative
of the beginnings of the Aesthetic
Movement in British art. Painted in the
same year, Frederic Leighton's *Golden
Hours* (Tapeley 1978 Chattels Trust) and
J.M. Whistler's *The Golden Screen* (Freer
Gallery of Art, Washington) are similarly
decorative, leisure-hour paintings; their
titles alone indicate the community
of ideas among progressive painters
in Britain at this time.

Certainly, the critics focused on the
formal qualities of the work, especially
its colour. F.G. Stephens wrote of the
'Venetian ardours' of the red dresses as
'made perfectly harmonious by the ash-

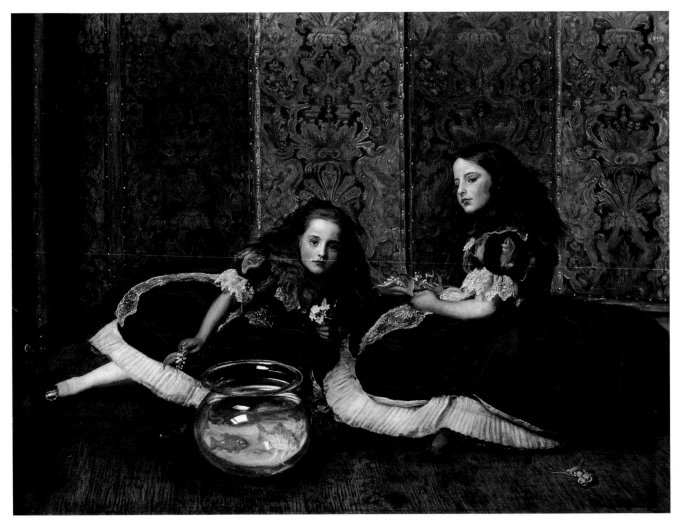

33

green and bronze-gold of an embossed screen . . . and by a glass bowl, which, by its glitter and clearness, as well as its high note of colour, serves to elevate and intensify that quality.'[2] For William Michael Rossetti, Millais had created a work that succeeded formally despite its subject: 'He has determined that we shall admire, on account of its painting, a picture of children whence the charm and *naïveté* of childhood are absent, and in which the metallic worldly key-note struck by two girls just emerging from infancy shall be sustained throughout. He has done it unflinchingly; and that which, in less strenuous hands, would have been a repulsive failure, comes out, in his, a strong artistic success.'[3]

Marion Pender married Sir George William Des Voeux in 1875, and lived to the age of ninety-nine. Her sister Anne did not marry.

First exhibited: Royal Academy, 1864 (289).

1. Artist's bank account, Coutts, 11 April 1864; payer unnamed, but probably Pender.
2. *Athenaeum*, 7 May 1864, p.650.
3. *Fraser's Magazine*, vol. 70, July 1864, p.68; reprinted in William Michael Rossetti, *Fine Art, Chiefly Contemporary: Notices reprinted, with Revisions*, 1867, p.231.

Further literature: Spielmann 1898, pp.64, 71–2, 90, 165, 170 (no. 88); Millais, *Life*, vol. I, pp.379, 381 (ill.); vol. II, p.472; Patience Young, 'Millais' *Leisure Hours*', *Bulletin of the Detroit Institute of Arts*, vol. 58, 1980, pp.118–26.

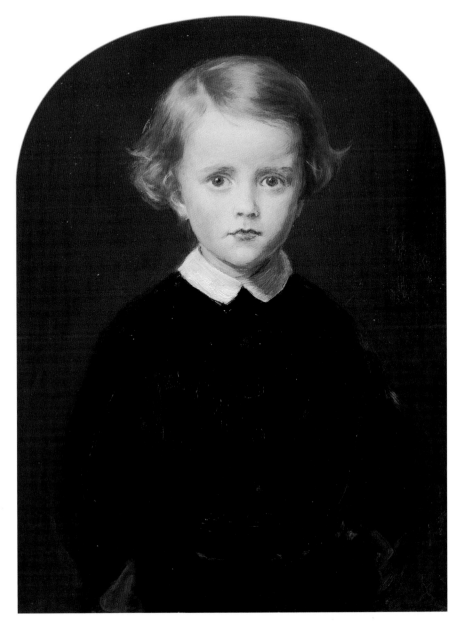

34

34
John Wycliffe Taylor (1859–1905)
Oil on panel
350 × 266mm (14 × 10⅝")
1864
Signed with monogram, lower right
Private collection, Greenwich, Ct.

John Wycliffe (usually known simply as Wycliffe) was the son of Tom Taylor, a critic and dramatist best known for his comedy *Our American Cousin* (1858).

Millais met Taylor in 1852, after he had published an enthusiastic review in *Punch* of Millais's paintings at that year's Royal Academy exhibition. He continued to review Millais favourably as art critic for *The Times*, and the two became friends. Taylor composed the lines of mock medieval English that were printed in the Academy exhibition catalogue to accompany Millais's painting *A Dream of the Past: Sir Isumbras at the Ford* (1856–7; Lady Lever Art Gallery, Port Sunlight).

According to a label on the back, Millais painted this portrait 'in fulfilment of his promise to the late Tom Taylor, that if he ever had a son, JEM would paint the child for many an act of friendly kindness, especially that in connection with the well known picture of Sir Isumbras, exhibited at the Royal Academy in 1857.' It was apparently to have been finished in time for the boy's fifth birthday on 24 April 1864, but work was delayed by the death of Millais's mother on the 22nd. On 26 April Tom Taylor wrote to his father-in-law Thomas Barker telling him of this, and reporting that 'The portrait promises to be wonderfully like, & is most pleasing'.[1] John Guille Millais states that it was not finished until the late autumn of that year. Tom Taylor's letter of thanks to Millais, presumably written immediately upon receiving the work, is dated 27 December. 'It is an exquisite picture of a child, and a perfect likeness,' he wrote. 'Both his mother and myself feel that you have given us a quite inimitable treasure, which, long years hence, will enable us to recall what our boy was at the age when childhood is loveliest and finest. Should we lose him – which Heaven avert – the picture will be more precious still.'[2]

This was not the first portrait of Wycliffe made by a famous friend of his father: in October 1863 Lewis Carroll had photographed him in costume as a knight in armour.[3]

As a young man Wycliffe studied art in Paris. But he seems never to have pursued a serious career in any field.

First exhibited: Grosvenor Gallery, *Winter Exhibition. IX: Works of Sir John E. Millais, Bt., R.A.,* 1886 (111).

1. Private collection.
2. Millais, *Life,* vol. I, p.383.
3. See Helmut Gernsheim, *Lewis Carroll, Photographer,* 1949, pl. 18.

Further literature: Spielmann 1898, p.170 (no. 91); Millais, *Life,* vol. II, p.472.

35

Hugh Cayley of Wydale (1861–1924)
Oil on canvas
724 × 470mm (28½ × 18½")
1866–7
Signed with monogram (probably overpainted or a later addition), lower right
Private collection

The sitter was the elder son of George Cayley, traveller, bohemian and author of *Las Alforjas; or, The Bridle Roads of Spain* (1853), and grandson of the Yorkshire landowner and MP Edward Stillingfleet Cayley of Wydale. His mother was Mary Wilmot. George Cayley and Millais were friends, members of a circle that included Cayley's fellow hispanophile Sir William Stirling-Maxwell, and the portrait was Millais's part in an exchange of gifts. In a contribution to a later edition of Cayley's book, Anne Thackeray Ritchie recalled: 'Sir John Millais once painted a charming picture of the elder boy, and received in return a beautiful silver tray with dolphin handles worked for him by George Cayley himself, whose silver work was very striking and beautiful.'[1]

The boy holds a peacock feather, a favourite symbol of beauty for the Aesthetic Movement, and Millais clearly intended the portrait as an essay in aestheticism: a beautiful child painted with a delight in richness of colour and brushwork. Given the Spanish interests of the boy's father, it was probably intended to recall Velázquez; Millais's Diploma Picture for the Royal Academy in 1868 was a similarly painterly study of a girl entitled *A Souvenir of Velasquez.*

At the Royal Academy exhibition of 1867, the critics likened the portrait to Van Dyck, Gainsborough and Reynolds.[2] The poet Swinburne, another friend of George Cayley and champion of aestheticism, thought it 'a lovely bit of painting'.[3]

First exhibited: Royal Academy, 1867 (236).

1. George J. Cayley, *The Bridle Roads of Spain,* 1908, p.18.
2. *The Times,* 4 May 1867, p.12; *Athenaeum,* 11 May 1867, p.628; *Art Journal,* June 1867, p.137.
3. Letter to Lady Jane Henrietta Swinburne, 7 May 1867; in Cecil Y. Lang, ed., *The Swinburne Letters,* vol. I, New Haven, 1959, p.243.

Further literature: Spielmann 1898, p.171 (no. 106); Millais, *Life,* vol. II, p.473.

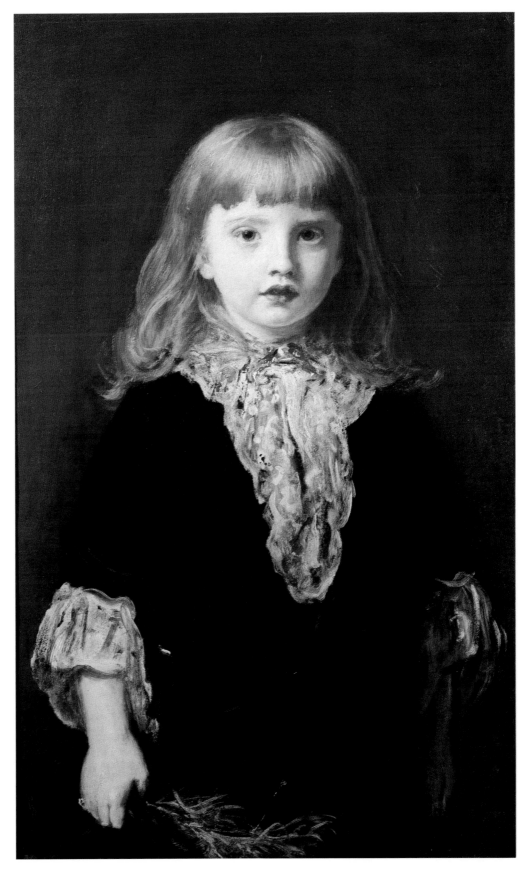

35

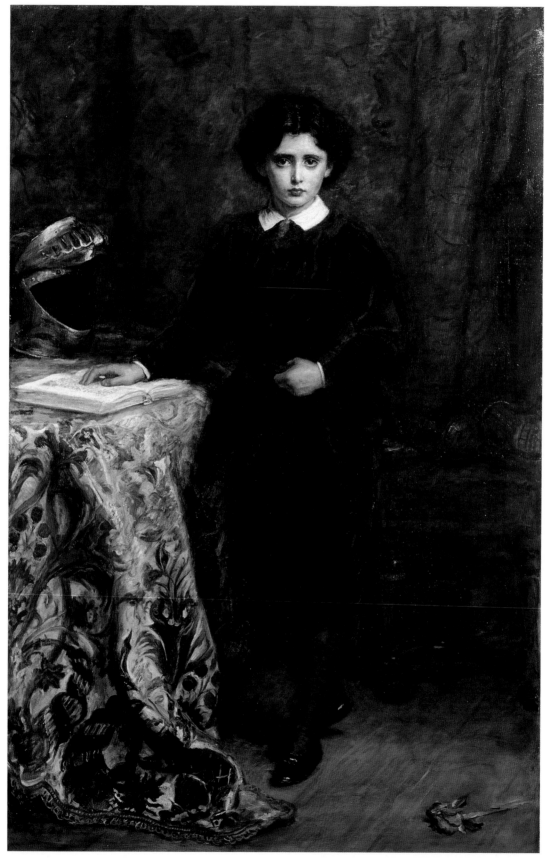

36

36

Charles Liddell (1861–1911)
Oil on canvas
1613 × 1054mm (63½ × 41½")
Signed with monogram and dated 1871,
lower left
Private collection

Charles Lyon Liddell was the son of an
engineer, Charles Liddell, and a cousin
of Alice Liddell, the inspiration for Lewis
Carroll's 'Alice' books. The portrait was
commissioned by the boy's father for
1,000 guineas.[1] According to Liddell
family tradition, Millais originally painted
him wearing a lace collar and cuffs but
he objected; the offending cuffs were
removed, and the collar replaced with
a narrower, plainer version. The story is
supported by fairly obvious *pentimenti*
around the collar. The sittings took place
in the summer of 1871, and on 5 August
that year Millais wrote to his wife: 'I have
finished the Boy Liddell, and send it
home next week.'[2]

Again according to a tradition in
the family, the book on the table is *Don
Quixote*, which seems highly plausible in
light of the knight's helmet near by. The
general disposition of this and other props
recalls that pivotal work in the history of
portraiture, Titian's *Philip II in Armour*.
Under the influence of Cervantes, the
boy's portrait seems to imply, he has been
transported in his imagination to the
Spain of three centuries before. Millais's
admiration for Spanish art was at its
height in the later 1860s and early 1870s;
he especially admired Velázquez, who
had also played off the Titian in his
portraits of Philip IV, and perhaps Millais
felt that he was following in his artist-
hero's footsteps.

Charles's velvet suit is also redolent
of the past, though a more recent, British
one. It is early nineteenth-century in
style, and seems to be based on Thomas
Lawrence's famous portrait of *Master
Lambton* (1825; private collection). It may

Titian, **Philip II in Armour**, oil on canvas, 1930 × 1110mm (77¼ × 44⅜"), 1550–51
Museo del Prado, Madrid

have been a special contrivance for the portrait or a costume that the boy actually wore, perhaps for fancy-dress occasions. It closely resembles the boys' velvet suits that became highly fashionable after the publication of Frances Hodgson Burnett's novel *Little Lord Fauntleroy* in 1886. For a discussion of the significance of this portrait as an image of childhood, see page 122.

First exhibited: Royal Academy, 1872 (280).

1. Artist's bank account, Coutts, 19 August 1871.
2. Millais Papers, Pierpont Morgan Library, New York.

Further literature: Spielmann 1898, p.172 (no. 139); Millais, *Life*, vol. II, p.475.

37

Beatrix Caird (1874–88)
Oil on canvas
584 × 432mm (23 × 17")
Signed with monogram and dated 1879, mid left
Private collection

Beatrix Ada Caird was the artist's niece, the only child of Effie's sister Sophie (see cat. no. 53) and her husband James Caird. Millais gave this portrait to his mother-in-law Sophia Gray in Perth, and later it passed to his wife's other sister Alice Stibbard. Sophie Caird died young in 1882, when Beatrix was only seven. Beatrix herself died at thirteen, and was buried in the same grave as her mother in Brompton Cemetery, London.

First exhibited: Royal Scottish Academy, Edinburgh, 1881 (408).

Literature: Spielmann 1898, p.174 (no. 201); Millais, *Life*, vol. II, pp.211 (ill.), 479; Bennett 1967, p.56, no. 98.

36 (detail)

37

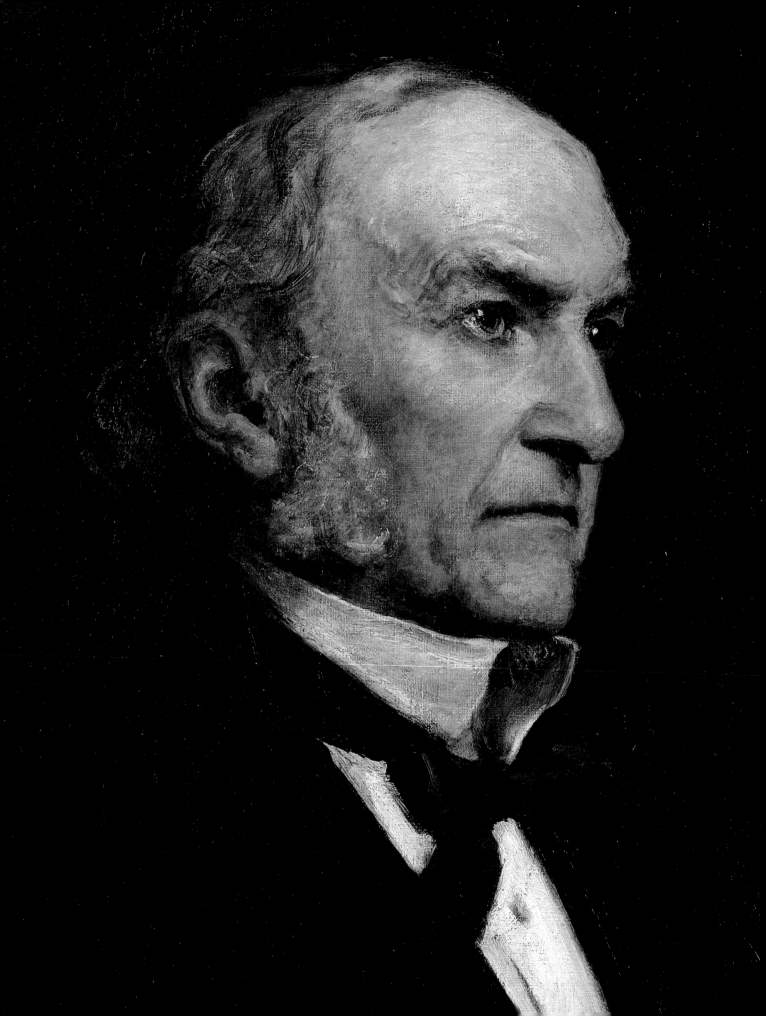

3

Portraits of Men: Millais and Victorian Public Life

H.C.G. Matthew

Millais, uniquely among major British artists, painted four Prime Ministers: Gladstone, Disraeli, Salisbury, and Rosebery. He thus had a splendid chance to epitomise late Victorian public life (though he was never asked to paint the Queen, nor does he seem to have sought to do so). Britain between the 1870s and the 1890s seemed at her zenith. Her great continental rival, France, had been contemptuously defeated by Prussia in 1870–71, and the consequent German Empire had not yet developed into a significant threat. The size of the British Empire increased from 7.7 to 11.4 million square miles between 1870 and 1910. Colonial wars were for the most part victorious wars, with – by twentieth-century standards – an exceptional ratio of land gained per casualty. At home, the Representation of the People Acts of 1867 and 1884 had incorporated the politically active sector of the working classes into the urban and rural constituencies, and the class-alarums of the upper and middle classes had been largely assuaged. Only the Irish question significantly challenged Victorian political stability. The impending gradual loss of Britain's unique, leading position in the world export markets was apparent but, in terms of income and standard of living in large countries, the prosperity of the mainland of the United Kingdom was rivalled only by the United States. It would not be difficult to portray Britain at this time as one of the most successful states in world history.

There were those who tried to do so. Some poets of Empire trumpeted supremacy, such as Alfred Austin (cynically and rather cruelly made Poet Laureate by Lord Salisbury in 1896); some politicians, such as Lord Lytton, abetted by Disraeli, glorified Empire – in Lytton's case through the Durbar of 1877, celebrating the Royal Titles Act of 1876 which made the Queen Empress of India. Social Darwinist categories began to be applied to 'races' within the Empire, always to the advantage of the white, and encapsulated in Tennyson's notorious line, 'Ev'n the black Australian dying hopes he shall return, a white.'[1] It is not difficult to produce examples of assumptions of instinctive superiority in respect of most British action and culture (except, perhaps, music).

But to do so would be rather, though not wholly, misleading. Relatively secure though the British were in those decades, and dominant though the Empire's presence was in world affairs, this was a time of uncertainty and even alarm. The Social Darwinists were Cassandrist as much as triumphalist, despite the apparent success of the 'white' Empires. The British countryside went through a major agricultural depression and consequent depopulation, which an urban-dominated parliament did little to alleviate.

There was a significant shake-out in manufacturing industry, with substantial short-term unemployment in certain areas (the word 'unemployment' was first used in the 1880s). Concern at the condition of the urban poor became a preoccupation, and the political élite worried about the possible growth of socialist parties of the left (another term that began to be used in British politics in the 1880s). The Irish question seemed intractable, choking the House of Commons with business which was further interrupted by Irish obstruction. Liberals believed that the Empire was becoming dangerously overstretched, but seemed unable to prevent further expansion even when in power themselves. Conservatives with an imperial mission despaired of convincing the country to take the Empire seriously. Even the navy, Britain's guarantee against the world, was a constant worry: when Alexandria was bombarded in 1882 prior to the invasion of Egypt, all the capital ships of the navy had to be assembled to blow up the defences of a moderately sized Egyptian city. The Free Trade Movement, which had hoped to capture the world, faced protectionism on the Continent, in the USA, and even in some of the colonies.

Caution was especially noticeable among some members of the political and cultural élite, and it may be examined through a brief exposition of the views of three leading Victorians. Each was painted by Millais in the 1880s, and each both formed and reflected aspects of the public mind. Tennyson, the sounding-board of the early Victorian intelligentsia, had seemed in his poem 'Locksley Hall' (1842) to be the epitome of nineteenth-century optimism. That poem had 'dipt into the future, as far as human eye could see' and, in what became one of the most famous of all Victorian couplets, seemed to anticipate the triumph of peace through free trade and representative government:

> Till the war-drum throbb'd no longer, and the battle flags were furl'd
> In the Parliament of man, the Federation of the world.[2]

But by the 1880s Tennyson thought worse of parliaments. In 1884, shortly after Gladstone had made him the first poet peer, he attacked his Reform Bill in a sonnet (however, under strong personal pressure from the Prime Minister, he voted with the Government in the Lords).[3] Then, in 1886, he reflected in *Locksley Hall. Sixty years after* the sentiment described by Lord Salisbury in a famous article of 1883 entitled 'Disintegration':[4]

> Gone the cry of 'Forward, Forward,' lost within a growing gloom;
> Lost, or only heard in silence from the silence of a tomb . . .
> 'Forward' rang the voices then, and of the many mine was one.
> Let us hush this cry of 'Forward' till ten thousand years have gone.[5]

Lord Salisbury had never been even a modest optimist; his was the voice not of disillusioned progress but of permanent pessimism. Gladstone's Liberal Government, elected by a huge majority in 1880, 'menaces us', Salisbury believed, 'in the most subtle and in the most glaring forms – in the loss of large branches and limbs of the Empire, and in the slow estrangement of the classes which make up the nation to whom that Empire

belongs'.[6] Gladstone's government succeeded in passing the Reform Act of 1884 after a struggle with the Lords, but his party did disintegrate, to the relief of Salisbury, over the Irish question in 1886. When Salisbury then took office after a general election fought mainly on the question of Irish home rule, Gladstone challenged the pessimism of what he called 'the classes' (as opposed to the masses). The means he chose was a review of Tennyson's poem, but the message he set out to convey was much more general. He attacked Tennyson's renunciation of progress in a fairly resounding riposte: it was clear that 'upon the whole the race has been reaping, and not scattering; earning, and not wasting; and that, without its being said that the old Prophet is wrong, it may be said that the young Prophet was unquestionally right'.[7]

This growing gloom provided the political and cultural context in which Millais painted the Prime Ministers Gladstone, Disraeli, Salisbury and Rosebery, just as he painted a number of other prominent men, including Lytton and Tennyson. These were important subjects, in every sense of the word. Millais has been much blamed by posterity – and especially by art critics in this century – for turning his attention away from Pre-Raphaelite history painting to the contemporary world of public life and, at least at first glance, changing to a subdued style. But to pursue the art of public portraiture was to place British painting in the central tradition of European art, and to maintain what in the seventeenth and eighteenth centuries had been one of the chief glories of British painting. Moreover, to try to excel at public portraiture was to try to meet a new and beguiling challenge – the role of the camera. Millais's portraits are an important comment on, and affirmation of, the values of the élite in these decades, and they accurately reflect the cast of mind of those engaged in the dispute about progress then current. They constitute a subtle record, and they also mark Millais's own accommodation with that élite. They catch the caution and the character of Britain's Prime Ministers at what, in retrospect, we can see as a moment of rare quality in the holding of that office.

Mid-Victorian political portraiture was as poor as its equivalent in the earlier part of the century had been spectacular. John Partridge, John Lucas and Sir Francis Grant had done their best with Lord Palmerston, Lord John Russell, Lord Aberdeen and the 14th Earl of Derby but, apart from Grant's portrait of Derby in his robes as Chancellor of the University of Oxford (1858; Examination Schools, Oxford), the results were wholly unmemorable; the one exception was G.F. Watts. Political life of the early Victorian years was most effectively caught by a brilliant series of drawings done for Grillion's Club largely by George Richmond (some were by Joseph Slater; the series is now at Killerton House, Devon). They show a self-conscious group of principled politicians and intellectuals, their virtue literally highlighted by Richmond's distinctive use of white chalk on the forehead. Never can a political élite have been made to look more gentle, more high-minded or more élitist (in the best sense of the term). Both Gladstone and Salisbury (then Lord Robert Cecil) were drawn by Richmond; fine engravings of the portraits were widely sold and reproduced (page 142). Millais would certainly have known of them.

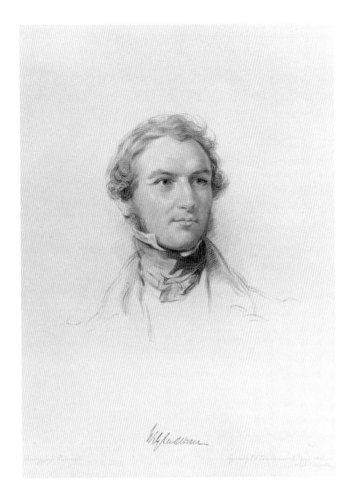

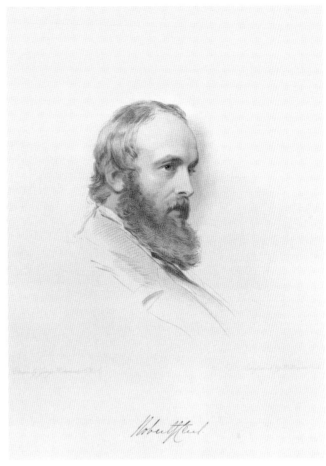

Grillion's Club was composed chiefly of Etonians who had entered quickly into metropolitan public life via Oxford or Cambridge. Millais, like Disraeli, watched this world from the margin – not exactly excluded, for English public life was never thoroughly exclusive – but without the easy and natural access that Eton, Harrow and Oxbridge gave. The artist's well-established family background in the Channel Islands gave him a base and a series of connections not very different from many of those in public life, but his education – first within the family, then at Mr Sass's preparatory school in Bloomsbury for artistic children, and from the age of eleven at the Royal Academy Schools – set him on a different course. Even so, he may well have had early contact with one of his future sitters: both he and the young Gladstone were regular attenders at breakfast parties given by the poet and littérateur Samuel Rogers, and they recalled in the 1890s that they were the last survivors of that circle (Rogers himself was old enough to have sat to Sir Thomas Lawrence in about 1825). Many similar connections developed during Millais's Pre-Raphaelite period. John Ruskin was at Christ Church, Oxford, just after Gladstone and shortly before Salisbury. Gladstone admired Ruskin, had him to stay at Hawarden Castle and wanted to make him Tennyson's successor as Poet Laureate in 1894. Pre-Raphaelitism was a thread that ran right through Gladstone's view of the arts

Left
Frederick Christian Lewis, after George Richmond
William Ewart Gladstone
Stipple engraving, 289 × 213mm (11⅜ × 8⅜")
1843
National Portrait Gallery, London

Above
William Holl, after George Richmond
Robert Gascoyne-Cecil, 3rd Marquess of Salisbury
Stipple engraving, 285 × 212mm (11¼ × 8⅜")
1861
National Portrait Gallery, London

and literature of the mid-nineteenth century. He attacked Tennyson in 1859 for his war-like poems written during the Crimean War, and believed he had betrayed the tradition of knightly gentility. The Gladstones patronised the Pre-Raphaelite sculptor Alexander Munro, and were friendly with Burne-Jones and G.F. Watts. It was perhaps not surprising that Gladstone became much the most painted subject of Millais's portraits of public figures.

Millais had been anticipated by Watts as an artist who moved from historical and allegorical themes to public portraiture, and the subject was in the air. Sir Robert Peel (Prime Minister 1841–6), had by 1846 extended his country house, Drayton Manor, to display his collection of portraits of colleagues and notable contemporaries, including Sir Walter Scott and Samuel Rogers; the gallery was sometimes called the 'Statesmen's Gallery'. Interestingly, Peel's view of his collection anticipates the approach of Watts and Millais: his commissioning letters to artists insist on the absence of adornment and on the importance of modern dress at a period when classical motifs were still prevalent.[8] Peel's experiment in national portraiture was well known. From about 1850, Watts embarked on a grand essay in pictorial biography of his own – 'The House of Life', as he later called it – and at the same time began a series of portraits of distinguished men of the time which was ultimately to be presented to the nation (one of the earliest, in 1851, was Lord

Sir Robert Peel's 'Statesmen's Gallery' at Drayton Manor, from *Country Life*, 28 March 1908

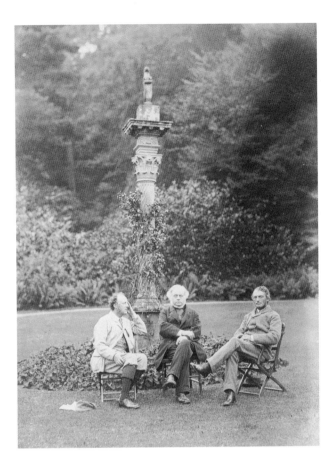

John Russell). This was before the establishment in 1856 of the National Portrait Gallery, which even then did not collect portraits of living persons for over a century. However, its foundation and galleries like Peel's expressed something of a change in the character and social context of political portraiture – the likelihood that, in the future, political portraits would be hung collectively in public places rather than in country house drawing rooms.

Watts's project was a one-man attempt at an up-to-date National Portrait Gallery, and his pictures were intended to be seen together. Since few of them were the result of commissions (most were painted for his own satisfaction), Watts's portraits were, to an unusual degree, kept together; though he developed a new approach to public portraiture, his immediate audience was private. His portraits were penetrating, but gloomy. Many were close-ups of head and shoulders, with a concentration on the face (see page 28). Ironically, given his collective objective, they are oppressive when seen *en masse*. The number of sittings he demanded exasperated his subjects, many of them busy people in full career. Though he sometimes used photographs, to 'shorten the sittings', these were employed to little effect. Gladstone wrote in 1878: 'Sat to Watts from 12 to 4. He would but for courtesy willingly have had more. This length of time is really a national vice in English artists'.[9] With the exception of John Stuart Mill and Henry Edward Manning, Watts's portraits give a sense of uncertainty, but it is unclear to the

viewer whether it was the subject or the artist who was indecisive. We may reasonably surmise that it was the latter, for most of Watts's subjects were in fact men of action. His unwillingness to complete portraits and the fact that most of them were rarely seen meant that Watts had a curious reputation as a portrait painter: he was clearly a distinguished artist, but there was a certain lack of definitiveness about his work.

Millais's art, by contrast, was always definitive in tone, even when he changed it. He painted portraits throughout his career, but in the early years of friends and private subjects only. In about 1871 he turned to regular portraits of major public figures. This change was of great importance for his own public career. It fitted the image of the country gentleman which Millais developed almost as soon as his wealth enabled him. The family's Scottish holidays were sporting in character, and Millais became an expert shot. He took a succession of shoots, starting with Kincraig near Aviemore in 1860, and when he took the tenancy of Birnam Hall from 1881, with sport on the Murthly Estate on the Tay, he was able to offer guests fishing on the finest salmon river in Scotland. He drew sparingly (though brilliantly) on these experiences for his paintings, but he made no attempt to emulate Landseer as an animal painter. His residences in Scotland coincided with the opening of the Highlands as a play area for the English propertied classes; the dinner parties he gave and attended there linked him socially to such people far more than would have been the case in London. Shooting with the Harcourts and the Cholmondleys and dining with the Duke of Argyll was not the usual social *milieu* of the Pre-Raphaelite artist. His son's biography perhaps exaggerates the extent to which Millais became a hunting-and-shooting obsessive (it recreates the father, perhaps excessively, in the son's image) but, even so, the social importance to Millais of his Highland holidays was considerable.

Millais's movement into the portraiture of public persons followed Gladstone's notable Liberal election victory in 1868; continued through the resurgence of conservatism led by Disraeli in 1874; reached its high point about the time of the Midlothian campaigns of 1879–80 and Gladstone's subsequent Liberal government, and ended during the dominance of Unionism under Lord Salisbury in the 1890s. This was a period of intense party strife. The Eastern Question and the imperial wars of the late 1870s – the period of 'jingoism' – were marked by the smashing of the windows of Gladstone's house by a Tory mob and by anti-Semitic caricaturing of Disraeli. The political animosity of the 1880s was reflected by Lord Salisbury's remark (a very strong one for the time) that it was understandable that Conservative MPs would not wish to converse with Gladstone, and by Liberal cries of 'Judas' at Joseph Chamberlain across the floor of the House after the party split of 1886 had become settled. The elevated disputes over the fate of progress of the sort carried on by Salisbury, Tennyson and Gladstone in the intellectual journals were matched by exceptionally highly charged politics.

Millais thus moved into the British political world at a time of major themes and major characters. In British public life, cartoonists have always been much more

"CRITICS."

(WHO HAVE *NOT EXACTLY* "FAILED IN LITERATURE AND ART.")—*See Mr. D.'s New Work.*

MR. G-D-S-T-NE. "HM!—FLIPPANT!" MR. D-S-R-LI. "HA!—PROSY!"

John Tenniel
'Critics'
Published in *Punch*, 14 May 1870, showing Gladstone and Disraeli reviewing each other's work and captioned:
'MR. G-D-S-T-NE. "Hm!—Flippant!"
MR. D-S-R-LI. "Ha!—Prosy!"'

influential than painters. By the time of Millais's portraits, cartoonists were almost as respectable as artists, and the sharp disjunction of the early years of the century – between, for example, Rowlandson and Lawrence – had disappeared. Britain's leading cartoonist was John Tenniel, a kindly figure whose cartoons never had enough bite to hurt and were not intended to do so; he reflected the movement in *Punch* away from radical criticism towards gentility. He was echoed in prose by Henry Lucy, who wrote the *Punch* political reports in a similarly pawky, rather whimsical tone. Both Tenniel and Lucy in their different ways caught some of the grandeur of the high Victorian period, and both were generally favourable to Liberalism but were equally attracted by what they saw as the folksy tradition of British Conservatism. They were both knighted by Liberal governments, by Gladstone and Asquith respectively, but neither honour caused the Tories annoyance. For Tenniel and Lucy, Gladstone was a reformer whose reforms went expectedly but not dismayingly astray, and Disraeli was a crafty novelist whose hostages to fortune were so abundant that his premierships could be represented by a succession of witticisms (many of them his own, in the form of quotations from his much earlier novels).

Tenniel's cartoons, much reproduced, were important in setting the tone at a time when newspapers had illustrations only on very important occasions, and the depiction of politics was left to weekly magazines such as *Punch* and the *Illustrated London News*; the

Maull & Polyblank
William Ewart Gladstone
Albumen print
203 × 149mm (8 × 5⅞")
1857
National Portrait Gallery,
London

latter also carried many engravings of portraits, as did *The Graphic* and various other of its competitors. From the 1850s, photographs of major public figures were commonly available, partly through the sale of *cartes de visite* (cheaply available from the early 1860s), and partly through grander and more expensive depictions in photographic series. Maull and Polyblank's *Photographic Portraits of Living Celebrities*, begun in 1856, was one of the earliest, and Gladstone was included in their first series. Gladstone latched on quickly to the importance of this new form of political communication, by which the voter might have a visual image of the party leader in his mind; when he was photographed by Downey in 1867 it was on condition that not more than sixpence was charged for the reproductions. Cheap popular biographies of politicians and other public figures often had a real photograph pasted in as the frontispiece; this gave, and still gives, such ephemeral publications a remarkable actuality. More elaborate depictions were available in series such as Downey's Cabinet Portrait Gallery which presented cabinet ministers alongside actresses and bishops, and the 'life and times' series in five or so volumes per politician, either with many real photographs pasted in, or in a cheaper edition with engravings. Although photographs provided a convenient means of visual communication with the electorate, they were not necessarily easy for politicians. The photographers demanded considerable stamina from their sitters: J.P. Mayall's photograph of Gladstone, taken in 1884, required an exposure of 120 seconds. Such portraits differed in intention from the

John Everett Millais
The Boyhood of Raleigh
Oil on canvas, 1206 × 1422mm (47½ × 56")
1869–70
Tate Gallery, London

artistic studies by photographers such as Julia Margaret Cameron, in that they aimed, doubtless deceptively, at simple realism rather than at the use of the photograph for consciously interpretative depiction. Cameron achieved in her prints the psychological penetration for which Watts so strenuously strove in his oils.

Through this variety of media, by the 1870s the public was fairly familiar with the appearance of its chief political figures – certainly to a much greater extent than was the case at the beginning of Victoria's reign. An artist such as Millais was thus to a considerable extent commentating on a face that was already well known, rather than introducing it to the viewer. His relationship to other forms of representation was therefore likely to be more complex and more intimate the better known the sitter. This was a new situation for a public artist, at least with respect to viewers beyond the court

and parliamentary circle. It meant that the picture could hardly avoid relating to the grammar of depiction established by others, mostly photographers. But to some extent it worked to the artist's advantage, for the public recognition was of representation rather than reality: when Gladstone, aged seventy-nine, was knocked down in Piccadilly by a cab that did not stop, he chased and caught the driver, and waited for the police with assistance from passers-by, without ever being recognised (even in our own day, it is common for 'well-known' faces not to be recognised when seen in the flesh on the street). The portrait of a public person was thus seen in the context of other public representations and to a great artist this would always be an advantage, for the medium of oil portraiture offered much more imaginative scope than cartoons or photography.

Millais worked towards his portraits by balancing the last of his major medieval subjects – *The Knight Errant* (1869–70; Tate Gallery, London), a highly controversial depiction of an armoured knight and a nude woman roped to a tree – with two paintings that caught the public mood, *The Boyhood of Raleigh* and *The North-West passage 'It might be done and England should do it'* (1873–4; Tate Gallery, London). Both of these were imperial in theme, but in an oblique and understated way: nothing could be further from the panoramas and exhibitions of imperial scenes that were the usual artistic discussion of the topic. They point the way to Millais's approach to his portraits of persons in public life. As with his medieval paintings, his portraits depend on an informed viewer's knowledge of context – the context in the case of his political portraits being chiefly supplied by photographs and cartoons.

George Grote may be regarded as the first prominent public figure painted by Millais (1870–71; Senate House, University of London, preceded by portraits of Sir John Fowler and Sir John Kelk). Millais painted Lord Lytton in 1876 (Victoria and Albert Museum, London), just before his departure for India as Victoria and Disraeli's Viceroy, armed with plans for the Durbar. In 1878 Millais began what became a series of British Prime Ministers: by 1887 he had painted all who held the premiership between 1868 and 1902 (Disraeli, Gladstone, Salisbury and Rosebery). These portraits were all commissioned by different private owners, such as the Duke of Westminster, and thus their eventual display together could hardly have been anticipated. Even so, and though painted over a considerable period, there is a remarkable consistency about them, especially the trio of Gladstone (the first portrait), Disraeli and Salisbury. They were painted with few sittings, photographs playing an important part in the process, and show a remarkable, restrained self-confidence on the part of the artist. They are quite undidactic. With one exception (and that rather a misleading one), they are painted before anonymous backgrounds – there is nothing in them to indicate high political office or even the world of politics. Millais followed Watts in painting no props; once the faces of prominent politicians had become well known to the public, the identifying clues planted by earlier artists – a copy of the budget, a parliamentary bill – were unnecessary. The influence of Velázquez – in whom Millais had much interest – is also of importance here.

page 150
William Ewart Gladstone
(1809–98)
Oil on canvas, 1257 × 914mm (49½ × 36")
Signed with monogram and dated 1879, lower right
National Portrait Gallery, London
Cat. no. 40

page 151
Benjamin Disraeli, 1st Earl of Beaconsfield
(1804–81)
Oil on canvas, 1276 × 931mm (50¼ × 36⅝")
Signed with monogram and dated 1881, lower left
National Portrait Gallery, London
Cat. no. 41

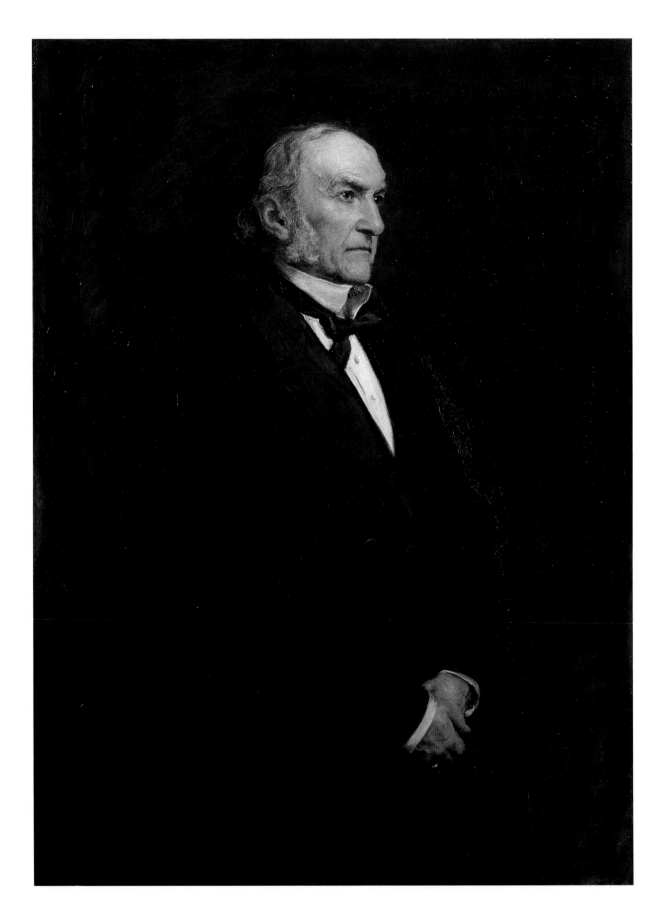

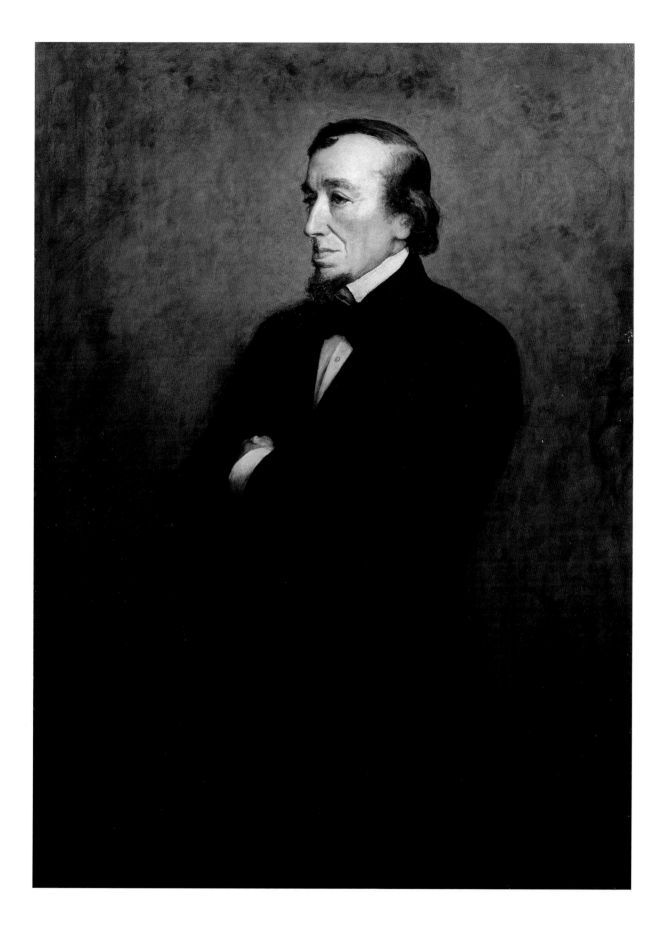

Heinrich Von Angeli
**Benjamin Disraeli,
1st Earl of
Beaconsfield**
Oil on canvas, 679 ×
549mm (26¾ × 21⅝")
1877
The Royal Collection
© Her Majesty The
Queen

But Millais's poses suggest more. These men were clearly persons of distinction, but without bravado or even great confidence. There is nothing in the series to suggest that these were the Prime Ministers of Britain at her zenith, and much to show that Millais perceived with some sensitivity his sitters' concerns about the future. The portraits are democratic in their absence of assertion of distinction, save by dignity and force of character: the viewer observes the Prime Minister person-to-person. The absence of court trappings and landscape background might be seen as emphasising the increasingly urban priorities of British politics, although all four of these Prime Ministers lived on rural estates. In that sense they represent the achievements of Victorian Liberal individualism and the tone of their times. Millais was also strikingly successful in taking on the camera, and matching or excelling it in the iconic presentation of public men. He used photographs to cut down on sittings, but he was by no means bound by them. He recovered for political portraiture a role that it had seemed to be fast losing.

The portraits of Gladstone and Disraeli (the latter painted in his last illness and exhibited soon after his death in 1881) are in effect a pair: each is two-thirds length against a dark background, the figures facing in opposite directions (pages 150–51). In both cases, Millais sought out his sitter. He told Gladstone: 'I have often wished to paint your portrait . . . one hour at a time is all I would wish'; he told the dying Disraeli, with pardonable exaggeration: 'I do not require more than *one* hour at a time and if I am as fortunate as I

W.&D.DOWNEY. COPYRIGHT.

was with Mr Gladstone 5 sittings will suffice'.[10]

Millais's Gladstone is George Richmond's young Tractarian of 1843, now quite elderly, still donnish-looking and somewhat preoccupied. It is the portrait of a religious intellectual, the author of *A Chapter of Autobiography* (1868) which charted Gladstone's view on church establishments, not a depiction of the orator and campaigner who embarked in 1879 on the Midlothian Campaign which ignited the political world and appalled the Queen by its supposed demagoguery. The sombre portrait of Disraeli significantly improves on that by Angeli commissioned by the Queen in 1877. Disraeli described the painting of the latter:

> Von Angeli's studio is the Queen's private dining-room, and it is furnished, and entirely fitted up, with the Pagoda furniture of the Brighton Pavilion. The fantastic scene, the artist himself, very good-looking, picturesque, and a genius, the P. Minister seated on a crimson chair on a stage, and the Private Secretary reading the dispatches, with his boxes, would make a good *genre* picture![11]

Millais's pose for Gladstone was fresh, and different from the existing portraits and photographs. It can hardly have been an accident that he used almost the same pose for Disraeli (but facing left rather than right), for the consequence is a remarkable pair of portraits, linking forever in similarity of treatment two statesmen usually perceived as

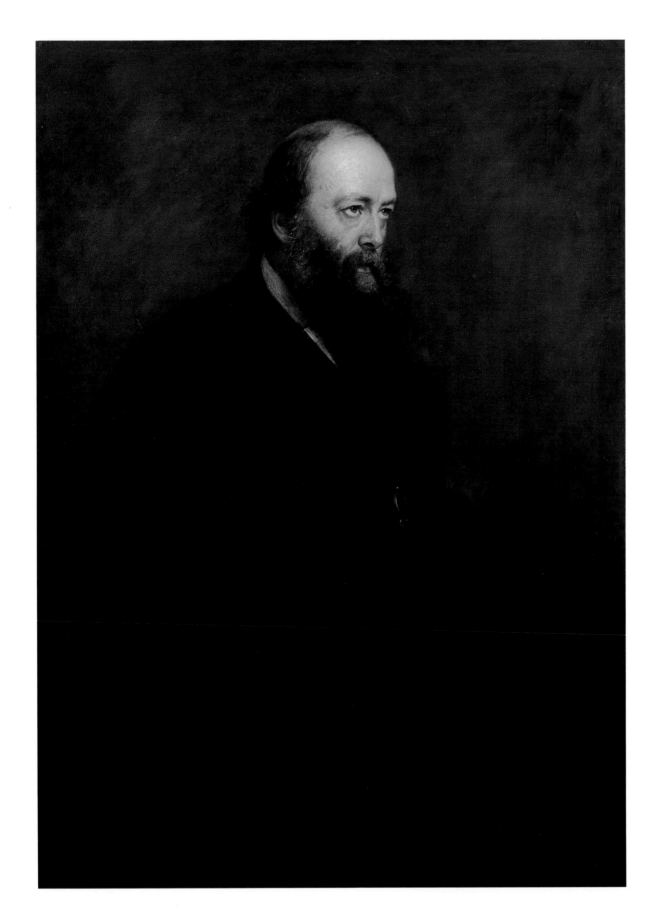

antithetical. The engravings of these portraits, though by different engravers for different publishers, were soon being sold as a pair. Even so, in using this pose for Disraeli, Millais followed almost precisely the well-known *carte de visite* photograph by Downey of Newcastle (page 153), and he probably did so as a wise precaution, since Disraeli died before the portrait was finished. While the photograph focuses on the extraordinary, impassive face, Millais with his very dark background and taut figure with folded arms shows the character through the body rather than the face, in a memorable pose. The angle and character of the nose is significantly different from that of the photograph, an important choice by Millais at a time when cartoons of Disraeli were sometimes stridently anti-Semitic.

Of the four Prime Ministers, the pose of Disraeli, delicately depicting his personal vanity, is the most assertive, the folded arms recalling Lawrence's two portraits of Wellington (c.1814–16).[12] Millais clearly found the pose convenient, for he used it again in his portrait of the physician Sir Richard Quain (1895–6; Royal College of Physicians, London). *Disraeli* was too late for the Royal Academy show in 1881, but was placed on an easel in the ante-room for guests to view as they entered for the customary opening dinner. This gave Disraeli a fine posthumous advantage; the occasion was one of acute embarrassment for Gladstone, the chief speaker at the dinner, who had been so troubled by having to eulogise Disraeli in the Commons that he had suffered a severe stomach upset. Gladstone noted in his diary that his speech to the Academy was 'this year especially difficult'. He briefly discussed the portraits of Disraeli and himself, remarking of the former: 'It is, indeed, an unfinished work. In this sense it was a premature death (Cheers). "Abstulit atra dies, ac funere mersit acebo [A black day bore him away and bitter death submerged him]".' At the request of the Queen, Millais made a copy of the Disraeli portrait at reduced size for the Royal Collection.

Lord Salisbury was the most pessimistic of all British Prime Ministers, perhaps the only one who believed the usual caveats of Conservatives about the limitations of political action. Millais's portrait of him – like those of Gladstone and Disraeli – is two-thirds length with the subject standing. By using the same pose Millais dignified Salisbury, who in 1882 was not yet undisputed leader of the Tory party, let alone Prime Minister (he became both three years later). He was the easiest of Millais's Prime Ministers to capture, given his great bulk, large beard and strong features. The portrait is effective and emphasises Salisbury's impassive stance; compared with Watts's depiction a year earlier it is a striking image. But it falls short of greatness; it may be that Millais found the depth of Salisbury's pessimism too disturbing to attempt to capture.

Millais painted Gladstone again in 1884–5 (page 176, right), this time in his Oxford doctoral robes, reflecting Gladstone's lifelong preoccupation with his university (he was buried in the same robes) and his desire to be seen not as a politician, but as an intellectual for whom politics was a second-order concern. Painted in the midst of the political crisis over the rejection of the Reform Bill by the House of Lords, and using a reference

John Everett Millais
Robert Gascoyne-Cecil, 3rd Marquess of Salisbury
Oil on canvas, 1273 × 933mm (50⅛ × 36¾")
1882
National Portrait Gallery, London

photograph taken by Rupert Potter, it shows Gladstone confident and benign. This portrait was the centre of a curious episode, which resulted in two portraits in the same pose, but the second by no means a replica of the first. It was originally commissioned by Gladstone's Oxford College, Christ Church, when attempts to provide one by Watts and W.B. Richmond had failed. 'I have Gladstone better than the first time . . . I never did so fine a portrait,' wrote Millais.[13] Lord Rosebery, visiting Millais's studio in 1884, saw the nearly completed picture, liked it, and offered Millais £1,000 for it, with Christ Church (also Rosebery's college) to have a half-length copy. Millais accepted the offer – a cool action given the importance of the college and of the sitter. When Gladstone heard of this odd transaction he offered to sit again, and Millais painted another portrait for the college in substantially the same pose in June and July 1885 (cat. no. 46), just as the second Gladstone government collapsed. This second version is much the fiercest of all Millais's political portraits – indeed, it is the only one that suggests the combative nature of the sitter's profession. It brilliantly captures an angry man of power, and it reflects Gladstone's capacity to break through the pessimism afflicting Millais's other Prime Ministerial sitters.

In the midst of the sittings for the 1885 portrait, and in an episode almost as confused as the painting of the two versions, Gladstone offered Millais a baronetcy. This was an important moment in official recognition of Victorian art. Gladstone had hoped to offer three baronetcies – the first hereditary titles in the history of British art – to Millais, Watts and Leighton. The Queen restricted him to two, and he chose Millais and Watts. Millais accepted with delight, but Watts declined. As Leighton knew of the offers to the other two, he could not immediately be offered a title as what would seem a consolation prize. So, in June 1885, Millais became uniquely favoured (Leighton followed in February 1886, and then outstripped Millais with a peerage on his deathbed in 1896). It would be wrong to make a political link between the Liberals and the Pre-Raphaelites, but the emergence of Millais as Gladstone's artistic baronet certainly fitted the latter's preoccupations, as had his ennoblement of Tennyson two years earlier.

Millais painted Gladstone once more, in 1889, with his grandson; the painting was presented to the Gladstones as a golden wedding present by the women's organisations of the Liberal party. The picture was a failure, however, and after exhibition in 1890 Millais repainted the head. In writing to the artist, Gladstone politely acknowledged the delightful portrayal of his grandson.

Rosebery was the last of Millais's premiers; it was painted in 1885–6 when he became Foreign Secretary, eight years before he succeeded Gladstone as Prime Minister. As with the other portraits of politicians, there is nothing to suggest the awesome extent of Rosebery's responsibilities. Instead, Millais presents him with a debonair but haunted, almost cornered, look, strikingly anticipating the erratic depressive that Rosebery became after the death of his wife in 1890.

Millais's portraits of Prime Ministers were of men absorbed by the complexities of office. Together with his portrait of Tennyson, they reflect – with the exception of the

Archibald Philip Primrose, 5th Earl of Rosebery
(1847–1929)
Oil on canvas, 1257 × 952mm (49½ × 37½")
Signed with monogram and dated 1886, upper left
The Earl of Rosebery
Cat. no. 47

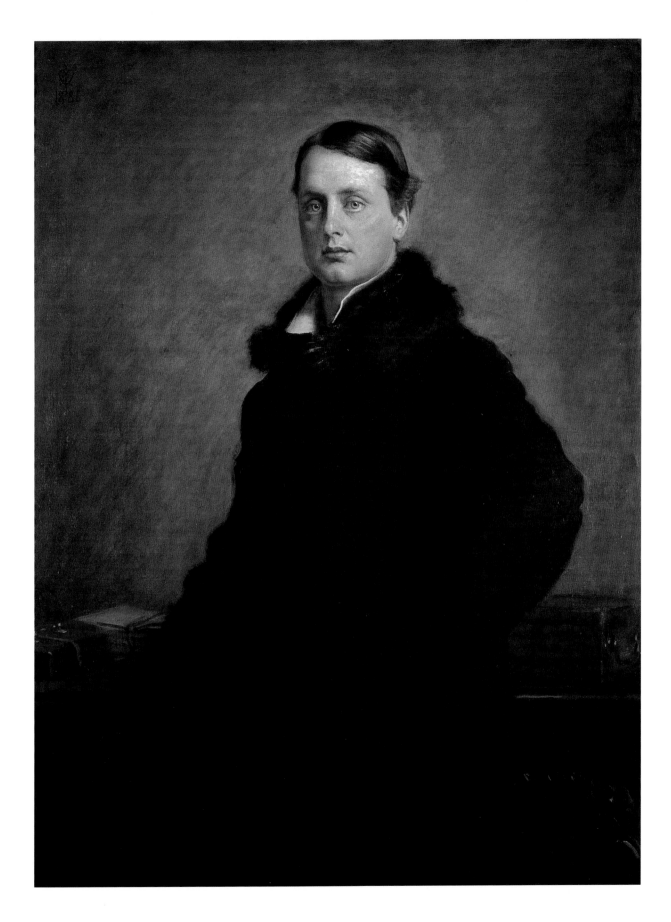

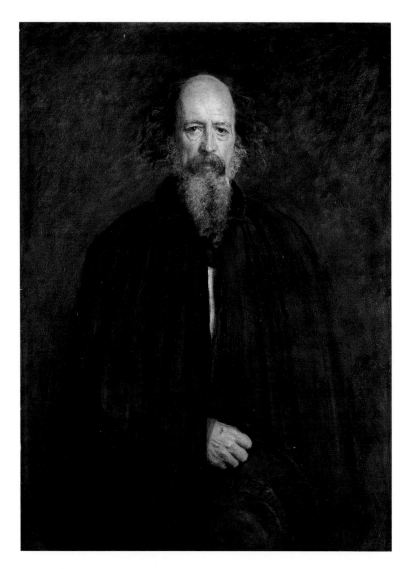

Alfred Tennyson
(1809–92)
Oil on canvas, 1270 ×
930mm (50 × 36½")
Signed with monogram
and dated 1881, lower
right
Trustees of the National
Museums and Galleries
on Merseyside
(Lady Lever Art
Gallery, Port Sunlight)
Cat. no. 42

third portrait of Gladstone – the caution rather than the optimism of the age. Millais could be brilliantly emblematic without being didactic – *The Boyhood of Raleigh* relied for its effect not on clues in the painting, like the Pre-Raphaelite works of the 1850s, but on the viewer's knowledge of context. Only an informed viewer could understand the imperial significance of this picture, as resonant as Tennyson's poem 'The Revenge' to which it obliquely refers. Millais's political pictures are not primarily emblematic: their poses are much sharper than those of Watts, and dwell in the mind, but without any apparent comment on the subject or his office. Millais succeeded in painting the Victorian élite in the high-minded way in which it saw itself while, at the same time, by the device of presenting figures dated only by their sombre clothes, asserting something of the timeless authority that they believed they had. Surprisingly, the most flamboyant of Millais's public portraits was that of Newman in his cardinal's robes. Newman, one might have thought, was eminently suited for the sombre style Millais had developed, but his scarlet robes give him the style of a pope painted by some latter-day Velázquez.

**John Henry, Cardinal
Newman**
(1801–90)
Oil on canvas, 1213 ×
953mm (47¾ × 37½")
Signed with monogram
and dated 1881,
lower left
National Portrait
Gallery, London, on
permanent display at
Arundel Castle, West
Sussex
Detail of cat. no. 44

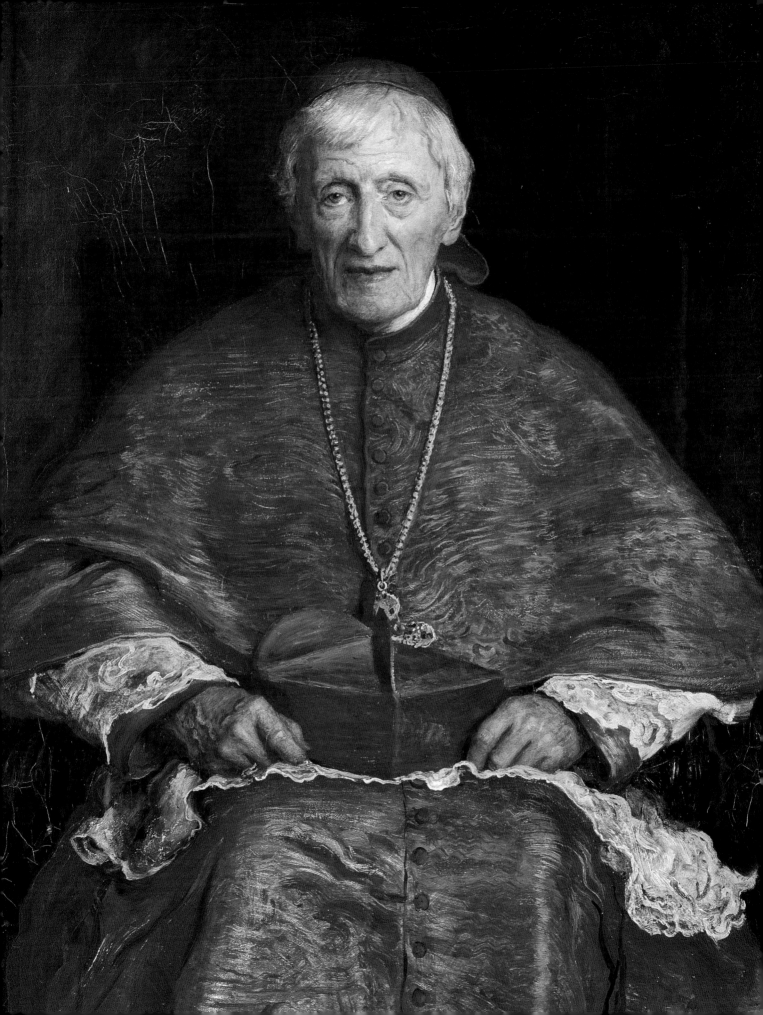

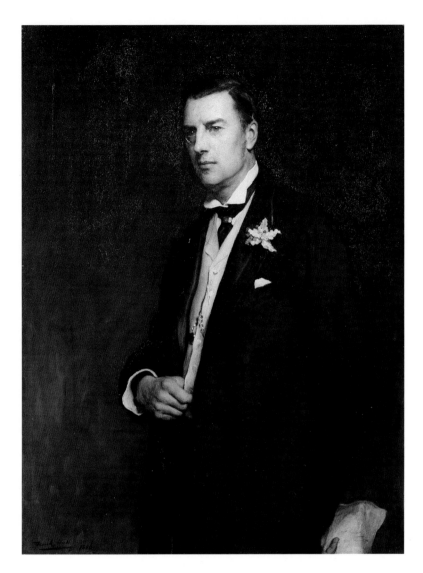

Frank Holl
Joseph Chamberlain
Oil on canvas, 1156 ×
864mm (45½ × 34")
1886
National Portrait
Gallery, London

Nothing dissociates the Victorians more from our own times than their belief that they stood at the summit of achievement and knowledge, and that even their disputes were of heroic significance. For all that Millais captured the caution of his sitters, he captured that quality also. The skill involved in so direct and simple an approach, in which the viewer's eye is immediately and solely directed at the figure, is shown by a glance at Frank Holl's 1886 portrait of Joseph Chamberlain, which is an attempt to replicate Millais's two-thirds length pose and present Joe as Gladstone, with disastrous results.

Millais's approach to public life was somewhat similar to that of his German contemporary, Franz von Lenbach. Rather more than Millais, Lenbach became primarily a portraitist. He also painted the political élite of his country, and with rather a similar approach. Though his most famous portrait of Bismarck showed him in uniform (unthinkable in a British political leader), most of his many portraits of Bismarck were of a worried man, with little of the swagger normally associated with the new German

Empire. Lenbach painted Gladstone on three occasions, in 1874, 1879 and 1886 (the last in a double portrait with the Bavarian theologian and friend of Gladstone, J.J.I. von Döllinger). More than Millais, Lenbach avoided Watts's predicament of many sittings for busy public men by extensive use of photographs. Posterity has gained from this, for his photographs of Gladstone for the 1879 portrait (Scottish National Portrait Gallery, Edinburgh) are among the finest ever taken of a Prime Minister, and much more striking than the portrait (the photographs are in the Lenbachhaus, Munich). Lenbach's photographs are quite similar to the 1885 Millais portrait and capture the Gladstone of the Midlothian Campaign. Lenbach's double portrait of Gladstone and Döllinger (German Embassy, London) reflects his varied approach, which is more pluralist than Millais's standard two-thirds length.[14] This enabled Lenbach to paint some portraits resembling those of Watts in their psychological close-up, and some those of Millais in their rather abstracted and slightly distanced and formal pose.

In the portraiture of British public life, Watts was the more innovatory artist, Millais the more successful. Millais's restrained style was too demanding for his successors. A.S. Cope's portrait of Sir William Harcourt (1904; National Portrait Gallery, London) in his robes as Chancellor of the Exchequer, with red dispatch boxes and budget papers, was a return to Sir Francis Grant's style, as were de Lazlo's Balfour, Orpen's Asquith and Fildes's Lloyd George, all in academic or political robes. Millais caught the high Victorians as they liked to see themselves, as intellectuals in politics, rather than as politicians *per se*. It was a striking epoch in British political history, and Millais's depiction of it matched the moment.

NOTES

1 Alfred Lord Tennyson, *Locksley Hall. Sixty years after*, 1886, p.12.

2 Alfred Tennyson, 'Locksley Hall', *Poems*, 1842.

3 Alfred Tennyson, 'Steersman, be not precipitant in thine act', quoted in J. Morley, *Life of William Ewart Gladstone*, 1903, vol. 3, p.132.

4 Lord Salisbury, 'Disintegration', *Quarterly Review*, vol. 3/2, October 1883.

5 See note 1.

6 Lord Salisbury, quoted in Paul Smith, ed., *Lord Salisbury on Politics*, Cambridge, 1972, p.342.

7 W.E. Gladstone, '"Locksley Hall" and the Jubilee', *Nineteenth Century* (January 1887), quoted in H.C.G. Matthew, *Gladstone: 1809–1898*, Oxford, 1998, p.337.

8 See, for example, Peel's letter to John Lucas of 18 November 1843 concerning his portrait of Gladstone, British Library, Add. MSS 40,536, f.138.

9 H.C.G. Matthew, op.cit., 1998, p.519. Watts later mutilated this portrait when the Governing Body of Christ Church, Oxford, which had commissioned it, asked for changes.

10 Ibid., p.520.

11 W.F. Monypenny and G.E. Buckle, *The Life of Benjamin Disraeli, Earl of Beaconsfield*, 6 vols., 1910–20; vol. VI, p.136. They note that the picture is 'not a pleasing likeness'.

12 One is in Wellington Museum, Apsley House, London; the other in the possession of the Marquess of Londonderry. Both are illustrated in Kenneth Garlick, *Sir Thomas Lawrence*, New York, 1989, p.279.

13 Millais, *Life*, vol. I, p.166.

14 The photographs and the double portrait are reproduced in Matthew, op. cit.

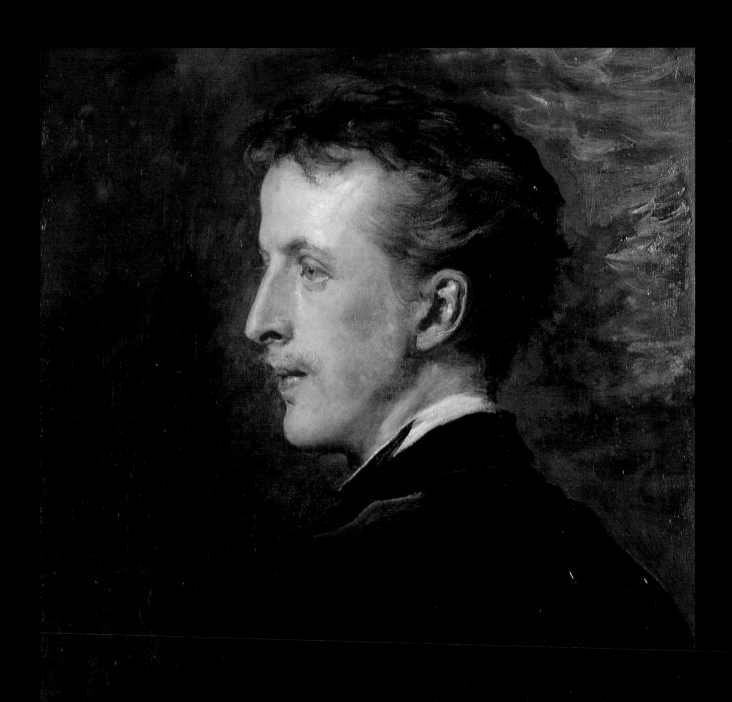

3
Portraits of Men

Catalogue by Malcolm Warner

38
Lord Ronald Gower (1845–1916)
Oil on canvas
600 × 462mm (23⅝ × 18⅛")
Signed with monogram and dated 1876,
lower left
From the RSC Collection with the
permission of the Governors of the
Royal Shakespeare Theatre

The youngest son of the Duke of Sutherland, Gower was a member of possibly the wealthiest aristocratic family in Victorian Britain. While still in his twenties, he served for seven years as Liberal MP for Sutherland. After giving up his seat in 1874 he began to spend long periods in Paris, where he trained as a sculptor. He showed various statues and statuettes at exhibitions in Paris and London, but his crowning achievement was the Shakespeare Memorial in Stratford-upon-Avon (1879–88). He was also an art critic and historian, and published books on the British portraitists Lawrence (1900), Reynolds (1902), Gainsborough (1903) and Romney (1904). Although the fact of Gower's active homosexuality was well known among his gay contemporaries, including Oscar Wilde, he managed to avoid any public exposure or scandal.[1]

Gower was on friendly terms with Millais, who also painted his sister Constance, Duchess of Westminster, and his nieces the Marchioness of Ormonde and Lady Beatrice Grosvenor (1875–6; The Duke of Westminster). In the course of a discussion of the seventeenth-century Dutch painter Frans Hals, he had also written astutely about Millais as a portraitist: 'We have one living artist whose portraits somewhat resemble those of Hals, both as to the light touch and spirited treatment of the heads and draperies; it is but in the last few years that John Everett Millais has taken up portrait painting (almost exclusively) and many regret that for a very remunerative

branch of the profession his ideal paintings seem to have been abandoned. Whether Millais has studied Hals, I know not, but there is no question that in his latest portraits our artist reminds one much of Hals.'[2] His view was not uncritical: a few months after this portrait was painted, he published an article in which he called him the foremost painter in England but again characterised his recent work as too much dominated by portraiture, and truthful at the expense of poetry and imagination.[3]

Gower gave his first sitting for the portrait on 5 April 1876, noting in his diary: 'To Millais's studio at eleven. He began to work soon after, and by one o'clock had made a capital sketch, almost in profile, life-size. He commenced by covering a fresh canvas with a low tone of Vandyck brown as groundwork, and then worked over this while the ground was still wet, painting in the head without any previous drawing. He works "con amore", and makes much use of a pier looking-glass. He makes one stand up all the time, and allows but little time for rest. However, he lets one talk and even smoke throughout the sitting.'[4] 'Four sittings, or rather standings, and the portrait was finished,' Gower later recalled; 'it was considered extremely like, and is a fine specimen of the great painter's second manner'.[5] Millais painted the work as a gift, and Gower returned the favour by giving Millais a drawing thought to be by Rubens.[6] The portrait was shown first in Wrexham (see below), then at the inaugural Grosvenor Gallery exhibition in 1877. Later, Gower presented it to the Shakespeare Memorial Theatre, of which he was a trustee.

In 1879 Gower helped prepare the way for Millais to paint Disraeli (see cat. no. 41); and in 1881 Millais gave him a bust-length version of the portrait of his sister, by this time deceased, a pendant to the present work (The Duke of Westminster).

First exhibited: Wrexham, *Art Treasures Exhibition of North Wales and the Border Counties*, 1876 (503).

1. See Philip Ward-Jackson, 'Lord Ronald Gower, the Shakespeare Memorial and the Wilde Era of London and Paris', *European Gay Review*, 1987, pp.52–65.
2. *A Pocket Guide to the Public and Private Galleries of Holland and Belgium*, 1875, p.166.
3. 'Living Artists', *Vanity Fair*, vol. XVI, 16 December 1876, pp.388–9.
4. Dunrobin Castle, quoted in Lord Ronald Gower, *My Reminiscences*, 1883, p.342.
5. Gower, loc. cit.
6. Now identified as by Watteau after Rubens (National Gallery of Art, Washington).

Further literature: Spielmann 1898, pp.173 (no. 179), 180; Millais, *Life*, vol. II, pp.477, 496; Bennett 1967, p.53, no. 88.

39

Thomas Carlyle (1795–1881)
Oil on canvas
1168 × 883mm (46 × 34¾")
1877
National Portrait Gallery, London
(NPG 968)

When Millais painted the Scottish social critic and historian Thomas Carlyle, one of the great sages of Victorian Britain, he was eighty-one years old and had written little of importance in the eleven years since the death of his wife Jane Baillie Welsh. The first two sittings took place on 26 and 28 May 1877, and Millais claimed that there were only three.[1] After the second, Carlyle wrote to his brother: 'Millais seems to be in a state of almost frenzy about finishing with the extremest perfection his surprising and difficult task; evidently a worthy man.'[2]

Carlyle was accompanied to the studio for sittings by his friend, disciple and biographer James Anthony Froude, who later recalled:

> In the second sitting I observed what seemed a miracle. The passionate vehement face of middle life had long disappeared. Something of the Annandale peasant had stolen back over the proud air of conscious intellectual power. The scorn, the fierceness was gone, and tenderness and mild sorrow had passed into its place. And yet under Millais's hands the old Carlyle stood again upon the canvas as I had not seen him for thirty years. The inner secret of the features had been evidently caught. There was a likeness which no sculptor, no photographer, had yet equalled or approached. Afterwards, I knew not how, it seemed to fade away. Millais grew dissatisfied with his work and, I believe, never completed it.[3]

It was supposedly on arriving for a sitting that Carlyle made his much-quoted remark about the artist's luxurious home: 'Millais, did painting do all that? . . . Well, there must be more *fools* in this world than I had thought!'[4]

Since the beginning of May 1877, J.M. Whistler's portrait of Carlyle (1872–3; Glasgow Art Gallery and Museum) had been on show at the Grosvenor Gallery, and Millais may well have undertaken his own in a spirit of competition. Why he failed to finish it is uncertain, although the problem may have been the lack of a commission: it is not clear that Froude or anyone else had promised to pay for the portrait when and if it was finished, and Millais had probably begun it as a speculative venture. If so, he would have been especially sensitive to unfavourable opinions, and there were certainly visitors to the studio who took a strong dislike to the work. Carlyle's friend Mrs Anstruther felt that it showed 'merely the mask; no soul, no spirit behind', and 'looked modern'.[5] According to a story told by the Earl of Carlisle, another lady told Millais: 'you have not painted him as a philosopher or sage but as a rough-shire peasant,' at which he 'laid down his palette and never touched the work afterwards.'[6] With neither a commission nor apparently any great liking for Carlyle,[7] Millais may indeed have thrown up his hands at such comments.

The portrait was eventually bought from the artist in its unfinished state by an old friend, Reginald Cholmondeley, who sold it to the National Portrait Gallery in 1894. On 17 July 1914, it was slashed with a butcher's cleaver by the suffragette Anne Hunt: she inflicted three gashes across the face, which are still visible.

First exhibited: Grosvenor Gallery, *Winter Exhibition. IX: Works of Sir John E. Millais, Bt., R.A.*, 1886 (16).

1. Letter to George Scharf, Director of the National Portrait Gallery, c.1894 (NPG archives).
2. Alexander Carlyle, ed., *New Letters of Thomas Carlyle*, 1904, vol. II, pp.332–3.
3. James Anthony Froude, *Thomas Carlyle. A History of his Life in London 1834–1881*, 1884, vol. II, pp.460–61.
4. D.A. Wilson and D.W. MacArthur, *Carlyle in Old Age*, 1934, p.406.
5. Ibid., p.405.
6. Note by George Scharf, 30 November 1894 (NPG archives).
7. See Walter Sichel, *The Sands of Time*, 1923, p.45.

Further literature: Spielmann 1898, pp.148, 173 (no. 188), 182; Millais, *Life*, vol. II, pp.89 (ill.), 478; Bennett 1967, p.54, no. 92; Richard Ormond, *National Portrait Gallery: Early Victorian Portraits*, 2 vols., 1973, pp.87–8, 94, pl. 163.

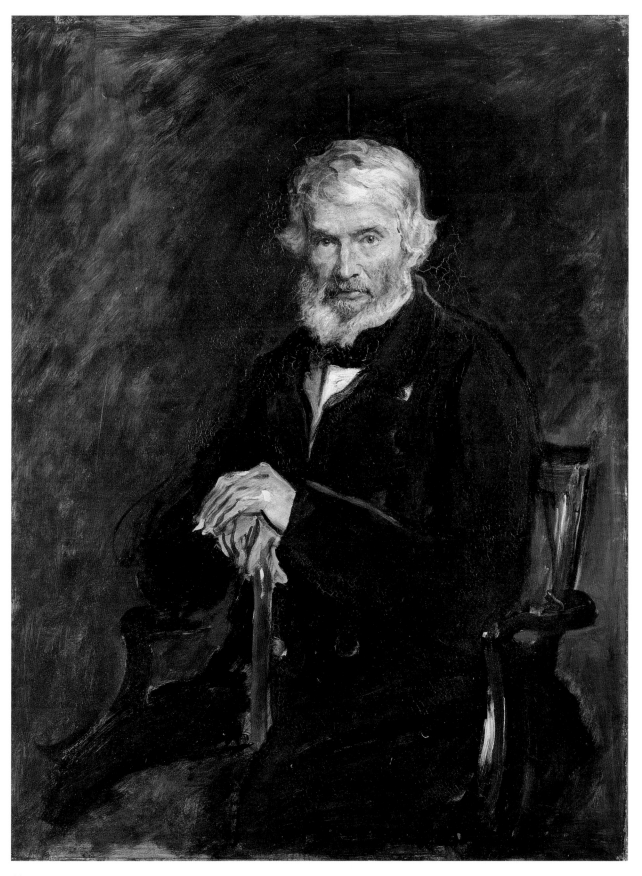

39

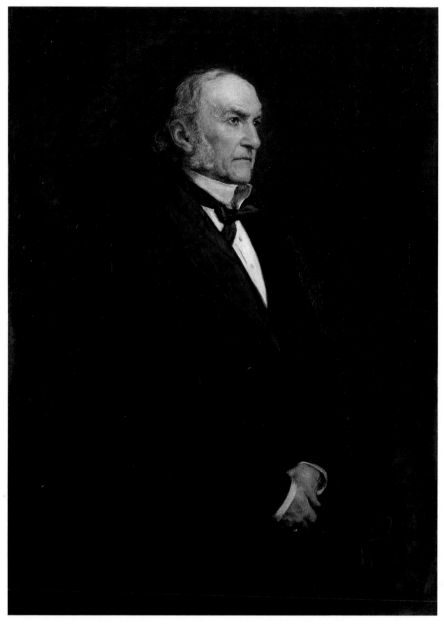

40

40
William Ewart Gladstone (1809–98)
Oil on canvas
1257 × 914mm (49½ × 36")
Signed with monogram and dated 1879,
lower right
National Portrait Gallery, London
(NPG 3637)

'I have often wished to paint your
portrait,' Millais wrote to Gladstone on

16 March 1878. 'From our last meeting
the desire has become so strong, that
I do not hesitate to ask the favour of a
sitting . . . One hour at a time is all
I would wish.'[1] Gladstone was not in
power at the time: there had been four
years of Conservative government under
his great political rival Disraeli (see cat.
no. 41), and he was leading the Liberal
opposition. In 1878 his stance over
Britain's involvement in the Russo-

Turkish war and its settlement was
stirring strong feelings, and in April his
house in Harley Street was attacked by a
mob who hustled him and his wife in the
street. Following the success of his
famous Midlothian Campaign, he was to
defeat Disraeli and become Prime
Minister for a second time in the general
election of April 1880.

There were six sittings for the
portrait, between 26 June and 6 August
1878; Gladstone noted the length of each
of the first five in his diary, a total of
eight hours.[2] A photograph of the work
in an unfinished state is in an album at
Aberdeen Art Gallery; it also appears
unfinished, with blank strips at either
side, in a photograph of the artist's
studio.[3] The inscribed date indicates that
it was not finished until 1879.

Gladstone recalled the sittings in a
letter of 4 November 1897 to the artist's
son John Guille Millais:

It was at his own suggestion, and
for his own account, that he
undertook to paint me, while I
rather endeavoured to dissuade him
from wasting his labour on an
unpromising subject. He, however,
persisted. I was at once struck with a
characteristic which seemed to me to
mark him off from all other artists
. . . to whom I have sat. It was the
intensity with which he worked, and
which, so far as I may judge, I have
never seen equalled . . . I have had
interesting conversations with your
father, but not to any large extent
during the sittings . . . The result
of your father's practice was that, of
all the painters I have ever sat to, he
took the fewest sittings. This, as well
as his success, was due, I think, to
the extraordinary concentration
with which he laboured. He had
no energies to spare; and no wonder,
when we see what energies he put
into his pictures. Although I think
the highly-finished portrait in the

possession of Sir Charles Tennant [the present work] was completed upon sittings not amounting to five hours [sic], I beg you to understand that their comparative brevity was not owing to impatience on my part, for, in truth, I never felt any. He always *sent* me away.[4]

This was the first of Millais's portraits of great Victorian statesmen, in all of which he showed an intelligent assimilation of ideas from the Old Masters. His highly animated brushwork suggests vigour and dynamism on the part of the sitters, and the plain backgrounds against which they are painted creates a strong sense of their inner power, both mental and spiritual. He admired Rembrandt and Frans Hals, whose work much impressed him on a visit to the Netherlands in 1875, and the greatest of his artist-heroes was Velázquez. His aim in much of his later portraiture seems to have been to carry on the portrait tradition forged by these seventeenth-century masters but with a modern, realist inflection: for all the allusions to the art of the past, the physical fact of Gladstone's presence in the studio, posing for his portrait, is allowed to come through.

When the portrait was shown at the Royal Academy exhibition of 1879, most of the reviewers focused on what it supposedly revealed of the sitter's state of mind. 'Here we see him as time and conflict, the latter part of it painful and protracted, have made him . . . a noble and pathetic picture,' observed *The Times*.[5] 'The action is one which has often been remarked in the manner of the late Premier,' wrote F.G. Stephens in the *Athenaeum*, 'and it assorts with the expression of the face, which bears the look of a mind overborne by passionate desire to leap out in words, and yet for the time self-controlled, but thus compelled, with such difficulty as the clasping together of the hands betrays.'[6] The *Magazine of Art* described

Gladstone's head as 'distinguished by an almost religious nobility of expression'.[7] According to Beatrix Potter, Disraeli once remarked of the portrait that 'there was just one thing in the face which Millais had not caught, that was the vindictiveness.'[8]

The portrait was bought from the artist by the dealers Agnew's for £1,000 including copyright, and shortly afterwards sold by them to Gladstone's staunch supporter in the House of Lords, the Duke of Westminster – whose portrait Millais had also painted in 1871–2 (private collection). In 1886 Westminster sold the portrait after falling out with Gladstone over the Irish Home Rule issue; it was bought from him through Agnew's by Sir Charles Tennant, who presented it to the nation in 1898. Agnew's published a highly successful and popular mezzotint after the work, engraved by Thomas Oldham Barlow, in 1881.

Clearly Millais and Gladstone liked and admired one another, and they remained on friendly terms. On New Year's Day 1881, Millais sent the statesman's wife a bust-length version of the portrait as a gift (Glasgow Art Gallery), and a few days later the Gladstones entertained the Millaises to dinner at 10 Downing Street.[9] In October 1884 Millais stayed with the Gladstones at Hawarden, and when Gladstone wrote to offer him a baronetcy on 24 June 1885, it was 'with a very lively satisfaction, both personal and public'.[10] Millais was to paint him three more times: twice in the robes of a D.C.L. of Oxford (1884–5; see cat. no. 46) and finally in a double portrait with his grandson (1889–91; private collection).

First exhibited: Royal Academy, 1879 (214).

1. British Museum: Add Ms 44456 f.170.
2. M.R.D. Foot and H.C.G. Matthew, eds., *The Gladstone Diaries*, Oxford, 1968–94, vol. IX, pp.325, 327, 329, 331, 333, 336.
3. See Geoffroy Millais, *Sir John Everett Millais*, 1979, p.13.

4. Millais, *Life*, vol. II, pp.114–17.
5. 3 May 1879, p.5.
6. 3 May 1879, p.573.
7. II, June 1879, pp.150–51.
8. Leslie Linder, ed., *The Journal of Beatrix Potter from 1881 to 1897*, 1966, p.117.
9. See Millais, *Life*, vol. II, p.208.
10. Ibid., p.177.

Further literature: Spielmann 1898, pp.37, 125, 174 (no. 199), 179; Millais, *Life*, vol. II, pp.66, 110–14, 479, 495; Bennett 1967, p.55, no. 95.

41

Benjamin Disraeli, 1st Earl of Beaconsfield (1804–81)
Oil on canvas
1276 × 931mm (50¼ × 36⅝")
Signed with monogram and dated 1881, lower left
National Portrait Gallery, London
(NPG 3241)

Millais and Disraeli had met socially, but came together for the present portrait thanks largely to the intercession of Lord Ronald Gower (see cat. no. 38). In May 1879, with Millais's first portrait of Gladstone on show at the Royal Academy (cat. no. 40), Gower lobbied Disraeli – who was Prime Minister at the time – at a meeting of the Trustees of the National Portrait Gallery. 'I did my best to persuade him to give Millais a few sittings', he noted in his diary for 10 May. 'He said of Millais that he actually had said that he would not require more than 4 or 5 "but" he added "I suppose that means 8 or 9" – but he said he would consider it, and I hope that if he is really anxious to paint him as a pendant to his picture of Gladstone it may still be carried out.' On the following day Gower reported this conversation to Millais, commenting in his diary that 'it would be quite a national misfortune did he miss the opportunity of painting him.' On 12 May he noted Millais's reply: 'Gladstone sat to me only 5 times if I remember aright but it depends upon the humour

one is in whether so short a time is sufficient, however I will gladly take my chance,' adding 'If Dizzy does sit then the print of the picture should be dedicated methinks to me.'[1] The portrait as painted is close in size to the portrait of Gladstone and clearly planned, to some extent, as Gower suggested, as a pendant. When the two works (or the prints after them) are placed together, Gladstone and Disraeli seem to confront one another as they did for many years across the floor of the House of Commons.

The sittings did not take place until March 1881, a year after Disraeli's crushing defeat by Gladstone at the 1880 general election, by which time he was already in the grip of his last illness. Millais wrote to him on 28 February 1881: 'I know that sitting to an Artist is attended with great inconvenience to every public man, but I do hope you will allow me to make a portrait of your Lordship . . . I do not require more than *one* hour at a time and if I am as fortunate as I was with Mr Gladstone, 5 sittings will suffice'.[2] Disraeli replied on 2 March: 'I am a very bad sitter, but will not easily forego my chance of being known to Posterity by your illustrious pencil.'[3] He gave a first sitting on 8 March; cancelled another on the following day because he was confined to bed; and seems to have given a second and third between the 14th and the 16th.[4]

'He walked upstairs to the studio with some difficulty,' wrote John Guille Millais, 'and the task of posing in the standing attitude was at the time too much for his strength, so all that could be done was to paint the head in and make a rough outline of his figure as he stood for a moment or two previous to being seated on the high-backed chair which was placed for him on the dais. He came only three times to the studio, and the last time his pluck alone carried him through his self-imposed ordeal.'[5]

On 31 March Millais wrote to his wife: 'Unfortunately, Lord Beaconsfield has been taken seriously ill, but I have got his likeness fairly well, if he is unable to sit again. I called yesterday and saw Lord Barrington [Disraeli's private secretary], who told me that he (Beaconsfield) is very anxious for this portrait to be in the Royal Academy, and will get the Queen's command to admit it – the only way to get it in now. He hopes to be well enough to sit again in April, but today's bulletin is ominous.'[6] Disraeli died on 19 April, and shortly afterwards the Queen did command that the portrait be shown at the forthcoming Royal Academy exhibition. According to John Guille Millais, the artist left the face as it was and worked on the background and the frock coat.[7]

At the Royal Academy exhibition, which opened on 2 May, the portrait was hung on a screen draped with funereal black crepe; this can be seen in William Powell Frith's painting *The Private View at the Royal Academy Exhibition in 1881* (private collection) and in Linley Sambourne's cartoon of the portrait being contemplated by a thoughtful Gladstone.[8] The portrait and its copyright had already been been bought from Millais, for 1400 guineas, by the Fine Art Society. It was bought from them during the exhibition by W.H. Smith of newsagency fame. Smith was MP for Westminster and had served under Disraeli as First Lord of the Admiralty (he was the original of Sir Joseph Porter in Gilbert and Sullivan's *H.M.S. Pinafore)*; he formed a collection of statesmen's portraits, and later commissioned Millais's of Lord Salisbury (1882; National Portrait Gallery, London). The Fine Art Society published a mezzotint after the portrait, engraved by Hubert von Herkomer, in 1882; it is the same size as the Agnew's mezzotint after the Gladstone portrait, and was clearly intended to make a matching pair.

Reviewing the portrait at the Academy exhibition, F.G. Stephens felt that 'the attempts made to advance, if not to finish, the work were not entirely successful. Nevertheless we have something like the energy and pathos, if not the tragical grotesqueness, of an antique mask in the gaunt, sorrowful, and feverish features, and subtly rendered suggestions of long-endured pain, and strength, but not energy, failing.'[9]

The Queen had the portrait brought to Buckingham Palace for a special viewing during the exhibition. She disliked the sadness about the face, and when she commissioned Millais to paint her a reduced replica sent him some photographs of Disraeli that she hoped he would use to modify the expression; one showed 'the peculiar expression about the corner of the mouth suggesting a keen sense of humour'.[10] The replica, which Millais delivered to the Queen on 15 October 1881, remains in the Royal Collection.[11]

First exhibited: Royal Academy, 1881 (274A).

1. Dunrobin Castle; see also Lord Ronald Gower, *My Reminiscences*, 1883, p.286.
2. Hughenden Papers: B/XXI/M/390.
3. Millais, *Life*, vol. II, p.134.
4. Ibid., vol. I, p.430; vol. II, pp.138–9. For a photograph of the upper part of the portrait after the second sitting, see vol. II, p.135.
5. Ibid., vol. II, p.134.
6. Ibid., p.137.
7. Ibid.
8. Illustrated in Charles Carter, 'A Gallery of Artists' Portraits. A Yardstick of Tasse', *Apollo*, vol. 73, January 1961, p.3.
9. *Athenaeum*, 4 June 1881, p.756.
10. Letter from her private secretary, Lord Abercromby, 29 June 1881; in Millais, *Life*, vol. II, p.140.
11. Oliver Millar, *The Victorian Pictures in the Collection of Her Majesty The Queen*, 2 vols., Cambridge, 1992, p.186, no. 495, pl. 418.

Further literature: Spielmann 1898, pp.144–6, 175 (no. 234), 179; Millais, *Life*, vol. II, pp.480, 495; Leslie Linder, ed., *The Journal of Beatrix Potter from 1881 to 1897*, 1966, p.96; Bennett 1967, p.56, no. 100.

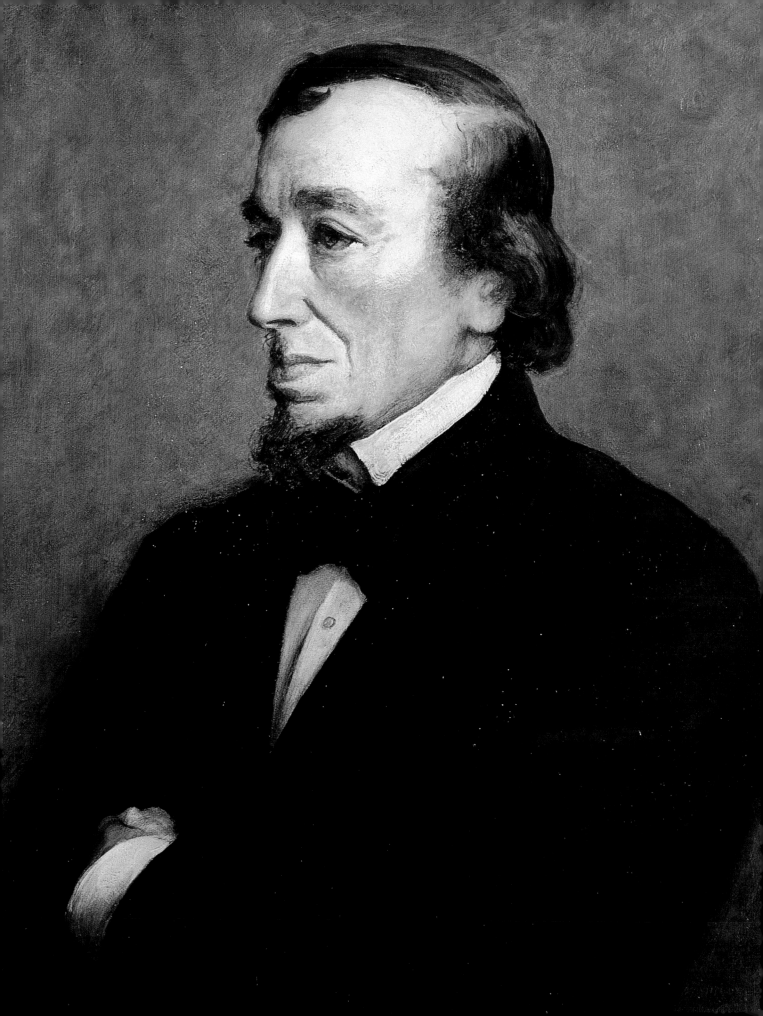

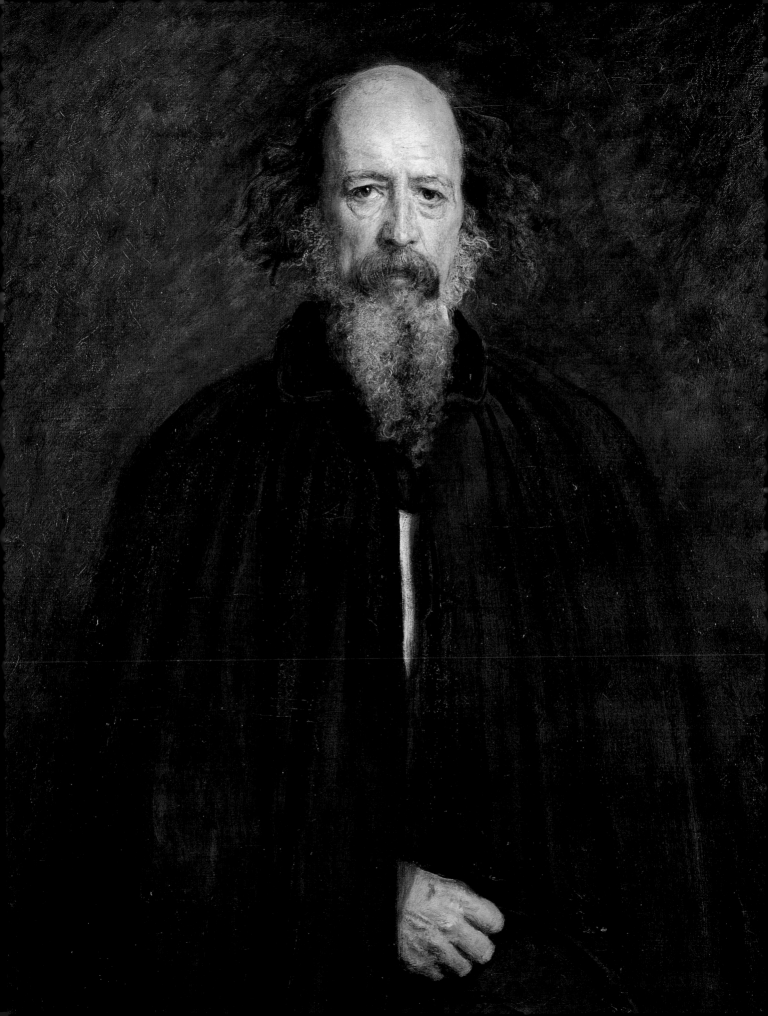

42

Alfred Tennyson (1809–92)
Oil on canvas
1270 × 930mm (50 × 36½")
Signed with monogram and dated 1881,
lower right
Trustees of the National Museums and
Galleries on Merseyside (Lady Lever Art
Gallery, Port Sunlight)

Millais was devoted to the poetry of
Tennyson and derived subjects from it
throughout his career; he based his early
painting *Mariana* (1850–51; Makins
Collection), for instance, on Tennyson's
poem of the same name. They met for
the first time in 1852. In the autumn of
1854 Millais was a guest for a few days
at Farringford, the poet's home on the
Isle of Wight, and his *Autumn Leaves* of
1855–6 (page 109) may have been
inspired by the visit; it is certainly
charged with Tennysonian imagery.
Also in 1854, the artist began work on
the eighteen illustrations he contributed
to the 'Moxon Tennyson' (published
1857). The two men were never close,
however, and John Guille Millais noted
that his father always found Tennyson
'somewhat of an enigma'.[1] When
Tennyson died, Millais wrote to Philip
Calderon: 'At one time I knew Tennyson
well, but of late years saw little of him –
I think not at all since I painted his
portrait, which, without immodesty, I
am sure is the best of him. From my
earliest days I have been a worshipper of
his works.'[2]

The portrait was commissioned by
the Fine Art Society on 9 March 1881.[3]
Millais's old friend Joseph Jopling was
employed by the Society at the time;
he had organised the small Millais
retrospective that had opened there in
February that year, and was keen to add
the Tennyson portrait to the exhibition
before it closed. The sittings took place
in March–April. On 29 March, Millais
wrote to his daughter Effie that the poet

had been to the studio twice, and
a couple of days later to his wife:
'Tennyson has just gone, and comes again
tomorrow'.[4] According to a report in the
Athenaeum, there were seven sittings
altogether.[5] On 6 April the Fine Art
Society agreed to the price of 1,000
guineas inclusive of copyright; on 27
April they signed a cheque to the artist;
and on 11 May they sold the portrait to
Tennyson's close friend James Knowles,
founder and editor of the *Nineteenth
Century*.[6] It was added to the Millais
exhibition as planned. In the following
year the Society published a mezzotint
after the work by Thomas Oldham
Barlow.

Millais told the poet's son Hallam
that he considered the work 'the finest
portrait he had ever painted'.[7] Apparently
it found little favour with the poet,
however, who is said to have remarked:
'It has neither a brain nor a soul, and I
have both.'[8]

First exhibited: Fine Art Society, *The Collected
Work of John Everett Millais,* 1881 (19).

1. Millais, *Life*, vol. II, pp.41–2.
2. Ibid., p.143.
3. Directors' Minute Book, Fine Art Society.
4. Private collection; Millais, *Life*, vol. II,
p.137.
5. 23 April 1881, p.566.
6. Directors' Minute Book, Fine Art Society.
7. Hallam, Lord Tennyson, *Alfred Lord
Tennyson. A Memoir By His Son,* 2 vols., 1897;
vol. II, p.261.
8. Sir Charles Tennyson, *Alfred Tennyson,*
1949, p.458.

Further literature: Spielmann 1898, pp.37, 60,
175 (no. 224), 181; Millais, *Life*, vol. II, pp.480,
497; Bennett 1967, pp.56–7, no. 101; Mary
Bennett, *Artists of the Pre-Raphaelite Circle.
The First Generation. Catalogue of Works in the
Walker Art Gallery, Lady Lever Art Gallery and
Sudley Art Gallery,* National Museums and
Galleries on Merseyside, 1988, pp.154–5.

43

Sir Henry Thompson (1820–1904)
Oil on canvas
1257 × 914mm (49½ × 36")
Signed with monogram and dated 1881,
lower right
Tate Gallery, London

Sir Henry Thompson, a remarkably
versatile surgeon and amateur artist,
came from a Baptist family in Suffolk.
Admitted a Fellow of the Royal College
of Surgeons in 1853, from 1866 he
was Professor of Clinical Surgery at
University College Hospital, and from
1874 Consulting Surgeon and Emeritus
Professor. His speciality was the removal
of bladder stones, an operation he
performed on Leopold I, King of the
Belgians, and Napoleon III. He was also
well known as a proponent of cremation,
an interest fired by his zeal for hygiene in
general. He studied painting under Alfred
Elmore and Alma-Tadema, and between
1865 and 1885 showed a number of his
pictures at the Royal Academy.[1] He was
a keen amateur astronomer, a serious
collector of china, and the author of a
couple of novels. He was knighted in
1867 and created a baronet in 1899.

Thompson and Millais were in touch
about sittings for the portrait as early as
9 February 1881, when Thompson wrote
offering to come to the studio during the
following week.[2] Work had still not
begun, however, by 31 March.[3] In
his autobiographical reminiscences,
Thompson noted that the sittings finally
took place in early summer, and that he
sat for an hour or a little more on six or
seven occasions, every fifth or sixth day.
His reminiscences provide a valuable
account of Millais's methods as a
portraitist. 'At my first visit,' he recalled,

I found a canvas about 50 × 38 inches
placed on an easel; alongside of
which I was directed to stand, i.e. on
the same plane with the canvas, and
at about the same distance from

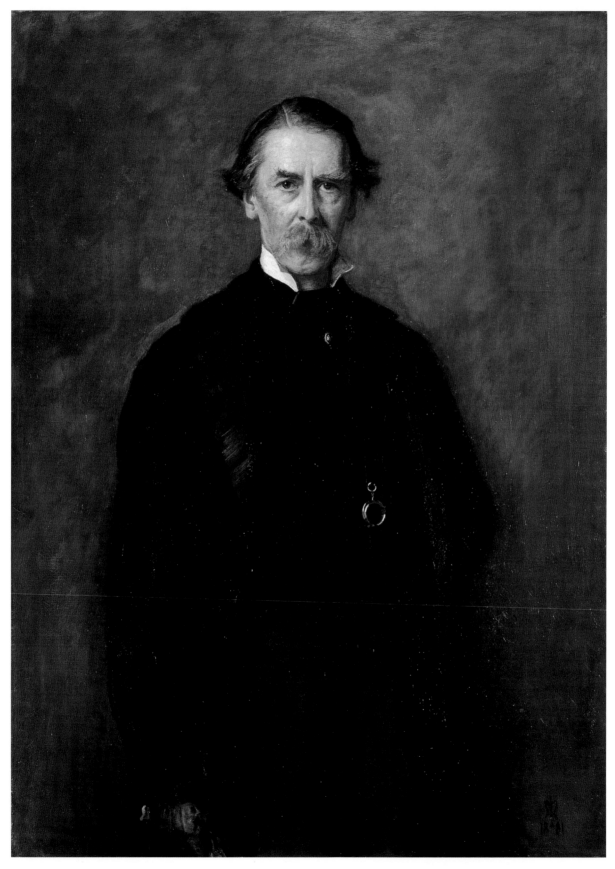

43

himself. Having surveyed me intently at a distance of about three or four yards, and settled the pose desired, he commenced by taking a large palette in his left hand, and still keenly regarding his subject from that distance advanced four steps and made a few touches of outline in colour. He then retreated the same number of steps backwards to his post of observation facing me, noting carefully as he did so, the result. With very few exceptions, every line or touch was done by the same process from the commencement of the work to the finish. Thus he could compare the strength of colour and the value of light and shade in the portrait and the sitter respectively to a degree which cannot be attained by sitting or standing before a canvas within say two feet of the eye, while the sitter is at least six or seven feet distant.[4]

Thompson calculated that the artist walked at least a mile in the course of each sitting.

First exhibited: Royal Academy, 1882 (127).

1. For a portrait sketch of Millais painted by him in 1881, see Millais, *Life*, vol. II, p.144.
2. Millais Papers, Pierpont Morgan Library, New York.
3. Millais, *Life*, vol. II, p.137.
4. Zachary Cope, *The Versatile Victorian. Being the Life of Sir Henry Thompson, Bt.*, 1951, p.103.

Further literature: Spielmann 1898, pp.129–30, 175 (no. 225); Millais, *Life*, vol. II, pp.134, 137, 143, 145 (photograph of the portrait in an unfinished state), 430, 480.

44
John Henry, Cardinal Newman
(1801–90)
Oil on canvas
1213 × 953mm (47¾ × 37½")
Signed with monogram and dated 1881, lower left
National Portrait Gallery, London, on permanent display at Arundel Castle, West Sussex
(NPG 5295)

With John Keble and Edward Pusey, Newman led the 'Oxford Movement' within the Church of England, a revival of High Church traditions that deeply affected the religious and cultural climate of early Victorian Britain. The Pre-Raphaelite Brotherhood was in sympathy with its mood and principles, and Millais's early religious paintings show its influence. Newman seceded to the Roman Catholic Church in 1845 and was ordained in Rome in the following year. He was made a Cardinal in 1879.

The idea that Millais should paint Newman was suggested by the 15th Duke of Norfolk, who wrote to the Cardinal on 6 April 1881 asking him if he would be willing to sit; the portrait

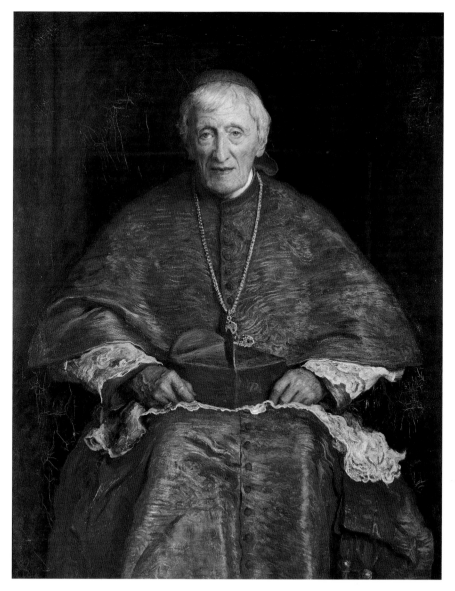

44

was to be done at the expense of Norfolk and some other friends, and donated to a public gallery in London. Newman agreed in a letter of 8 April.[1]

On 1 June Newman wrote to Millais consenting to a week of sittings at most, beginning on the 27th of that month.[2] In a letter to Gladstone of 1 July he mentioned having one scheduled for the 4th.[3] The painter Valentine Prinsep related an anecdote of Millais's shocking the priests who attended Newman at the first sitting by pointing to the sitter's chair on its dais and saying, 'Come, jump up, you dear old boy!' To this, John Guille Millais added in a footnote: 'Millais' actual words were, "Oh, your eminence, on that eminence, if you please," . . . and, seeing him hesitating, he said, "Come, jump up, you dear old boy!"'[4] In further letters of 17 and 21 July, Newman wrote that the sittings were over, and that the artist 'thinks his portrait the best he has done – and the one he wishes to go down to posterity by'.[5]

Writing in the *Athenaeum*, F.G. Stephens hailed the portrait as 'a masterpiece worthy to be reckoned with the greatest works that the Italians produced when portrait painting occupied the best hours of Titian, Tintoret, Sebastiano, and Bronzino':

> In some respects this splendid study of deep rose red and carnation tints . . . most nearly resembles a Velazquez. The brilliant illumination, the handling, frank and firm, somewhat free, if not loose, and the general simplicity of the means employed by Mr Millais are Sevillian rather than Venetian.[6]

In the event, the portrait was bought from Millais by Agnew's, the art dealers. They paid him £800, which included copyright, and published a reproductive mezzotint in 1884.[7] The Duke of Norfolk bought the painting from Agnew's in 1886 and it remained with his descendants until acquired by the National

Portrait Gallery in 1980, when the original idea of its belonging to a public gallery in London was at last fulfilled.

First exhibited: Royal Academy, 1882 (1514).

1. C.S. Dessain and T. Gornall, eds., *The Letters and Diaries of John Henry Newman*, 1976, vol. XXIX, pp.360–61.
2. Millais Papers, Pierpont Morgan Library, New York.
3. Dessain and Gornall, op. cit., 1976, vol. XXIX, p.389.
4. Millais, *Life*, vol. II, p.386.
5. Dessain and Gornall, op. cit., 1976, vol. XXIX, pp.395, 398.
6. 29 April 1882, p.544.
7. For a photograph showing the work in the studio of the engraver Thomas Oldham Barlow, see Frederic George Stephens, *Artists at Home. Photographed by J.P. Mayall*, 1884, opp. p.83.

Further literature: Spielmann 1898, pp.113, 174 (no. 219), 180; Millais, *Life*, vol. II, p.480; Richard Ormond, *National Portrait Gallery: Early Victorian Portraits*, 2 vols., 1973, p.341.

45
Self-portrait
Oil on canvas
345 × 297mm (13½ × 11¾")
Signed with monogram and dated 1883, mid left
City of Aberdeen Art Gallery and Museums Collections

This small self-portrait was commissioned by Alexander Macdonald of Aberdeen, owner of a granite works that supplied stone for the building of the Paris Opera. Macdonald had bought two paintings from Millais in the 1870s, both child subjects: *The Convalescent* in 1875, and *Bright Eyes* in 1877 (both City of Aberdeen Art Gallery). In 1880 the artist was visiting Macdonald's home, Kepplestone, and sat to the Scottish painter George Reid for a portrait sketch.[1] This fired a passion in Macdonald for collecting portraits of contemporary artists, of which he

eventually amassed a large number; they are all oval in format and on canvases of about the same size, which Macdonald himself would send to the artists.[2] His wife continued to add to the collection after his death in 1884 and it entered the City of Aberdeen Art Gallery, by the terms of his will, after her death in 1900. By that time it contained 92 portraits of 89 different artists.[3]

Millais contributed two works to the collection. He painted the first, a portrait of his friend George Du Maurier, at the end of 1882. He had agreed to undertake the self-portrait by 21 May 1883, when Macdonald wrote to him: 'Your note and its news are most delightful. The portrait will be all that could be wished, and I am most thankful to you for doing it.'[4]

Millais included himself in a good many of his early drawings, but his painted self-portraits are few. The most substantial is the one he painted in 1880 for the collection of self-portraits at the Uffizi Gallery in Florence.

1. Millais, *Life*, vol. II, p.446.
2. Allan James Hook, *The Life of James Clarke Hook, R.A., 1929–32*; vol. III, p.248.
3. See Charles Carter, 'A Gallery of Artists' Portraits. A Yardstick of Taste', *Apollo*, vol. 73, January 1961, pp.3–7.
4. Millais family collection.

Further literature: Spielmann 1898, pp.48, 176 (no. 257); Millais, *Life*, vol. II, p.482; Bennett 1967, p.57, no. 104.

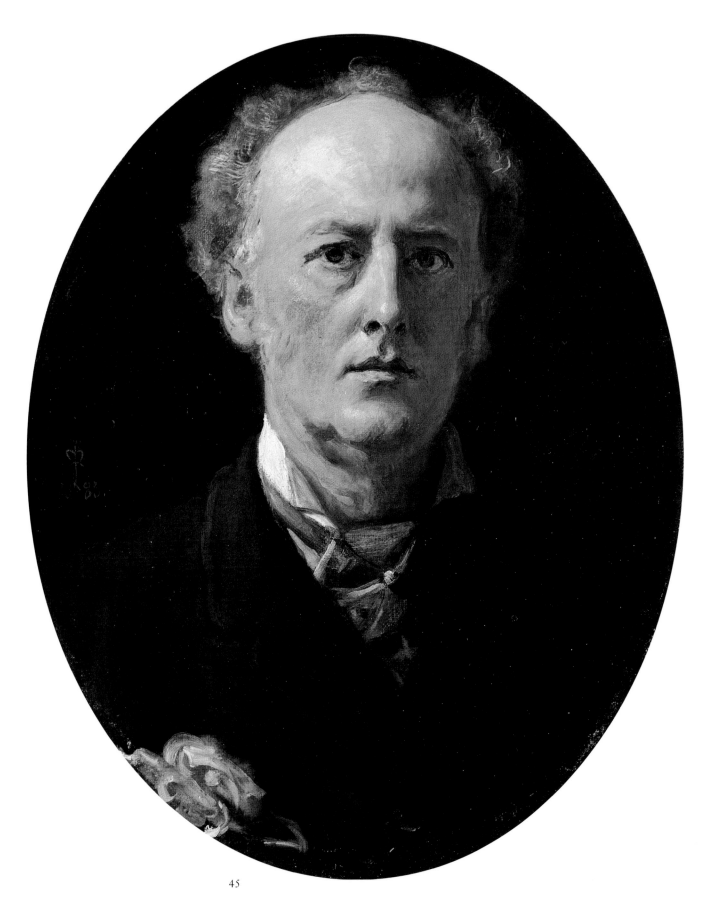

45

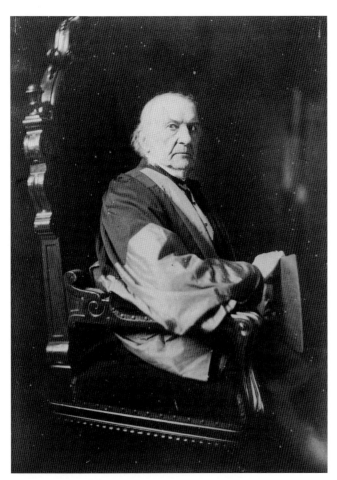

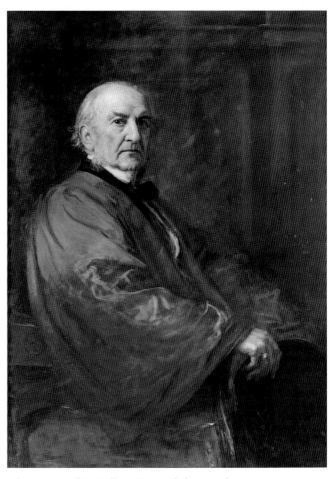

Rupert Potter, **Gladstone in Millais's studio**, during sittings for the 'Rosebery' portrait, albumen print, 197 × 142mm (7⅞ × 5⅝"), 28 July 1884, National Portrait Gallery, London

John Everett Millais, **William Ewart Gladstone**, oil on canvas, 1212 × 862mm (48½ × 34½"), 1884–5, The Earl of Rosebery, on loan to Eton College

46
William Ewart Gladstone (1809–98)
Oil on canvas
914 × 698mm (36 × 27½")
Signed with monogram and dated 1885, upper right
The Governing Body, Christ Church, Oxford

This is the third of Millais's four portraits of Gladstone (see cat. no. 40), this time showing him in the full-dress scarlet and crimson robes of a D.C.L. of Oxford University, which he was awarded in 1848. Millais himself had received the same honour in 1880. It is his most forceful image of the statesman, its elements of lighting, pose, costume and

technique drawn openly from the self-portraits of Rembrandt.

The work is a smaller version of a portrait intended at first for Christ Church but bought instead by Gladstone's supporter and junior minister Lord Rosebery (above right; and see cat. no. 47). Christ Church had decided some years before that it should have a portrait of Gladstone among those of other distinguished alumni in the college Hall, but attempts to secure a suitable likeness from G.F. Watts and William Blake Richmond had come to nothing. Finally, Millais undertook the task; six sittings were held between 7 July 1884 and 10 February 1885,[1] and the result was shown at the Grosvenor Gallery exhibition of

1885. Gladstone was Prime Minister at the time, and engaged in the passage of the Third Reform Act. Having sold this portrait to Rosebery, Millais proposed to paint a mere replica for Christ Church. 'Mr Gladstone had said that it was the last time he would sit,' Sir John Mowbray later recalled, 'but when he found that Lord Rosebery and not Christ Church had become the owner of the picture, and that Sir John Millais proposed to send a replica to Oxford, he said he would sit once more for Christ Church.'[2]

The extra sittings took place on 15 and 25 June and 13 July 1885, immediately after Gladstone and his government had been outvoted on the budget bill and forced to resign, ending

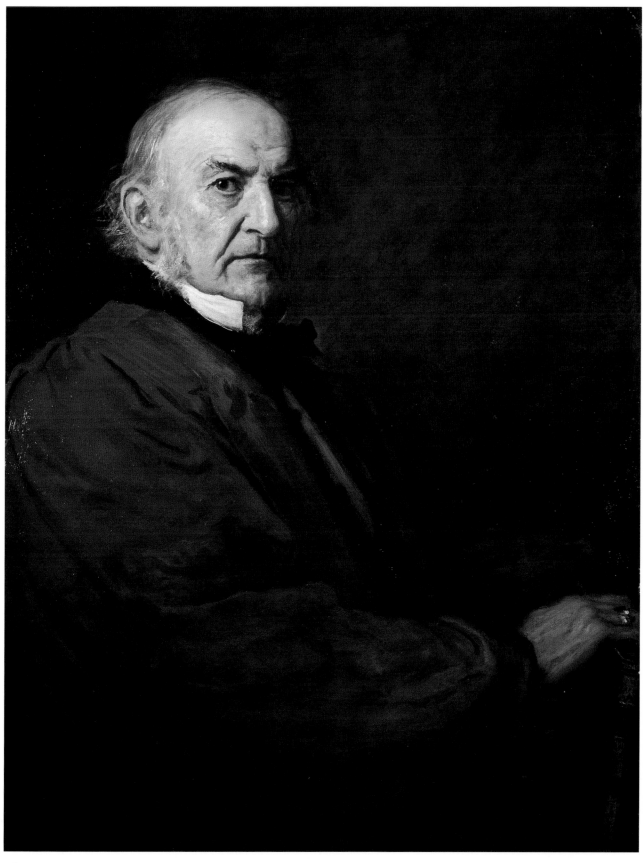

46

his second ministry. After each of the first two sittings, Rupert Potter took photographs of the portrait unfinished on the easel (see page 32).

The sitter is on the same scale as in the Rosebery portrait but painted on a smaller canvas, which seems to bring him closer to the viewer; this and his unkempt hair suggest a slightly more aggressive demeanour. The eyes in the Rosebery portrait reminded F.G. Stephens of 'a great raptorial bird staring defiance at his enemy',[3] and with the Christ Church version the image seems even more apt. Another difference between the two portraits lies in the prop Gladstone holds: a cap in the Rosebery version and a book in the Christ Church version. He holds an object not unlike a book in the photograph of him taken by Rupert Potter during the sittings for the Rosebery version (page 176, left), and Millais may have referred to this as he painted the subsidiary parts of the Christ Church version. The work was first hung in the Hall at Christ Church on 15 October 1885.[4]

First exhibited: Grosvenor Gallery, *Winter Exhibition. IX: Works of Sir John E. Millais, Bt., R.A.*, 1886 (46).

1. See M.R.D. Foot and H.C.G. Matthew, eds., *The Gladstone Diaries*, Oxford, 1968–94, vol. XI, pp.171, 174, 179, 182, 183, 293.
2. Sir John Mowbray, *Seventy Years at Westminster*, Edinburgh and London, 1900, p.343.
3. *Athenaeum*, 28 February 1885, p.286.
4. Sir John Mowbray, loc. cit.

Further literature: Spielmann 1898, pp.35–6, 161 (ill.), 176 (no. 276); Millais, *Life*, vol. II, opp. p.160 (photogravure), 483, 495.

47

Archibald Philip Primrose, 5th Earl of Rosebery (1847–1929)

Oil on canvas
1257 × 952mm (49½ × 37½")
Signed with monogram and dated 1886, upper left
The Earl of Rosebery

Rosebery was a prominent Liberal politician who served briefly as Prime Minister. He succeeded his father as Earl of Rosebery in 1868 at the age of twenty. In 1878 he married Hannah, daughter and heiress of Baron Mayer de Rothschild of Mentmore, and they had four children. From his home at Dalmeny, near Edinburgh, he organised the first modern electioneering campaign, the famous Midlothian Campaign, which helped return Gladstone in 1880. In the House of Lords he built a high reputation for his powers of oratory. He held junior posts in Gladstone's second ministry (1880–85), and was Foreign Secretary in his third (1886) and fourth (1892–94). In 1894 he succeeded Gladstone as Prime Minister, but proved unable to lead the government from the Lords. His ministry fell in 1895, and in the following year he resigned the party leadership. A distinguished historian, he wrote biographies of Pitt, Napoleon and others, and assembled an impressive collection of Napoleonic memorabilia. He was also a highly successful racehorse owner, winning the Derby three times.

Millais was on friendly terms with Rosebery, who had commissioned him to paint his daughter Lady Peggy Primrose (1884; private collection) and bought one of the portraits of his political leader and hero, Gladstone (the first of the two Gladstone portraits of 1884–5; see cat. no. 46). The present portrait was also painted for Rosebery himself. The artist wrote to his wife on 12 June 1885: 'Lord Rosebery comes after Ascot week.'[1] A sitting was scheduled for

22 June, but Rosebery wrote to cancel owing to an eye complaint.[2] On 23 July he wrote that he had called on the artist twice: 'I wanted to talk to you, and to hope that my reluctance to wear a gown no longer mine has not caused you inconvenience. I would rather be painted like a harlequin than do that,' and on the 26th that he would come for a sitting on the following day.[3] Millais had perhaps suggested that he should be shown wearing the gown of the Lord Privy Seal, which was the office Rosebery held in Gladstone's government for a few months before its collapse in June.

A year later the portrait was still not finished, and Rosebery's statement in a letter to Millais of 23 July 1886 that he was coming the next day probably refers to a sitting.[4] About this time, Rupert Potter took photographs of the portrait in an unfinished state: a studio view in which it appears on an easel (page 18, bottom); and a detail of the head and shoulders.[5] The inscribed date indicates that the work was finished by the end of that year.

When the portrait was shown at the Royal Academy exhibition of 1887, the critics remarked on the youthful appearance of the sitter. 'It is surely some years', wrote *The Times*, 'since he looked so very juvenile as his picture presents him'.[6]

First exhibited: Royal Academy, 1887 (509).

1. Millais Papers, Pierpont Morgan Library, New York.
2. Ibid.
3. Ibid.
4. Private collection.
5. Illustrated in Millais, *Life*, vol. II, pp. 259, 351.
6. 30 April 1887, p.10.

Further literature: Spielmann 1898, p.177 (no. 291); Millais, *Life*, vol. II, p.484.

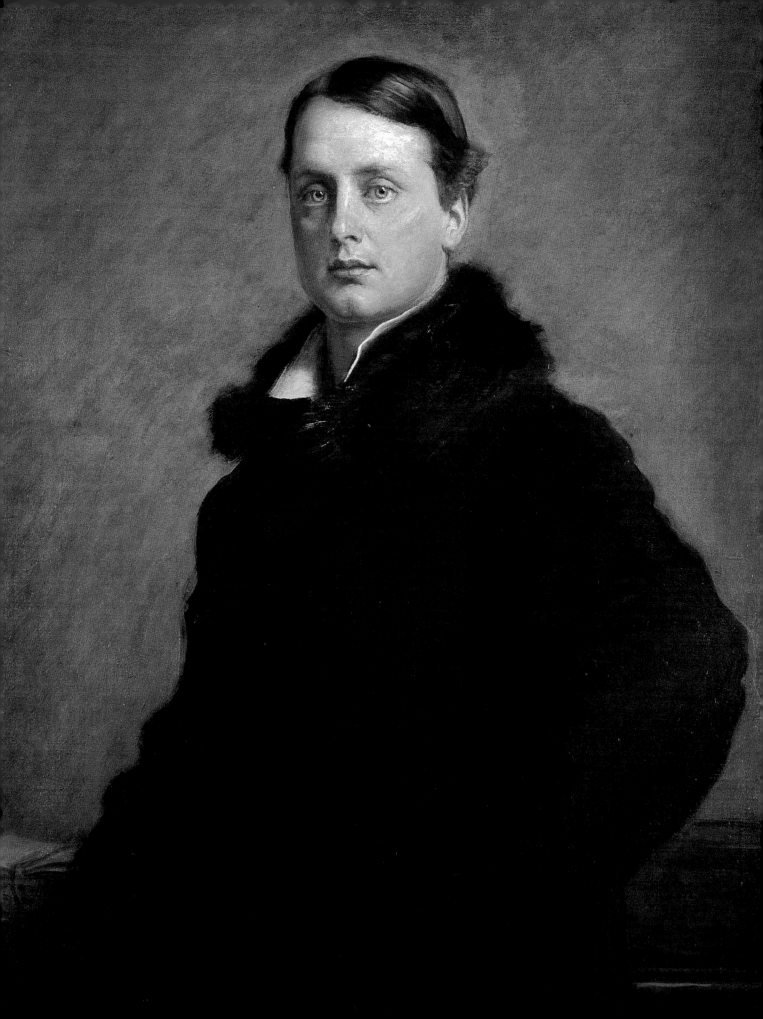

4
Portraits of Women: On Display

Kate Flint

> Millions of presumptuous girls, intelligent or not intelligent, daily affront their destiny, and what is it open to their destiny to *be*, at the most, that we should make an ado about it?[1]

Thus Henry James prefaced his fictional *The Portrait of a Lady* (1881), a novel in which he showed the young American, Isabel Archer, arriving in England, full of nebulous ambitions and an imagination overstocked with plots taken from the pages of romances. Whereas the possibilities for young women were widening considerably, Isabel finds herself, despite her energetic curiosity about life, commodified. She falls victim to the connoisseur Gilbert Osmond's passion for collecting beautiful artefacts: married to him, she is little more than another object in his exquisite collection. 'You wanted to look at life for yourself – but you were not allowed,' her dying cousin Ralph tells her. 'You were punished for your wish. You were ground in the very mill of the conventional!'[2]

At the time that Henry James wrote this novel, Millais was painting many of his portraits of female subjects. The three daughters of Walter Armstrong who sit, stiffly, playing cards in *Hearts are Trumps* (detail, pages 180–81) are, like Isabel, poised on the brink of their futures. Yet the very title of the picture suggests the conventions that entrap them. Despite the growing educational and employment opportunities opening up for women in the later decades of the Victorian period, the outlook for the majority of upper middle-class and upper-class girls was, in reality, changing only slowly. The expectation was that they would fulfil their roles as wives and mothers, mainstays of family life, active as hostesses – taking on the functions, if need be, of political hostesses – and be involved in charity works rather than being earners in their own right. Marriage was more than a personal rite of passage, but it performed a consolidating function. As the social historian Leonore Davidoff has reminded us in her study of Victorian high society, 'One of the most essential points of access to high status group membership is through marriage . . . This avenue of advancement took on new significance during our period. It often provided status legitimacy through one partner and new capital through the other.'[3]

One can contrast the formality of Millais's triple portrait, with its deliberate eighteenth-century echoes of Reynolds's *The Ladies Waldegrave* (page 184, top), with the far more relaxed composition of John Singer Sargent's *The Misses Vickers* (page 184, bottom). In the later picture, the girls are not all engaged in playing the same game,

Previous pages
Hearts are Trumps
Elizabeth, Diana and
Mary Beatrice
Armstrong
Oil on canvas, 1657 ×
2197mm (65¼ × 86½")
Signed with monogram
and dated 1872, lower
left
Tate Gallery, London
Detail of cat. no. 48

Sophie Caird
(1843–82)
Oil on canvas, 1270 ×
813mm (50 × 32")
Signed with monogram
and dated 1880, lower
right
Geoffroy Richard
Everett Millais
Collection
Detail of cat. no. 53

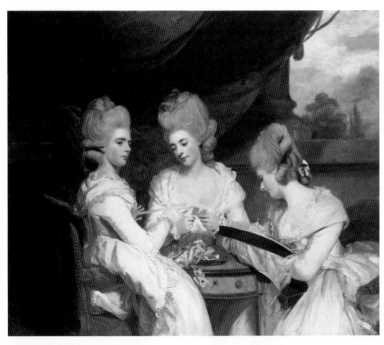

Joshua Reynolds
The Ladies
Waldegrave
Oil on canvas, 1435 ×
1680mm (56½ × 66⅛")
1780–81
National Gallery of
Scotland, Edinburgh

John Singer Sargent
The Misses Vickers
Oil on canvas, 1378 ×
1829mm (54¼ × 72")
1884
Sheffield City Art
Galleries

John Everett Millais
The Gambler's Wife
Oil on canvas, 864 ×
381mm (34 × 15")
1868
Private collection

where the rules — just like the rules of a hand of whist — are agreed and known to all. Rather, there is a suggestion in the bright openness of two of the girls' gazes, and in the introspection of the third, who is absorbed in her magazine, that they are in charge of their own external and internal lives. Even if the probable future for Sargent's subjects was the same as for Millais's, there is less of a sense that the artist is colluding in the predictable routines of a social ritual. Moreover, although Sargent's interior is comfortably furnished, the gleaming silver cream jug on the table acting as a synecdoche of social status, these individualised girls do not form the indivisible bond with their highly decorative environment that enfolds the Armstrong daughters, whose flouncy, lacy dresses partake of the same impractical ornamentation as the Chinese screen and the oriental guéridon tables. Like the azaleas banked behind them, they are the product of careful cultivation. Millais's picture is as much a celebration of the artificial milieu inhabited by his subjects, and of the financial worth (and aesthetic taste) to which it testifies, as it is of their youth and beauty.

A card game may represent the leisured lifestyle of the female Armstrongs, but it bears, too, suggestions of gambling. In a painting from three years earlier, *The Gambler's Wife* (page 185), Millais played on this theme: a much more plainly dressed woman picks up the cards that her husband has left scattered on a table-top after a night's dissipation. Here, the delicately wrought furniture combines with the woman's sorrowful expression to indicate the social position that has been endangered, perhaps lost, as a result of his speculation. The upturned ace of hearts on the end of the table tells how the token of love has become the sign of a different and destructive passion. With the Armstrongs, the stake is their appearance; the risk lies in the unpredictable course of a marriage, the future proclivities of a husband. But Millais's portraits, unlike his subject paintings, do not usually seek to suggest narratives: *Hearts are Trumps* is a rarity in this respect, even if the plot on which it is predicated is as orthodox as the romances that Isabel Archer consumed, and hardly invites the speculative investment of the spectator's imagination.

It would be strange, indeed, if Millais were seen to be questioning dominant assumptions about gender and women's role through his canvases. Although the goldfish bowl that plays such a central part of the composition in his portrayal of the young Pender girls in *Leisure Hours* (cat. no. 33) has been read as a critical comment on the circumscribed yet highly visible life led by girls in the upper middle classes,[4] such social commentary would not have been explicitly looked for by the patrons who commissioned him. More than this, Millais's public image was increasingly one that played up his masculinity, his conventionality. 'Manly is the only word which will accurately describe the impression he made,' claimed Lillie Langtry.[5] A photographic portrait by Rupert Potter of 1881 shows him as 'the keen sportsman, whose prowess with the gun, the rod, and the long putting-cleek . . . whose spirits, whether in the saddle or on foot, commanded the admiration of the many for whom the triumphs of Art are a lesser achievement' (see page 15).[6] He was, wrote James Harlaw in 1913, 'a hero of vigorous personality, sturdy self-confidence, manly courtesy, and unbudging tenacity of purpose . . . He grew into the figure of perfect manhood with mental and physical attributes of the best.'[7] His manliness was linked to his nationality, and his increasingly perceived status as someone who represented patriotic ideals: – 'a great jolly Englishman . . . Anglo-Saxon from skin to core'.[8]

Millais's expressions of admiration for female attractiveness formed part of his performance of masculinity. 'No pretty face passed him in the street without recognition,' commented Harlaw, and in calling this a 'very happy trait',[9] he indicated how the painter's voiced preferences could be read as part of a male bonding rite as well as intentional flattery. J.G. Millais's life of his father, which reinforces this impression of the artist as a somewhat clubbish connoisseur of womanly beauty, includes an anecdote from another portrait painter and pupil of his, Archie Stuart-Wortley. He recollected 'the intense interest with which we all listened, during a discussion on the beauties of the present day, to his views on their comparative measures.'[10] He apparently ranked

John Everett Millais
Louise Jopling
Oil on canvas, 1251 ×
762mm (49¼ × 30")
1879
Private collection

Georgina, Lady Dudley, above all other women in this respect, though he thought that Lillie Langtry ran her close. And his attitudes were apparent, too, in the account given by the artist Louise Jopling of her first meeting with him, at a private view in 1871:

> I was walking with the artist, Val Prinsep. 'Here comes Millais,' he said.
>
> I was tremendously excited at having the chance of seeing the great man, and I gazed at him with respectful admiration. Val said in passing:
>
> 'Good show of Old Masters.'
>
> 'Old Masters be bothered!' riposted Millais, as, with twinkling eyes, he looked at me, 'I prefer the young Mistresses!'
>
> Val roared with laughter.[11]

For a man to spend some, perhaps many, hours with a female sitter, even if she were chaperoned, 'is often productive of great intimacy between artist and sitter,' as Jopling was also to note.[12] Perhaps the verbal flattery in which Millais famously engaged was not only a form of safe flirtatiousness but, in its very overtness, provided a kind of defence mechanism that defused any potential suggestion of impropriety.

Millais's flattery of women, however, did not extend to pictorial falsification. He gave Stuart-Wortley useful hints about the painting of a woman's portrait – 'it always should be *under* life-size and, so to speak, stand back in its own atmosphere behind the frame' – but he refused to over-idealise his subjects' appearance: 'very severe against false enlargement of the eyes'.[13] One 'handsome woman of the Juno type . . . had hoped that he would present her, after the fashion of some of his portraits, as a woman of the soft, clinging, essentially dependent type of beauty – in fact, the very opposite of what she was herself,' but he declined to modify his depiction: she and her husband were so uncomplimentary that he agreed to free them from the commission.[14] Louise Jopling sat for him 'with all the knowledge of a portrait painter', and 'Of course I naturally made my expression as charming as I possibly could', with an imperceptible smile on the lips and a 'tender, soft expression' in the eyes. She testified, in other words, to her awareness of the degree to which portrait painting can be a form of collaboration, sitters producing through their poses a version of the personalities they wish to see displayed, manipulating their command of contemporary codes of physical appearance. Or not. Because Jopling then tells how, caught up in conversation, she 'forgot to keep on my designedly beautiful expression', and Millais caught, instead, a far more defiant, commanding and individualistic look (page 187).[15]

Millais's portraits of women fall into three major categories. In the first instance, there are paintings of members of his family: his wife Effie, her sisters Alice (later Mrs Stibbard) and Sophie (later Mrs Caird), his daughters Effie, Mary and Alice. Although the three daughters were depicted together in *Sisters* (page 113), Millais's canvases do not seek to celebrate the cohesion of family groups, or to suggest, through multiple intersecting looks,

the complex ways in which family subjects are constituted in relation to each other, and the emotional bonds that link all families. Millais generally painted his family members singly, unless he borrowed them as models for subject pictures. The inevitable personal dynamics in play not just between artist and sitter, but between husband and wife, father and daughter, are hidden from the observer: reading the way in which Mary Millais stares uncompromisingly out of the canvas or the younger Effie takes up a coquettish pose becomes an imaginative exercise, in which one can only second-guess reality.

Second, there are a larger number of commissioned portraits, both of members of the aristocracy (particularly the family of the Duke of Westminster) and of those whose family wealth came from trade. Again, with the exception of the twin daughters of T.R. Hoare (cat. no. 51), the tendency is to paint them singly, a shift in emphasis from the earlier decades of the century, when a work like Charles Robert Leslie's *The Grosvenor Family* served to highlight continuity not just between current family members but with their dynasty's handsome material history. 'Family heirlooms', writes the cultural sociologist Pierre Bourdieu,

> not only bear material witness to the age and continuity of the lineage and so consecrate its social identity, which is inseparable from permanence over time; they also contribute in a practical way to its spiritual reproduction, that is, to transmitting the values, virtues and competences which are the basis of legitimate membership in bourgeois dynasties.[16]

Few of Millais's portraits reproduce much by way of heirlooms. Furnishings tend rather to provide signs through which character and role may be read: quiet, decorous domesticity in the case of Mrs Leopold Reiss's book and ferns (1876; Manchester City Art Galleries); the tea-table of the urban hostess at Mrs Joseph Chamberlain's right elbow (detail, opposite). A notable exception is the inheritance of land depicted in the portrait of the first Duchess of Westminster (1875–6; The Duke of Westminster); she is shown on the terrace of Cliveden House, which had been the home of her parents the Duke and Duchess of Sutherland, with its three hundred acres of parkland stretching down towards the Thames and Windsor Forest. Yet, as with this work – which was to hang in the main dining room at Eaton, the Westminsters' other country residence, together with large canvases of bear and lion hunts by Rubens and Snyders – Millais's portraits had the potential to become family heirlooms in their own right, providing images of female virtue and value: value both intrinsic, and economic.

Millais was a highly fashionable (and expensive) portrait painter, so to call upon him to commemorate a bride or a daughter could be as much to make a clear social statement about one's own perceived rank and status as it was to express a particular aesthetic preference. A number of his works present young women at moments of transition, on their marriage – at its crudest, his collaboration in presenting them as marriageable commodities could increase their market value:

> Apropos of the Armstrongs' portraits, a story went about that Mrs Armstrong, coming to London with her three pretty daughters, asked her fellow-country woman, Lady Millais, how she should proceed to make her daughters a success in London. 'Get Sir John to paint their portraits. They will be the girls most talked of in the coming season.' And it was very good and sound advice. When the picture of the three girls playing cards was exhibited, the daughters of Mr Armstrong were recognized wherever they went, and people at once asked to be introduced to such pretty girls, and the result was that they had a most successful season.[17]

Nor was Millais's collaboration limited to the execution of the portrait: the girls' brother, the critic Walter Armstrong, later noted that he also designed the dresses, with their pink ribbons and yellow lace.[18]

Not all commissioned portraits partook in such conspicuous commodification, however: John Heugh had Millais paint his elderly mother (and pious parrot) to celebrate her 'calm, dignified, intelligent' old age (page 192).[19] Nor, for that matter, are social values rendered so readily legible in the third, smaller, group of portraits that take their impetus from Millais's own choice of female subject – ranging from the captivating beauty of the late 1870s, Lillie Langtry, to a close family friend, Charles Dickens's daughter Kate. A gift on the occasion of her marriage, this work, while showing her in a fashionable outfit, is notable for its refusal to flatter her or soften the lines of her haughty, interesting face. While Millais had a reputation for 'making his sitters live and breathe, of making

Mary Chamberlain
(1864–1957)
Oil on canvas, 1321 × 991mm (52 × 39")
Signed and dated 1891, upper left
Birmingham Museums and Art Gallery
Detail of cat. no. 55

Isabella Heugh
Oil on canvas, 1205 ×
1045mm (47½ × 41⅛")
Signed with monogram
and dated 1872,
lower left
Musée d'Orsay, Paris.
Gift of Edmund Davis
Cat. no. 50

their flesh like flesh, their eyes like eyes, with a living intelligence burning in them, if not always with a strong mind or soul behind',[20] this is the one portrait of a relatively young woman in which strength of mind and personality is the dominant impression conveyed. Even so, Millais used a common enough pose for it – similar to that employed by Whistler, for example, in his depiction of Louise Jopling.

These categories of portrait raise different, but interlinked, questions about the politics of display. They call into question the feasibility of making any neat dividing lines between public and private lives. If their execution was in part prompted by private, affective motives – the desire to celebrate a family member or to mark the occasion of a marriage – and if their final destination was customarily a domestic one, hanging in the drawing or dining rooms of private residences, almost all of them were also exhibited publicly, at the Royal Academy or, from 1877, at the Grosvenor Gallery. The practice of judging personality by appearance – clichés of physiognomy were used by artist and critic alike within the field of genre and narrative painting – did not cease when the subject was an actual person.[21] Reviews repeatedly bore witness to the merging of aesthetic and moral judgement; moreover, it is unclear which counted more, the aesthetics of the canvas or of the sitter. The *Saturday Review* noted with approval that Mrs Joseph Chamberlain 'looks quietly out of the canvas';[22] the *Art Journal* commented that Lillie Langtry's 'features, if rather large, are generous, free, and comely';[23] the *Athenaeum* commended the

Kate Perugini
(1839–1929)
Oil on canvas, 1245 ×
787mm (49 × 31")
Signed with monogram
and dated 1880, lower
right
Mr and Mrs Richard
P. Mellon
Cat. no. 54

'naturalness' of Mrs Herbert Gibbs's lips (at a time when cosmetics were increasingly used, this may well refer to more than their expression) 'and that grave sort of espièglerie which lights the eyes, so clear and sincere, with character.' Hers is a 'beautiful, healthy English face'.[24] Exhibitions themselves were sites of display in more ways than one – they were events in the social calendar of the upper classes, and hence one more location in which a woman's appearance was appraised and assessed as an index of her fashionability. In this respect, a woman was just as vulnerable, or more so, to the calculating and judgemental eyes of other women, habituated as they were to recognising the tokens of dress that revealed the hand of a particular designer, the purchase from a modish establishment or a flourish of originality, and to evaluating the cachet of the wearer accordingly. A different type of gaze, perhaps, from the more overtly sexualised one that informed popular male discourses of beauty, but one that could surely be turned as much on to the costumes and adornments worn by a sitter as on to those that were being promenaded in a social gathering.

Late nineteenth-century social commentators seized on the significance of the growing European preoccupation with fashion. Thorstein Veblen, developing his theories about conspicuous consumption in *The Theory of the Leisure Class* (1899), noted how, usually, 'the conscious motive of the wearer or purchaser of conspicuously wasteful apparel is the need of conforming to established usage, and of living up to the accredited standard of taste and reputability.' Behind this, he saw the desire to signify economic worth (whether to one's own social group, or to the group one wished to join) through the capacity for consumption, and to demonstrate to social inferiors that one could consume without producing.[25] Georg Simmel similarly remarked how fashion is 'a product of class division' and performs 'the double function of holding a given social circle together and at the same time closing it off from others.'[26]

Ideas and images about what constituted the fashionable were circulated through the press – *Queen* (founded 1861) was particularly important in this respect, followed by *Lady's Pictorial* (1881–1921), *The Lady* (founded 1885) and *The Gentlewoman*.[27] Improved technologies for picture reproduction increased the role played by the visual within these magazines as within advertising, which even more conspicuously linked the promotion of certain notions of beauty to purchasing power (or, at the very least, to fantasies about partaking of a particular lifestyle).[28] Moreover, the images that were exchanged through print were not limited to artists' impressions of dress, but included actual people. Particularly after the development of the half-tone plate in the 1880s and 1890s, society news was illustrated by small inset pictures – of brides, of social events. And, playing their role in the development of what constituted 'taste' in the broader social sense, paintings were also reproduced, especially those from the Royal Academy exhibitions. Society portraits, in other words, and the fashions that they depicted, formed part of a whole matrix of visual information about what constituted fashion, something that, moreover,

Clarissa Bischoffsheim
Oil on canvas, 1364 × 918mm (53¾ × 36⅛")
Signed with monogram and dated 1873, lower left
Tate Gallery, London
Detail of cat. no. 49

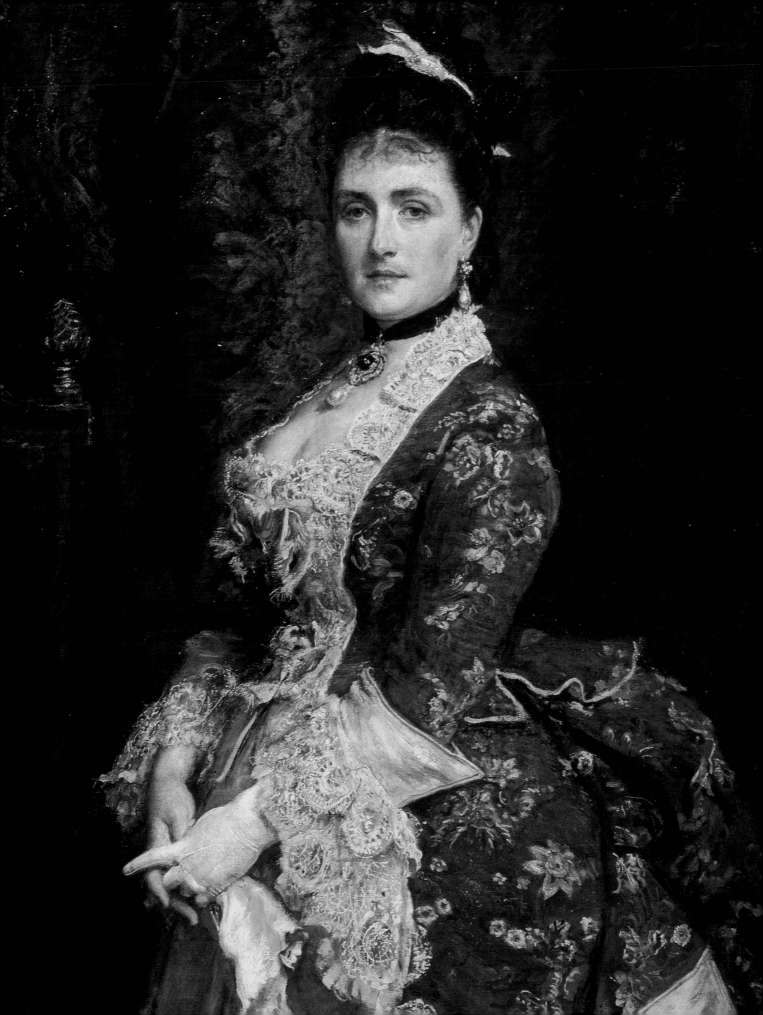

was represented not as fixed and codified but as constantly changing. The papers created this flux and taught readers how to ride it. They offered the knowledge necessary to read others off from their dress and also to produce oneself as a fashionable lady, with the aid of paper patterns and shopping tips. The discursive and the economic were inextricable.[29]

The critic of the *Saturday Review* remarked that it appeared to be Millais's 'habit, before he takes his first sitting, to send the lady off to a fashionable milliner'. He went on, with even greater sarcasm: 'what seems a little strange is, that when she returns to the studio she presents a costume which would be looked on as a screaming horror in any quiet, tasteful drawingroom.'[30] He had the extravagant dress of Mrs Bischoffsheim in mind (detail, page 195). In Millais's portraits of this period, one can trace such phenomena as the bust-emphasising ruffles that came and went on bodices; the shift towards a narrow line in the mid-1870s; the subsequent trend for a wide sash on waist or hip; the late 1870s fashion for dresses made with sleeves and bodice in two contrasting materials; the modish use in the same period of a rich, reddish shade called 'Etna', seen in the portrait of Eveleen Tennant (1874; Tate Gallery, London); the mid-1880s taste for rich, dark colours as dress fabrics began to correspond with the contemporary taste in interior decoration, and the differing types of low décolletage considered suitable for formal evening wear.[31]

According to Roland Barthes in *The Fashion System* (1967), fashion is 'the language of a mother who preserves her daughter from all contact with evil'.[32] It is 'a place that is somewhat adjacent to Utopia', where there is 'neither pain nor harm nor suffering.'[33] With their largely anonymous backgrounds – dark walls or drapes designed to show off the luminosity of skin; leafy banks; suggestions of bowers or terraces – Millais's paintings similarly extract women from any contact with difficult emotions. There is no hint of private difficulties ('Pleasure-loving Constance had not been his ideal mate', Gervas Huxley wrote in his biography of the First Duke of Westminster. 'Nor, in the later years of their marriage, can he have been unaware of her infidelities'[34]) nor of financial ones. Yet the last decades of the nineteenth century were ones in which the aristocracy was coming under increasing economic strain as a result of the agricultural depression. The hidden content of Millais's portraiture lies in the shifts of economic and social power that, taken as a whole, they represent. His patrons constituted a mixture of old society families and those whose money came from industry and commerce. Indeed, the two started to overlap. Millais's last society portrait was of Candida Louise, Marchioness of Tweeddale (1895–6; private collection). Earlier in the decade, her husband, the fifth Marquess, had disposed of the outlying part of his Roxburghshire lands: his extensive Scottish estates were generally unprofitable, so he entered into business. By the date of his wife's portrait, he was the director of nineteen companies, Governor of the Commercial Bank of Scotland, President of the Scottish Widows Fund, and chairman of four telegraph companies.

The London social scene became a prime site for furthering the amalgamation of new wealth and the existing élite, and the 'marriage market' played a major role in this.[35] The popular novelist Marie Corelli wrote of the 'absolute grim fact that in England, women – those of the upper classes, at any rate – are not today married, but bought for a price.'[36] Her polemic was linked to scorn about how the aristocracy was abandoning the 'honesty, simplicity, sympathy, and delicacy of feeling' that she claimed had characterised it, exchanging them for hypocrisy and 'vulgarity of wealth'.[37] For her, wealth had come to be a substitute, in this context of social display, for real beauty: 'Most of the eulogized "beauties" of the Upper Ten to-day, have, or are able to get, sufficient money or credit supplied to them for dressing well, – and not only well, but elaborately and extravagantly, and dress is often the "beauty" instead of the woman.'[38]

Yet, conversely, in this period of new social mobility, beauty could also have its own value in establishing connections. 'Beauty blushing unseen is a waste of wealth which political economy forbids us to sanction,' commented one advice manual. 'To be beautiful implies to be seen, and it follows that one of women's first duties is to be visible.'[39] The example of Lillie Langtry shows how effectively this natural advantage could be deployed, and also illustrates the close relationship between the commodification of beauty and contemporary portraiture.

Arriving in London shortly after her marriage in 1874, Langtry attended a reception at the home of Sir John and Lady Sebright in Lowndes Square; the invitation came through the seventh Viscount Raleigh, a friend of her father whom she had met in her home island of Jersey. By the end of the evening, it would seem, she had not only established herself as the latest talking point of society who was to receive countless invitations to other functions, but had been sketched by Frank Miles, and asked to sit for her portrait by Millais. She was painted by Edward Poynter, by George Frederic Watts (very demurely, as *The Dean's Daughter*), and by Edward Burne-Jones on the lower steps of *The Golden Stairs*. Millais used her as a model in *Effie Deans*; Whistler made two etchings of her; Leighton executed a bust of her. More than that: 'The photographers, one and all, besought me to sit. Presently, my portraits were in every shop-window, with trying results, for they made the public so familiar with my features that wherever I went – to theatres, picture-galleries, shops – I was actually mobbed.'[40] Nor did the commercialisation of Langtry's features stop there: Pears' Soap used her image several times in their advertising material, and for one advertisement in *The Illustrated London News* in late 1881 she was paid £132, her weight in pounds.[41] She was, in other words, a 'professional beauty' – a term that carried such an aura of calculation, self-presentation, and design that Valentine Prinsep could use its invented obverse, *An Unprofessional Beauty*, as the title of his portrait of a fashionable, but relatively natural and relaxed, young woman (*c*.1880; South London Gallery).

However flagrantly self-promoting the public circulation of her image might appear to have been, and however lacking in decorum, middle-class notions of respectability

carried little weight in what Langtry herself called 'the gay devil-me-carishness of London's smart set' – the world of politicians and financiers, of Ascot and Cowes. Moreover, the particular mode of her visibility started a trend:

> after the shopkeepers had exhibited my pictures in their windows alongside royalties and distinguished statesmen, all the pretty women in society rushed pell-mell to be photographed, that they, too, might be placed on view. They were portrayed in every imaginable pose. Anything the ingenuity of the camera-man could devise to produce an original or startling effect was utilised with more or less happy results. Some smothered themselves in furs to brave photographic snowstorms; some sat in swings; some lolled dreamily in hammocks; others carried huge bunches of flowers (indigenous to the dusty studio and looking painfully artificial), and one was actually reproduced gazing at a dead fish![42]

Such light-hearted self-presentation throws into relief the formality of Millais's portraiture of women, even when critics commended his canvases, or those portrayed in them, for their 'naturalness'. Moreover, it shows that society women could enjoy flaunting their conspicuousness: while some commentators might deplore the commercialisation and commodification of the female form, those who were actually commodified did not always share in these qualms, but could be willing participants.

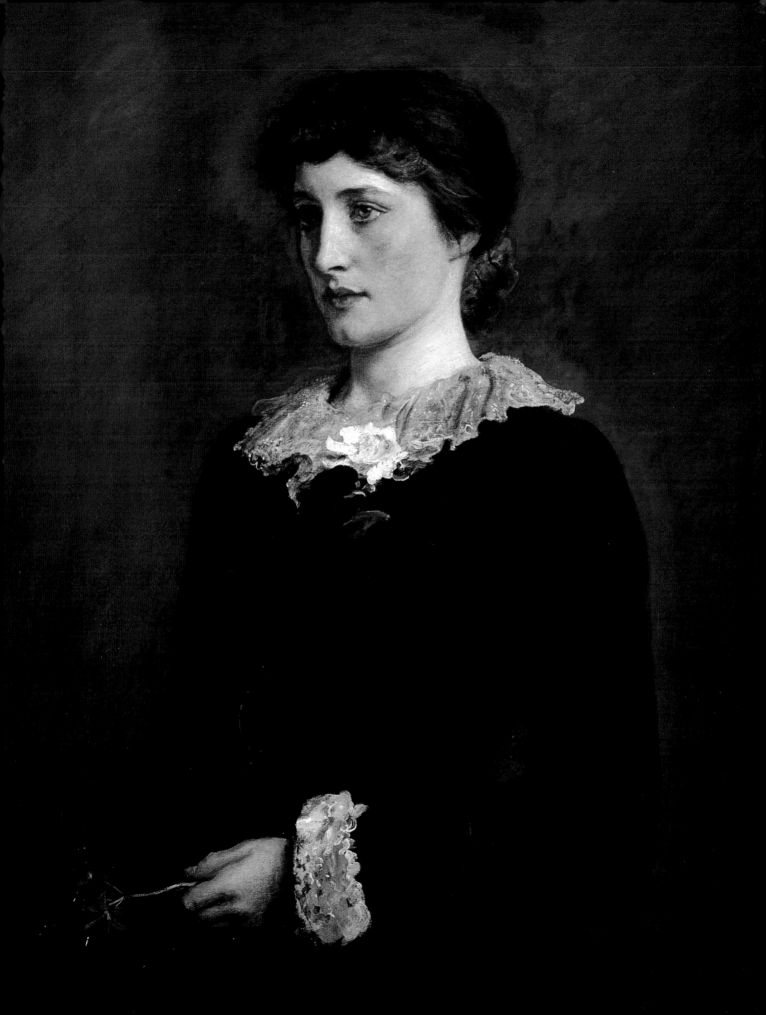

Was Langtry 'in' society, or was she not? She became the first acknowledged mistress of the Prince of Wales, and had a relationship – and a daughter – with his nephew, Prince Louis of Battenberg. Yet it was not her sexual activity that was to cause a shift in how she was perceived socially, but the fact that out of financial necessity she took up acting. Despite the growing respectability of actresses, the performing woman was constructed in male-configured language as 'more than an actress – as a renegade female, one fundamentally different from normative wives and mothers, marginally "feminine" if feminine at all.'[43] To act on stage was to possess a voice, to take control over an audience. Lord Henry Wotton, in Oscar Wilde's *The Picture of Dorian Gray*, articulated, in his languid, epigrammatic way, the dominant attitude of his class when he remarked: 'Women are a decorative sex. They never have anything to say, but they say it charmingly.'[44]

Visibility in a portrait, whether painted or photographic, was one thing. All a woman was expected to present was herself, her essence: her exterior, including its trappings as well as her pose and expression, spoke for her. Millais's reputation rested, in part, on a belief that he could capture his subjects' identities. Langtry herself testified to his aesthetic honesty. She had hoped to be 'draped in classic robes or sumptuous medieval garments, in which I should be beautiful and quite transformed'; Millais, however, insisted that she wore the simple black dress in which she habitually appeared in society (detail, page 199). As the sittings progressed, she 'realised that he loved only the actual and the truth, and that, in his portraits, he dissimulated nothing, rather emphasising the individuality of the sitter than deviating from nature to embellish his subject'.[45]

But an impression of 'the actual and the truth', derived from an individual's silent exterior, is precisely that – an impression, an image, a constructed version of a subject which draws on, and plays to spectators versed in, visually expressed social codes. Millais was adept at manipulating these, while satisfying his patron's demands that he express personality – many of his sitters, coming from a milieu where they were well aware of the importance and value of display and self-presentation, were ready and able participants in the task of performing an identity. Nor was this milieu alien to Millais. He was, wrote the contemporary critic Frederick Wedmore, 'a man with the instincts of a great gentleman – the frankness, geniality, directness, loyalty – and, withal, a bit of a Philistine: the price he paid for being British so typically'.[46] Sharing the values of the class he portrayed, blending conservatism and flirtatiousness in his own attitudes towards his female subjects – this both accounts for his extraordinary popularity as a painter of women in the later decades of the nineteenth century, and explains the ways in which these works, however conventional some of them may now appear, function so interestingly as documents of a period when the role of women was under transition. If recent critical attention to the culture of this time has tended to emphasise the pioneering woman, the individualist, the 'new woman', Millais's portraits help us to place such social rebellion in the context of the stifling expectations it was seeking to look beyond.

NOTES

1 Henry James, *The Portrait of a Lady* (1881, rev. 1909; repr. Penguin, 1963), p.xi.

2 Ibid., p.577.

3 Leonore Davidoff, *The Best Circles. Society Etiquette and the Season*, 1973, p.49.

4 For this argument, see, for example, Patience Young, 'Millais's "Leisure Hours"', *Bulletin of the Detroit Institute of Arts*, vol. 58, no. 3, 1980, pp.118–26; no biographical evidence that Millais was concerned with women's restricted lives, however, is forthcoming.

5 Lillie Langtry, *The Days I Knew*, 1925, p.39.

6 Spielmann 1898, p.43.

7 James Harlaw, *The Charm of Millais*, London and Edinburgh, 1913, pp.10–11.

8 Spielmann 1898, op. cit., p.43.

9 Harlaw, op. cit., p.15.

10 Millais, *Life*, vol. II, p.62.

11 Louise Jopling, *Twenty Years of My Life, 1867 to 1887*, 1925, p.49.

12 Ibid., p.64. Admittedly, this was with reference to the context in which she became engaged to Joseph Jopling, her second husband.

13 Ibid., p.65.

14 Millais, *Life*, vol. II, p.346. The painting, of Mrs Arthur Kennard (1879; private collection), was none the less eventually bought by her family.

15 Jopling, op. cit., pp.140–41.

16 Pierre Bourdieu, *Distinction. A social critique of the judgement of taste*, 1979; trans. Richard Nice, London and New York, 1984, pp.76–7.

17 Jopling, op. cit., pp.156–7. Jopling did not vouch for the truth of this story, but made no attempt to deny its likelihood.

18 Walter Armstrong, 'Sir John Millais, Royal Academician. His Life and Work', *Art Annual*, (Christmas number of the *Art Journal*), 1885, p.17.

19 John Heugh to John Millais, quoted in Millais, *Life*, vol. II, p.41.

20 Spielmann 1898, p.37.

21 For the relationship between physiognomy and painting, see Mary Cowling, *The Artist as Anthropologist*, Cambridge, 1989.

22 *Saturday Review*, LXXI, 13 June 1891, p.714.

23 *Art Journal*, n.s. XVII, 1878, p.145.

24 *Athenaeum*, no. 3314, 2 May 1891, p.574.

25 Thorstein Veblen, *The Theory of the Leisure Class: An Economic Study of Institutions*, 1899; repr. 1970, p.119.

26 Georg Simmel, *Philosophie der Mode*, 1905; trans. in *Simmel on Culture*, ed. David Frisby and Mike Featherstone, London and New Delhi, 1977, p.189.

27 See Margaret Beetham, *A Magazine of Her Own? Domesticity and desire in the woman's magazine, 1800–1914*, 1996.

28 See Lori Anne Loeb, *Consuming Angels. Advertising and Victorian Women*, New York, 1994.

29 Beetham, op. cit., p.104.

30 *Saturday Review*, XXXV, 7 June 1973, p.749.

31 The best record for shifts in fashion is to be found in the pages of women's magazines, particularly *Queen* and *The Lady*, but for an overview see Penelope Bryde, *Nineteenth Century Fashion*, 1992.

32 Roland Barthes, *Le Système de la mode* (1967; trans. as *The Fashion System*, 1985); reviewed by Angela Carter, repr. in *Shaking a Leg. Journalism and Writing*, 1998, p.143.

33 Carter, ibid.

34 Gervas Huxley, *Victorian Duke. The Life of Hugh Lupus Grosvenor, First Duke of Westminster*, 1967, p.120.

35 See Davidoff, op. cit.; W.L. Guttsman, *The British Political Elite*, 1963, and F.M.L. Thompson, *English Landed Society in the Nineteenth Century*, 1963.

36 Marie Corelli, *The Modern Marriage Market*, 1898, pp.19–20.

37 Marie Corelli, *Free Opinions Freely Expressed on Certain Phases of Modern Social Life and Conduct*, 1905, pp.96, 98.

38 Ibid., p.187.

39 Mrs H.R. Haweis, *The Art of Beauty*, 1878, p.259.

40 Langtry, op. cit., p.46.

41 Sonia Hillsdon, *The Jersey Lily. The Life and Times of Lillie Langtry*, St Helier, 1993, p.71.

42 Langtry, op. cit., p.49.

43 Kerry Powell, *Women and Victorian Theatre*, Cambridge, 1997, p.3.

44 Oscar Wilde, *The Picture of Dorian Gray*, 1891; repr. Penguin, 1985, p.54.

45 Langtry, op. cit., p.53.

46 Frederick Wedmore, *Memories*, 1912, p.134.

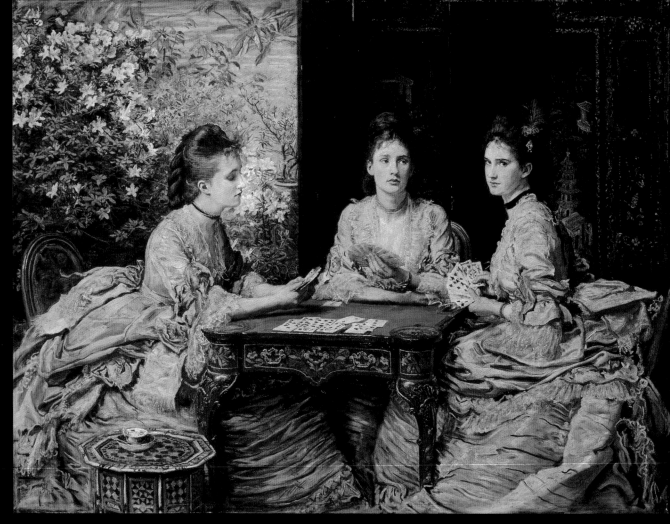

4
Portraits of Women

Catalogue by Malcolm Warner

48

Hearts are Trumps
Elizabeth, Diana and Mary Beatrice
Armstrong
Oil on canvas
1657 × 2197mm (65¼ × 86½")
Signed with monogram and dated 1872,
lower left
Tate Gallery, London

The sitters were the daughters of Walter Armstrong of Ennismore Gardens, Knightsbridge, London, who commissioned the work for 2,000 guineas.[1] They became, respectively, Mrs Tennant-Dunlop, Mrs J. Herbert Secker and Mrs Rowland Ponsonby Blennerhassett. The girls' brother, named Walter Armstrong like their father, became a prominent art critic and in 1885 published one of the first substantial monographs on Millais.

According to John Guille Millais, the artist was keen to paint a triple portrait of fashionable ladies after reading a review of his works that claimed that he was 'quite incapable of making such a picture of three beautiful women together in the dress of the period as Sir Joshua Reynolds had produced in his famous portrait of "The Ladies Waldegrave"' (page 184, top).[2] Millais would have known the Reynolds portrait well – it was at Strawberry Hill in Twickenham, where he was a frequent guest of Frances, Countess Waldegrave – and it certainly appears to have provided a starting point for *Hearts are Trumps*: his three sitters are similarly posed around a table, with their faces seen from a variety of angles, and their dresses and hairstyles are fashionable nineteenth-century versions of eighteenth-century originals. According to the younger Walter Armstrong, Millais designed the details of the dresses himself.[3]

His intention was not merely to match Reynolds, however, but to surpass him: he set out to do Sir Joshua over

again from Velázquez (through the great liveliness of his brushwork) and at the same time to introduce into grand portraiture some touches of realism and modernity. As Armstrong wrote, 'The arrangement is, of course, not a little reminiscent of a famous Sir Joshua; but there is a bravura in the execution, and a union of respect for the minutest vagaries of fashion with breadth of hand and unity of result, which has never been excelled since the days of Don Diego Velazquez.'[4] The work also sets itself apart from the Reynolds in its modern and fashionable oriental decorations: the guéridon, the screen and the bank of azalea blossoms. Both the eighteenth-century and oriental references are typical of the Aesthetic Movement, which was at its height in British art and design at this time.

In 1868 Millais had painted a portrait of three of his own daughters, also in dresses inspired by the eighteenth century and against a background of azaleas, under the title of *Sisters* (page 113), and it was this work that won him the lucrative commission to paint *Hearts are Trumps*. On 5 August 1871 he wrote to his wife: 'I dine with a Mr Armstrong this evening who from seeing the "Sisters" picture wants me to paint his three daughters. They know the price and are prepared to give anything I ask, and I go and see the girls this evening.'[5] According to a story related by Louise Jopling, the girls' mother had asked Millais's wife Effie how she should make her daughters a success in London society, to which Effie had replied that she should have them painted by Millais: 'And it was very good and sound advice. When the picture of the three girls playing cards was exhibited, the daughters of Mr Armstrong were recognized wherever they went, and people at once asked to be introduced to such pretty girls, and the result was that they had a most successful season.'[6]

The title of the portrait is a mock eighteenth-century *double entendre* that

refs both to the game of cards that the girls are playing, which is dummy whist, and to their marriageable status: at this stage in their lives, the affairs of their hearts take precedence over all else. Millais may have borrowed the idea from James Archer's small painting of the same title shown at the Royal Academy in 1866 (private collection); this also shows three girls in eighteenth-century dress playing cards, one of them revealing a good hand in hearts to the viewer, as in the Millais. On the other hand, there are actual eighteenth-century paintings that employ the same conceit – portraits by Philippe Mercier and Johann Zoffany, for instance – and Millais and Archer may merely have been drawing on the same sources.

Some four years after the portrait was painted, the sitters' father went bankrupt and was forced to sell it at Christie's.[7] It was bought through Agnew's for 1,300 guineas by Diana Armstrong's husband J. Herbert Secker, and so remained in the family. The Tate Gallery bought it through the Chantrey Bequest from the Revd Walter Secker in 1945.

First exhibited: Royal Academy, 1872 (223).

1. Artist's bank account, Coutts, 3 May 1872.
2. Millais, *Life*, vol. II, p.39.
3. Walter Armstrong, 'Sir John Millais, Royal Academician. His Life and Work', *Art Annual* (Christmas number of the *Art Journal*), 1885, p.17.
4. Ibid.
5. Millais papers, Pierpont Morgan Library, New York.
6. Louise Jopling, *Twenty Years of My Life, 1867 to 1887*, 1925, p.157.
7. 26 February 1876 (72); see also *The Times*, 28 February 1876, p.6.

Further literature: Spielmann 1898, pp.65, 121, 131, 133–34, 172 (no. 136), 183; Millais, *Life*, vol. II, pp. 39–40, 475; Charles Emile Hallé, *Notes from a Painter's Life*, 1909, p.70; Bennett 1967, pp.50–51, no. 78; Andrew Wilton, *The Swagger Portrait*, Tate Gallery, 1992, pp.188–9, no. 63.

49
Clarissa Bischoffsheim

Oil on canvas
1364 × 918mm (53¾ × 36⅛")
Signed with monogram and dated 1873, lower left
Tate Gallery, London

The daughter of Joseph Biedermann of Vienna, the sitter married Henry Louis Bischoffsheim, a prominent Dutch financier of the house of Bischoffsheim and Goldschmidt, in 1856. Their home, Bute House in South Audley Street (now the Egyptian Embassy), was the centre of a wealthy and cosmopolitan social circle; they were also well known as art collectors.[1] He died in 1908, and she around 1925.

Millais wrote to his wife on 19 April 1872 that he would be beginning Mrs Bischoffsheim's portrait 'in a few days,'[2] although the date on the work indicates that it was not finished until the following year.

At various times the Bischoffsheims owned a number of Old Master portraits, including works by Reynolds, Gainsborough and earlier artists working in Britain. Mrs Bischoffsheim's costume and bearing in the portrait may have been designed to fit in with these; a large, anonymous portrait of Queen Henrietta Maria that they later presented to the National Portrait Gallery offers some suggestive points of comparison, although whether it was actually in their collection in 1872–3 is unknown. Though an historical hybrid, Mrs Bischoffsheim's magnificently embroidered dress is clearly intended to suggest the eighteenth century, like the girls' dresses in *Hearts are Trumps* (cat. no. 48). In these and other works of around the middle of his career, Millais was playing to an ever-growing Victorian nostalgia for the supposed grace and beauty of pre-industrial, pre-modern times: the taste for the eighteenth century was especially fashionable, in both

painting and design, and constituted one of the most important aspects of the Aesthetic Movement.

In his review of the portrait at the Royal Academy exhibition of 1873, F.G. Stephens pointed to Millais's technical debt to Velázquez, a near commonplace of critics' remarks on Millais's portraiture at this time. 'The splendour and vigour, the intensity and richness of the painting in this picture surpass anything even this artist has produced,' he wrote. 'He has worked in the mood of Velasquez, and so far succeeded, that Velasquez would not be ashamed of the result'.[3]

In 1881–2 Millais painted a portrait of Mrs Bischoffsheim's sister Lucy, Mrs James Stern (private collection; see page 19, top). There is another portrait of Mrs Bischoffsheim by Léon Bonnat in the Musée Bonnat, Bayonne.

First exhibited: Royal Academy, 1873 (228).

1. See the sale of their collection, Christie's, 7 May 1926.
2. Millais papers, Pierpont Morgan Library, New York.
3. *Athenaeum*, 3 May 1873, p.570.

Further literature: Spielmann 1898, pp.37, 60, 121, 172 (no. 145), 179; Millais, *Life*, vol. II, pp.37 (ill.), 40, 475, 495; Bennett 1967, pp.51–2, no. 81; Andrew Wilton, *The Swagger Portrait*, Tate Gallery, 1992, pp.190–91, no. 64.

50
Isabella Heugh

Oil on canvas
1205 × 1045mm (47½ × 41⅛")
Signed with monogram and dated 1872, lower left
Musée d'Orsay, Paris. Gift of Edmund Davis

The sitter was the widow of a Presbyterian divine, Hugh Heugh. She was born Isabella Clarkson, daughter of the Revd John Clarkson, first minister of the General Associate Congregation of

49

50

Ayr. She married Heugh on 21 June 1809 and they lived in Glasgow, where from 1821 until his death in 1846 he was minister to the large, newly formed Presbyterian congregation at Regent Place. At the time Millais painted her portrait she was in her nineties.

The work was commissioned by the sitter's son John Heugh, who already owned Millais's *Christ in the Carpenter's Shop* (page 106) and *Trust Me* (1861–2; Forbes Magazine Collection). In view of his mother's age, he tried to persuade the artist to depart from his normal practice and paint her at home rather than in the studio. 'Two things you mention are all right – your price and your making the portrait *in your own way*,' he wrote to Millais on 26 September 1872. 'But about the place where you can paint it, I am quite at a loss'.[1] How the issue was resolved is unknown. John Guille Millais remembered his father's amusement at the extreme religiousness of the Heugh family: even the parrot that appears in the portrait would frequently say 'Let us pray' during sittings.[2]

Whistler's famous portrait of his mother, another elderly widow, had been shown at the Royal Academy exhibition earlier in the same year. Millais was always observant of Whistler, and painted *Mrs Heugh* as a variation on the same theme, a Rembrandtesque riposte to Whistler's extreme aestheticism. Whereas the Whistler tends towards flatness and abstraction, the Millais is modelled and tactile; the Whistler is a restrained 'Arrangement in Grey and Black', the Millais rich in contrasts of red and green; the Whistler is painted thinly, the Millais impasted; the Whistler is strangely impersonal, while the Millais asserts a real human presence. It is curious that these two paintings are now in the same collection: the Whistler was bought by the French State in 1891 and the Millais donated by the famous collector Edmund Davis in 1915; whether Davis had any

James McNeill Whistler, **Arrangement in Grey and Black, No. 1: Portrait of the Painter's Mother**, oil on canvas, 1429 × 1625mm (56¼ × 64"), 1871, Musée d'Orsay, Paris

idea of the connection between them is unknown.

John Heugh wrote to let Millais know that the work had arrived safely at his home on 13 February 1873: 'All my ladies are in raptures at the likeness, and at the picture – position, accessories, colour, tone, are all in such harmony. They tell the story so simply and so truly, just as if one walked into the room and saw her in her calm, dignified, intelligent, but reposing old age'.[3]

When the work was shown at the Royal Academy exhibition of 1873, the critic of the *Art Journal* remarked: 'The colour is massed in the face in a manner hitherto unexampled. No head-study perhaps has ever been worked with such a mass of paint, and the artist's contempt for form in the use of it exposes him to much adverse criticism . . . It is the most powerful work he has ever painted, and forming, as it were, a period in

the history of our Art, might serve as the text for a volume.'[4]

First exhibited: Royal Academy, 1873 (21).

1. Millais Family Collection.
2. Millais, *Life*, vol. II, p.41.
3. Ibid.
4. *Art Journal*, New Series, vol. XII, June 1873, p.166.

Further literature: Spielmann 1898, pp.37, 60, 65, 113–14, 121, 133, 172 (no. 135), 183; Millais, *Life*, vol. I, p.437 (ill.); vol. II, p.475.

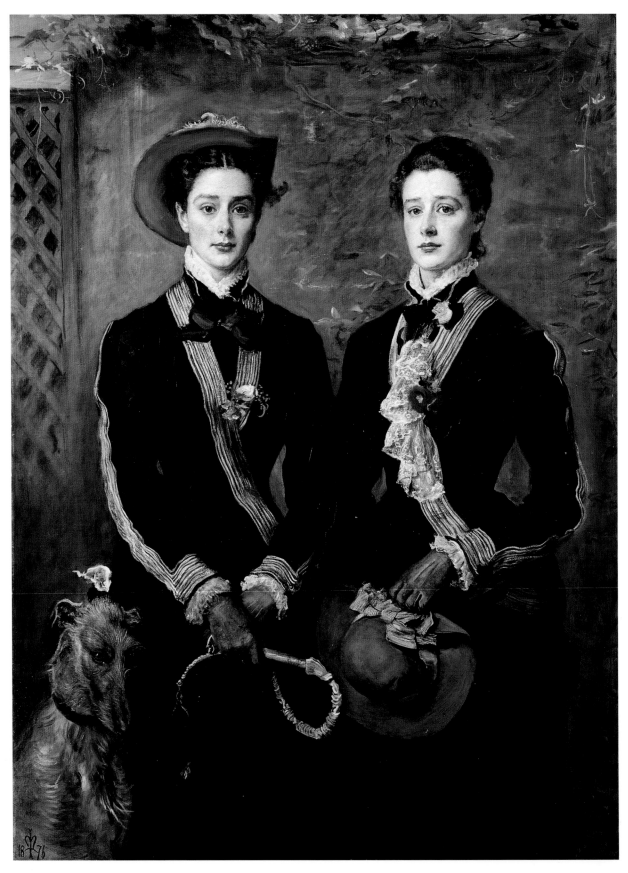

51

51
Twins
Kate Hoare (1856–1948) and
Grace Hoare (1856–1946)
Oil on canvas
1535 × 1137mm (61⅜ × 45½")
Signed with monogram and dated 1876,
lower left
Private collection

The twins are Kate Edith (left) and Grace Maud (right). Born on 27 January 1856, they were two of the fourteen children of Thomas Rolls Hoare, a wealthy paint and varnish manufacturer of the firm of Noble & Hoare. Millais may have been introduced to the family by his brother William, who was on friendly terms with them as he was with Hoare's business partner, John Noble (see pages 111–12). Both of the twins later became wives of naval officers. Kate married Captain Hugh Gough, who served for much of his career on the Royal Yacht; and Grace married Lieutenant Sydney Eardley-Wilmot, who became a Rear-Admiral, received a knighthood, and wrote a number of books on the Navy.

Millais wrote to his daughter Mary on 16 December 1875 that he had begun the portrait the day before, calling the twins 'really pretty, elegant girls'.[1] Later there was some dispute between him and the girls' parents about their outfits. On 12 April 1876 his friend Louise Jopling wrote to her husband: 'He has had to paint out the riding-habits of the twins, as their people don't like them, and he says they look better in other things, so the objectionable hats will go too, I suppose'.[2] It is hard to assess what changes Millais may have made at this stage, although there are fairly clear *pentimenti* in the work, for instance above Kate Hoare's hat. The portrait was presumably finished when Millais received his fee of 1,500 guineas on 23 August 1876.[3]

For reasons unknown, there was a hiatus between the completion of the portrait and its exhibition. It was shown for the first time at the Grosvenor Gallery exhibition of 1878. Millais sent female portraits of a high bravura to the first five of the Grosvenor exhibitions: three small oval portraits of ladies of the Duke of Westminster's family in 1877; *Twins* in 1878; *Alice Stibbard* (private collection) in 1879; *Sophie Caird* (cat. no. 53) and *Louise Jopling* (page 187) in 1880, and *Kate Perugini* (cat. no. 54) in 1881.

In the company of the paintings by Burne-Jones that were the talk of the Grosvenor exhibition, *Twins* struck the more conservative critics as a welcome breath of fresh air, natural and wholesome. 'There is no self-conscious melancholy in those clear, frank eyes,' remarked the *Daily News*, 'no enfeebled and affected attitudinising in the simple maidenly bearing'.[4] The critic of *The Times* called the girls 'two Maid Marians of the 19th century, looking as if they had been brought up in the air of the woods and moors'.[5] Some pointed out that the painting of twins was a special test of the portraitist's powers of characterisation. 'They are facially, of course, wonderfully alike,' observed the *Daily Telegraph*, 'yet the rare skill of the painter has succeeded in giving to each twin a marked and distinctive individuality . . . one graceful brunette stands "at ease," her head and neck in complete and charming repose; while the other stands at "attention," erect, alert, and in full nervous and muscular mobility.'[6] According to family tradition, this was very much the difference between the twins' features in life: Kate's were more serene and Grace's slightly anxious.

Millais was especially keen to have *Twins* included in his retrospective exhibition at the Grosvenor in 1886, writing to the girls' mother on 29 November 1885: 'it is very necessary to get all my best works, and the one you

have I consider is in that category.'[7] Mrs Hoare duly agreed to lend the work.

First exhibited: Grosvenor Gallery, 1878 (22).

1. Millais Papers, Pierpont Morgan Library, New York.
2. Louise Jopling, *Twenty Years of My Life, 1867 to 1887*, 1925, p.95.
3. Artist's bank account, Coutts.
4. *Daily News*, 1 May 1878.
5. *The Times*, 2 May 1878, p.7.
6. *Daily Telegraph*, 1 May 1878.
7. Private collection.

Further literature: Spielmann 1898, pp.67, 124, 173 (no. 167); Millais, *Life*, vol. II, pp.83, 348, 445, 477.

52
A Jersey Lily
Lillie Langtry (1853–1929)
Oil on canvas
1160 × 850mm (45⅝ × 33½")
1877–8
Signed with monogram, lower right
Jersey Museums Service

The 'professional beauty' Lillie Langtry made her sensational entrance into London society at a party given by Sir John and Lady Sebright in May 1876. According to her autobiography, she and Millais met at the Sebrights' and he asked her to sit for him then.[1] He was not, however, to be the first to paint her portrait. By the time he began the work in 1877 or 1878, Edward Poynter already had a portrait of her under way (Jersey Museums Service). In an undated letter, Langtry wrote to Millais: 'Shall I come on tuesday at 3 o'clock if that is convenient. Will you write a line to say what sort of dress I should wear but I suppose it doesn't matter the first times. I mustn't let Mr Poynter know that I am sitting to you as I swore not to sit to anyone until he had finished.'[2]

Millais shows Langtry in the simple black gown that she wore at the Sebrights' in mourning for the death of

210 MILLAIS: PORTRAITS

her younger brother Reggie; it had become part of her persona as the pure, classical beauty who needed no elaborate dresses or jewellery. She wears a gardenia at her neck and holds a Guernsey lily in her hand. The title *A Jersey Lily* refers of course to Langtry herself: the pun draws attention both to the lily-white fairness of her complexion, and to her background in Jersey, which was also the artist's own childhood home. It was after the Millais portrait was exhibited at the Royal Academy in 1878, Langtry later recalled, that 'the Jersey lily' caught on as her sobriquet.[3]

The Millais and Poynter portraits were both shown at the Academy exhibition that year, and the reviewers generally preferred the Millais. The only strong objection was raised by Henry James, who wrote: 'Mrs Langtry's admirable beauty is quite of the antique, classical, formal, and, to return to the word I began with using, plastic order: but Mr Millais paints her as if he meant to make her pass for the heroine of a serial in a magazine.'[4] By this time Langtry was widely known to have become the mistress of the Prince of Wales. Millais was also an enthusiastic admirer of Langtry's beauty and they became close friends.[5]

Millais painted the portrait without a commission and kept it himself for some time. His friend Joseph Jopling was apparently trying to buy it towards the end of 1878, perhaps on behalf of the Aberdeen collector Alexander Macdonald (see cat. no. 45). 'Don't go and send me a check, or cheques, for goodness sake for Mrs L.'s portrait,' Millais wrote to Jopling on 25 November. 'I have to make a head from it for herself – besides, I must let McDonald [sic] know there is no hurry about it and I rather like having it in my studio.'[6] He did paint a 'head' of Langtry as a present for her; according to her autobiography, she in turn gave it to an American friend (its present whereabouts

are unknown).[7] How long the larger portrait remained in Millais's studio is a matter for speculation; by the time of his retrospective exhibition at the Grosvenor Gallery in 1886, it belonged to Henry Martyn Kennard. A mixed method engraving by Thomas Oldham Barlow was published by H. Blair Ansdell in 1881.

First exhibited: Royal Academy, 1878 (307).

1. Lillie Langtry, *The Days I Knew*, 2nd edn., 1925, pp.38–40.
2. Private collection.
3. Lillie Langtry, op. cit., pp.53–7.
4. John L. Sweeney, ed., *The Painter's Eye. Notes and Essays on the Pictorial Arts by Henry James*, Cambridge, Mass., 1956, p.169.
5. In the autumn of 1879 she visited him during his annual holiday in Scotland, staying with the family at Eastwood, Dunkeld; for a photograph of them together by Rupert Potter, see Geoffroy Millais, *Sir John Everett Millais*, 1979, p.12.
6. Private collection.
7. Lillie Langtry, op. cit., p.57.

Further literature: Spielmann 1898, pp.111, 173 (no. 190), 180; Millais, *Life*, vol. II, pp.91, 478.

53
Sophie Caird (1843–82)
Oil on canvas
1270 × 813mm (50 × 32")
Signed with monogram and dated 1880, lower right
Geoffroy Richard Everett Millais Collection

Born Sophie Gray, the sitter was a younger sister of the artist's wife Effie. As a child she was caught up in the tense, entangled relations between Effie, Millais and Ruskin. Millais admired her beauty, drew her portrait and, following his marriage to Effie, used her as a model in his paintings *Autumn Leaves* (page 109) and *Spring* (1856–9; Lady Lever Art Gallery, Port Sunlight).

Sophie suffered from mental ill health, and in her mid twenties had a severe breakdown. Millais wrote to Holman Hunt on 2 March 1869: 'My wife's sister Sophie Gray has been ill a whole year, and away from home, with hysteria'.[1] In 1873 she married James Key Caird, a wealthy jute manufacturer in Dundee. The couple spent part of their honeymoon in Paris with two other newly married couples: Sophie's other sister Alice, the artist Louise Jopling, and their husbands. Jopling later wrote: 'she was one of the most fascinating women I have ever met. She had an inimitable manner of describing people, and events, that made them live before you.'[2] The Cairds had one child, Beatrix Ada, whom Millais painted in 1879 (cat. no. 37). The cause of Sophie's death at the age of only thirty-eight is unknown, but seems likely to have been suicide. On 19 March 1882, the day after her funeral at Brompton Cemetery, Millais wrote to Hunt: 'Sophy (my wife's sister) was *buried* yesterday. Her last illness was so distressing I have denied myself to everybody'.[3]

He probably began the portrait during his visit to Scotland in August–November 1879. He had certainly painted the head by 7 January 1880, and wrote to Effie on that date: 'I am longing to make a sketch of poor Sophie in a black dress. The head is admirable, and so like her. I am going to have it and Lord Wimborne [another portrait under way at the time] photographed so that I can work on the small one and copy onto the original'.[4] If Millais went ahead with this plan, it would be one of the first known instances of his using photographs of unfinished paintings to sketch on, a practice he engaged in frequently for the rest of his career; unfortunately, no such photographs of the portraits of Sophie or Lord Wimborne have survived. His intention of showing Sophie in a black dress came to nothing: in the portrait as

53

finished her sleeves and sash are black, but the dress is light blue. He sent the work to the Grosvenor Gallery exhibition of 1880 along with his portrait of Sophie's friend Louise Jopling (page 187). Millais seems to have painted the portrait for himself and Effie rather than for Sophie herself, her husband or the Gray family, and he kept it, at least initially, in his studio (see page 19, top).

First exhibited: Grosvenor Gallery 1880 (54).

1. Huntington Library, San Marino, California: Holman Hunt Collection, 412.
2. Louise Jopling, *Twenty Years of My Life, 1867 to 1887*, 1925, p.67.
3. Huntington Library, San Marino, California: Holman Hunt Collection, 424.
4. Millais papers, Pierpont Morgan Library, New York.

Further literature: Spielmann 1898, pp.121, 174 (no. 211); Millais, *Life*, vol. II, p.479; Bennett 1967, p.56, no. 99; Mary Lutyens, *Millais and the Ruskins*, 1967, p.153.

54
Kate Perugini (1839–1929)
Oil on canvas
1245 × 787mm (49 × 31")
Signed with monogram and dated 1880, lower right
Mr and Mrs Richard P. Mellon

The sitter was the third child and younger daughter of the writer Charles Dickens. Millais was a friend of her father, knew her as a girl, and used her as a model for his painting *The Black Brunswicker* (1859–60; Lady Lever Art Gallery, Port Sunlight). In 1860 she married the artist's old friend Charles Collins (see cat. no. 8). He died in 1873, and just over a year later she married the painter Carlo (or Charles Edward) Perugini; born in Naples, he had moved to England as a young man and become naturalised. Millais attended their wedding on 4 June 1874, and the couple became members of his closest circle of

54

artist friends. Kate was herself a painter, and showed examples of her work – charming genre pictures featuring children – at the Royal Academy, Grosvenor Gallery and elsewhere from

1877. In 1882 she provided illustrations for *The Charles Dickens Birthday Book*, compiled and edited by her sister Mamie.

Kate Perugini recalled the painting of this portrait in a letter of 1 July 1898 to

John Guille Millais: 'When I went to him for the first sitting, being anxious to save him trouble, I had put on a plain black dress, and placed myself in an easy attitude with my back to him and my profile turned towards him. "That's capital," he said, "I am going to paint you just like that." I didn't stir, and at the end of two hours, when he told me I might have a rest, I found I could scarcely hobble across the room, so stiff had my easy attitude made me.'[1]

Millais gave the portrait to her husband as a belated wedding gift. It is the same size as his portrait of another artist in his circle, Louise Jopling (page 187); both were painted as gifts, and they were shown at successive Grosvenor Gallery exhibitions, the portrait of Louise Jopling in 1880 and that of Kate Perugini in 1881.

F.G. Stephens saw the work at the Grosvenor and found it 'an animated, brilliant study.'[2] Another admirer was the French critic Théodore Duret: 'This is only a sketch, it is true, but the sketch is at least a bold one: viewed from the back, with her head turned, the model shows grace and elegance.'[3]

First exhibited: Grosvenor Gallery, 1881 (67).

1. Millais, *Life*, vol. II, p.373.
2. *Athenaeum*, 30 April 1881, p.599.
3. *Gazette des Beaux-Arts*, 2nd series, XXIII, June 1881, p.552.

Further literature: Spielmann 1898, pp.108, 174 (no. 208); Millais, *Life*, vol. II, p.479.

55

Mary Chamberlain (1864–1957)
Oil on canvas
1321 × 991mm (52 × 39")
Signed and dated 1891, upper left
Birmingham Museums and Art Gallery

The sitter was the American-born wife of Joseph Chamberlain, MP for Birmingham. Her father, William Crowninshield Endicott, was also in politics: he was a Massachusetts lawyer who served as Secretary of War under President Grover Cleveland. She and Chamberlain met in 1887, while he was on a diplomatic mission to the United States, and they were married in Washington the following year. She was his third wife (one of his sons from a previous marriage was Neville Chamberlain, the future Prime Minister) and twenty-eight years his junior. Having broken with the Liberal party over Home Rule, Chamberlain served from 1895 to 1903 as Colonial Secretary in the Conservative governments of Salisbury and Balfour, retired from politics in 1906 after a paralytic stroke, and died in 1914. Mary Chamberlain remained in England, and in 1916 married the Revd William Hartley Carnegie, rector of St Margaret's Westminster, a canon of the Abbey and chaplain to the Speaker of the House of Commons. She was a renowned hostess who kept up a reputation for generous entertaining through both of her marriages, the Second World War, and an active old age.

On 20 May 1889 Chamberlain wrote to Millais: 'Will you kindly inform me what your price would be for a portrait of Mrs Chamberlain same size as your picture in the Grosvenor which I think is exquisite in style and grace.'[1] The picture he had in mind was the genre subject *Shelling Peas* (1889; private collection, on loan to Leighton House Museum, London), which may have been the model not only for the size of the portrait but for its domestic setting: the sitter is taking afternoon tea. The portrait was presumably more or less finished by 25 July 1890 when Chamberlain sent Millais a letter of thanks and a cheque for 1,000 guineas;[2] although the inscribed date suggests that further work was done in the following year before the Royal Academy exhibition. Its appearance prior to certain finishing touches and changes of detail is recorded in a photograph (private collection): the main differences are that the sitter wears a glove on her left hand, and a print or watercolour occupies the upper left corner of the composition.

A portrait of Mrs Chamberlain by Sargent, painted in 1902, is at the National Gallery of Art, Washington.

First exhibited: Royal Academy, 1891 (237).

1. Private collection
2. Private collection; and artist's bank account, Coutts, 28 July 1890.

Further literature: Spielmann 1898, pp.138, 177 (no. 316); Millais, *Life*, vol. II, pp.285, 485.

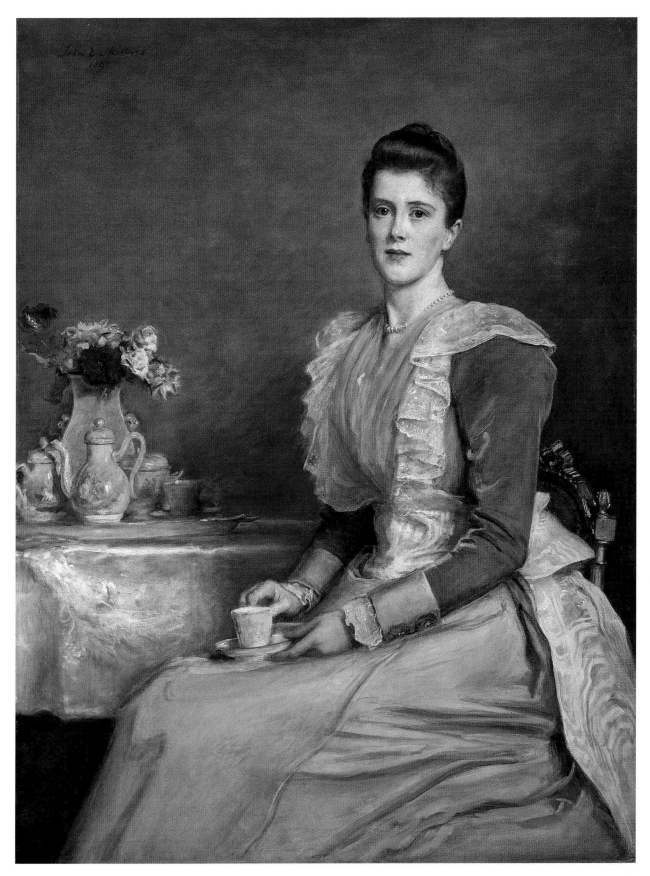

55

BIBLIOGRAPHY

Place of publication is London unless otherwise stated

The following frequently cited books are abbreviated in the notes and catalogue entries:
 Bennett 1967
 Millais, *Life*
 Spielmann 1898
and full details of them can be found in the entries below.

Ariès, Philippe, *Centuries of Childhood: A Social History of Family Life*, trans. from the French by Robert Baldick, New York, 1962

Armstrong, Walter, 'Sir John Millais, Royal Academician. His Life and Work', *Art Annual* (Christmas number of the *Art Journal*), 1885

Baldry, Alfred Lys, *Sir John Everett Millais: His Art and Influence*, 1899

Barlow, Paul, 'Facing the past and present: the National Portrait Gallery and the search for "authentic" portraiture', in Joanna Woodall, ed., *Portraiture: Facing the Subject*, Manchester and New York, 1997

Barrington, Emilie Isabel, 'Why is Mr. Millais our Popular Painter?', *Fortnightly Review*, vol. 38, n.s. 32, July 1882

Barrington, Emilie Isabel, Mrs Russell, *Reminiscences of G.F. Watts*, 1905

Barthes, Roland, *Le Système de la mode*, 1967; trans. as *The Fashion System*, 1985

Beetham, Margaret, *A Magazine of Her Own? Domesticity and desire in the woman's magazine, 1800–1914*, 1996

Bennett, Mary, PRB *Millais* PRA, exh. cat., Royal Academy of Arts, Walker Art Gallery, Liverpool, 1967 [abbrev. as Bennett 1967]

Bennett, Mary, *Artists of the Pre-Raphaelite Circle. The First Generation. Catalogue of Works in the Walker Art Gallery, Lady Lever Art Gallery and Sudley Art Gallery*, National Museums and Galleries on Merseyside, 1988

Birkett, Jeremy and John Richardson, *Lillie Langtry. Her Life in Words and Pictures*, Poole, 1979

Bourdieu, Pierre, *Distinction. A social critique of the judgement of taste*, 1979; trans. Richard Nice, 1984

Bradley, Laurel, 'From Eden to Empire: John Everett Millais's "Cherry Ripe"', *Victorian Studies*, vol. 34, no. 2, Winter 1991

Bryde, Penelope, *Nineteenth Century Fashion*, 1992

Carey, John, *The Intellectuals and the Masses: Pride and Prejudice among the Literary Intelligentsia, 1880–1939*, 1992

Carlyle, Alexander, ed., *New Letters of Thomas Carlyle*, 1904

Carter, Angela, *Shaking a Leg. Journalism and Writings*, Vintage, 1998

Carter, Charles, 'A Gallery of Artists' Portraits. A Yardstick of Taste', *Apollo*, vol. 73, January 1961

Casteras, Susan P. and Colleen Denney, eds, *The Grosvenor Gallery: A Palace of Art in Victorian England*, New Haven and London, 1996

Champneys, Basil, *Memoirs and Correspondence of Coventry Patmore*, 2 vols, 1900

Collier, Hon. John, *The Art of Portrait Painting*, 1905

Cook, E.T. and Alexander Wedderburn, eds, *The Works of John Ruskin* (Library Edition), 39 vols, 1903–12

Cope, Zachary, *The Versatile Victorian. Being the Life of Sir Henry Thompson, Bt.*, 1951

Corelli, Marie, *The Modern Marriage Market*, 1898

Corelli, Marie, *Free Opinions Freely Expressed on Certain Phases of Modern Social Life and Conduct*, 1905

Coveney, Peter, *The Image of Childhood*, rev. edn, Harmondsworth, 1967

Cowling, Mary, *The Artist as Anthropologist. The representation of type and character in Victorian art*, Cambridge, 1989

Davidoff, Leonore, *The Best Circles. Society Etiquette and the Season*, 1973

Davis, Tracy C., *Actresses as Working Women. Their social identity in Victorian culture*, 1991

Dessain, C.S. and T. Gornall, eds, *The Letters and Diaries of John Henry Newman*, vols 29–30, 1976

Donovan, Claire, and Joanne Bushnell, *John Everett Millais 1829–1896: A Centenary Exhibition*, exh. cat., Southampton Institute, Southampton, 1996

Evans, Joan and John Howard Whitehouse, eds, *The Diaries of John Ruskin*, 3 vols, Oxford, 1956–9

Faberman, Hilarie, '"Best Shop in London": The Fine Art Society and the Victorian Art Scene', in Susan P. Casteras

and Colleen Denney, eds, *The Grosvenor Gallery: A Palace of Art in Victorian England*, New Haven and London, 1996

Ferriday, Peter, 'Millais: An Apprentice of Genius', *Country Life*, vol. 141, 19 January 1967

Foot, M.R.D. and H.C.G. Matthew, eds, *The Gladstone Diaries with Cabinet Minutes and Prime-Ministerial correspondence*, 14 vols, Oxford, 1968–94

Franz von Lenbach 1836–1904, exh. cat., Stadtische Galerie im Lenbachhaus, Munich, 1987

Fredeman, William E., *Pre-Raphaelitism, A Bibliocritical Study*, Cambridge, Massachusetts, 1965

Fredeman, William E., ed., *The P.R.B. Journal. William Michael Rossetti's Diary of the Pre-Raphaelite Brotherhood 1849–1853*, Oxford, 1975

Frith, William Powell, *John Leech. His Life and Work*, 2 vols, 1891

Froude, James Anthony, *Thomas Carlyle. A History of his Life in London 1834–1881*, 1884

Garlick, Kenneth, *Sir Thomas Lawrence*, New York, 1989

Gernsheim, Helmut, *Lewis Carroll, Photographer*, 1949

Gladstone, W.E., '"Locksley Hall" and the Jubilee', *Nineteenth Century*, January 1887

Goodison, J.W., *Fitzwilliam Museum, Cambridge. Catalogue of Paintings. Volume III, British School*, Cambridge, 1977

Gower, Lord Ronald, *A Pocket Guide to the Public and Private Galleries of Holland and Belgium*, 1875

Gower, Lord Ronald, *My Reminiscences*, 1883

Grieve, Alastair, 'Ruskin and Millais at Glenfinlas', *Burlington Magazine*, vol. 138, April 1996

Guttsman, W.L., *The British Political Elite*, 1963

Hallé, Charles Emile, *Notes from a Painter's Life*, 1909

Harlaw, James, *The Charm of Millais*, London and Edinburgh, 1913

Haweis, Mrs H.R., *The Art of Beauty*, 1878

Higonnet, Anne, *Pictures of Innocence. The History and Crisis of Ideal Childhood*, 1998

Hillsdon, Sonia, *The Jersey Lily. The Life and Times of Lillie Langtry*, St Helier, 1993

Hilton, Tim, *John Ruskin. The Early Years, 1819–1859*, New Haven and London, 1985

Hirsch, Marianne, *Family Frames. Photography, narrative and postmemory*, Cambridge, Massachusetts and London, 1997

Hook, Allan James, *The Life of James Clarke Hook, R.A.*, 3 vols, privately printed, 1929–32

Houfe, Simon, *John Leech and the Victorian Scene*, 1984

Houghton, Walter E., *The Victorian Frame of Mind 1830–1870*, New Haven and London, 1957

Hunt, William Holman, *Pre-Raphaelitism and the Pre-Raphaelite Brotherhood*, 2 vols, 1905

Huxley, Gervas, *Victorian Duke. The Life of Hugh Lupus Grosvenor. First Duke of Westminster*, Oxford, 1967

Ingelow, Jean, *Poems*, 1863

Ingelow, Jean, *Studies for Stories from Girls' Lives*, 1866

James, Henry, *The Portrait of a Lady*, 1881, rev. 1909; repr. Harmondsworth, 1963

Jopling, Louise, *Twenty Years of My Life, 1867 to 1887*, London and New York, 1925

Keary, C.F., 'John Everett Millais', *Edinburgh Review*, vol. 191, January 1900

Lang, Andrew, *Notes on a Collection of Pictures by Mr J.E. Millais RA*, Fine Art Society, 1881

Lang, Cecil Y., ed., *The Swinburne Letters*, 6 vols, New Haven, 1959–62

Langtry, Lillie, *The Days I Knew*, 2nd edn, 1925

Lenbach, Franz von, 1836–1904, Stadtische Galerie im Lenbachhaus, Munich, 1987

Linder, Leslie, ed., *The Journal of Beatrix Potter from 1881 to 1897. Transcribed from her code writing by Leslie Linder. With an appreciation by H.L. Cox*, 1966

Loeb, Lori Anne, *Consuming Angels. Advertising and Victorian Women*, New York, 1994

Low, Frances H., 'Some Early Recollections of Sir John Everett Millais, Bart., P.R.A.', *The Strand Magazine*, vol. 11, January–June 1896

Lutyens, Mary, *Millais and the Ruskins*, 1967

Lutyens, Mary, 'Millais's Portrait of Ruskin', *Apollo*, vol. 85, April 1967

Lutyens, Mary, 'Selling the Missionary', *Apollo*, vol. 86, November 1967

Lutyens, Mary and Malcolm Warner, eds, *Rainy Days at Brig o' Turk. The Highland Sketchbooks of John Everett Millais*, Westerham, 1983

Matthew, H.C.G., *Gladstone 1809–1898*, Oxford, 1998

Millais, Geoffroy, *Sir John Everett Millais*, 1979

Millais, John Guille, *The Life and Letters of Sir John Everett Millais, President of the Royal Academy*, 2 vols, 1899 [abbreviated to: Millais, *Life*]

Millar, Oliver, *The Victorian Pictures in the Collection of Her Majesty The Queen*, 2 vols, Cambridge, 1992

Mills, J. Saxon, *Life and Letters of Sir Hubert Herkomer*, 1923

Montgomery, Maureen E., '*Gilded Prostitution*'. Status, money, and transatlantic marriages, 1870–1914*, 1989

Monypenny, W.F. and G.E. Buckle, *The Life of Benjamin Disraeli, Earl of Beaconsfield*, 6 vols, 1910–20

Morley, J., *Life of William Ewart Gladstone*, 3 vols, 1903

Mowbray, Sir John, *Seventy Years at Westminster*, Edinburgh and London, 1900

Oldcastle, John, 'Mr. Millais' House at Palace Gate', *Magazine of Art*, vol. 4, 1881

Ormond, Richard, 'Portraits to Australia: a group of Pre-Raphaelite drawings', *Apollo*, vol. 85, January 1967

Ormond, Richard, *National Portrait Gallery: Early Victorian Portraits*, 2 vols, 1973

Parris, Leslie, ed., *Pre-Raphaelite Papers*, 1984

Pennell, Joseph and Elizabeth R., 'John Everett Millais, Painter and Illustrator', *Fortnightly Review*, vol. 66, n.s. 60, September 1896

Phillips, Claude, 'Millais's Works at Burlington House', *The Nineteenth Century*, vol. 43, March 1898

Pointon, Marcia, *Hanging the Head. Portraiture and Social Formation in Eighteenth-Century England*, New Haven and London, 1993

Powell, Kerry, *Women and Victorian Theatre*, Cambridge, 1997

The Pre-Raphaelites, exh. cat., Tate Gallery, 1984

Prettejohn, Liz, 'Aesthetic Value and the Professionalization of Victorian Art Criticism 1837–78', *Journal of Victorian Culture*, vol 2, no. 1, Spring 1997

Reynolds, A.M., *The Life and Work of Frank Holl*, 1912

Roberts, Keith, 'From P.R.B. to P.R.A.', *Burlington Magazine*, vol. 109, January 1967

Rossetti, William Michael, *Fine Art, Chiefly Contemporary: Notices reprinted, with Revisions*, 1867

Salisbury, Lord, 'Disintegration', *Quarterly Review*, vol. 3/2, October 1883

Sichel, Walter, *The Sands of Time*, 1923

Simmel, Georg, *Philosophie der Mode*, Berlin, 1905; trans. Mark Ritter and David Frisby in *Simmel on Culture*, ed. David Frisby and Mike Featherstone, London and New Delhi, 1977

Smith, Paul, ed., *Lord Salisbury on Politics*, Cambridge, 1972

Spielmann, Marion H., 'In Memoriam: Sir John Everett Millais, P.R.A.', *Magazine of Art*, vol. 19, September 1896 (supplement)

Spielmann, Marion H., *Millais and His Works. With special reference to the exhibition at the Royal Academy 1898 . . . With a Chapter 'Thoughts on Our Art of To-Day' by Sir J.E. Millais, Bart., P.R.A.*, Edinburgh and London, 1898 [abbrev. to Spielmann 1898]

Staley, Allen, *The Pre-Raphaelite Landscape*, Oxford, 1973

Stephens, Frederic George, *English Children as Painted by Sir Joshua Reynolds*, 1867

Stephens, Frederic George, *Artists at Home. Photographed by J.P. Mayall . . . with Biographical Notes and Descriptions by Frederic George Stephens*, 1884

Stephens, H.F., *Frederic George Stephens and the Pre-Raphaelite Brothers*, privately printed, 1920

Stevenson, R.A.M., 'Sir John Everett Millais, P.R.A.', *Art Journal*, vol. 60, January 1898

Story, Alfred T., *The Life of John Linnell*, 2 vols, 1892

Surtees, Virginia, ed., *Reflections of a Friendship. John Ruskin's Letters to Pauline Trevelyan, 1848–1866*, 1979

Surtees, Virginia, ed., *The Diaries of George Price Boyce*, 1980

Sussman, Herbert, *Victorian Masculinities: Manhood and Masculine Poetics in Early Victorian Literature and Art*, Cambridge, 1995

Sweeney, John L., ed., *The Painter's Eye. Notes and Essays on the Pictorial Arts by Henry James*, Cambridge, Massachusetts, 1956

Symons, Arthur, 'The Lesson of Millais', *The Savoy, an Illustrated Monthly*, no. 6, October 1896

Tennyson, Alfred, Lord, *Locksley Hall. Sixty years after*, 1886

Tennyson, Sir Charles, *Alfred Tennyson*, 1949

Tennyson, Hallam, Lord, *Alfred Lord Tennyson. A Memoir By His Son*, 2 vols, 1897

Thompson, F.M.L., *English Landed Society in the Nineteenth Century*, 1963

Thomas, Ralph, Jr, *Serjeant Ralph Thomas and Sir J.E. Millais, Bart., P.R.A.*, privately printed, 1901

Thwaite, Ann, *Emily Tennyson: The Poet's Wife*, 1996

Underhill, John, 'Character Sketch: Sir John Everett Millais, Bart., R.A.', *Review of Reviews*, vol. 11, April 1895

Veblen, Thorstein, *The Theory of the Leisure Class: An Economic Study of Institutions*, 1899; with intro. by C. Wright Mills, 1925; repr. 1970

Ward-Jackson, Philip, 'Lord Ronald Gower, the Shakespeare Memorial and the Wilde Era of London and Paris', *European Gay Review*, 1987

Warner, Malcolm, *The Drawings of John Everett Millais*, exh. cat., Arts Council of Great Britain, 1979

Warner, Malcolm, 'John Everett Millais's *Autumn Leaves*: "a picture full of beauty and without subject"', in Leslie Parris, ed., *Pre-Raphaelite Papers*, 1984

Watson, J.N.P., *Millais. Three generations in nature, art, and sport*, 1988

Watts, G.F., *The Hall of Fame*, National Portrait Gallery, 1975

Watts, M.S., *George Frederic Watts*, 1912

Wedmore, Frederick, *Memories*, 1912

Wilde, Oscar, *The Picture of Dorian Gray*, 1891; repr. Penguin, 1985

Wilson, D.A. and D.W. MacArthur, *Carlyle in Old Age*, 1934

Wilton, Andrew, *The Swagger Portrait. Grand Manner Portraiture in Britain from Van Dyck to Augustus John 1630–1930*, exh. cat., Tate Gallery, 1992

Woodall, Joanna, ed., *Portraiture: Facing the Subject*, Manchester and New York, 1997

Woolner, Amy, *Thomas Woolner, R.A. Sculptor and Poet. His Life in Letters*, 1917

Young, Patience, 'Millais' *Leisure Hours*', *Bulletin of the Detroit Institute of Arts*, vol. 58, 1980

PICTURE CREDITS

The National Portrait Gallery is grateful to A.A. Barnes Photography for photographing a number of the works illustrated in this book.

The publisher would also like to thank the copyright holders for kindly giving permission to reproduce the works illustrated in this book. Locations and lenders are given in the captions, and further acknowledgements are given below. Every effort has been made to contact copyright holders; any omissions are inadvertent, and will be corrected in future editions if notification is given to the publisher in writing.

INDEX

Page numbers in **bold** refer to catalogue entries of works exhibited, all of which are illustrated. Page numbers in *italic* refer to other illustrations.